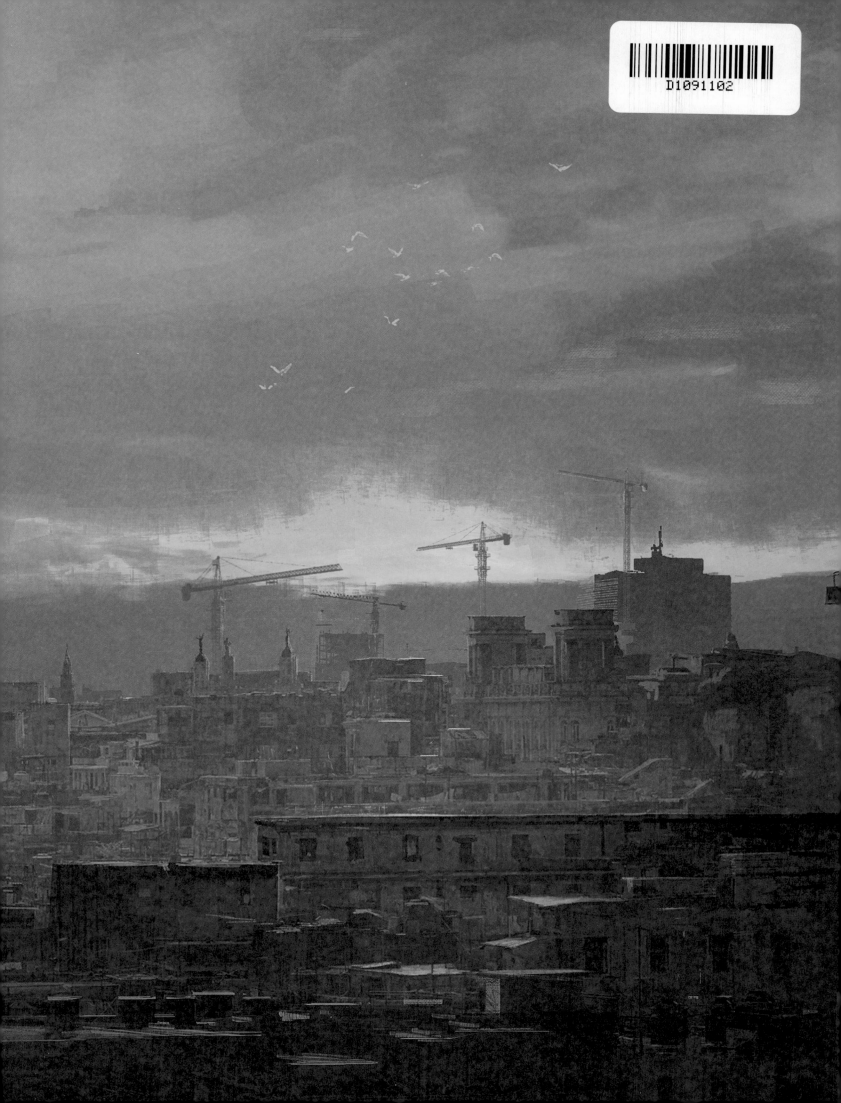

DARK HORSE BOOKS

Mike Richardson — Publisher
Ian Tucker — Editor
Brett Israel — Associate Editor
David Nestelle — Designer
Special Thanks to Allyson Haller, Chris Horn, and Ann Gray.

THE ART OF FAR CRY 6

Published by Dark Horse Books
A division of Dark Horse Comics LLC
10956 SE Main Street
Milwaukie, OR 97222

DarkHorse.com
Library of Congress Cataloging-in-Publication Data

Names: Ubisoft (Firm)
Title: The art of Far Cry 6 / Ubisoft.
Description: First edition. | Milwaukie : Dark Horse Books, [2021] |
 Summary: "Ubisoft's hit series, Far Cry returns in the newest
 installment, Far Cry: Tetra! The country of Yara is under tyrannical
 rule as Anton Castillo aims for a utopian society. However, only the
 elite will be allowed in the paradise he creates and the rest are forced
 into labor camps. And here is where the Guerrilla Revolution is born.
 Dark Horse Books and Ubisoft team up for The Art of Far Cry: Tetra, a
 beautiful full-color hardcover that is perfect for new and old fans of
 the Far Cry franchise"– Provided by publisher.
Identifiers: LCCN 2020032061 | ISBN 9781506724348 (hardcover) | ISBN
 9781506724355 (epub)
Subjects: LCSH: Far Cry (Game) | Video game–Design. | Computer art.
Classification: LCC GV1469.35.F37 A76 2021 | DDC 794.8/166–dc23
LC record available at https://lccn.loc.gov/2020032061

First edition: October 2021
Ebook ISBN 978-1-50672-435-5
Hardcover ISBN 978-1-50672-434-8

10 9 8 7 6 5 4 3 2 1
Printed in China

THE ART OF FARCRY6

DARK HORSE BOOKS

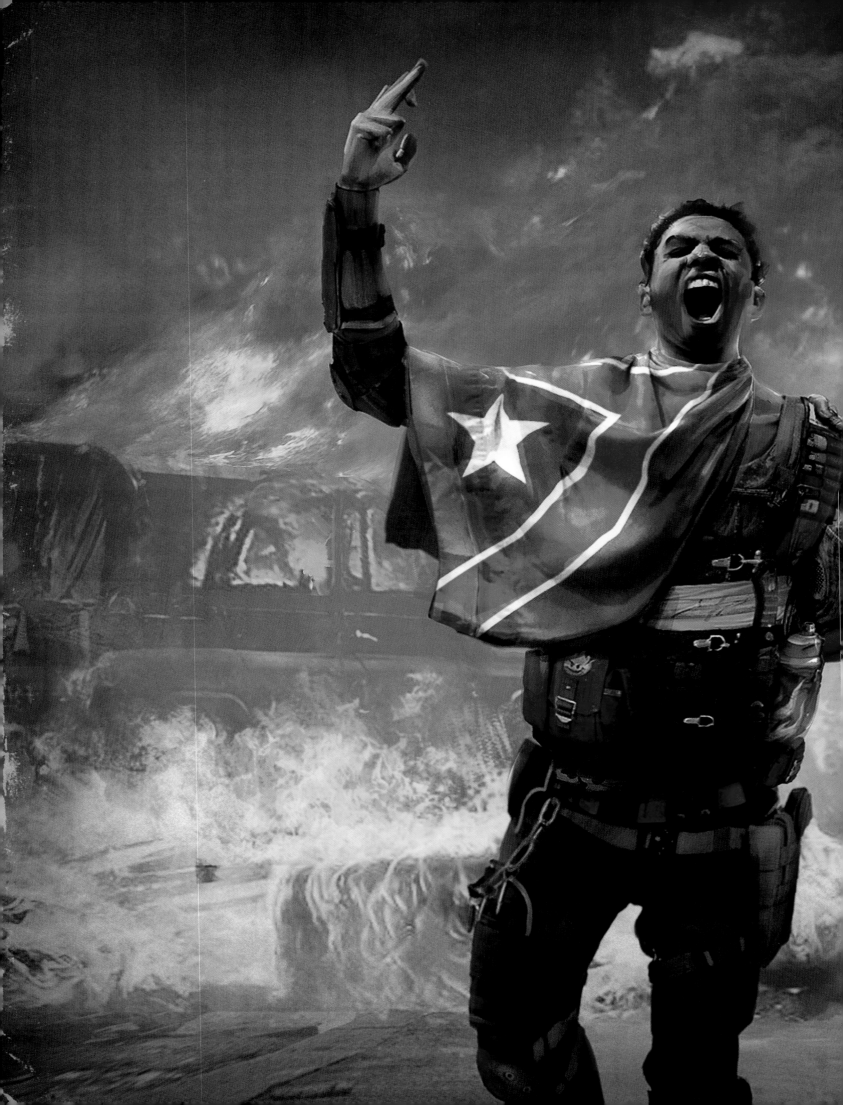

CONTENTS

IGNITING THE REVOLUTION

Years ago, when we started our journey on *Far Cry 6*, the team had an enormous challenge ahead of them. How would they create something fresh for fans and new players while building on the exotic worlds and bold characters from previous games in the *Far Cry* brand? We first needed our inviting paradise. After much research into the rich history and beauty of Cuba, we found it to be the perfect inspiration for Yara, an island frozen in time. This location became the backdrop for our story, where the player, Dani, becomes entwined in the conflict between Antón Castillo's authoritarian regime and the guerrillas of Libertad. Even though Cuba was our main source of inspiration, we always looked to neighbors in the Caribbean or South America for other ideas. Authenticity is important to build a rich, immersive world such as Yara, and Latin America has so many elements to pull ideas from.

When building the vision and foundations for the art direction, we

To build our paradise we needed to push the variety in our architecture, biomes, and wildlife while always looking for opportunities to surprise the player with something new and exotic. Opposition (or contrast) is important because it creates something unique and inviting to explore. It can be seen in the difference between Libertad's gear and weapons and the uniformity of Antón's military. *Resolver* is a way of life in Yara and is the spice of our game. With a little ingenuity, the player can access a wide assortment of unique weapons, gadgets, and vehicles, all crafted from everyday household items. Finally, we focused on authenticity, which is really the secret for building immersive worlds. We wanted to create a history for our island and build layers of details to add to the rich narrative and ground Yara in reality. With Cuba we were inspired by the history of the proud and resilient people, the beauty of the classic cars, and the variety of the architecture, some of it modern and some in a state of beautiful decay.

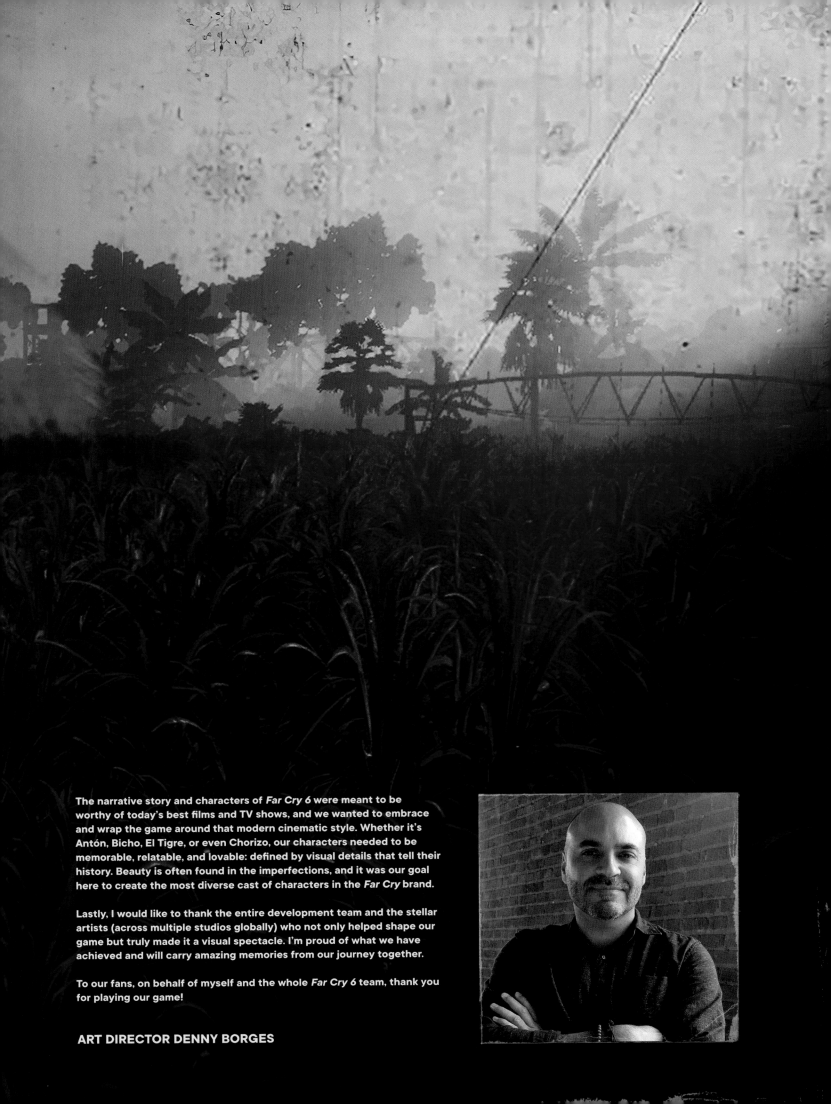

The narrative story and characters of *Far Cry 6* were meant to be worthy of today's best films and TV shows, and we wanted to embrace and wrap the game around that modern cinematic style. Whether it's Antón, Bicho, El Tigre, or even Chorizo, our characters needed to be memorable, relatable, and lovable: defined by visual details that tell their history. Beauty is often found in the imperfections, and it was our goal here to create the most diverse cast of characters in the *Far Cry* brand.

Lastly, I would like to thank the entire development team and the stellar artists (across multiple studios globally) who not only helped shape our game but truly made it a visual spectacle. I'm proud of what we have achieved and will carry amazing memories from our journey together.

To our fans, on behalf of myself and the whole *Far Cry 6* team, thank you for playing our game!

ART DIRECTOR DENNY BORGES

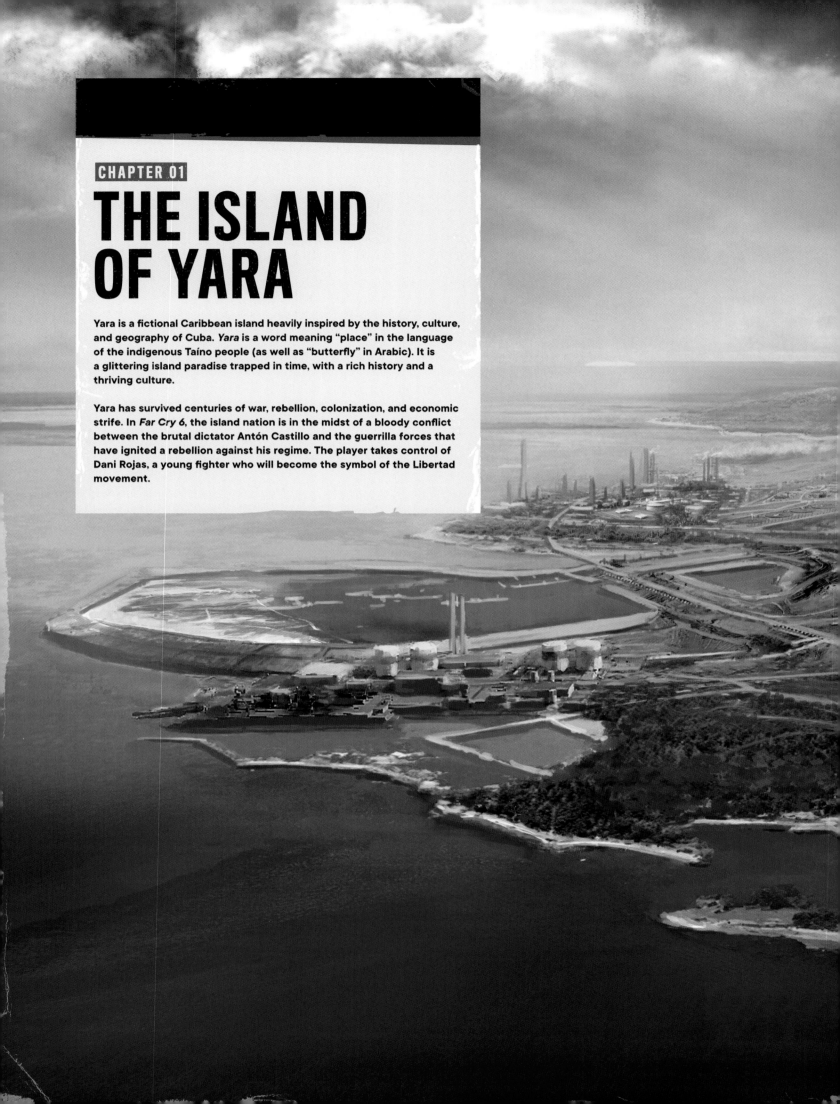

THE ISLAND OF YARA

Yara is a fictional Caribbean island heavily inspired by the history, culture, and geography of Cuba. *Yara* is a word meaning "place" in the language of the indigenous Taíno people (as well as "butterfly" in Arabic). It is a glittering island paradise trapped in time, with a rich history and a thriving culture.

Yara has survived centuries of war, rebellion, colonization, and economic strife. In *Far Cry 6*, the island nation is in the midst of a bloody conflict between the brutal dictator Antón Castillo and the guerrilla forces that have ignited a rebellion against his regime. The player takes control of Dani Rojas, a young fighter who will become the symbol of the Libertad movement.

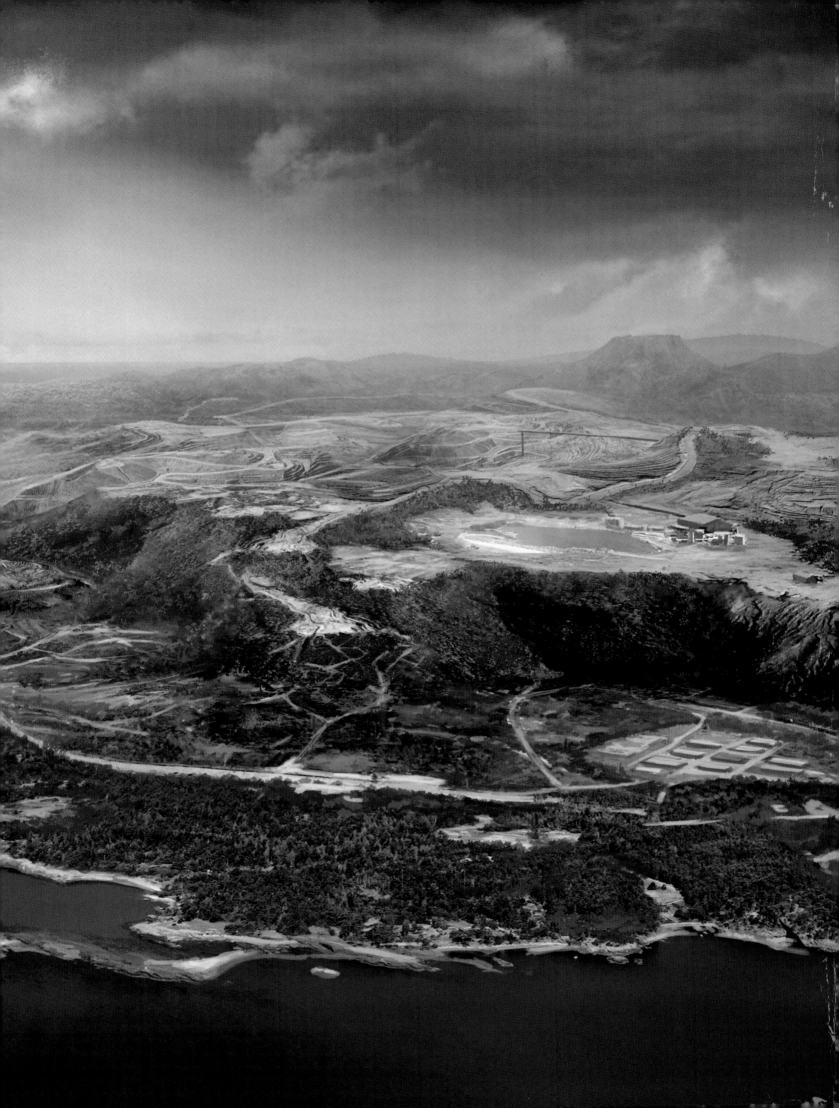

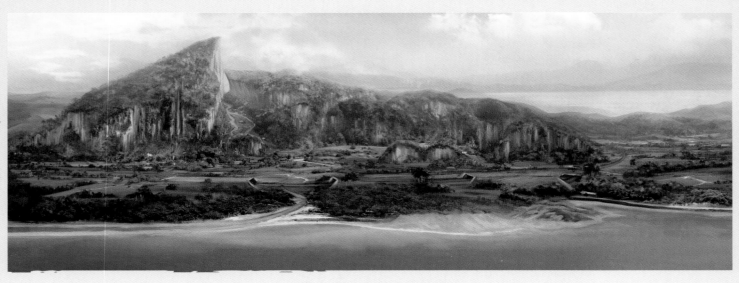

The peak of this mountain was drawn in the shape of a shark's fin.

ISLAND BIOMES

Yara is a lush tropical island paradise with diverse geography, including towering *mogote* hills, sparkling beaches, humid jungles, swampy marshlands, and open agricultural plains.

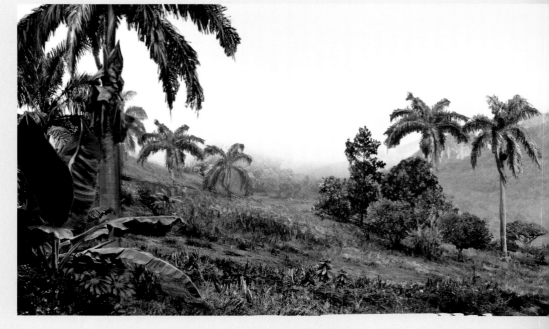

A cross-section exploration of the shoreline and coral reefs guides the team to the desired look.

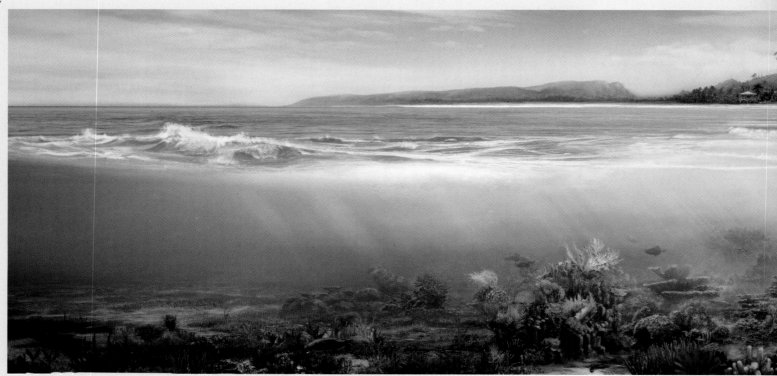

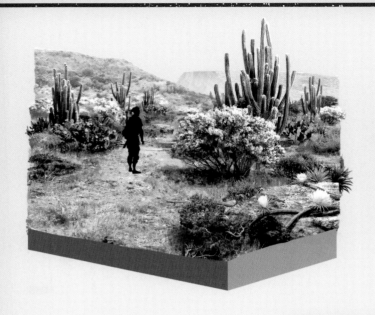
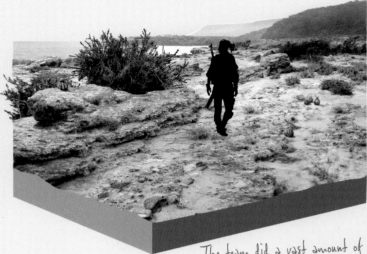

The team did a vast amount of research to bring a wide variety of biomes to Yara.

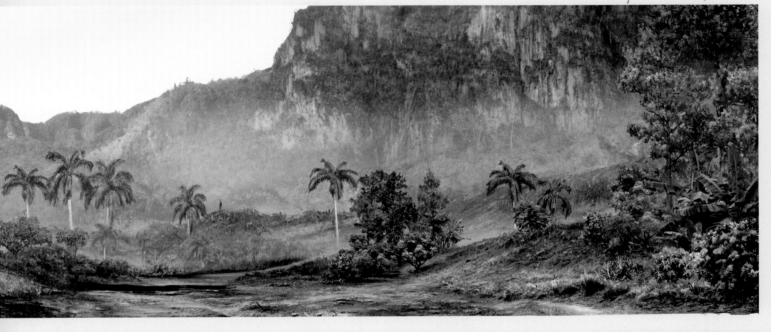

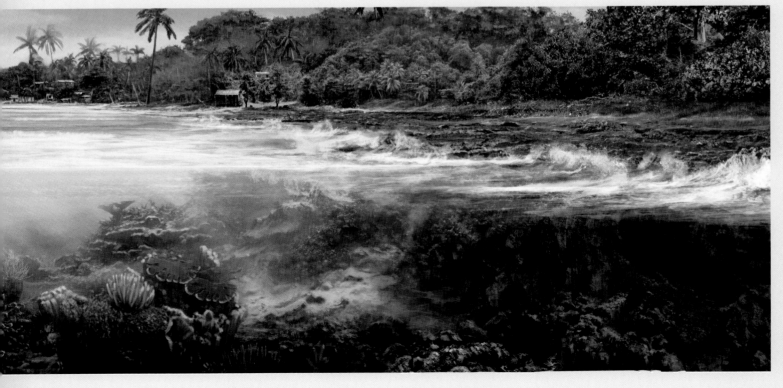

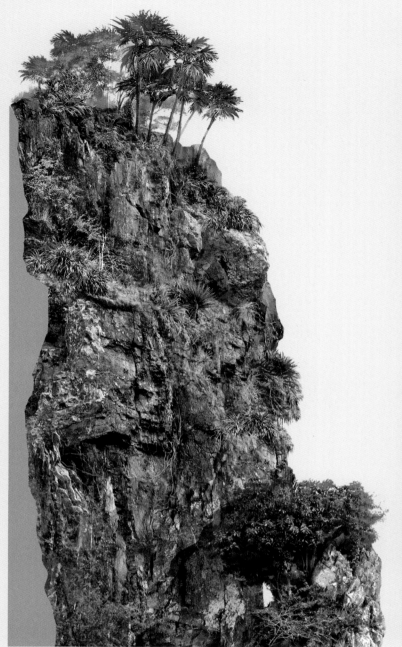

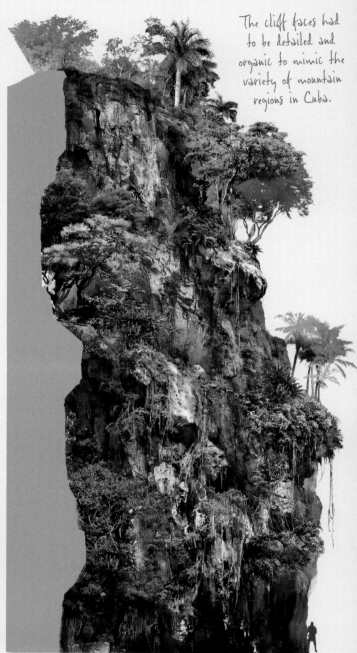

The cliff faces had to be detailed and organic to mimic the variety of mountain regions in Cuba.

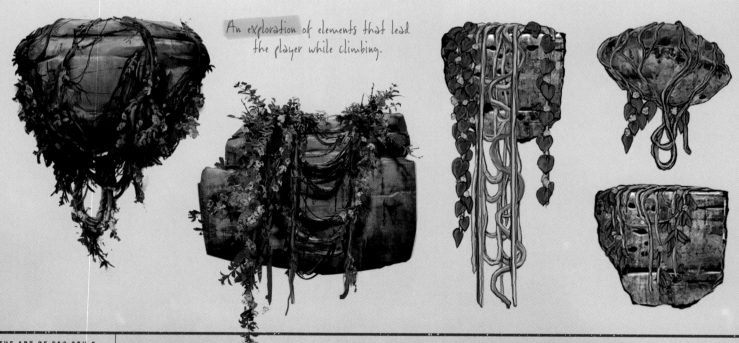

An exploration of elements that lead the player while climbing.

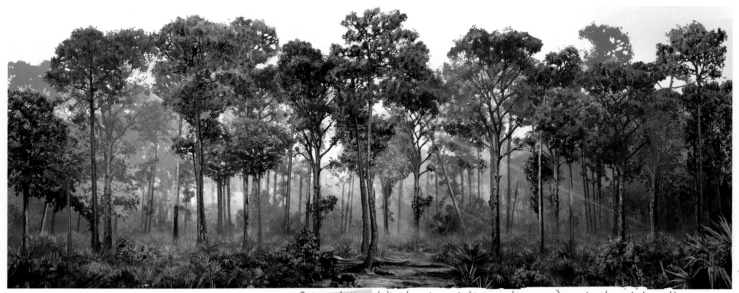

Quick studies of light and mood through the game's moderate and dense biomes.

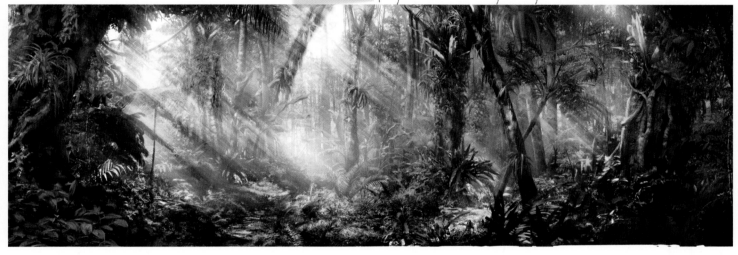

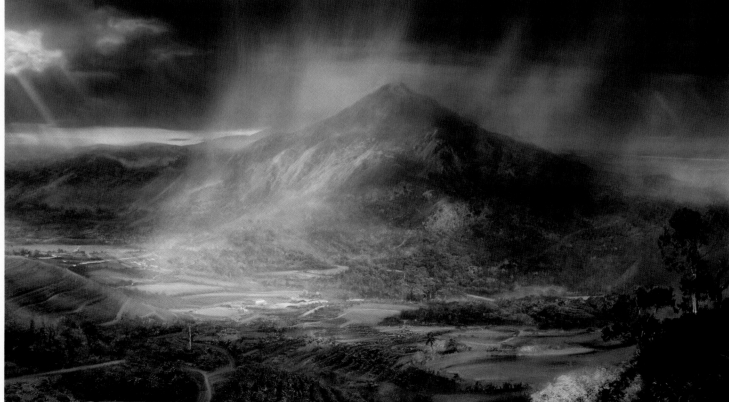

These concepts are also about shape languages that will pull the player in and make them want to explore.

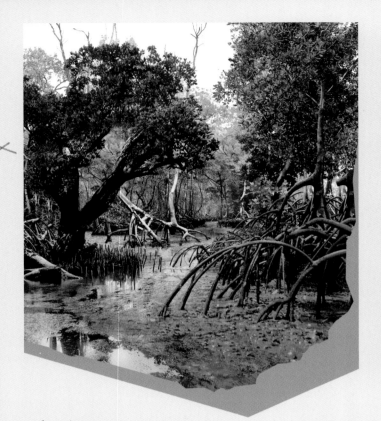

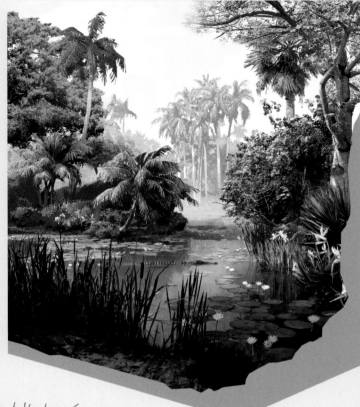

From the mangroves of the Balaceras swamps to the red limestone soil of the Lozanía fields, the team gave players various new and authentic environments to explore.

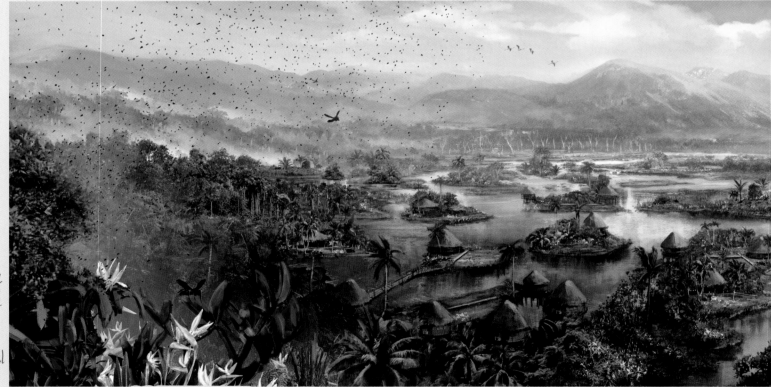

A slice of the island spanning from the agricultural lands in Madrugada to the waterways in Valle de Oro.

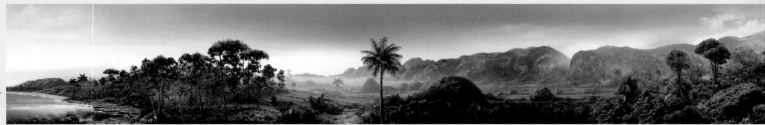

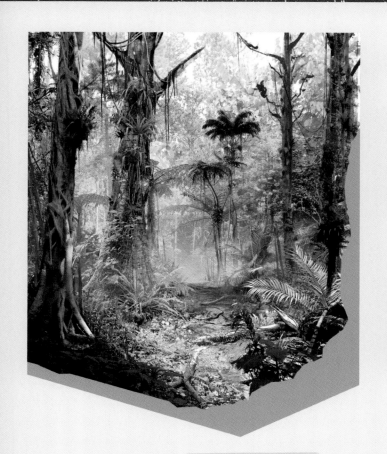

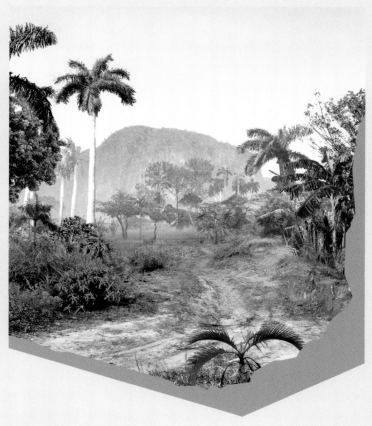

These concepts present slices of the world. It was ensured that lots of variety was created across the island of Yara.

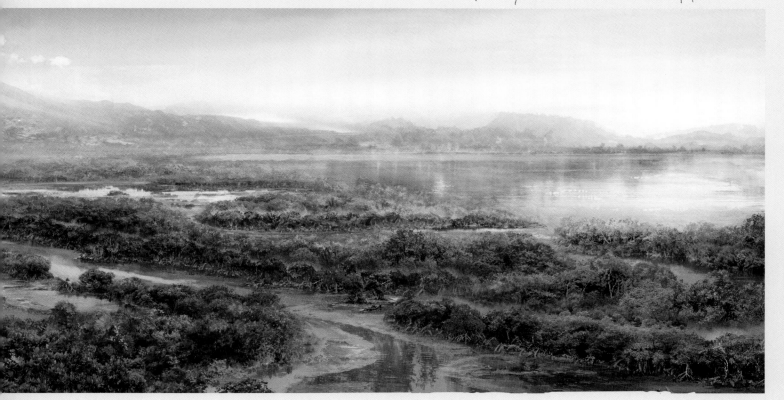

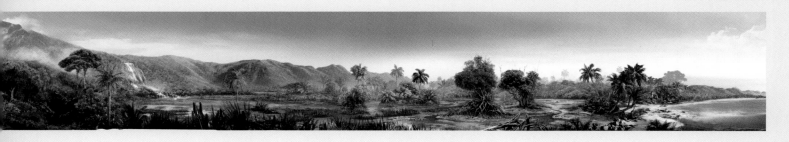

The beaches are left wild to offer detail and natural beauty.

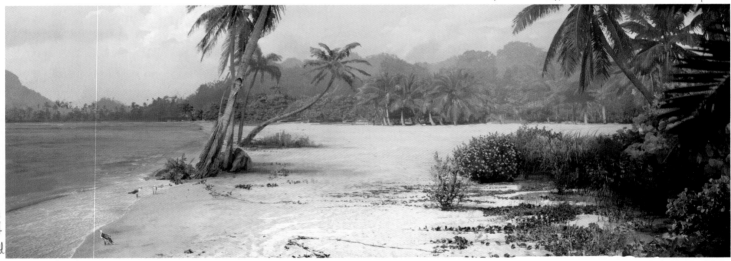

Quick weather studies that were executed to nail the subtle weather shifts.

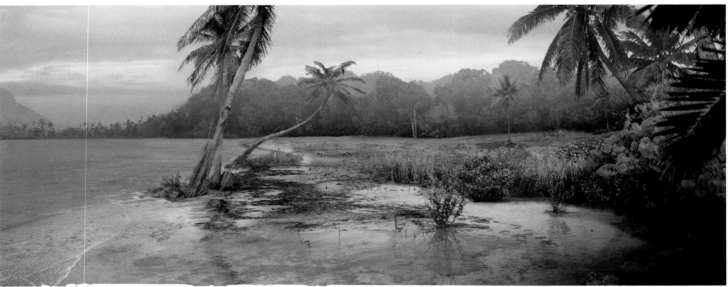

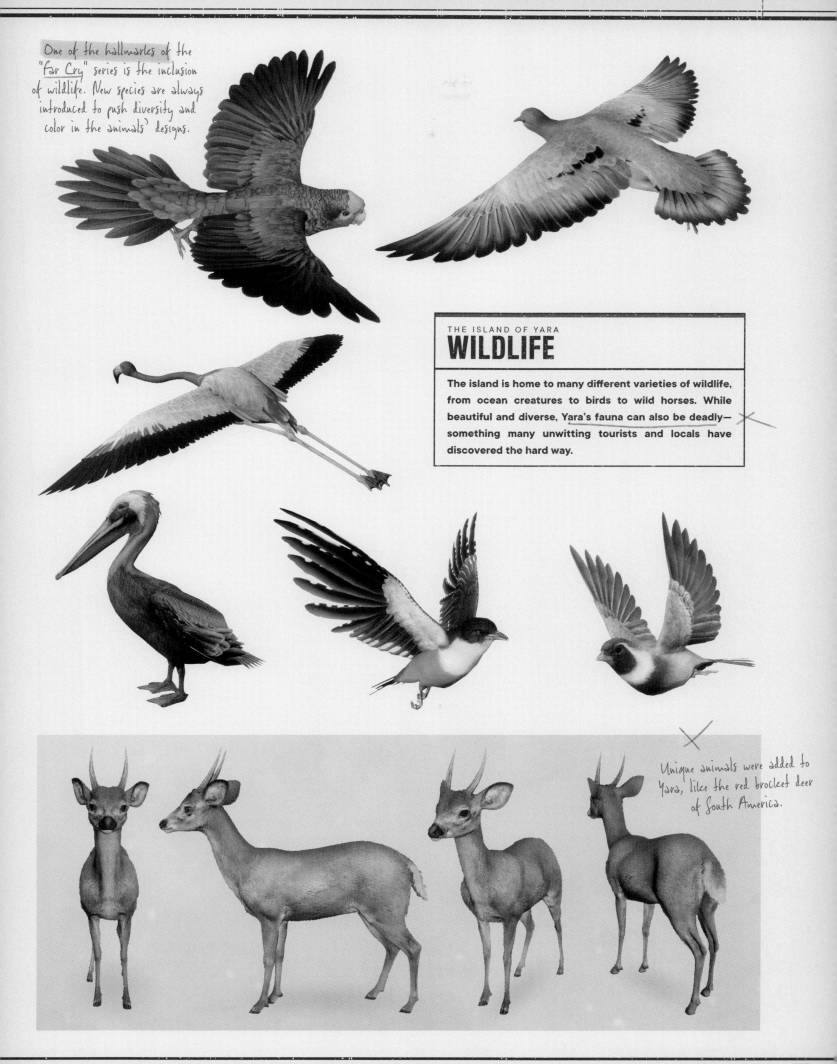

One of the hallmarks of the "Far Cry" series is the inclusion of wildlife. New species are always introduced to push diversity and color in the animals' designs.

THE ISLAND OF YARA
WILDLIFE

The island is home to many different varieties of wildlife, from ocean creatures to birds to wild horses. While beautiful and diverse, Yara's fauna can also be deadly—something many unwitting tourists and locals have discovered the hard way.

Unique animals were added to Yara, like the red brocket deer of South America.

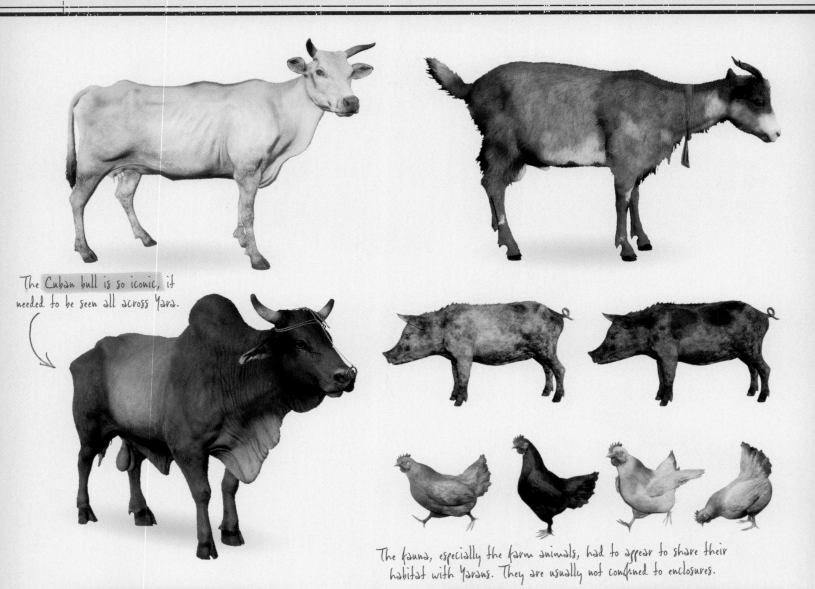

The Cuban bull is so iconic, it needed to be seen all across Yara.

The fauna, especially the farm animals, had to appear to share their habitat with Yarans. They are usually not confined to enclosures.

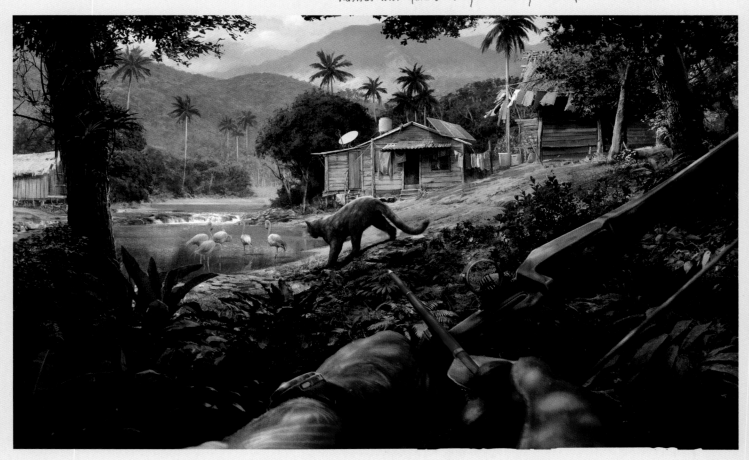

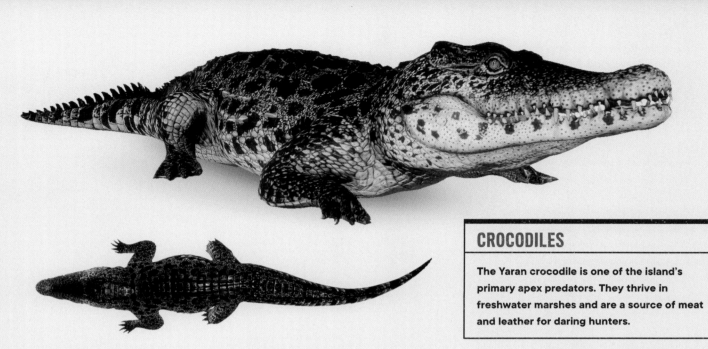

CROCODILES

The Yaran crocodile is one of the island's primary apex predators. They thrive in freshwater marshes and are a source of meat and leather for daring hunters.

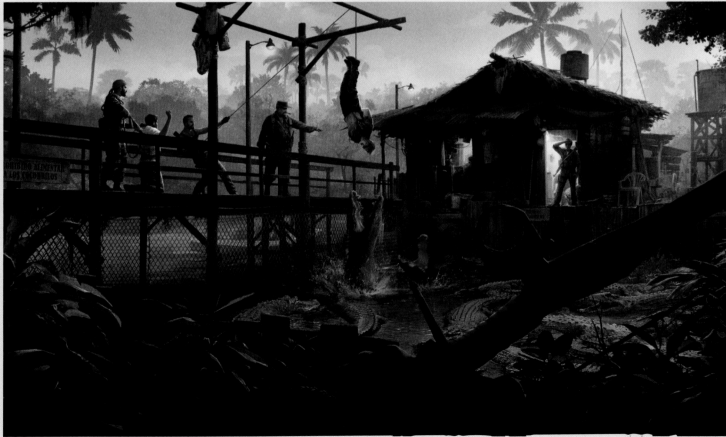

This concept was the inspiration for the introduction to Máximas Matanzas.

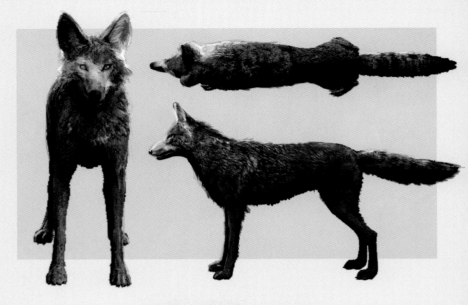

THE ISLAND OF YARA
LEGENDARY ANIMALS

There are monsters dwelling deep in the jungles and swamps of Yara that are only spoken of in frightened whispers—monsters whose names are legend. Whether manmade monstrosity, cheap carnival trick, or true supernatural beast, all of these creatures are more than a match for an average hunter.

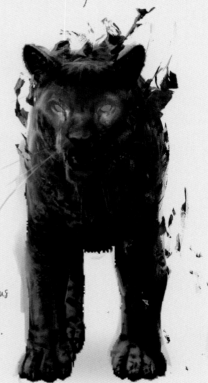

The mysterious Triada cat called Oluso.

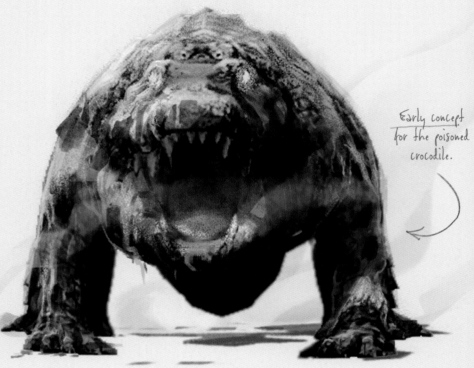

Early concept for the poisoned crocodile.

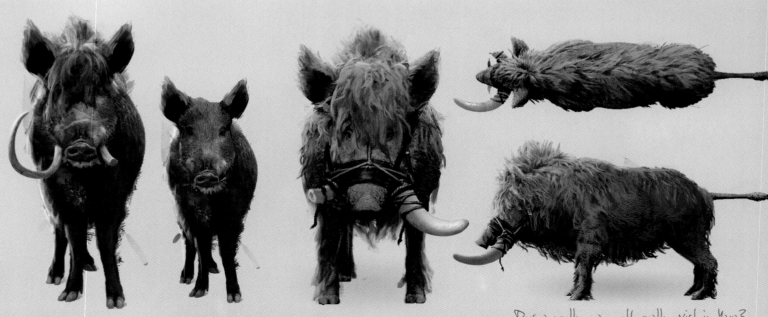

Does a woolly mammoth really exist in Yara?

THE ISLAND OF YARA
CIVILIANS

Yara's citizens are proud, industrious, and resourceful, finding creative solutions to complex problems, and surviving by making use of whatever they have at hand—a philosophy they call *resolver*. Music, car culture, and sports (especially boxing and baseball) are their most popular pastimes. Vital tourist income has disappeared under Castillo's reign, increasing the class and wealth divide that was already threatening to tear the country in half.

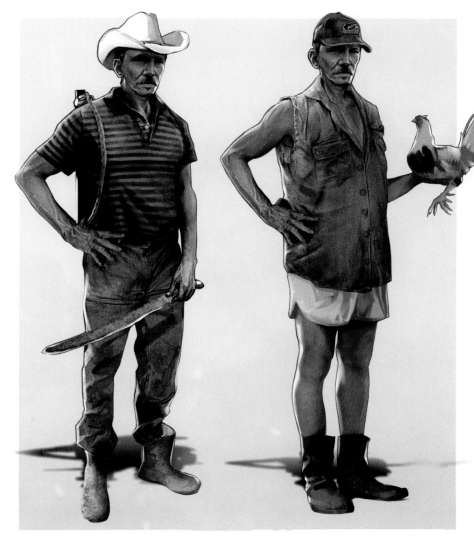

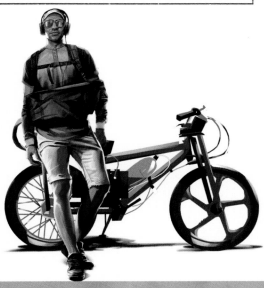

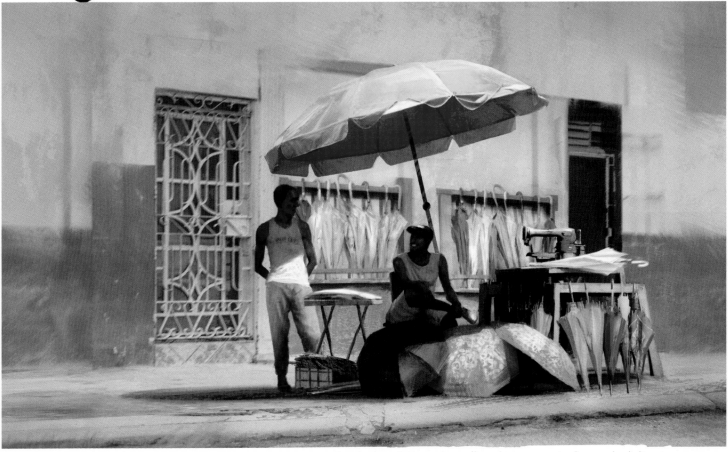

Concept art of curbside vendors selling their wares in the heat of the day.

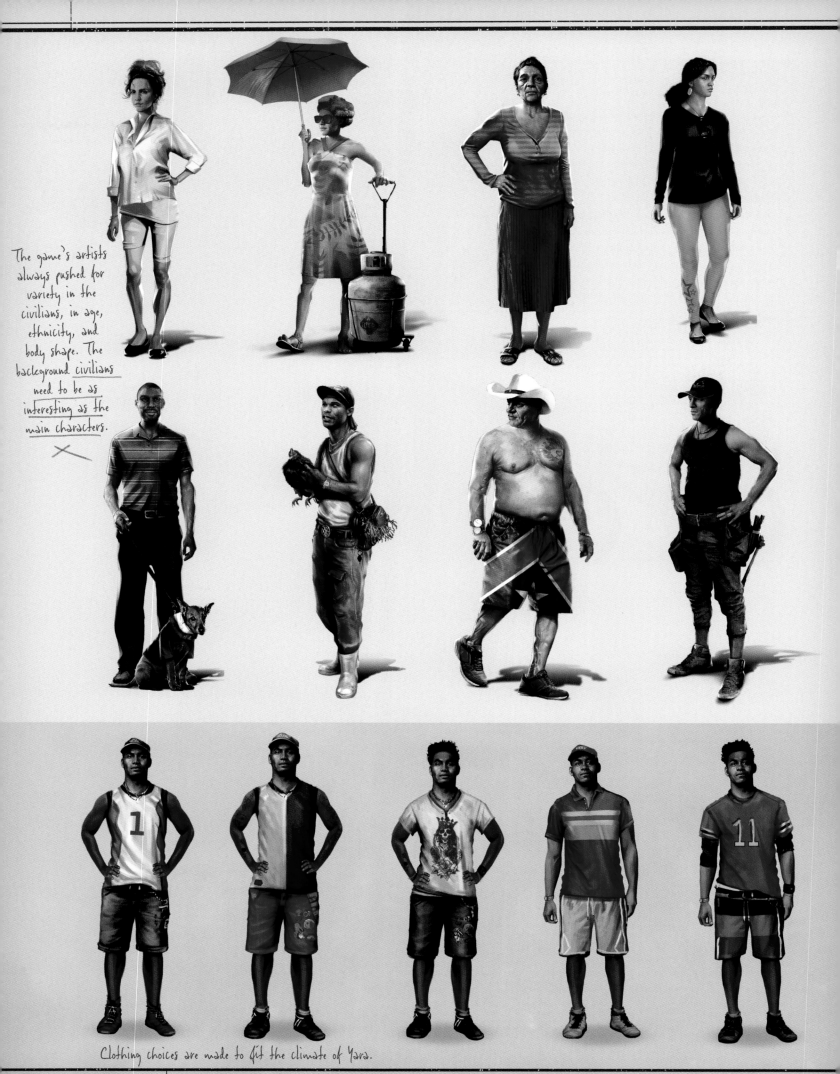

The game's artists always pushed for variety in the civilians, in age, ethnicity, and body shape. The background civilians need to be as interesting as the main characters.

Clothing choices are made to fit the climate of Yara.

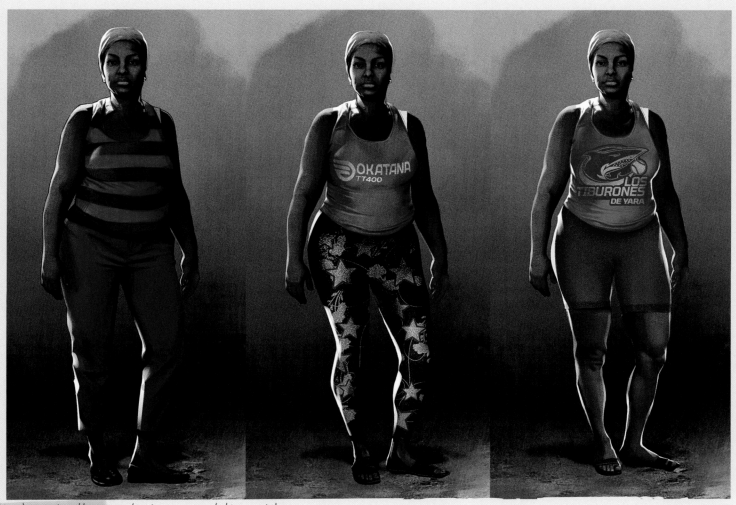

Bold colors and patterns are found on many of the proud Yarans.

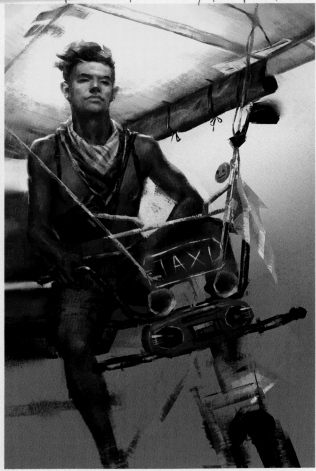

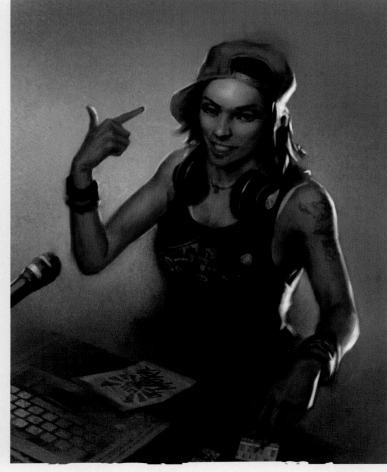

Yarans will make do with what they have and experiment with their fashion. Self-expression is important.

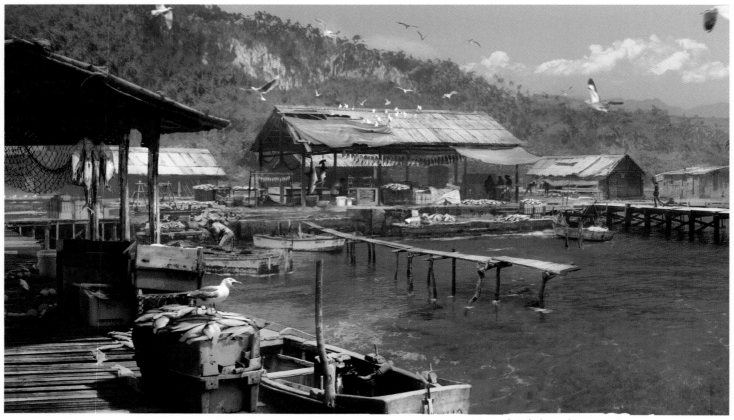

× Concept art for a Yaran harbor.

FISHING

Both a key industry and a leisure activity, fishing is synonymous with life for many Yarans. The military naval blockade imposed by Castillo has crippled this industry by disrupting marine habitats, which has forced many locals to seek alternative employment.

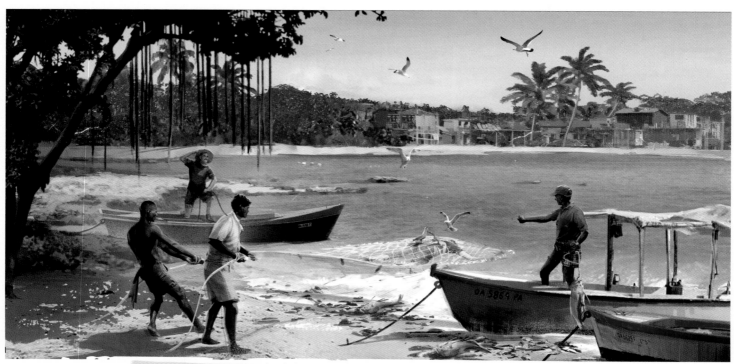

A picture-postcard paradise that turns out to be something else when examined closer: a typical "Far Cry" experience.

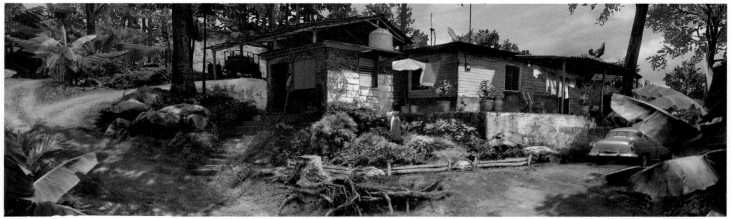

A mountain home in El Este.

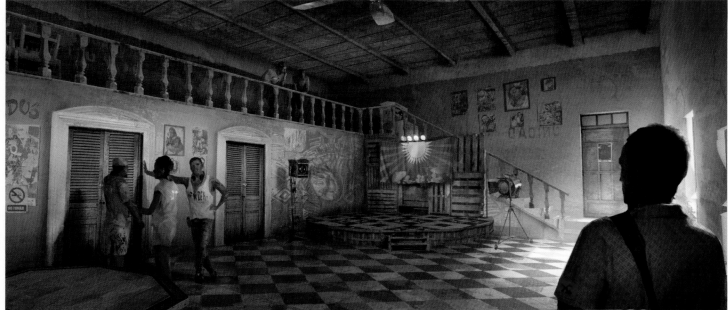

Homes are made colorful to stand out against the lush backdrops. The color palette is inspired by the farm homes and interiors of Cuba.

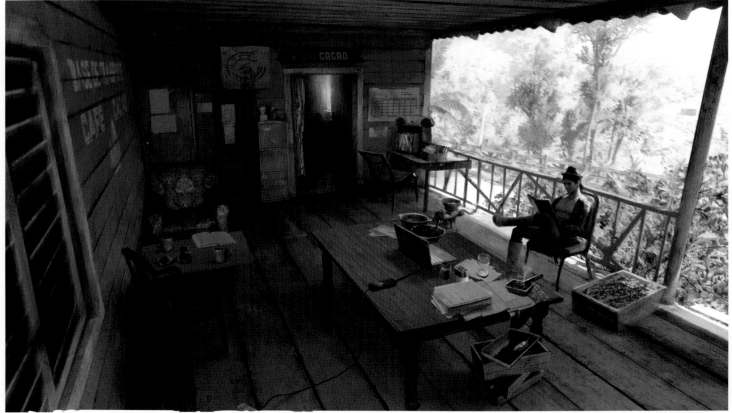

Yarans often do business from the front of their homes for maximum exposure.

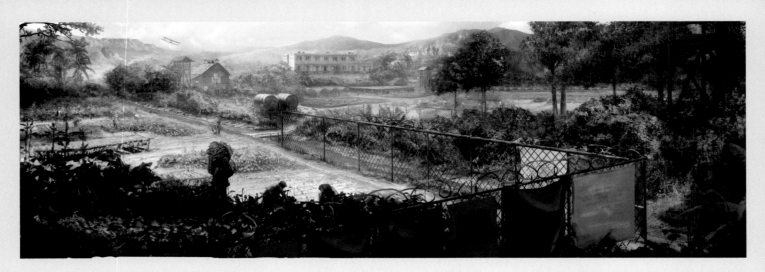

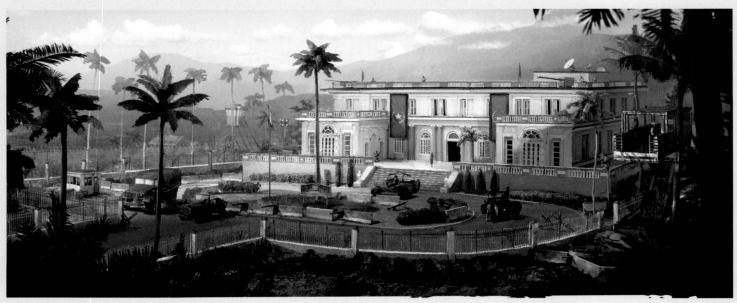

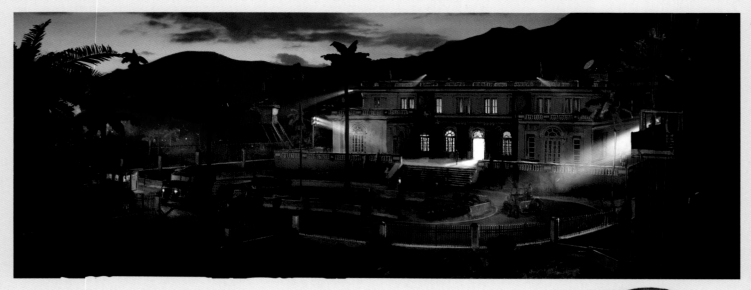

CIGAR FACTORY

The ancestral home of the Castillo family, this plantation is used for Viviro operations supervised by General José Castillo.

HEALING CIGAR

Sometimes you just need a cigar on hand to cauterize a small wound.

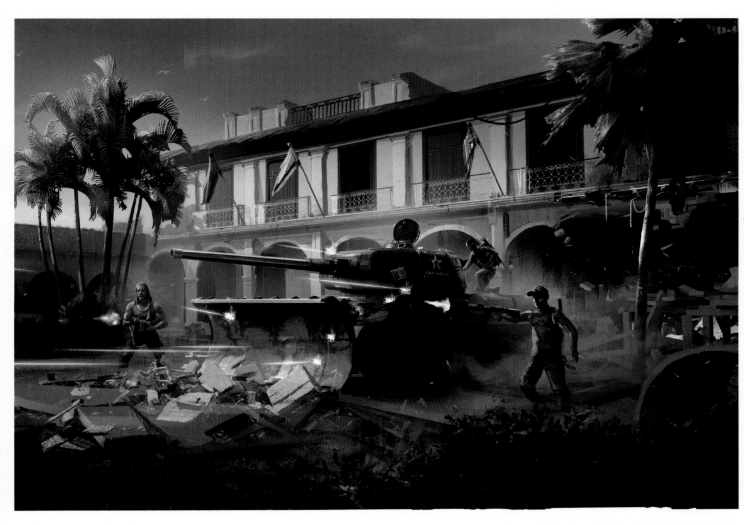

An early concept for one of the missions in El Este, featuring an "old friend."

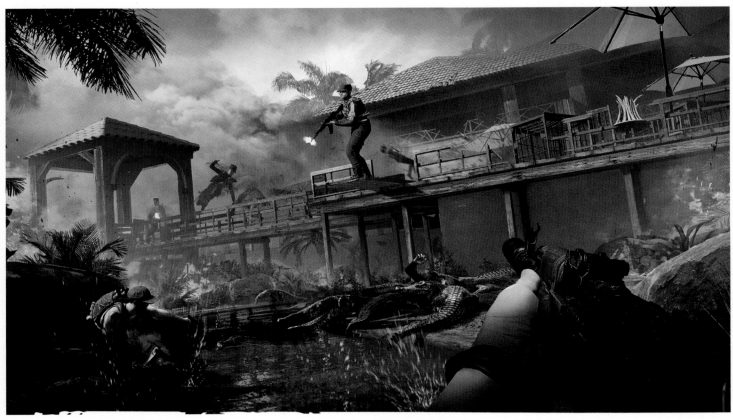

Dynamic storytelling in the concepts is key to showing the chaos and emotion the art team looks for. This one is for a special operation. Geele Lola.

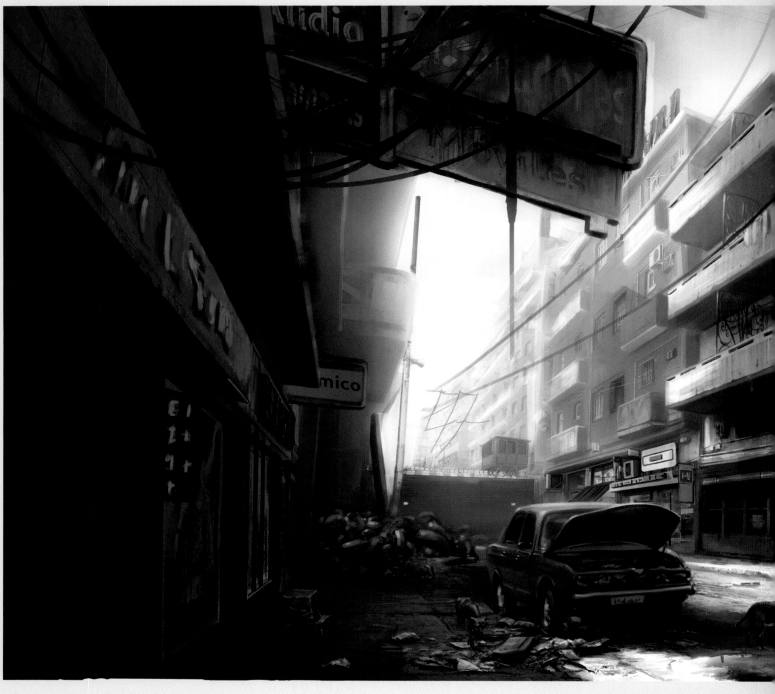

THE ISLAND OF YARA
THE CITY

Yara's capital city, Esperanza, is modeled on the Cuban capital of Havana. It is a sprawling urban center splashed with color, life, and culture. Its distinctly beautiful historical architecture hides a crumbling infrastructure that threatens to collapse entirely under the city's forced military occupation. The Torre del León, Antón Castillo's seat of power, dominates the city skyline and overlooks his many supporters who live there.

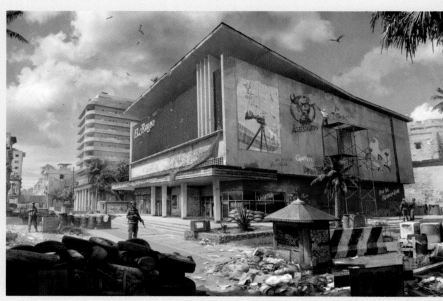

The iconic cinema house in Esperanza saw better days before the conflict. Antón's oppression extends to the arts.

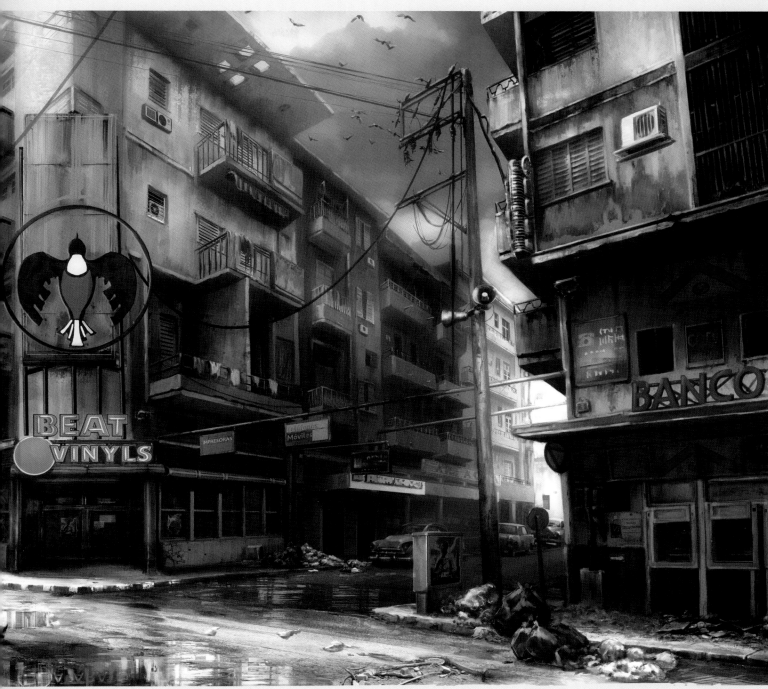

A once bustling city corner now lies abandoned, a testament to both lost lives and lost dreams.

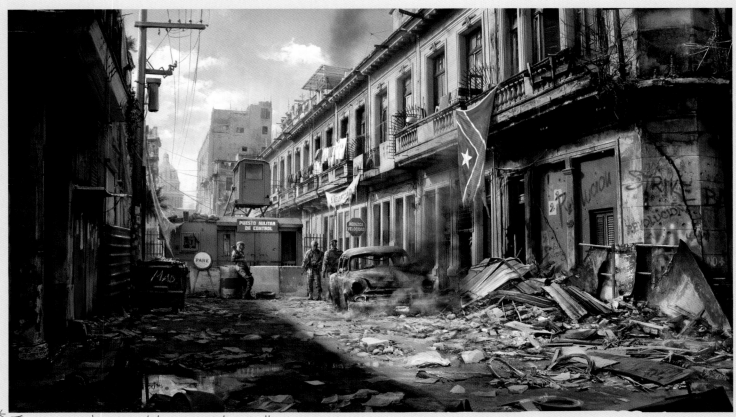

✳ These scenes explore some of the checkpoints and alleys seen in Esperanza.

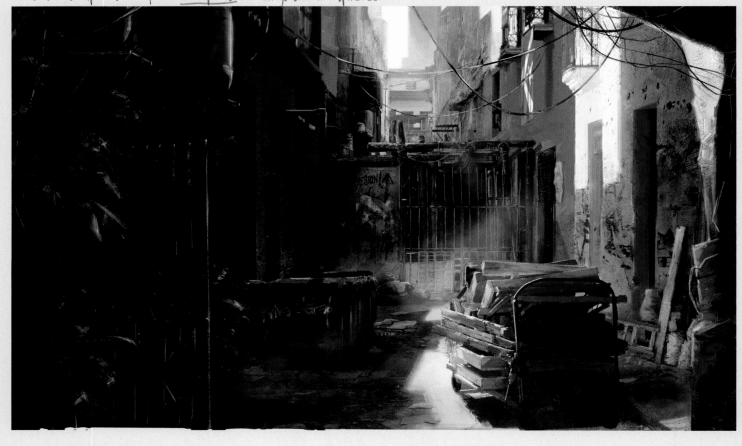

Many of the back alleys in Esperanza are in need of repair and represent the decay of the city. These details are needed to sell the "frozen-in-time" atmosphere the creative team wanted to achieve.

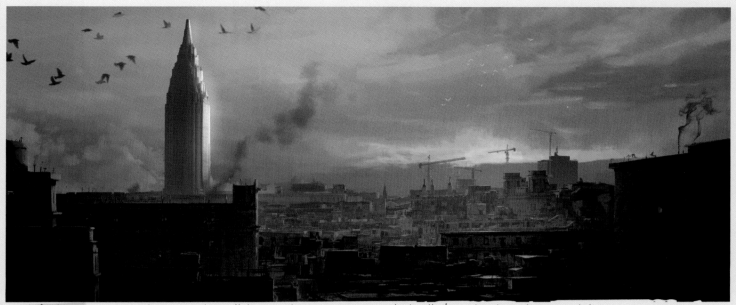

Antón's tower, inspired by the shape of a bullet, needs to be grand and visible to all. Here it catches the rays of the morning.

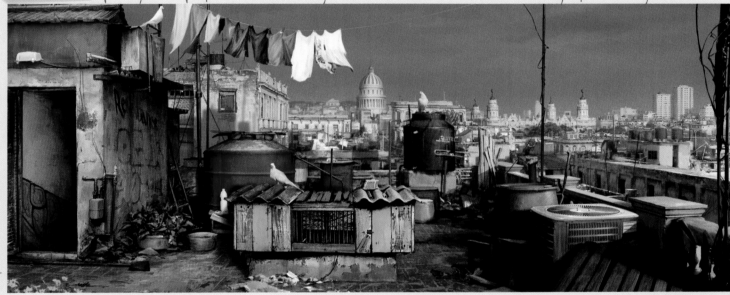

Early exploration for rooftops and the city skyline.

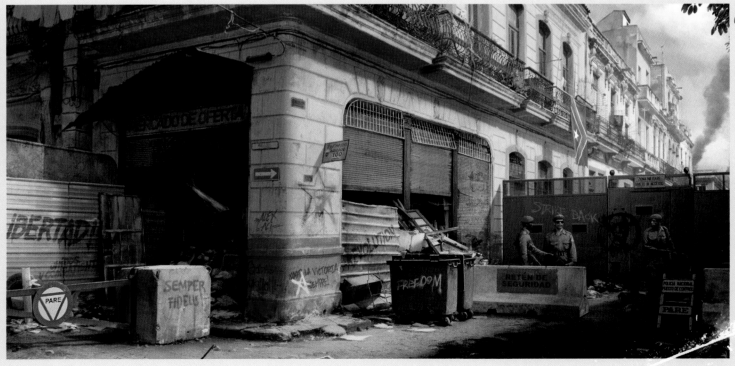

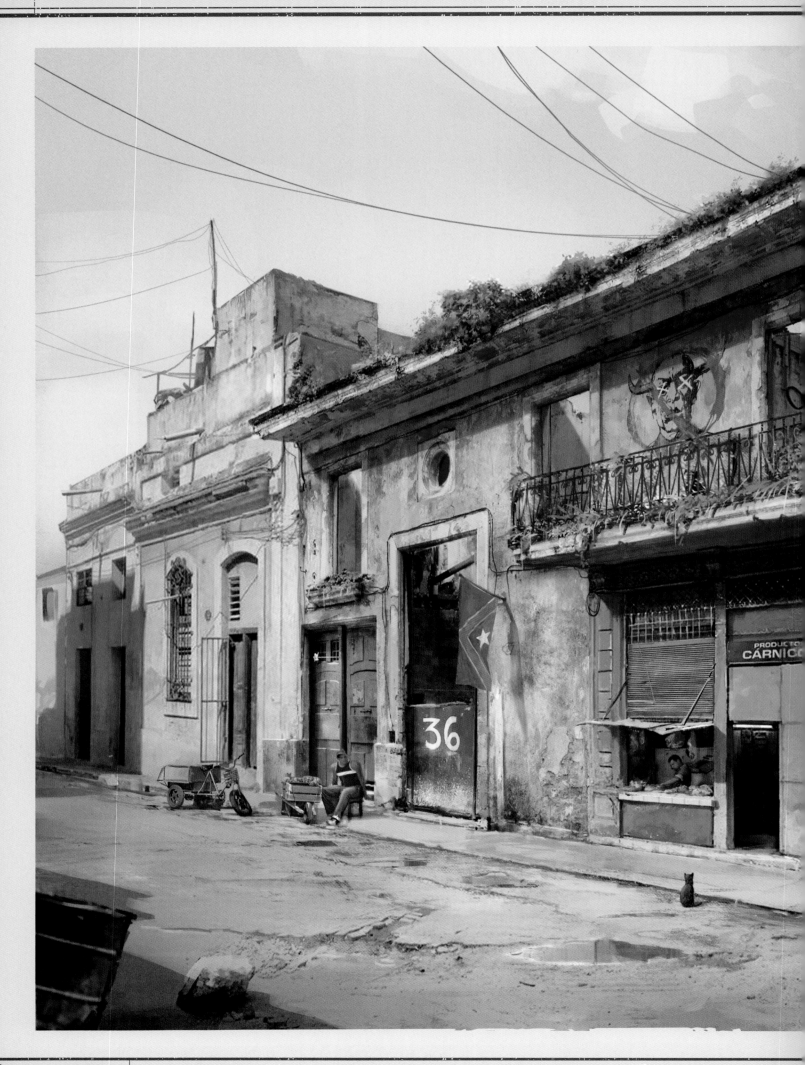

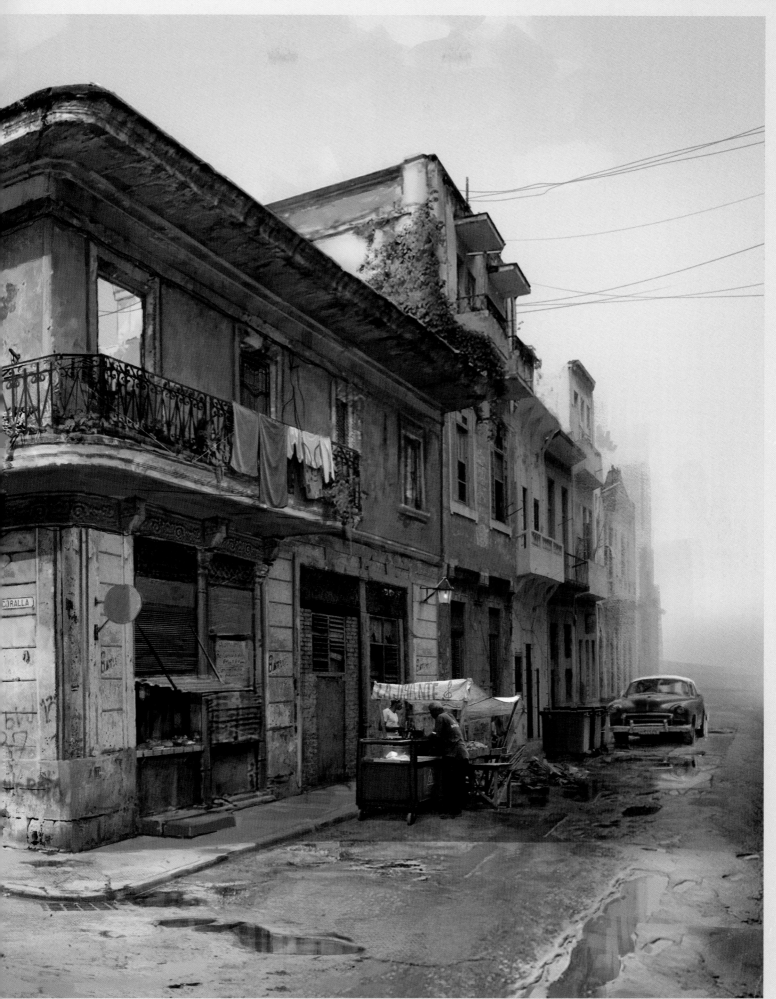

On this island frozen in time, Yara's buildings are in a constant state of decay. Beauty is always found in the imperfect.

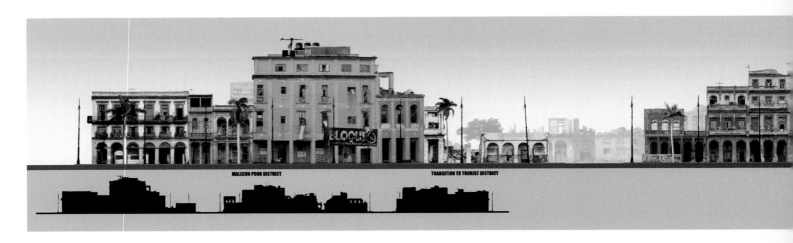

MALECON POOR DISTRICT

TRANSITION TO TOURIST DISTRICT

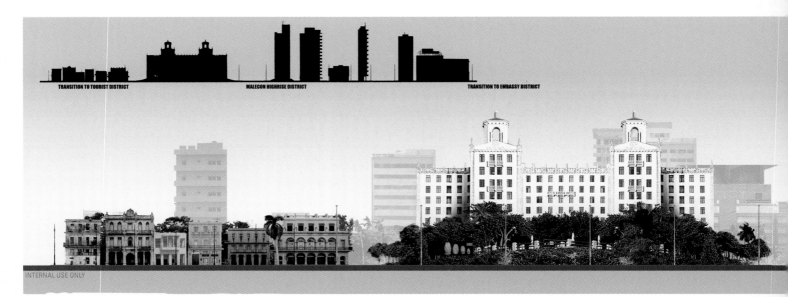

TRANSITION TO POOR DISTRICT

MALECON TOURIST DISTRICT

TRANSITION TO HIGHRISE DISTRICT

TRANSITION TO TOURIST DISTRICT

MALECON HIGHRISE DISTRICT

TRANSITION TO EMBASSY DISTRICT

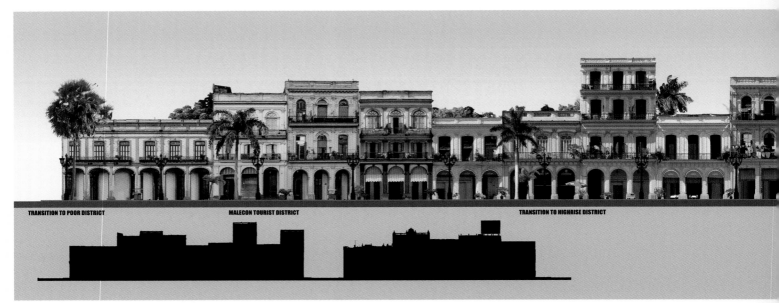

INTERNAL USE ONLY

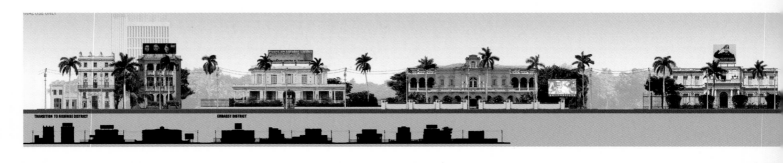

TRANSITION TO HIGHRISE DISTRICT

EMBASSY DISTRICT

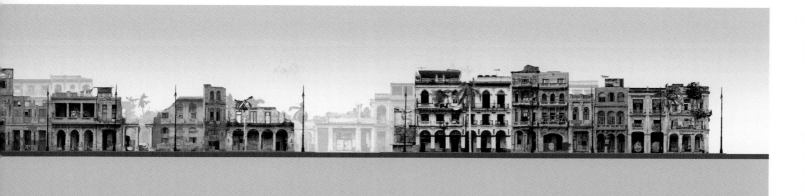

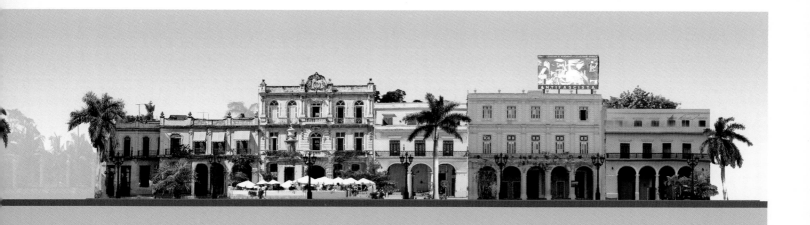

COSTANERA DISTRICT

This coastal highway trailing the northern edge of Esperanza is inspired by Havana's Malecón and was a popular tourist destination, pedestrian thoroughfare, and residential district before Castillo locked Yara's borders. The bright pastel façades of its historic buildings can no longer be appreciated by travelers.

The various districts in Esperanza showcase areas of wealth and modernity, and areas of erosion and ruin. Antón promises to rebuild paradise at any cost.

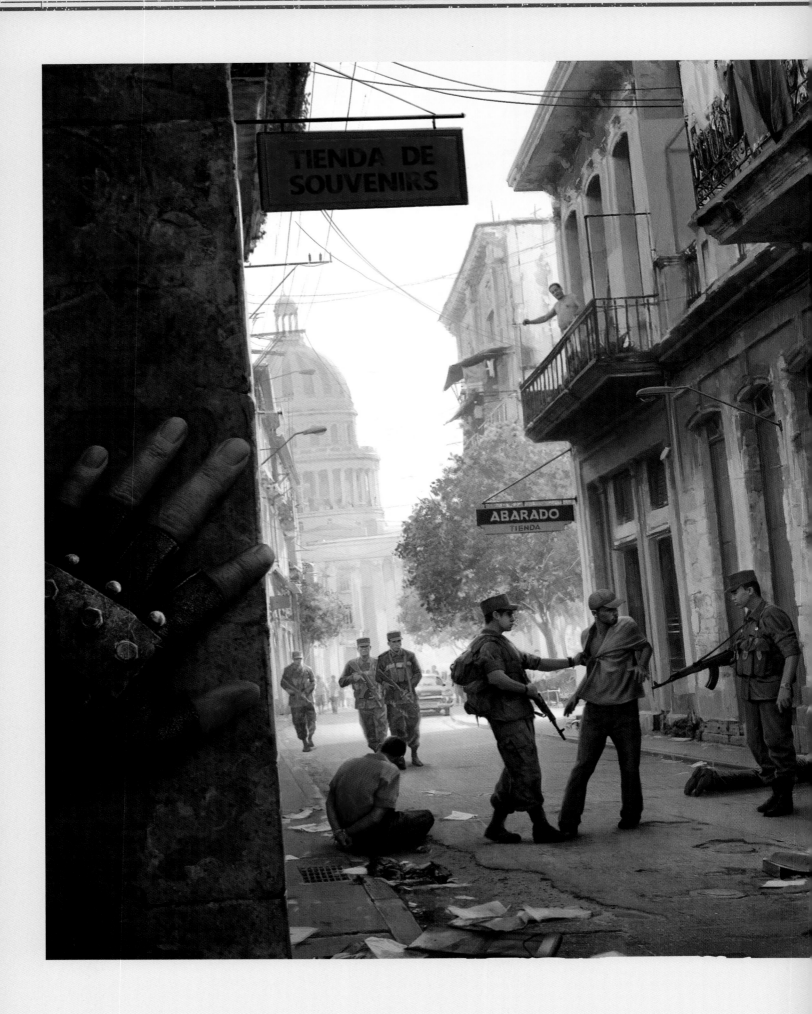

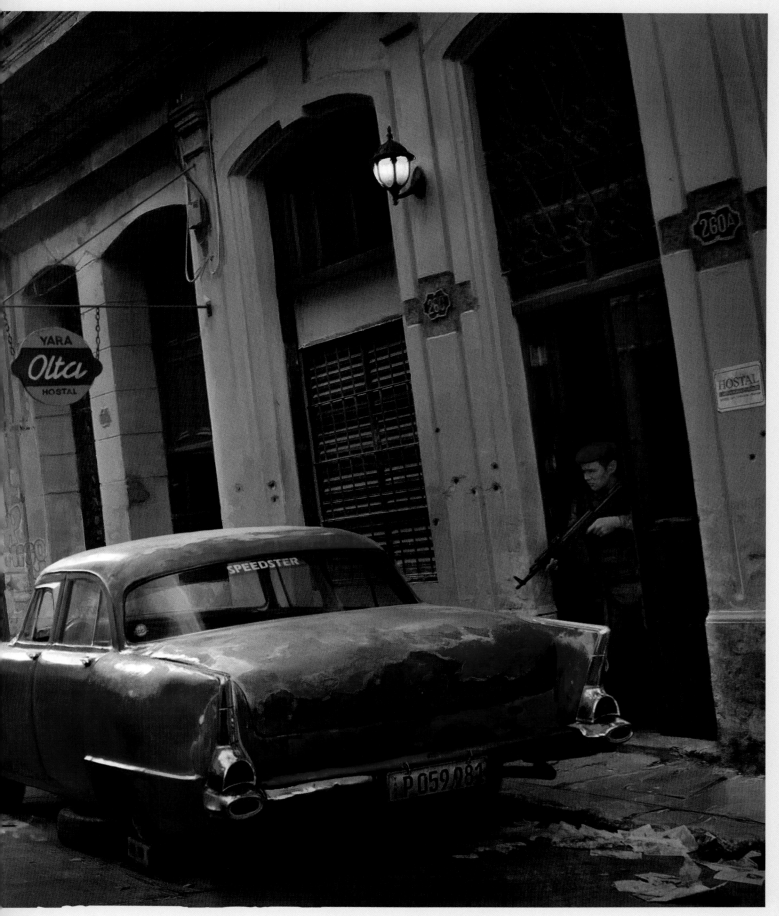

✗ One of the earliest concepts created to develop the game's visual style. The concept team is always encouraged to tell a story that grounds their work in the fiction of "Far Cry."

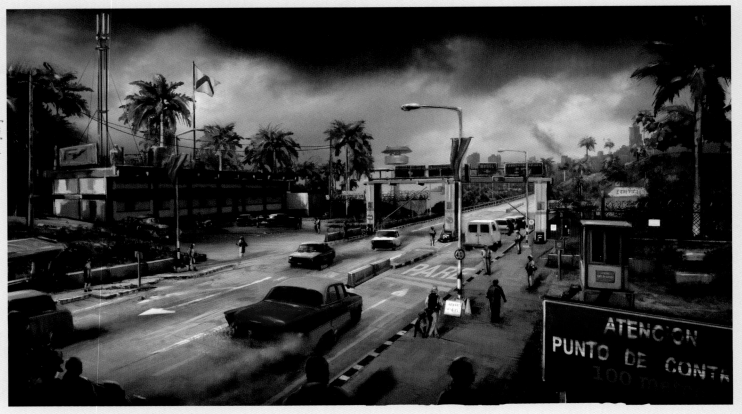

One of the major _checkpoints_ encountered before entering Esperanza.

MILITARY

Yara's **Fuerzas Nacionales de Defensa (FND)** is the iron fist of Castillo, supporting his effort to rebuild paradise by enforcing the law, protecting the island's borders, overseeing the Outcast program, and suppressing all dissidents—especially of the guerrilla variety.

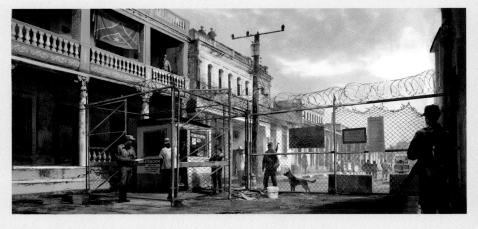

Rural checkpoints are scattered across Yara.

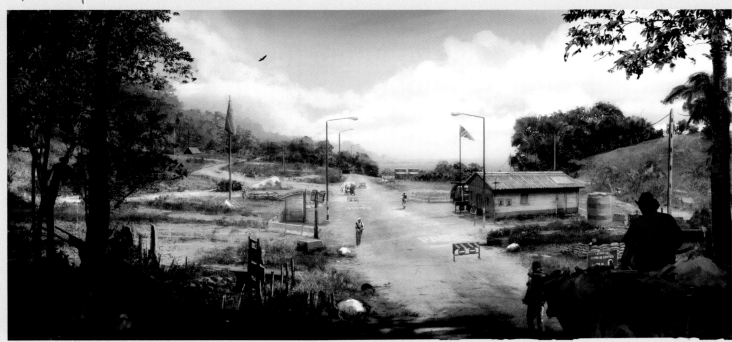

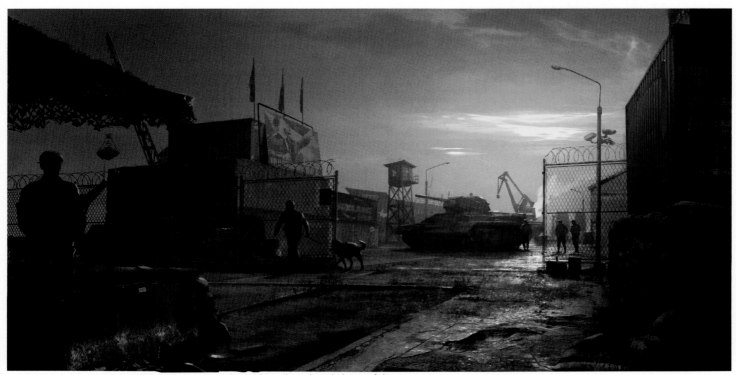

The tank is often rolled out to demonstrate the strength of the military.

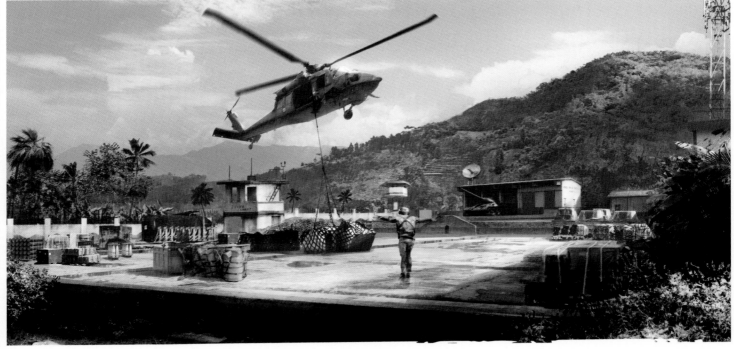

Checkpoints are a way to control the people of Yara.

SPECIAL OPERATIONS

Lola Tafalla is a cab driver with a finger on Yara's pulse. She knows everything that happens on the island, including some of the biggest and baddest criminal operations—and can take Dani straight to them if they're brave enough. These special operations are unique opportunities for Libertad to gain ground against some of Yara's wildest despots.

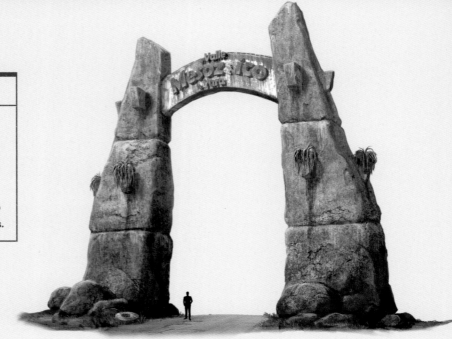

The theme of imperfection extends to the menagerie of park dinosaurs. The artists wanted to show their decay and add some humor to their look.

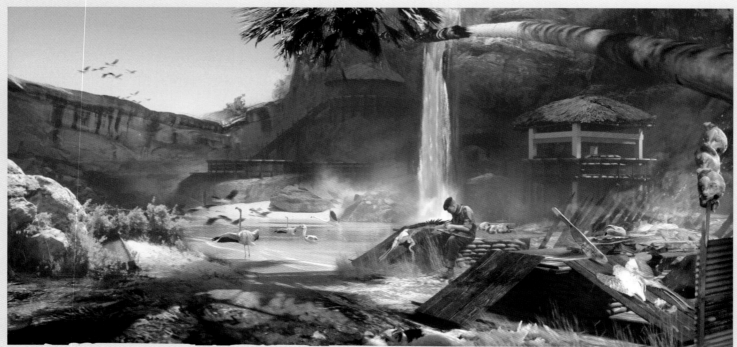

In order to survive, some desperate folks are forced to eat flamingos. The team always looks for twisted ideas to pack into "Far Cry."

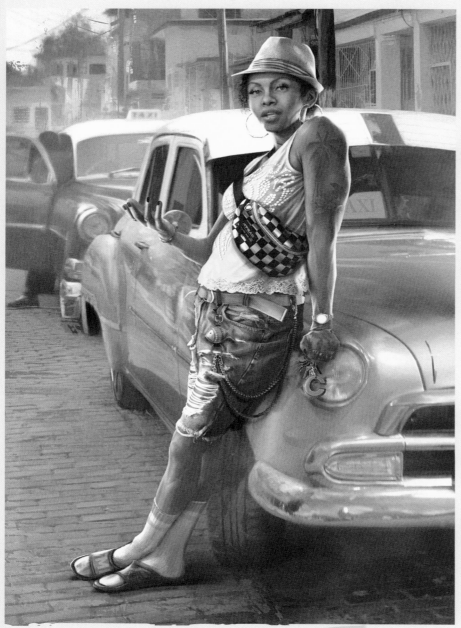

Lola needs to fit in as a civilian, but secretly serves Libertad.

Concept for the biological weapon and heat-run device used in Special Operations.

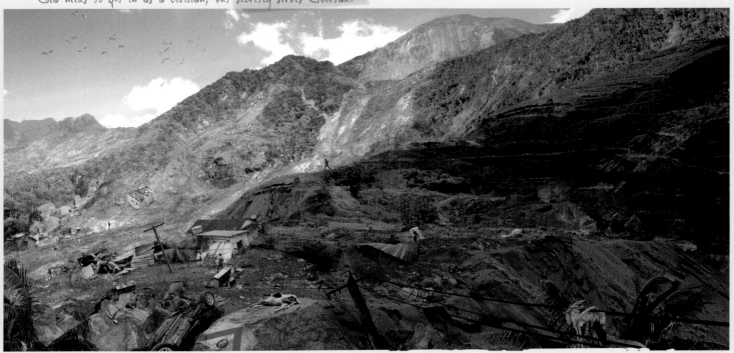

OKATANA TT400

ZAG

Wildebeest

 PINNACLE

 YATOMI SUNA

 MINAYEV MIN 57

Brave

 KAMAROV 1500

 WARDEN

 VESPUCCI PERFORMANCE TIRES

RAKOFF

ANCHOR TRED

TECUMSEH

Chorro Burbuja Jugo

LAS GUERRILLAS DE YARA

CAÑA DE ORO

Azúcar PRODUCTO DE YARA

 CROCO TAXI

 BURRO BLANCO

 ARBOL BLANCO 100% DE AGAVE TEQUILA REPOSADO

 DOS MONJAS RON AÑEJO

 RELOJERO

 Café Sol

 U-127 *Bodega*

 CARNICERIA UNIDAD 335

 PANADERÍA DE YARA

 ELECTRÓNICA EDUARDO

 JAZZ FESTIVAL INTERNACIONAL DE YARA

 El verdadero sabor de Yara Jugo de Sandia

 EL RON #1 DE YARA ORGULLO DEL TORO

 GRAN PREMIO DE YARA FEB.1

 YARA EXPLORA TU PARAISO

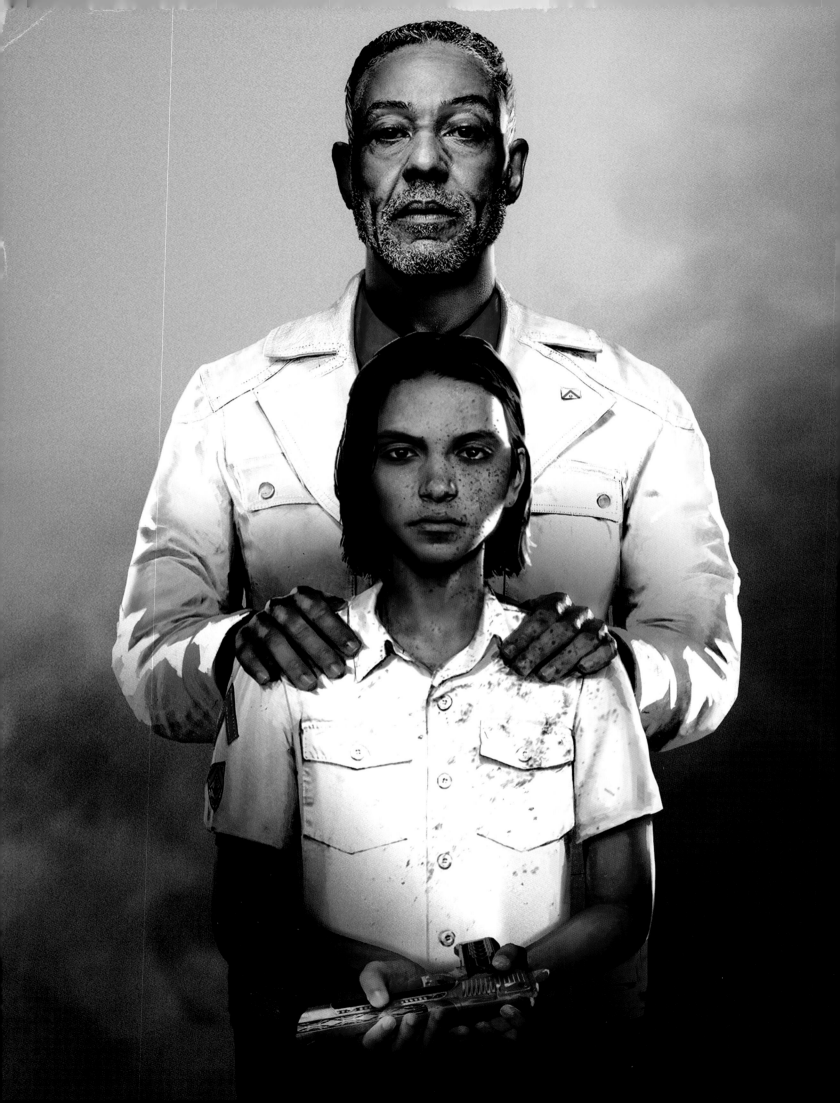

THE CASTILLO REGIME

Antón Castillo's government is based on a promise to "rebuild paradise," a vision which aims to return Yara to the wealth, pride, and ideals of his father Gabriel's pre-1967 reign. With the help of Dr. Edgar Reyes, Antón has developed a cancer treatment drug called Viviro which he vows will restore Yara's economy and workforce, built on the backs of Yara's poorest people and others who do not qualify to him as "True Yarans." Antón's single-minded pursuit of this goal—and of training his teenage son Diego to be his successor—has transformed Yara from an emerging tourist destination to an island on full military lockdown. Roads are blocked by checkpoints and patrols, families are separated into forced labor camps, and propaganda is disseminated through loudspeakers and billboards across the country. The more Antón tightens his grip, the more unstable Yara becomes . . . and the more people are driven to stand up against him.

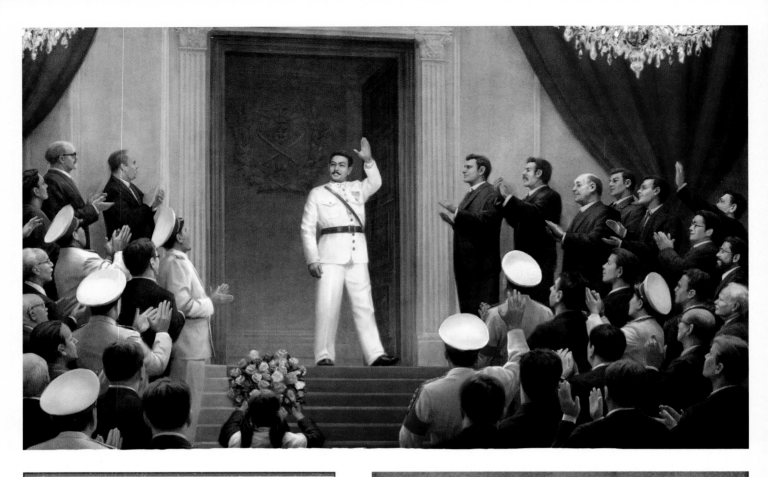

GABRIEL CASTILLO

Antón Castillo's father, Gabriel, the first to earn the title "Lion of Yara," was descended from a long line of Yaran rulers going all the way back to the Spanish conquistadors. His rise to power was fast and brutal, and he reigned over a corrupt empire built on casinos, American Mafia money, and luxury tourism during what is called Yara's Golden Age. The 1967 revolution against his regime ended in his public execution and the imprisonment of his wife and teenage son.

"Brash," "arrogant," "confident," and "modern" are words kept in mind when designing the military uniform, with visibility being key for gameplay as well. →

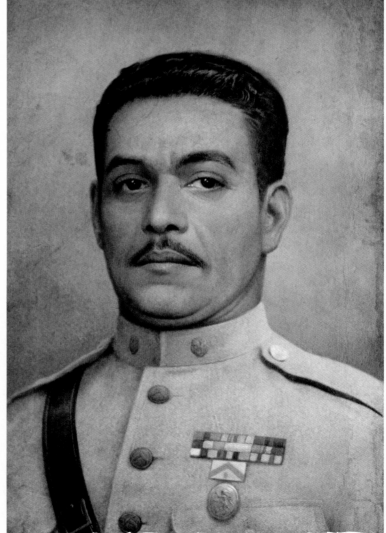

It was important to develop concepts for Antón's parents, Gabriel and Yolanda. Their history is just as important as the current tale being told.

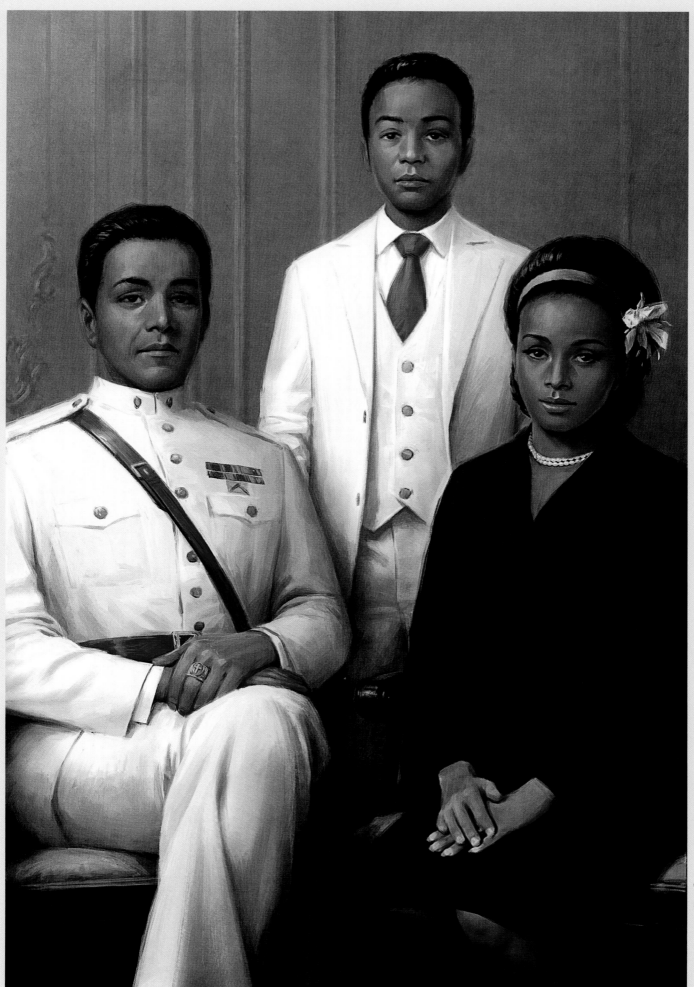

A younger Antón in a family portrait. He gravitates to his mother here. She was just as important to him as his father's legacy, grounding him with a bit of humanity.

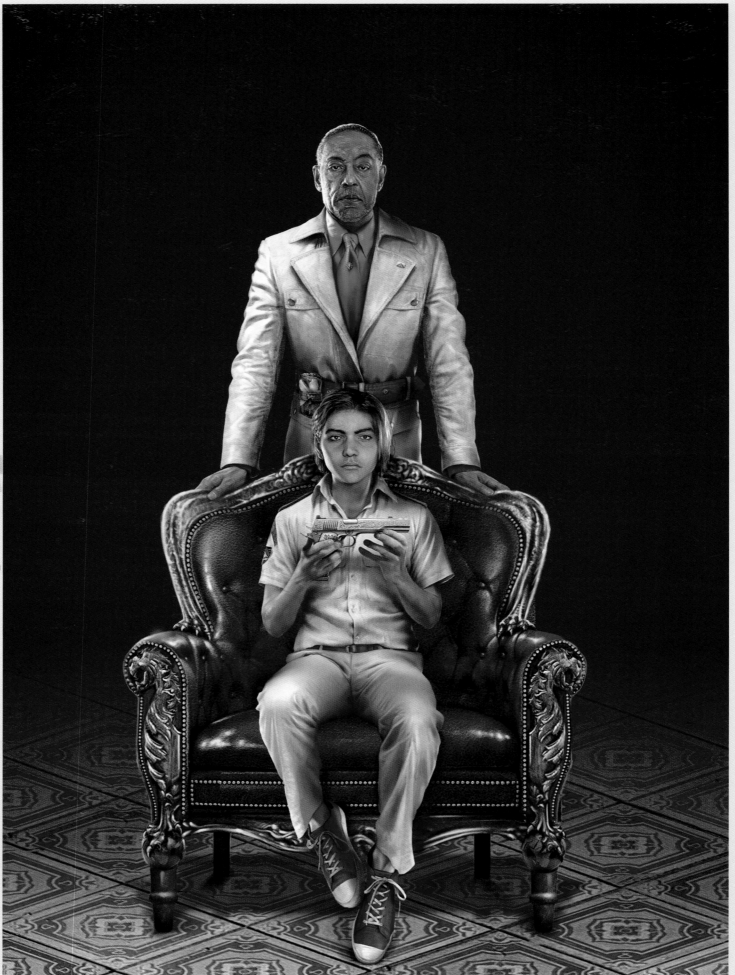

Antón's brand and clothing are directly inspired by the military style and flag of his father.

THE CASTILLO REGIME
ANTÓN CASTILLO

Born into power, Antón was groomed from an early age to rule. Imprisoned at thirteen while his father was executed by guerrillas, he was taught by his mother, Yolanda, who instilled in him a belief that the Castillos were lions and that he would adopt his father's mantle. Antón gathered a tight circle of loyalists, and his political power grew. After the death of Yara's president, Santos Espinosa, Antón ensured his own election. Once in power, his vision was twofold: secure his legacy through an heir, and fund an experimental cancer drug that would bring his vision to rebuild paradise to fruition.

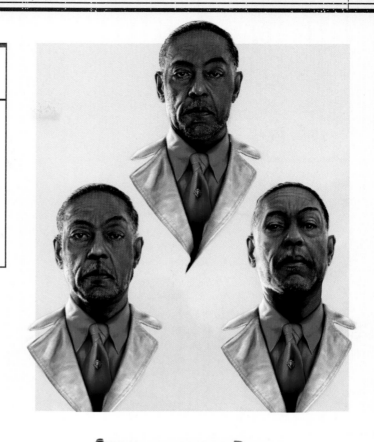

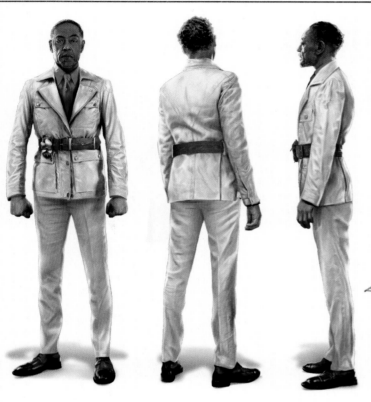

Antón's unique gun is made of gold and ivory with a Spanish lion on the grip.

Every detail of Antón's outfit is rich in narrative layers, from his white vintage riding jacket to the tobacco pruner on his belt.

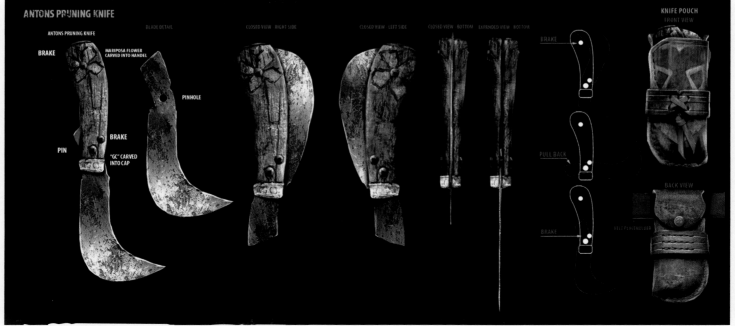

ANTONS PRUNING KNIFE

BLADE DETAIL CLOSED VIEW - RIGHT SIDE CLOSED VIEW - LEFT SIDE CLOSED VIEW - BOTTOM EXPANDED VIEW - BOTTOM

ANTONS PRUNING KNIFE

BRAKE MARIPOSA FLOWER CARVED INTO HANDEL

PINHOLE

BRAKE

PIN "GC" CARVED INTO CAP

BRAKE

PULL BACK

BRAKE

KNIFE POUCH
FRONT VIEW

BACK VIEW

On his belt, Antón carries a tobacco pruner from his youth and the sunrise mariposa flower, a reminder of his mother.

The small scar on his right brow is a subtle link to Dani. Dani has the same scar over the same brow. It implies their destinies are linked in this tale.

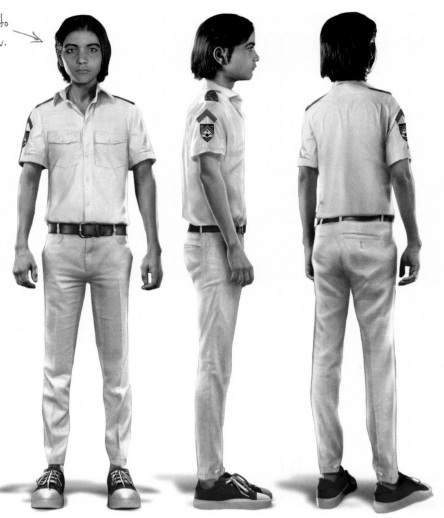

DIEGO CASTILLO

Diego is the president's only child. He is being groomed to be the next leader of Yara, but secretly has no desire to rule. However, Diego has never admitted this to his father out of fear of what he might do. As a result, he's a confused, privileged teen caught between a desire to be his own person and a duty to be what his father and society expect of him.

✳ There's a duality on display in Diego. He is almost forced to wear the military style of clothing, but he has a rebellious side like most teenagers. The blue-and-white hoodie is a nod to Libertad, and the lyrics from Máximas Matanzas written on his pants would not please his father.

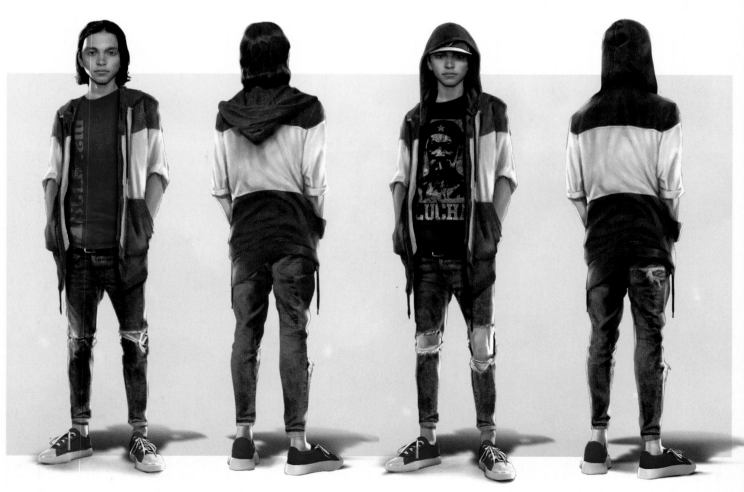

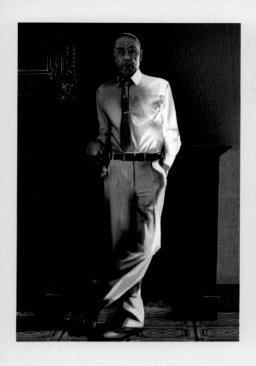
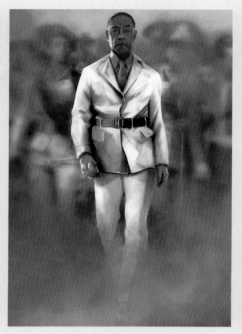
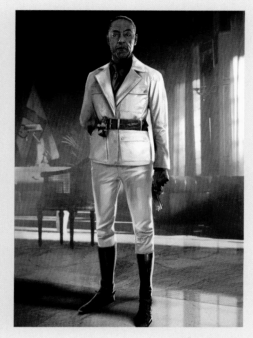

A FATHER-SON DICTATORSHIP

Wherever Antón goes, so does Diego. As the vessel for the Castillo legacy, Diego is being primed to rule according to his father's "lessons" on leadership—brutal, violent tactics to maintain control. For the good of the family. For the future of Yara. But Diego has many choices ahead of him, and whether he will truly follow in his father's steps is uncertain.

Lions even adorn the arms of one of Antón's chairs.

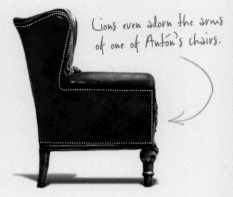

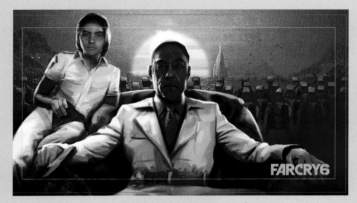

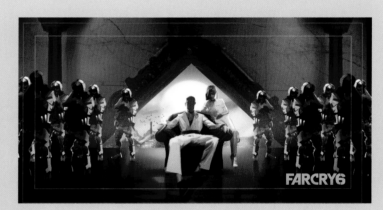

Exploration for the game's marketing banners and posters.

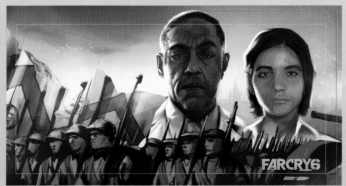

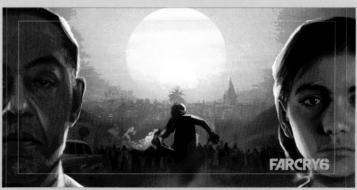

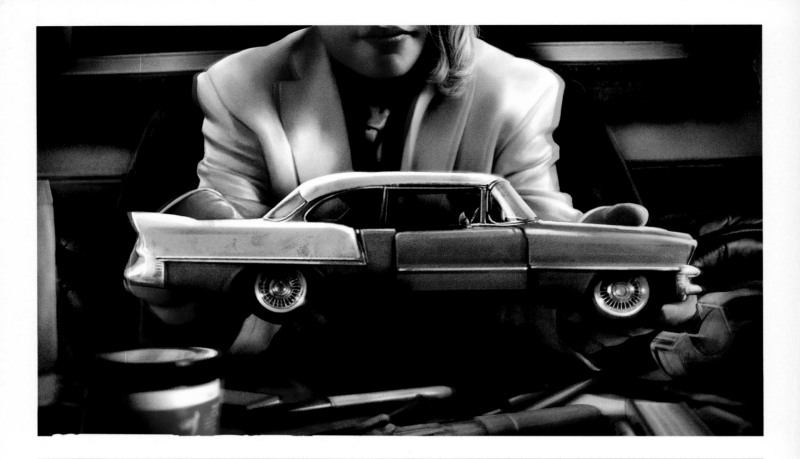

DIEGO'S TOY

In the first cinematic trailer for *Far Cry 6*, Antón and Diego are introduced as the teenager is building a model car and his father presses a live grenade into his hands. Only Antón would teach such a dangerous lesson, but to him, there's no difference between holding a grenade and running a country: both are matters of life and death.

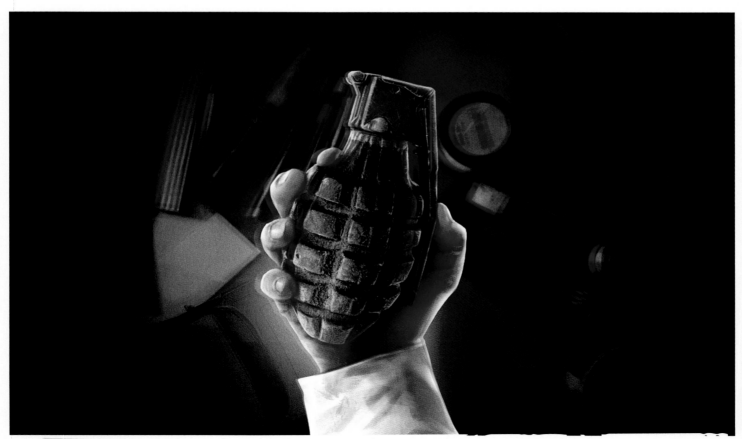

Some very early storyboards to pitch the game's reveal trailer. The scene with Diego and the grenade is designed to be evocative and chilling.

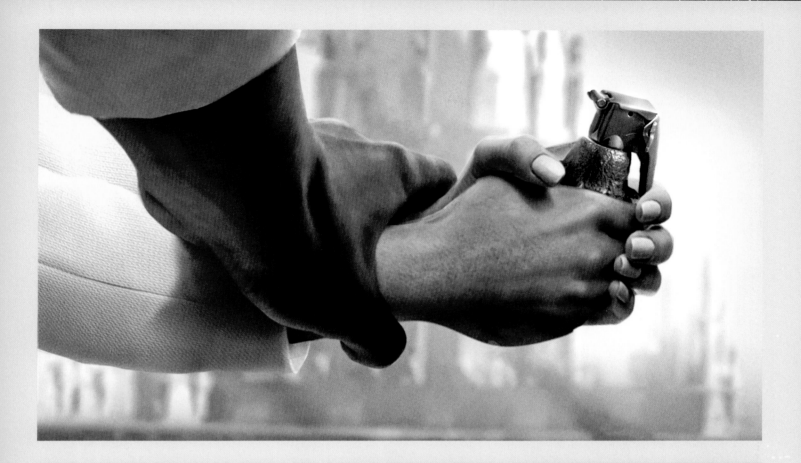

CGI TRAILER DESIGN

Antón wants to teach Diego the importance of control, and he uses a grenade to illustrate his point: Yara is a country on the verge of exploding into chaos, and only by gripping it tightly can he prevent its destruction. Below in the street, protesters are beaten and restrained, and Diego is left with a choice: will he maintain his grip, like his father wants—or will he let go?

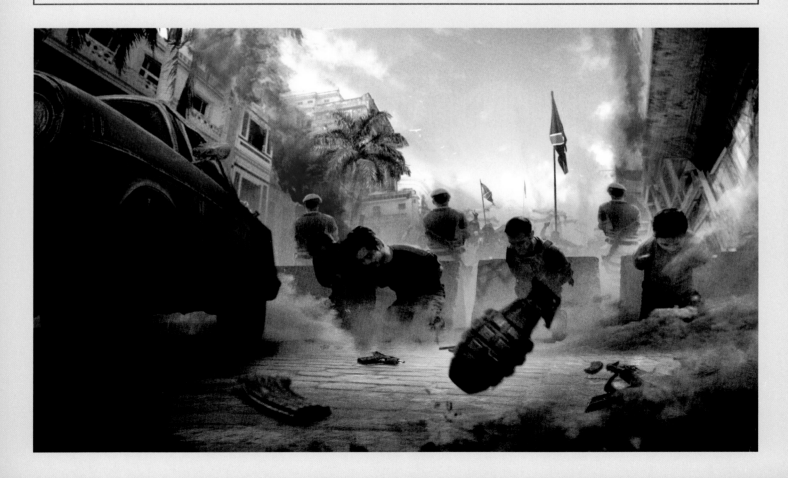

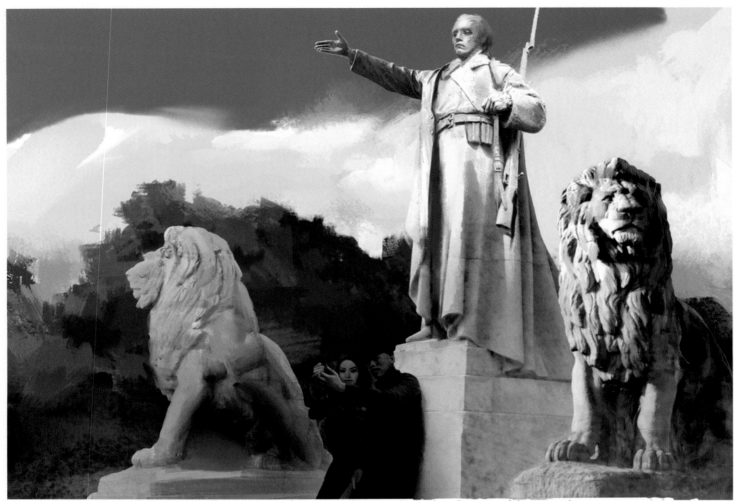

A symbol for the Castillo regime, the lion is used to demonstrate strength and military might.

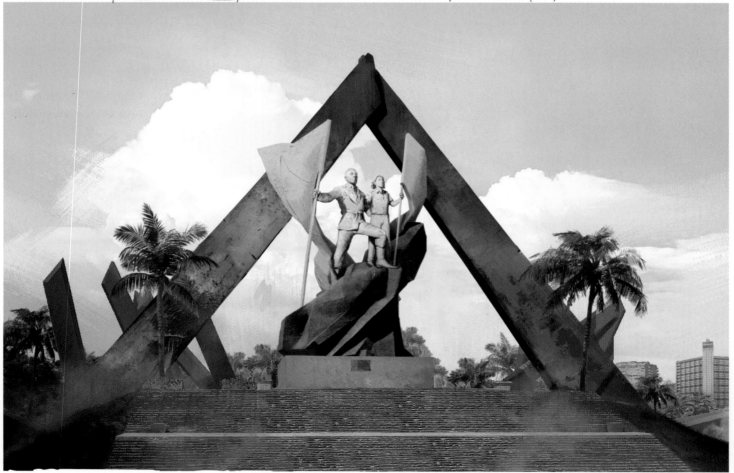

Monuments are important to the landscape of Yara. Antón is showing his hubris with this one.

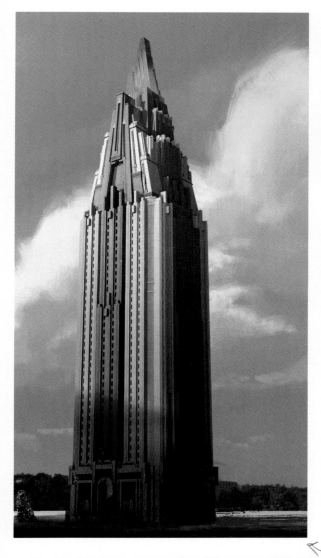

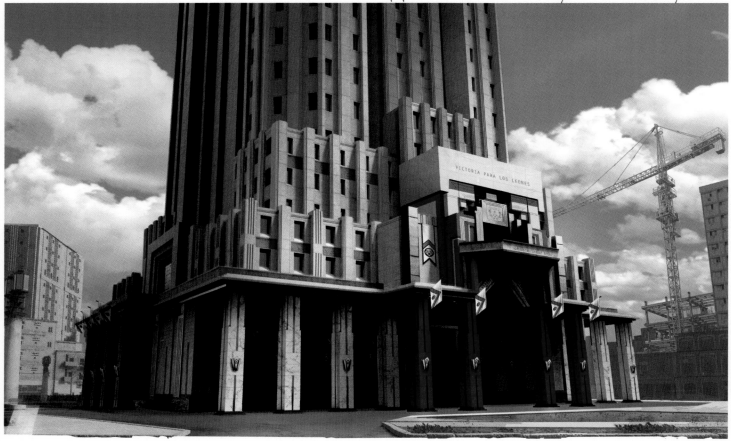

LA TORRE DEL LEÓN

Constructed shortly after Antón's election, the Torre del León (Tower of the Lion) is visible all across Yara and serves to remind every citizen of his reach and ambition. While a beautiful example of art deco craftsmanship, it is also a symbol of oppression and one of Libertad's primary targets.

The Torre del León is inspired by the shape of a bullet. It's a reminder of Antón's power over his people and intended to stand out against the older buildings surrounding it.

TRUE YARANS

Antón has divided the Yaran population into "True Yarans" and "Fake Yarans." True Yarans are Antón's most fervent supporters. They will follow his orders and beliefs without question and will even give up their friends, families, and neighbors if the president decides they do not belong. Fake Yarans are those who dare defy Antón. They are made up primarily of journalists, dissidents, protesters, and, of course, guerrillas.

True Yarans showing their support for El Presidente. They wear his brand and clothing from the previous election in Yara. The artists wanted to show that a variety of citizens from every class were among his supporters.

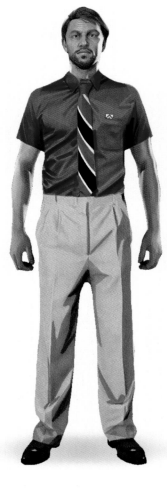

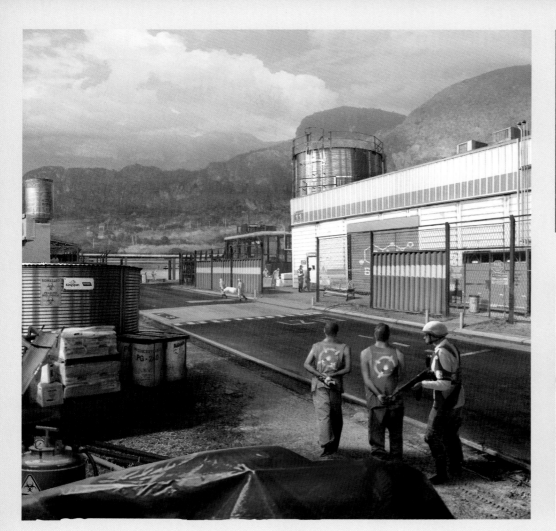

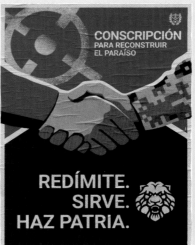

CONSCRIPCIÓN
PARA RECONSTRUIR
EL PARAÍSO

REDÍMITE.
SIRVE.
HAZ PATRIA.

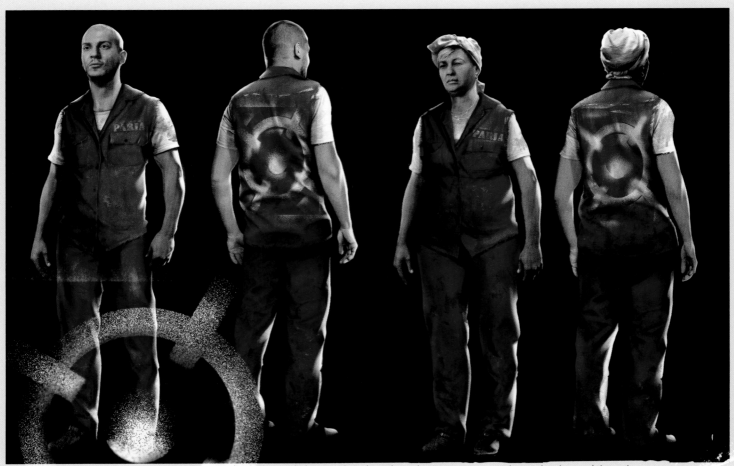

Outcasts needed a uniform and a symbol, so the art team put a target on their backs—something for the military to aim at if they decided to flee. This was another way for us to portray the enemy as villains.

One of the first explorations of how Antón's propaganda shows his leadership, pride, and power.

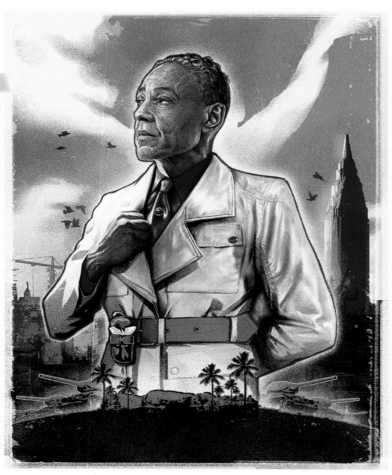

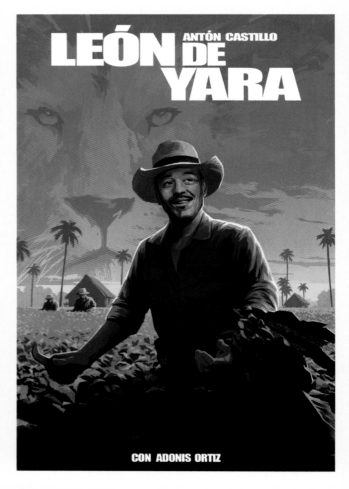

LEÓN DE YARA

ANTÓN CASTILLO

CON ADONIS ORTIZ

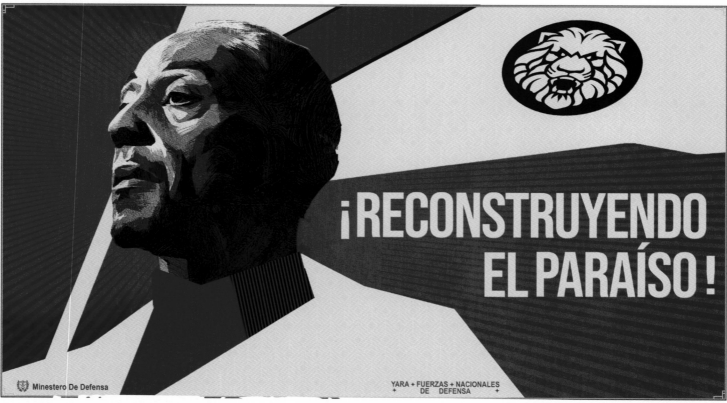

Minestero De Defensa

¡RECONSTRUYENDO EL PARAÍSO!

YARA + FUERZAS + NACIONALES
DE DEFENSA +

The autocratic style of this billboard communicates his strength as a leader of Yara.

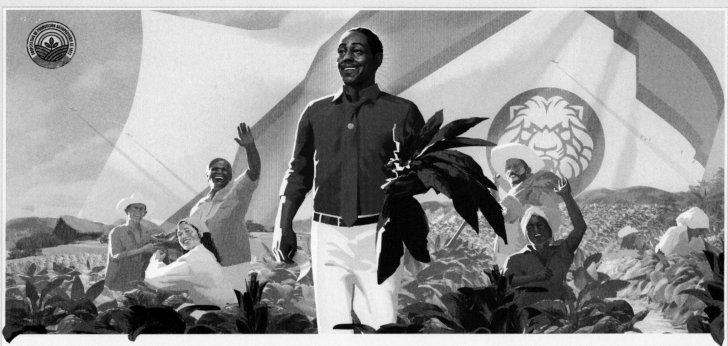

DE NUESTRAS MANOS PARA EL MUNDO: VIVIRO

Ministero De Defensa

YARA + FUERZAS + NACIONALES
+ DE DEFENSA +

Pictured here with his sleeves rolled up, Antón wants to be seen as a savior who is charming and approachable, a man of the people.

Murals are sometimes made by his supporters.

ANTÓN'S PROPAGANDA

Drawing on Yara's historical connection with Soviet-era Russia, Antón communicates his ideals and controls his populace through carefully crafted propaganda. The strong, simple iconography of these displays ensures his true meaning is always understood.

105 años poniendo a Yara
PRIMERO

Ministerio de Cultura

Concejo de Esperanza

This more modern propaganda billboard showcases what Antón is offering the people of Yara: the promise of modernization.

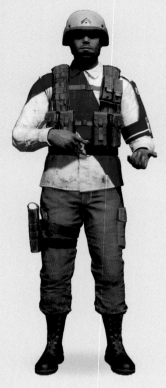
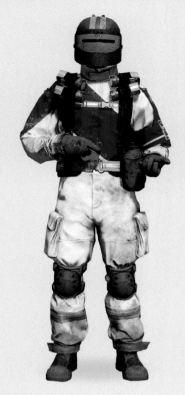
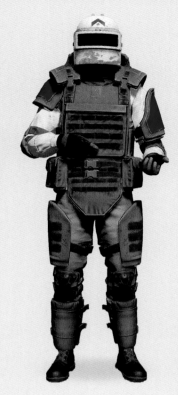
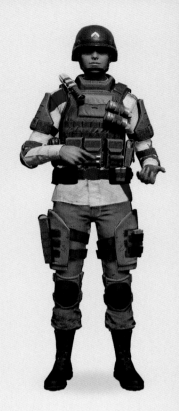

The red and white of Antón's brand are directly translated to his military forces.
The military had to be stripped of personal expression, in contrast to Libertad.

MILITARY ARCHETYPES

A massive injection of funding into Yara's military forces has resulted in a soldier for every situation, from frontline assaulters to stealth snipers. Extensively trained in specialized weaponry and tactics, each fighter presents a unique threat.

 YARA FND **YARA FDN** **YARA FDA** **YARA FDT** **YARA CBM**

| ARMY | NAVY | AIR FORCE | GROUND | MECHANIZED |

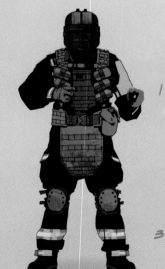

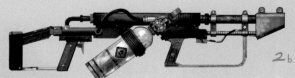

1b. 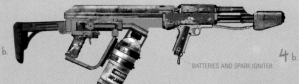 2b.

Explorations for the enemy's flamethrower. The enemies have weapons that almost look like hand-me-downs, showing imperfection and lots of former use.

ELECTRODE IGNITER

3b. 4b.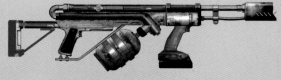

BATTERIES AND SPARK IGNITER

ARCHETYPE FLAMER

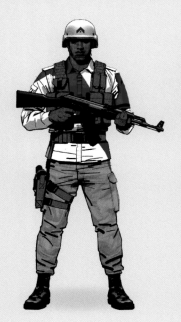
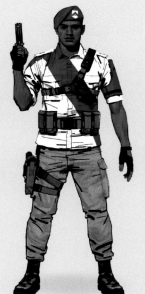
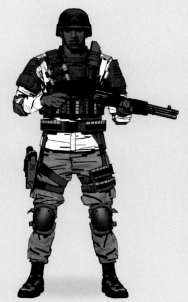

Every branch of Yara's military models their uniform on the coloring and iconography of Yara's distinctive white-and-red flag. The flag's iconic chevron is displayed as a kind of sash across the chest, suggesting each soldier's devotion to their country.

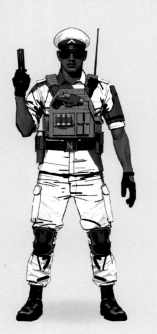
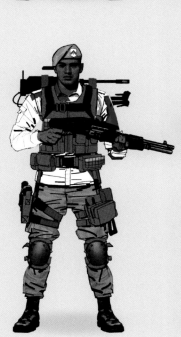
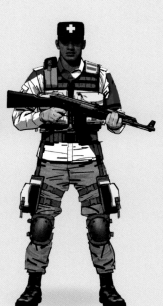
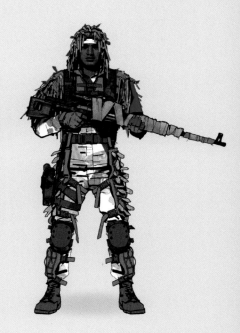

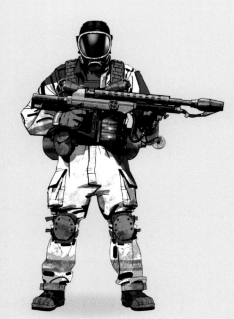
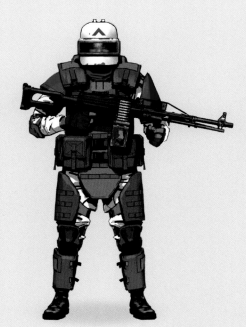
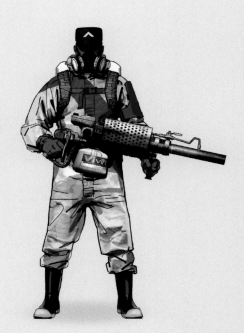

Silhouette and variety are important when designing a wide array of enemy archetypes.

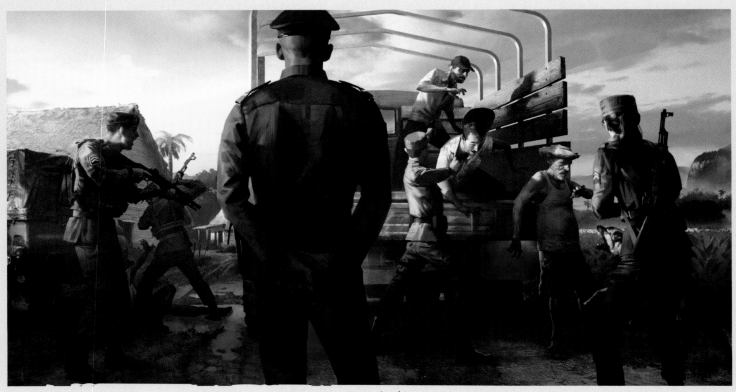

For many of the concepts representing oppression, the enemy had to be faceless in order to showcase the emotions of the oppressed civilians.

OLD DOG

General Raúl Sanchez, better known by his nickname, "Old Dog," is a legendary figure in Yaran war history. He served under Antón's father, Gabriel, suffering imprisonment and torture at the hands of guerrillas. He was Antón's protector during his formative years and maintains a strict loyalty to him and Diego.

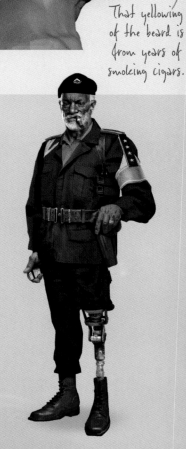

That yellowing of the beard is from years of smoking cigars.

Some explorations for Old Dog. He represents someone who has seen lots of conflict, and would hopefully also be memorable to players.

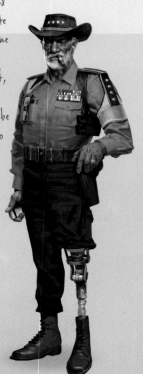
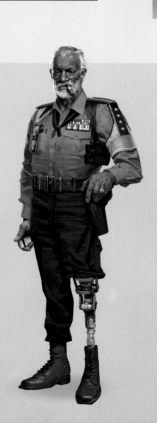
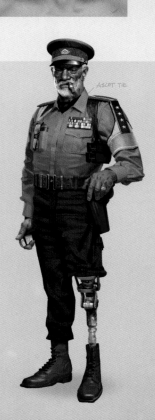

ASCOT TIE

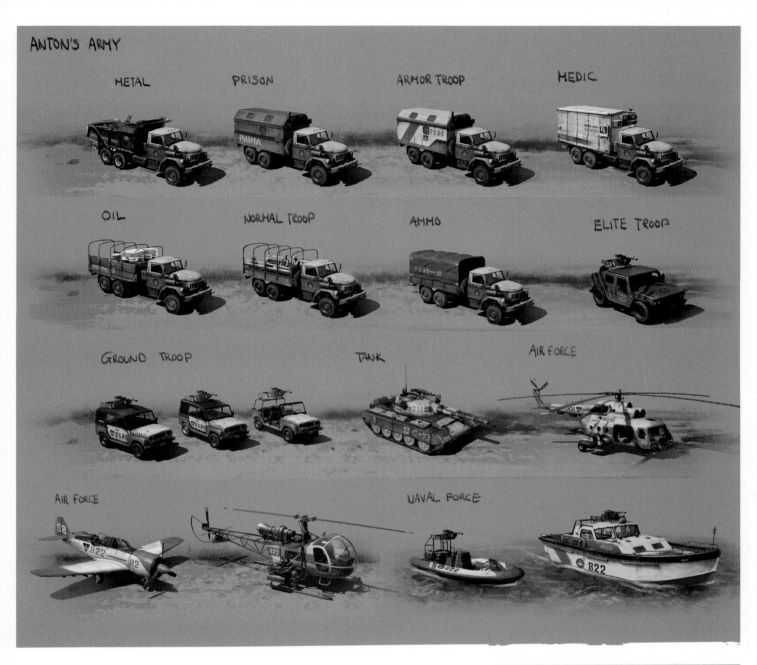

ANTON'S ARMY

METAL PRISON ARMOR TROOP MEDIC

OIL NORMAL TROOP AMMO ELITE TROOP

GROUND TROOP TANK AIR FORCE

AIR FORCE NAVAL FORCE

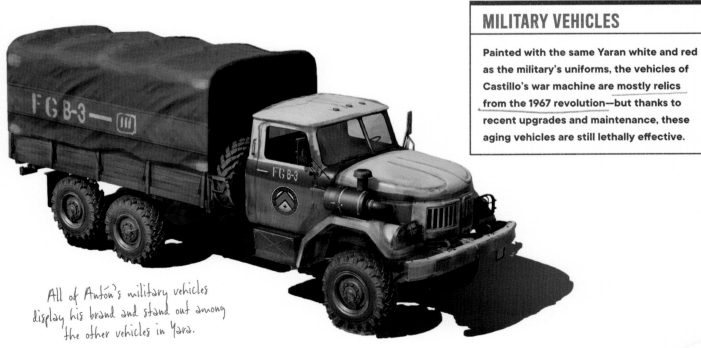

All of Anton's military vehicles display his brand and stand out among the other vehicles in Yara.

MILITARY VEHICLES

Painted with the same Yaran white and red as the military's uniforms, the vehicles of Castillo's war machine are mostly relics from the 1967 revolution—but thanks to recent upgrades and maintenance, these aging vehicles are still lethally effective.

BARRICADES

Deployed across Esperanza in a coordinated lockdown effort, these steel antiriot barriers were used on the infamous "Noche Muerta" to keep the city's citizens under tight control as Antón disposed of his enemies and began rounding up dissidents.

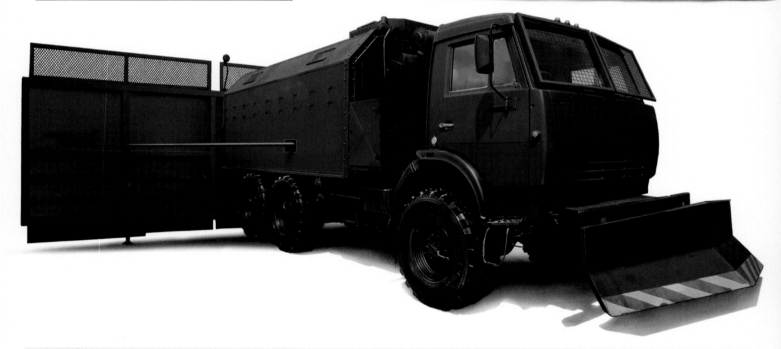

Barricades in downtown Esperanza needed to look like they were temporary fixtures.

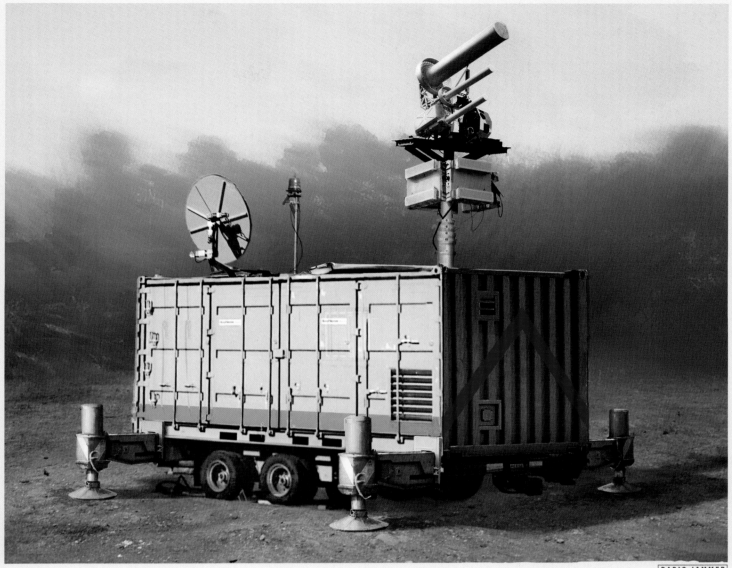

RADIO JAMMER

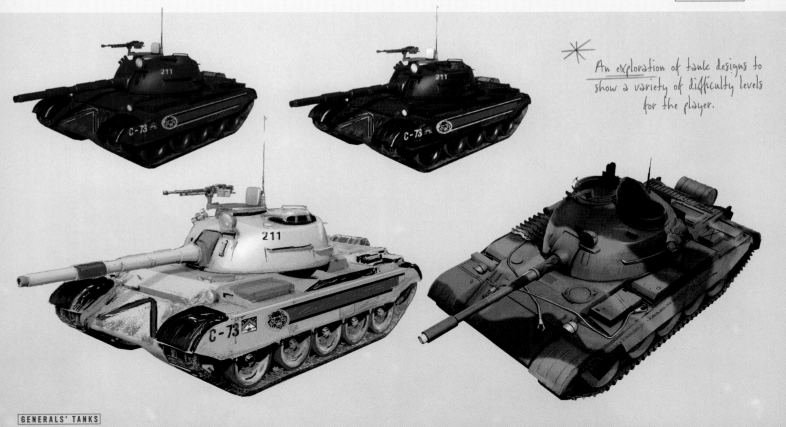

An exploration of tank designs to show a variety of difficulty levels for the player.

GENERALS' TANKS

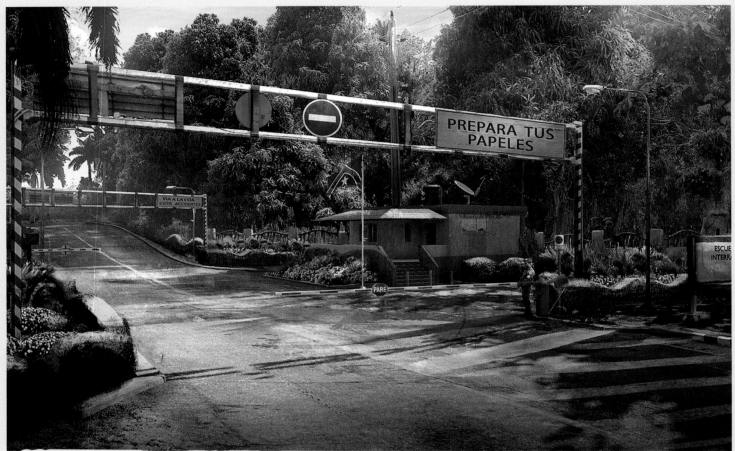

Military locations and interior spaces.

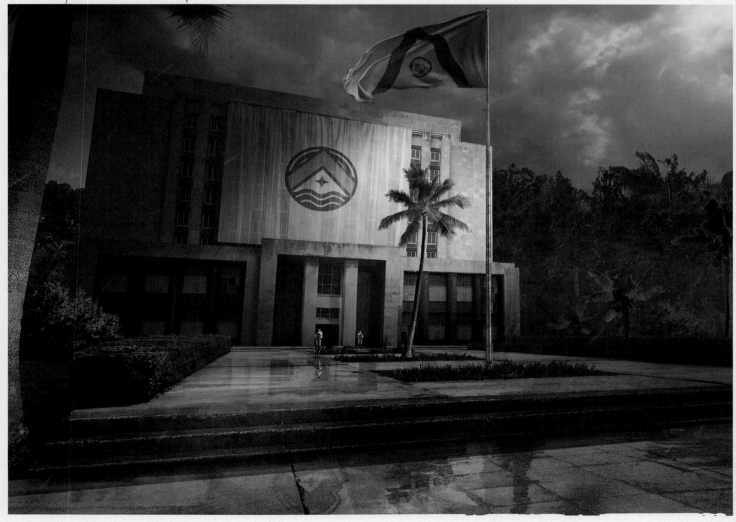

MILITARY PRESENCE

Castillo enforces his control over Yara's people by stationing his military across the island, installing checkpoints, taking over schools and businesses, and overseeing everything from Viviro production to TV commercial shoots.

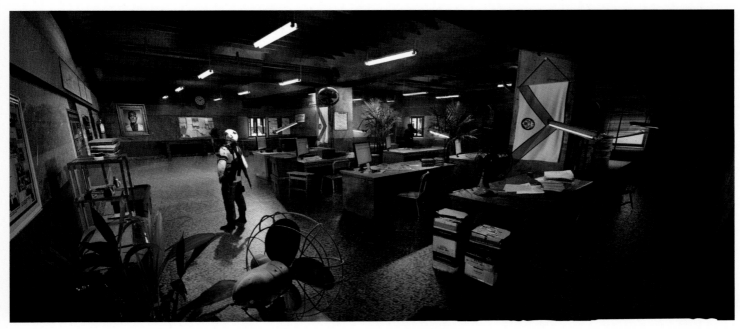

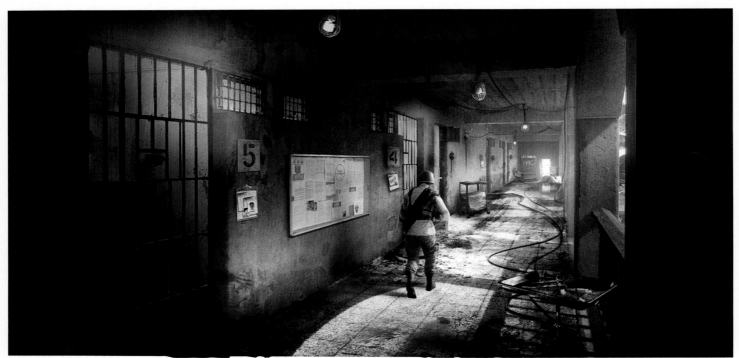

Lighting and mood are important to nail down these concepts. Yara is lit for function over vanity. Resources and power are limited on the island.

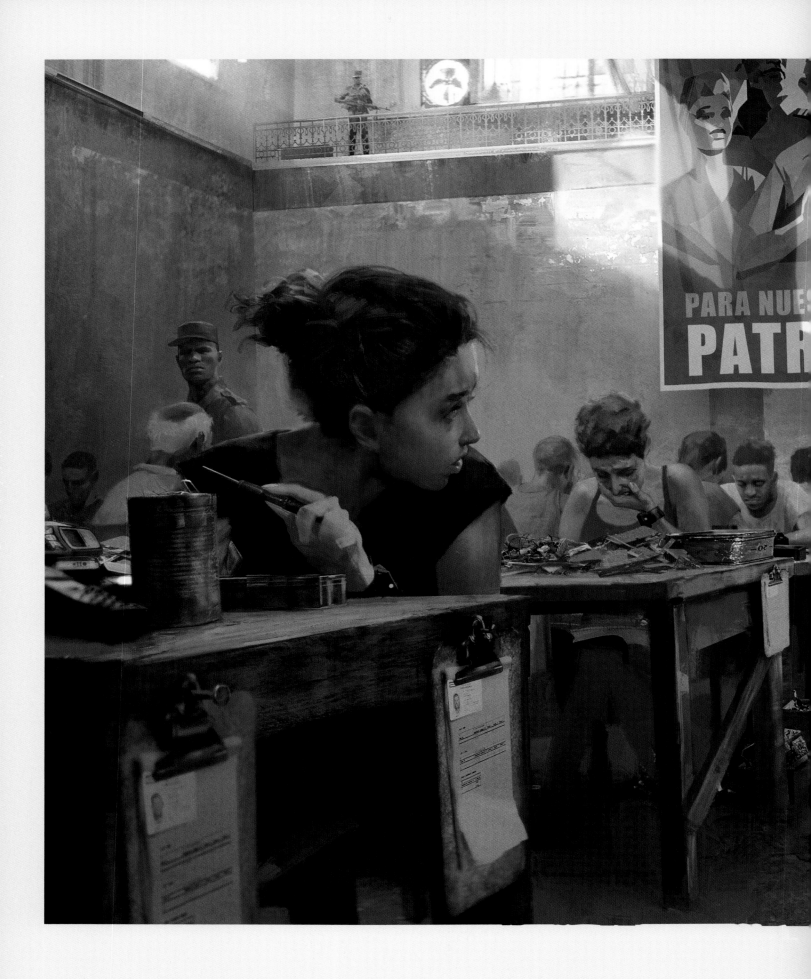

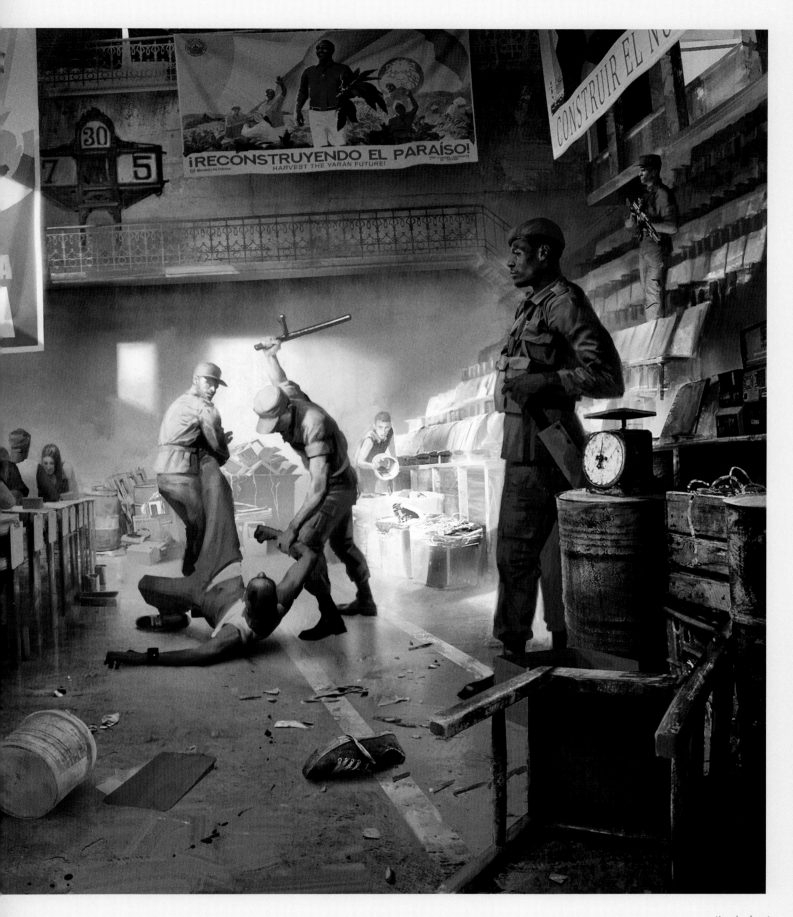

¡RECONSTRUYENDO EL PARAÍSO!
HARVEST THE YARAN FUTURE!

CONSTRUIR EL N

An early concept showing the oppression of the Outcasts forced to dismantle electronics for resale. Emotion is so important to capturing narrative concepts and ideas.

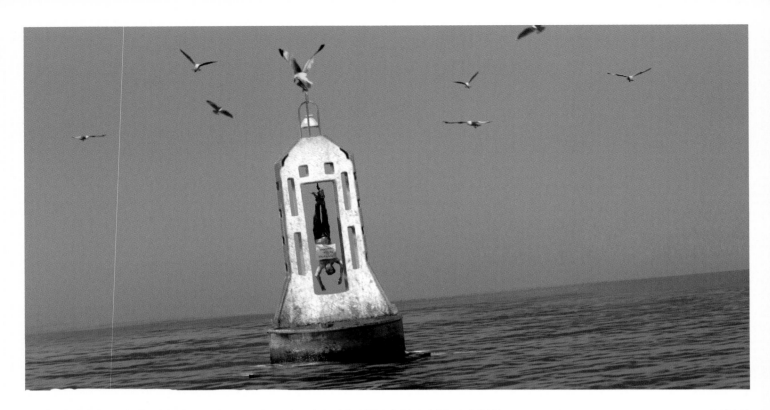

MILITARY VIOLENCE

Empowered by massive funding and little oversight, the armed forces run rampant across Yara, enforcing Castillo's will with no mercy. No one's safety is guaranteed. Are these simply rogue agents with too much power? Or is this exactly what Antón has ordered?

There is a mix of public and private atrocities in Yara. The military will display any act intended to send a message and instill fear in the populace. Other atrocities are more grotesque and often hidden from public view—including mass graves and rogue executions.

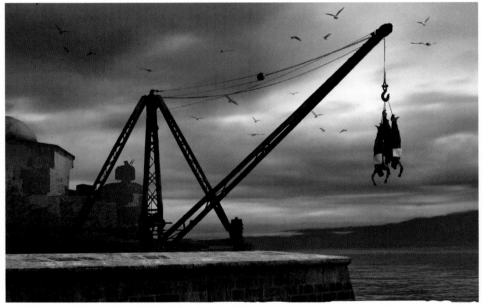

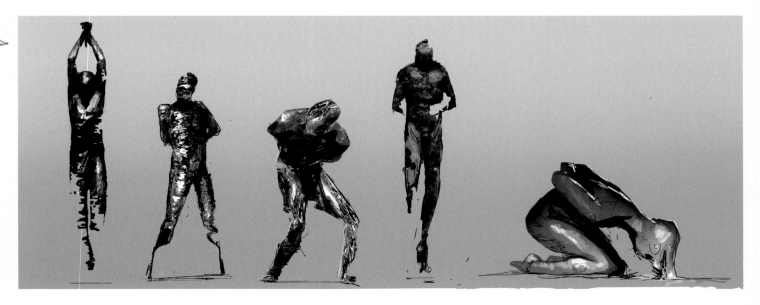

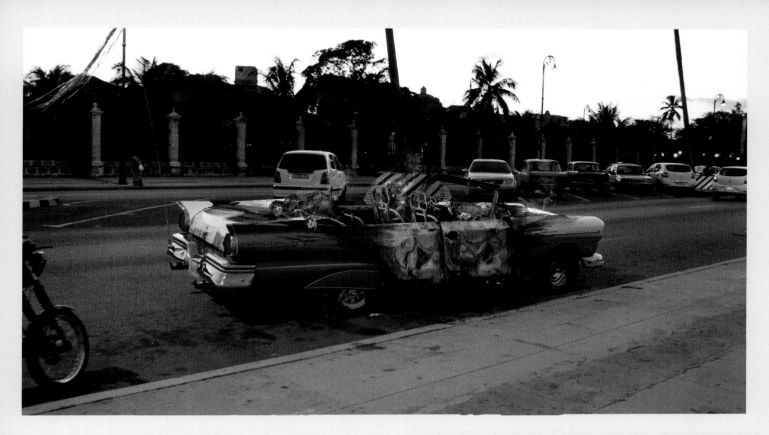

ATROCITIES

Yara is dotted with grim reminders of what Castillo's dream of paradise has cost. Whether it is the military, the guerrillas, or simply Yarans fighting Yarans, there is evidence everywhere of a country spinning out of control, where violence and brutality have become the norm.

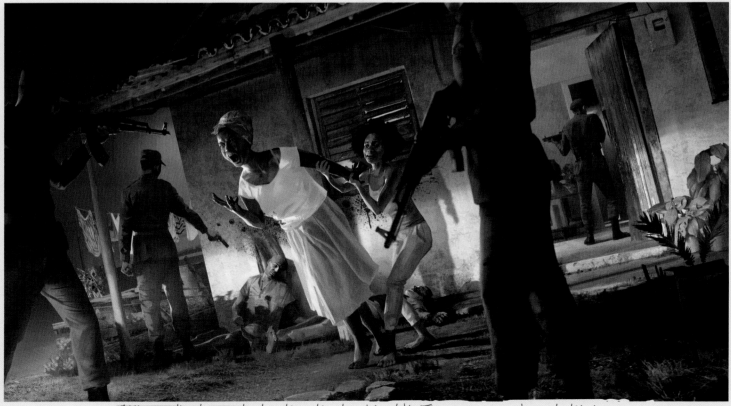

Adding emotion to concepts strengthens the story being told. There are so many layers to this image.

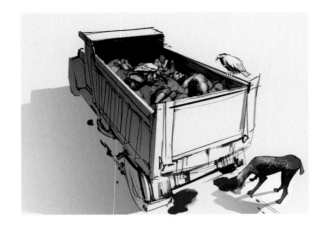

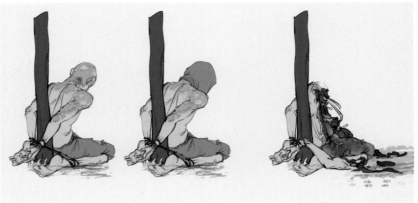

Sometimes the absence of bodies reveals violence as well.

EXECUTIONS

When the military says you have stepped out of line, run afoul of the rules, or simply are a Fake Yaran, it is as good as a death sentence. Summary executions are conducted on the spot, whether by traditional firing squad or even more inhumane methods.

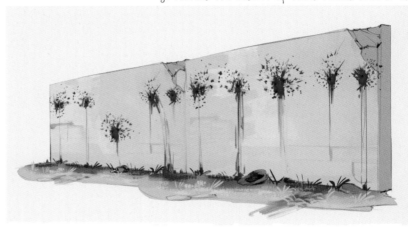

Wildlife attracts attention to hidden atrocities, drawing the player to these grisly locations.

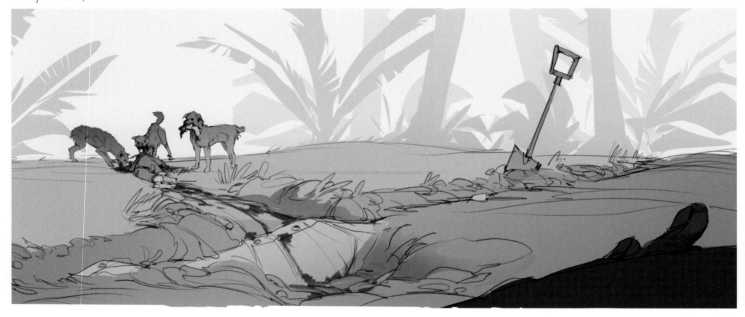

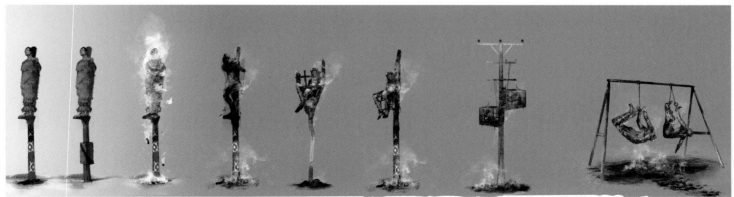

The "matchstick" executions are for public display of Outcasts, and were inspired by Roman executions.

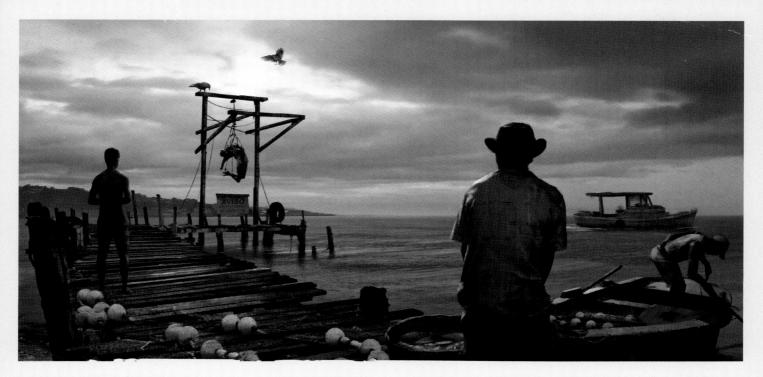

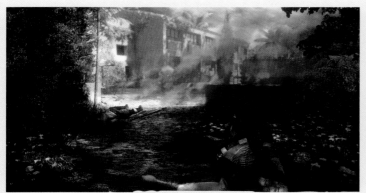

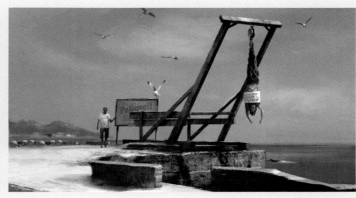

Citizens who tried to flee Yara are displayed like caught fish—an atrocity unique to the eastern parts of the island.

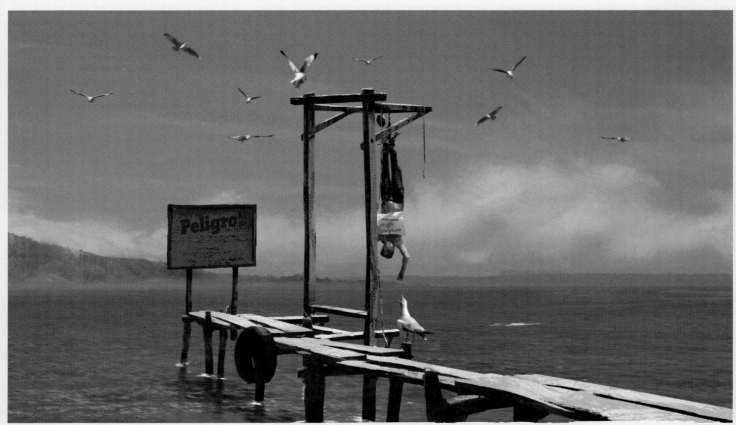

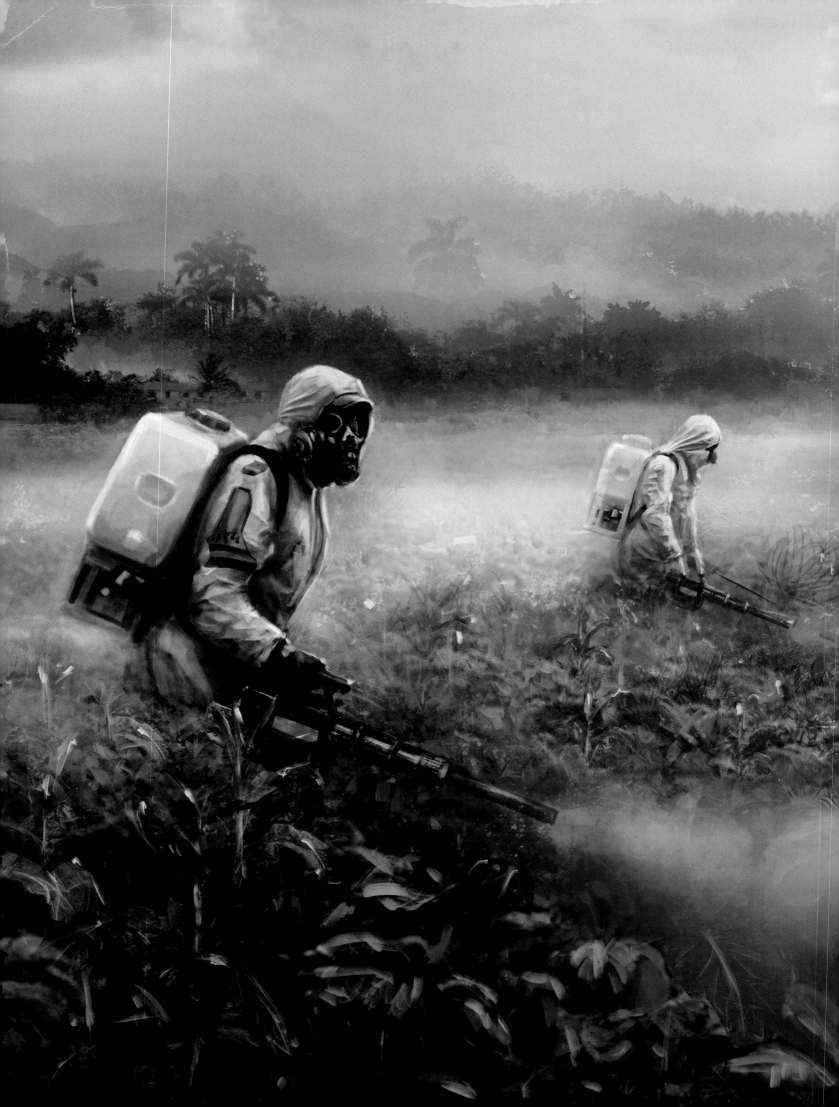

VIVIRO AND THE PHARMA INDUSTRY

Using Yara's native tobacco leaf and a highly toxic chemical spray, a chemist named Dr. Edgar Reyes developed an experimental cancer treatment drug he called Viviro. Most saw it as too expensive and dangerous. When Antón witnessed the success of the drug trials, however, he saw an opportunity to bring wealth to Yara and secure his election. Antón waited patiently for this opportunity, and on the death of President Santos Espinosa, he seized the chance to use Viviro as a key piece of his promise to rebuild paradise. Though rumors spread that the election was rigged, Antón won. With Reyes, Antón created the corporate front called BioVida and they immediately reorganized the country around production of the Viviro drug. Initially, its output proved too small to be economically viable, so the "Draft to Paradise" was created and the Outcast system of forced labor was introduced. Though his methods were both ecologically and ethically questionable, Antón's political power rested on his promise to heal Yara and the world, and so he pursued his vision to rebuild paradise. Tobacco fields were repurposed into Viviro grow ops, industrial infrastructure was refitted to serve the pharmaceutical pipeline, and Yara was transformed into a pharmacological production powerhouse—at the cost of the lives and safety of its citizens.

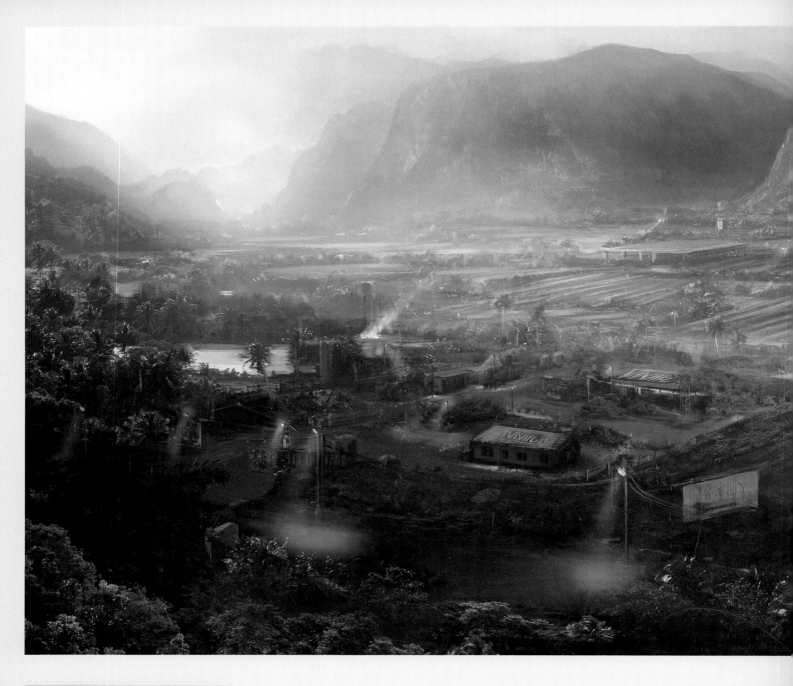

MODIFIED TOBACCO

The amount of cancer-treating compound in each tobacco plant is minuscule, meaning an entire island's worth of acreage is necessary to produce Viviro at a viable rate. This is why nearly every one of Yara's traditional tobacco fields has been claimed by the regime and sprayed with the toxic red chemical PG-240, which enhances the tobacco's properties. The Yarans who toil in the fields and suffer the devastating effects of breathing in this chemical call it "the Poison."

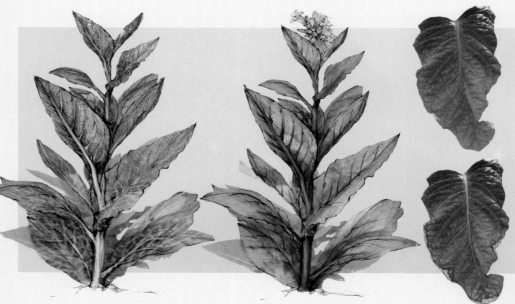

The leaves of tobacco plants turn red as a result of the PG-240 crop dusting and fumigation.

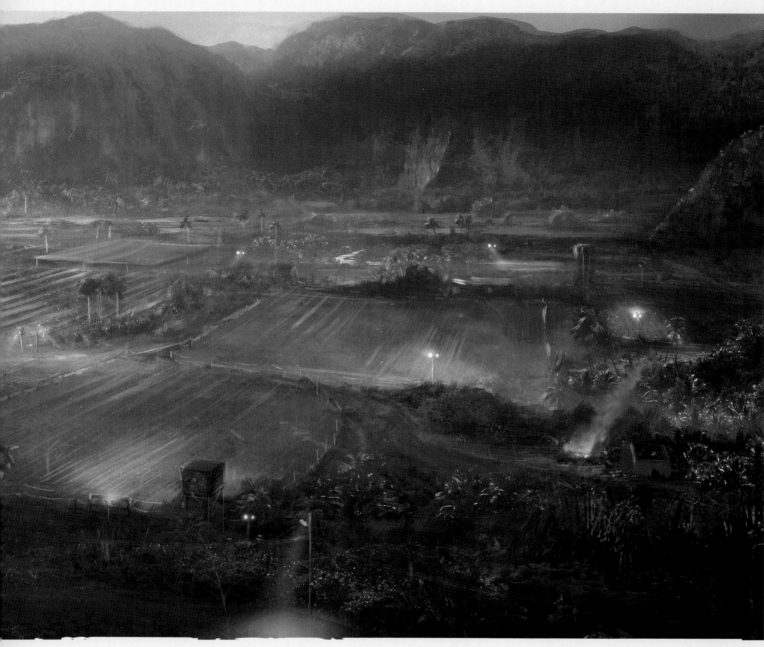

Concepts like this one are meant to encompass as much of a region as possible, so that the members of the production team all have the same vision for which to strive.

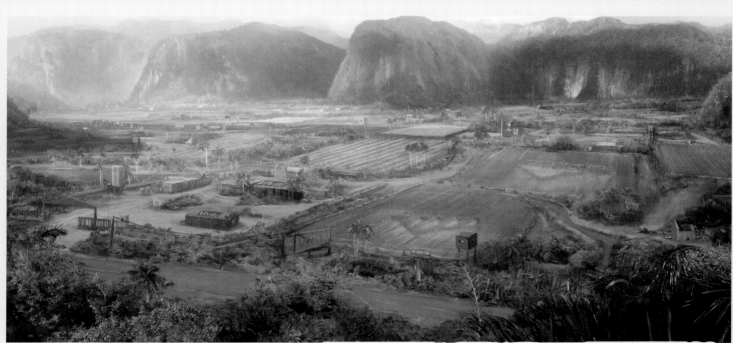

A standard modified-tobacco field against the backdrop of the mogote hills.

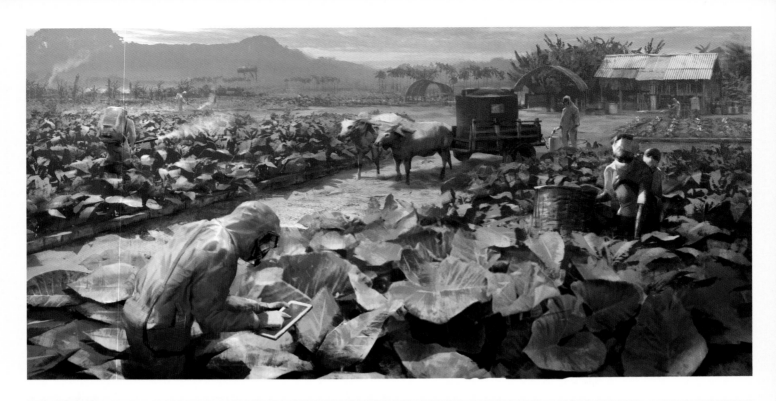

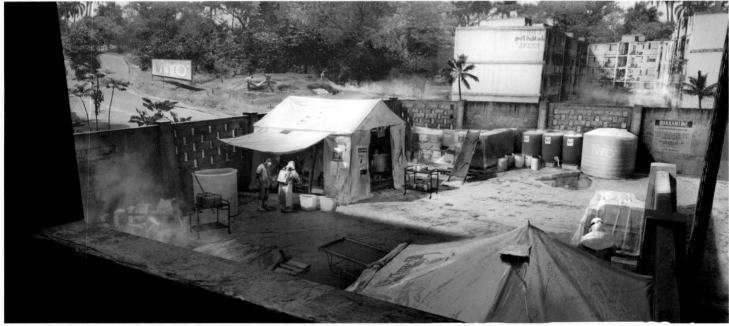

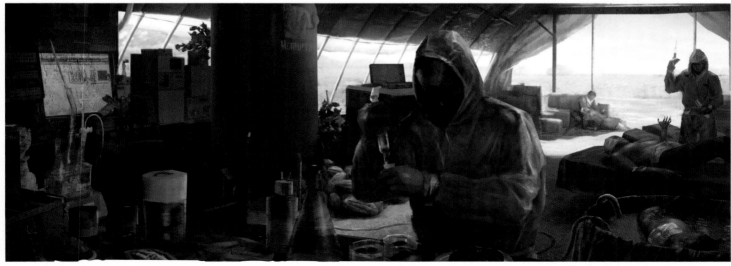

Exploration concepts for BioVida locations.

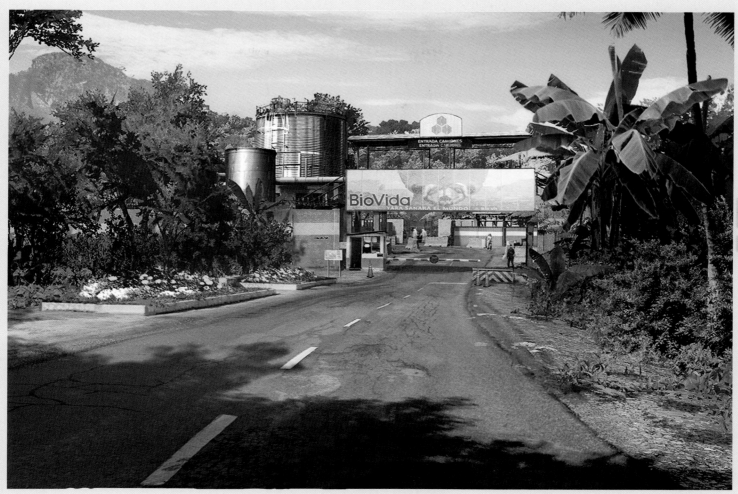

A view of the entrance to the BioVida plant where PG-240 is stored.

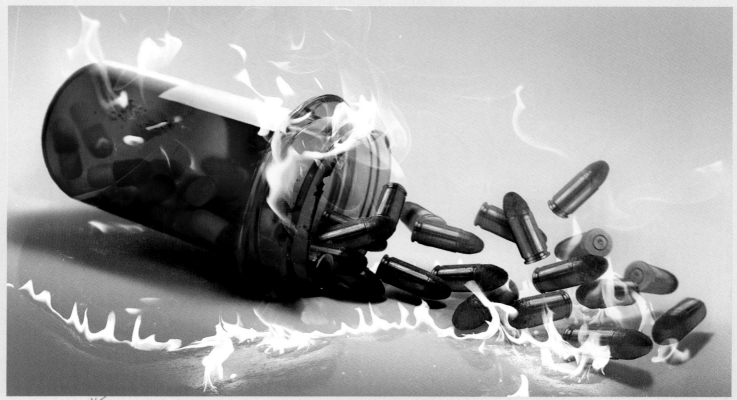

✳ A marketing image tying Viviro to conflict and the revolution.

BIOVIDA

Founded by Dr. Edgar Reyes, BioVida is the state-sponsored corporation that acts as the public face of the Viviro project. Its advertising appears everywhere in Yara, promising citizens that despite the in-humanity all around them, they are on the road to progress.

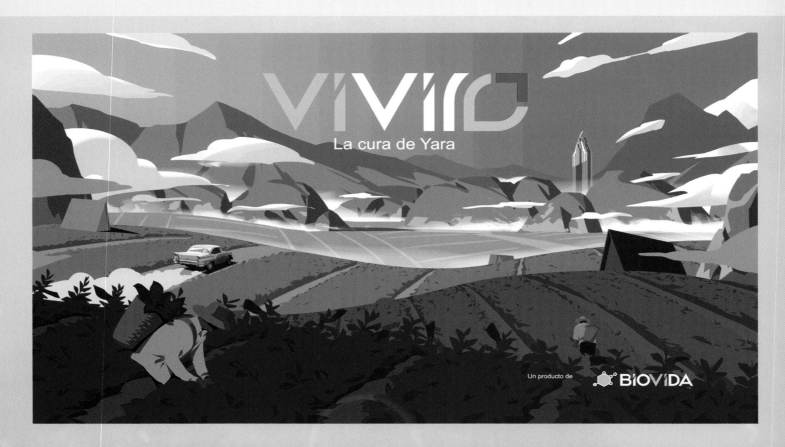

VIVIRO

The "VI" in "Viviro" reflects the roman numeral form of "6," for "Far Cry 6."

BIOVIDA

BIOVIDA

BioVida is the pharma branch of the military and the government.

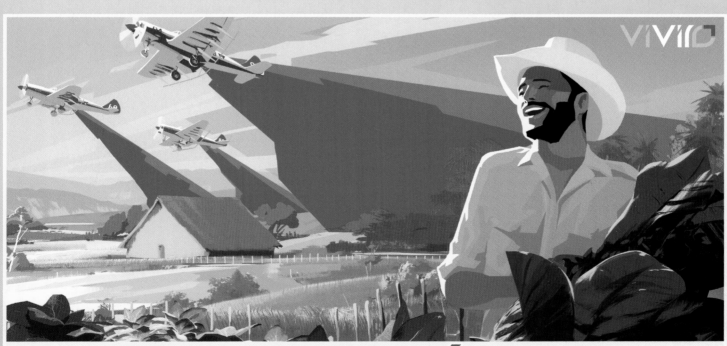

PURO Y ORGÁNICO!

VIVIRO

Minestero De Defensa

YARA + FUERZAS + NACIONALES
+ DE DEFENSA +

The "o" in "Viviro" is a modified tobacco leaf.

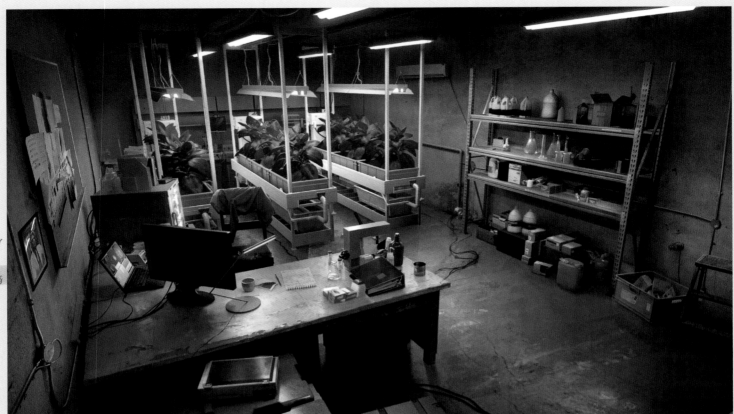

An interior view of Alejandro's lab.

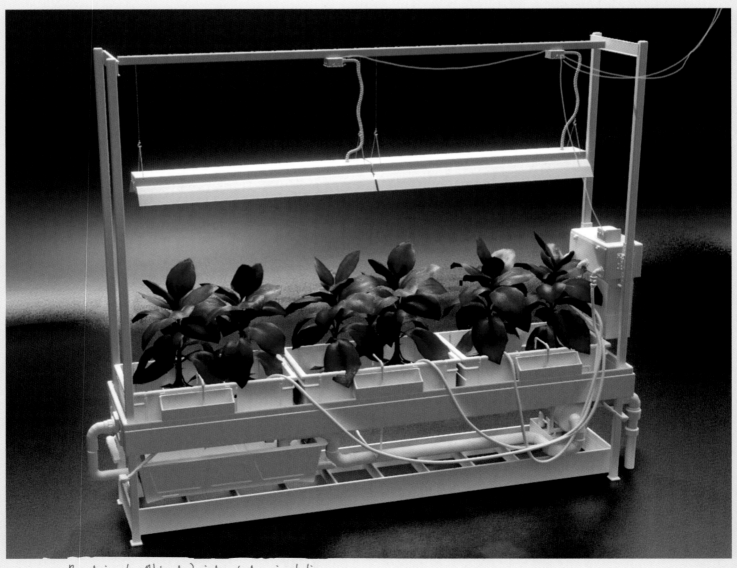

Prop design for Alejandro's indoor hydroponic station.

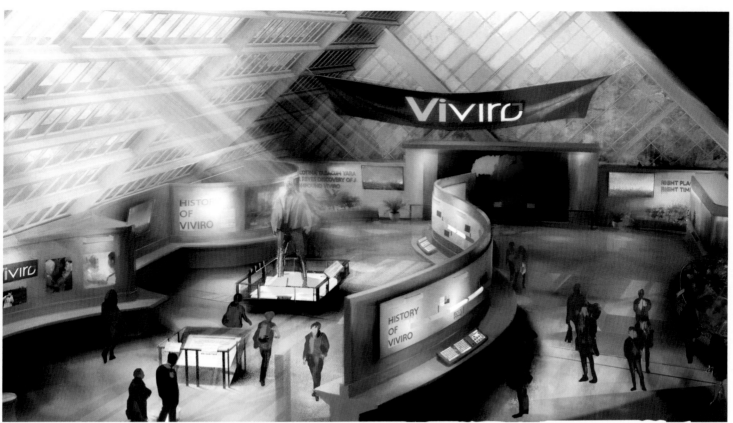

Layout design for the interior of the BioVida Center.

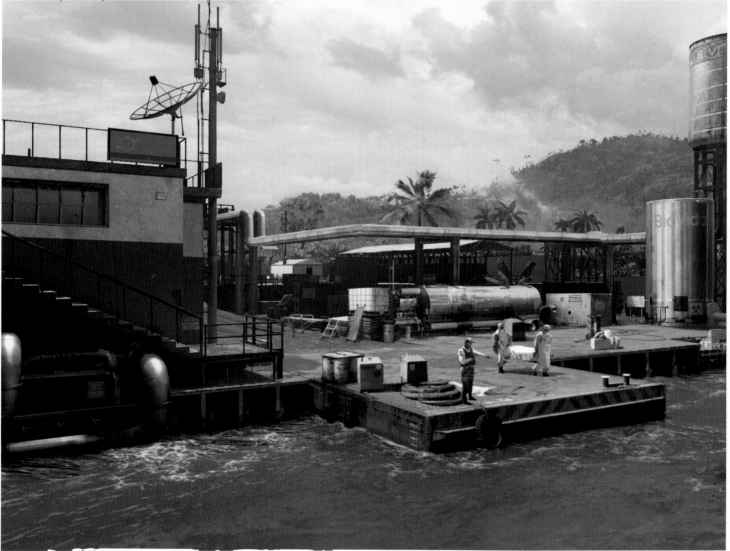

Concept for a BioVida plant in El Este.

Many of BioVida's pharmaceutical buildings are branded in white and a clinical shade of teal.

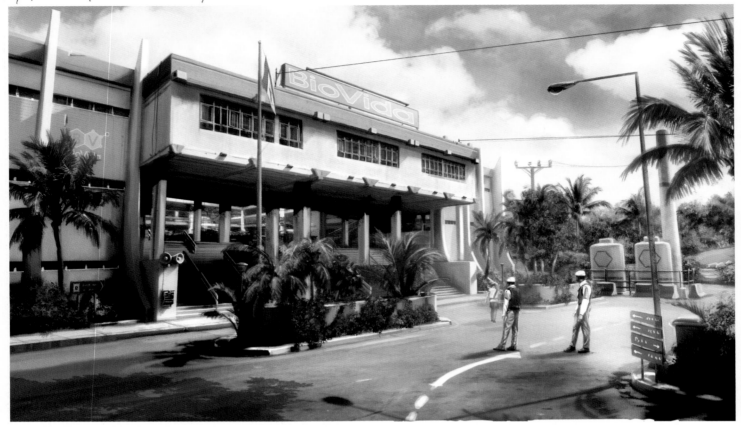

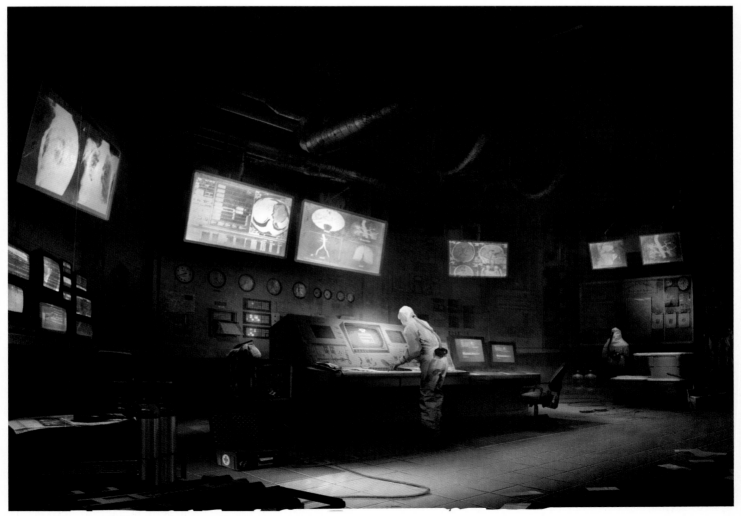

The control center to where PG-240 is created.

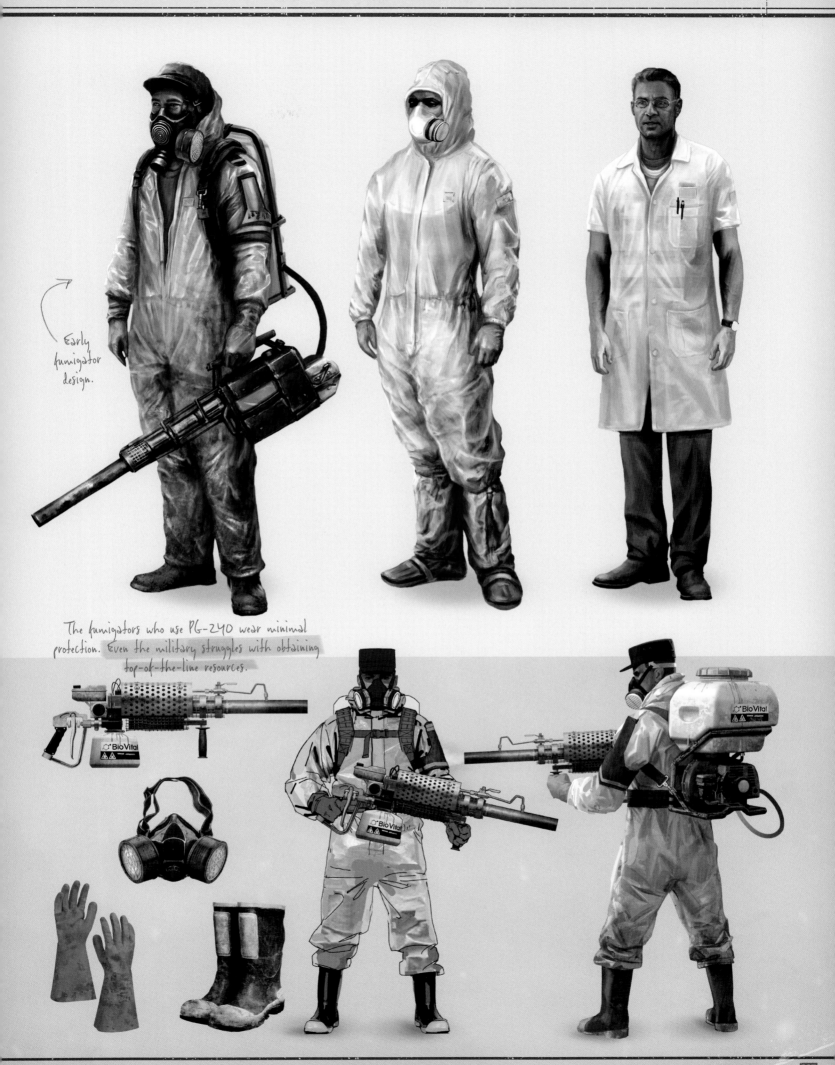

Early fumigator design.

The fumigators who use PG-240 wear minimal protection. Even the military struggles with obtaining top-of-the-line resources.

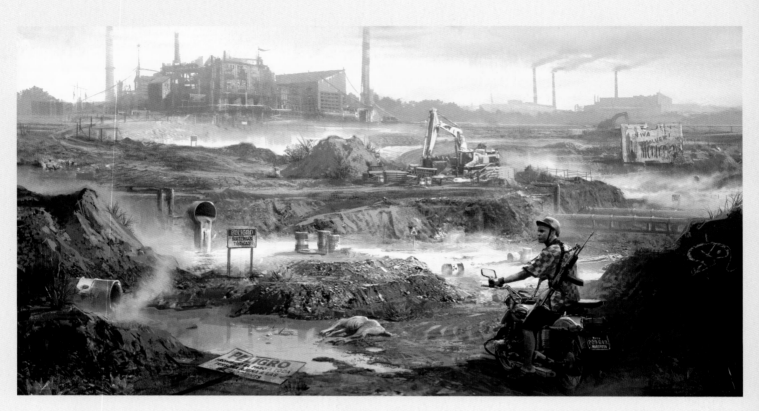

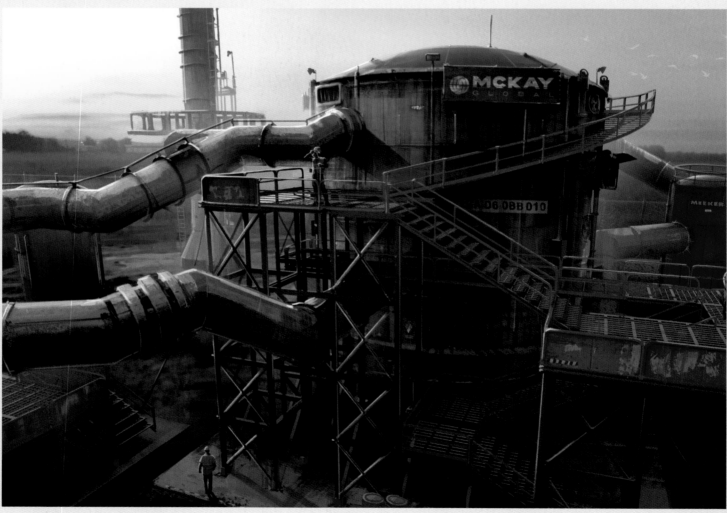

Concept of the PG-240 plant located near
the barren wastelands of La Joya.

Lighting study for an interior experimental testing lab.

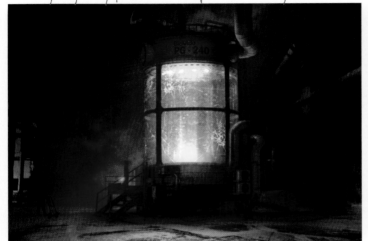

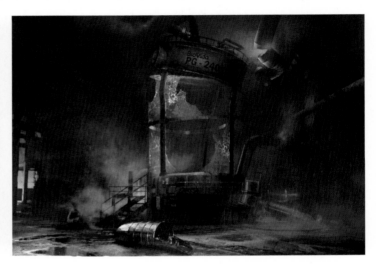

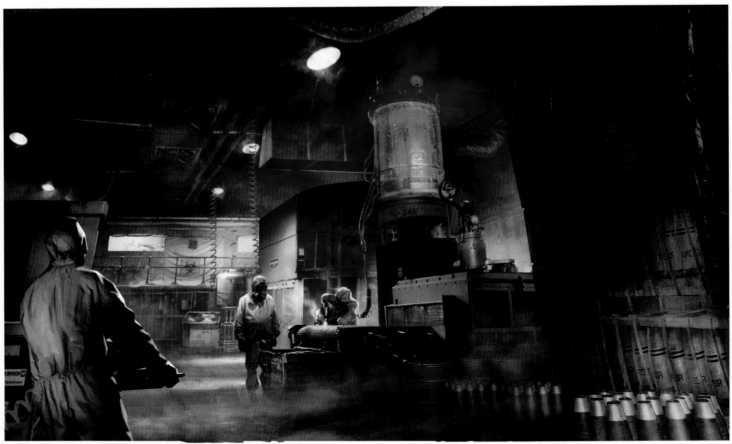

Lighting and layout study of where the Poison is being weaponized.

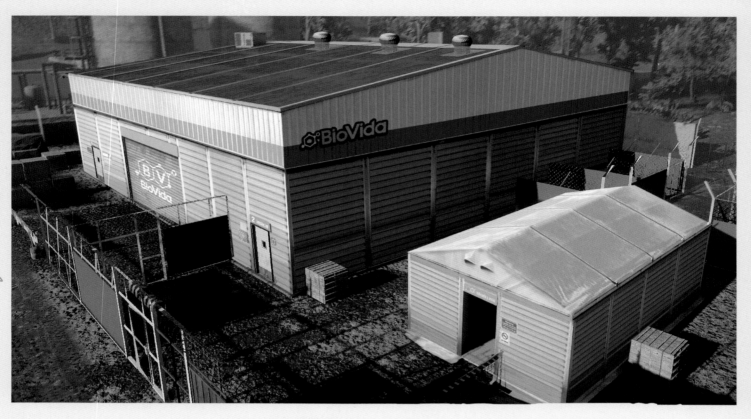

BioVida branding is also displayed on rural buildings used for animal testing.

ANIMAL TESTING

Before he was granted approval and funding by Antón, Dr. Reyes struggled to prove Viviro's viability and used livestock as his test subjects. These tests still continue, thanks to the government's total control of Yara's farms.

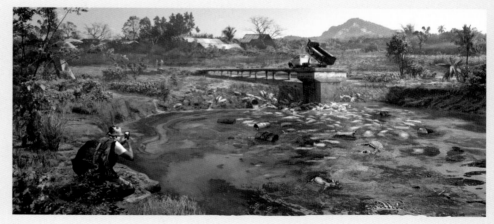

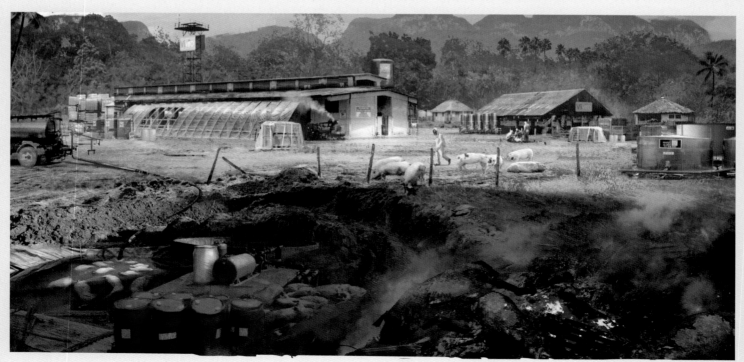

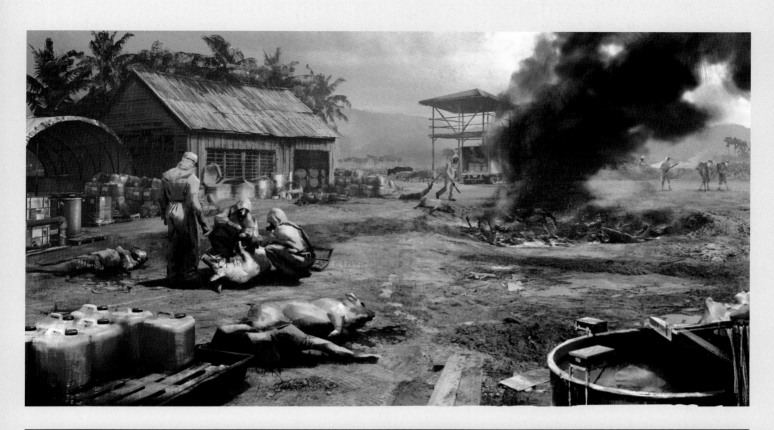

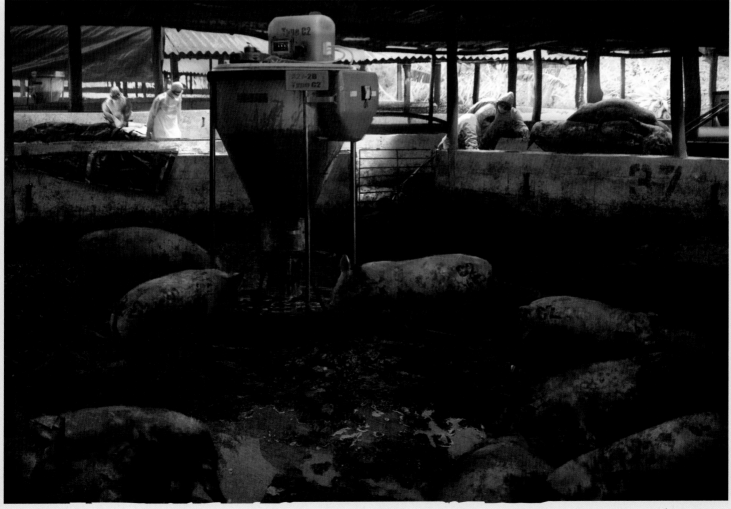

BioVida uses pigs for Viviro experimentation. These concepts show the inhumane conditions to which they are subjected.

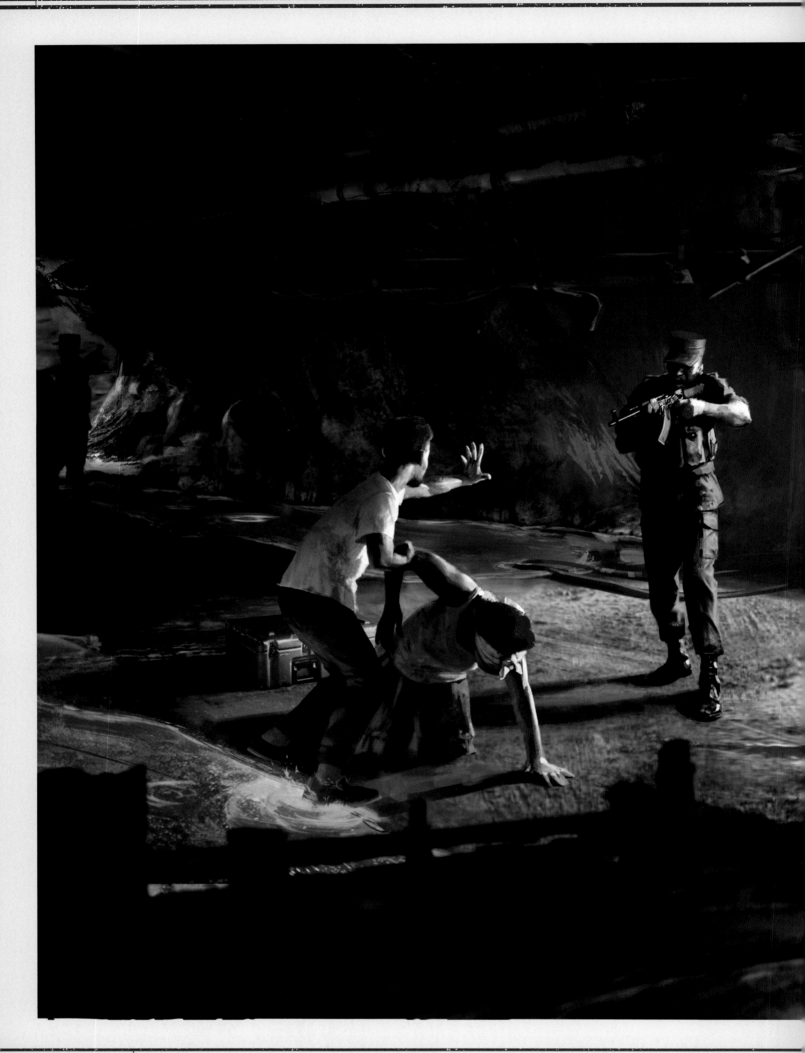

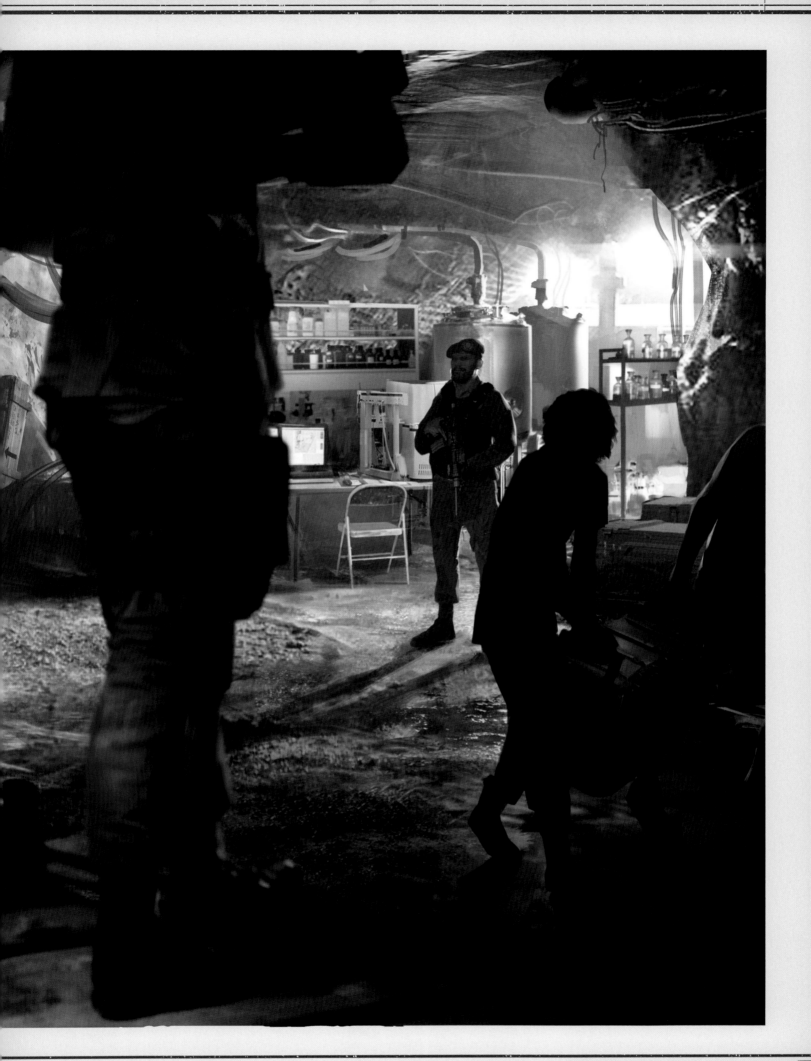

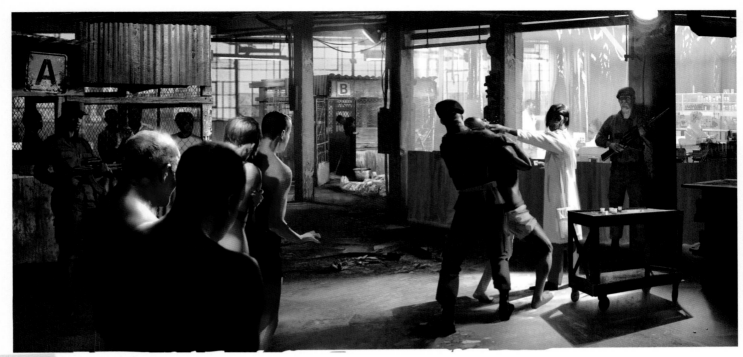

An early concept for human testing of Viviro on Outcasts.

HUMAN TESTING

Human trials had already begun in secret before Viviro was nationally funded, but once the Outcast program was in place and the regime had access to thousands of "disposable" bodies, testing kicked into overdrive. Age, gender, ethnicity, medical history, and consent don't matter—anyone and everyone is lined up and injected.

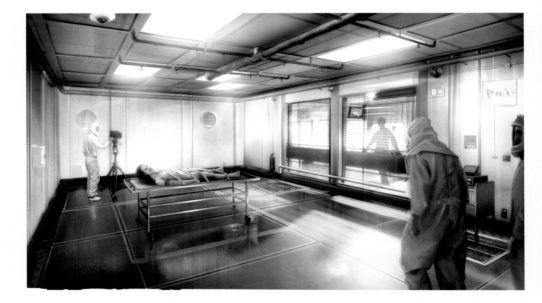

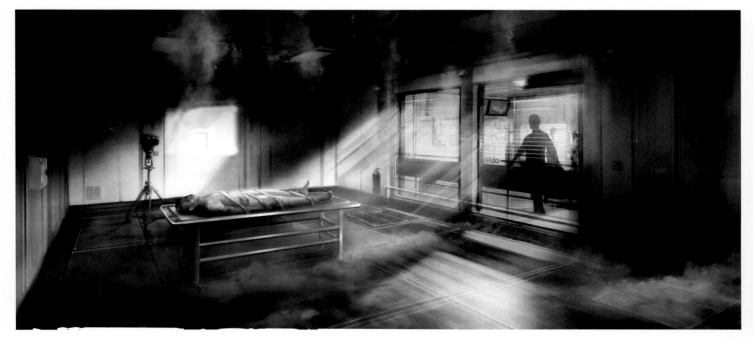

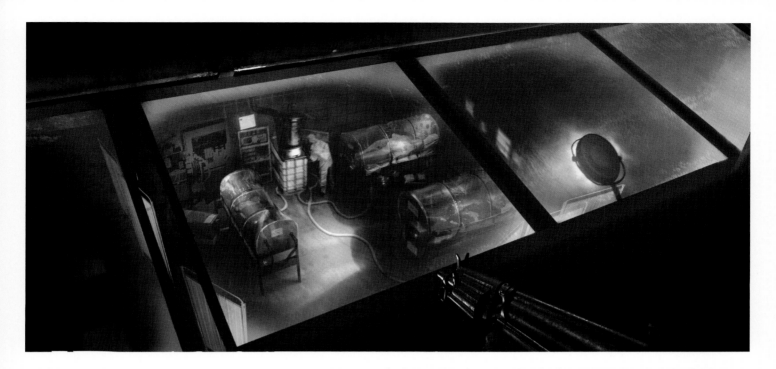

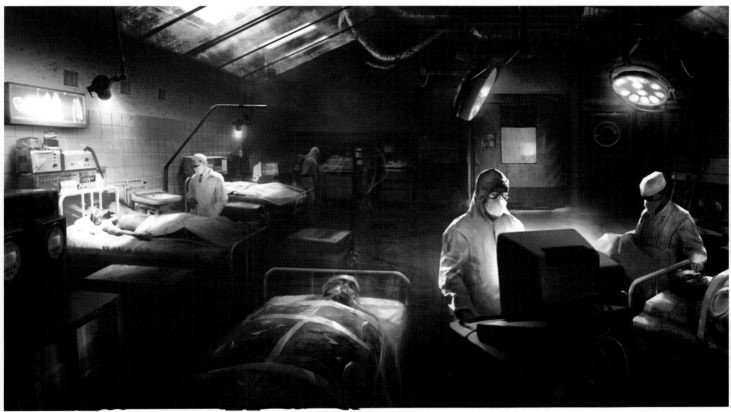

EXPERIMENTS

Like many totalitarian regimes, Antón's government has a vested interest in preserving and expanding its military might. The Viviro program proved to be a convenient way to achieve this through the potential application of the PG-240 toxin as a chemical weapon. To test its effects on the human body, individuals are selected from the Outcast program and subjected to horrific experimentation that often results in agony, illness, and death.

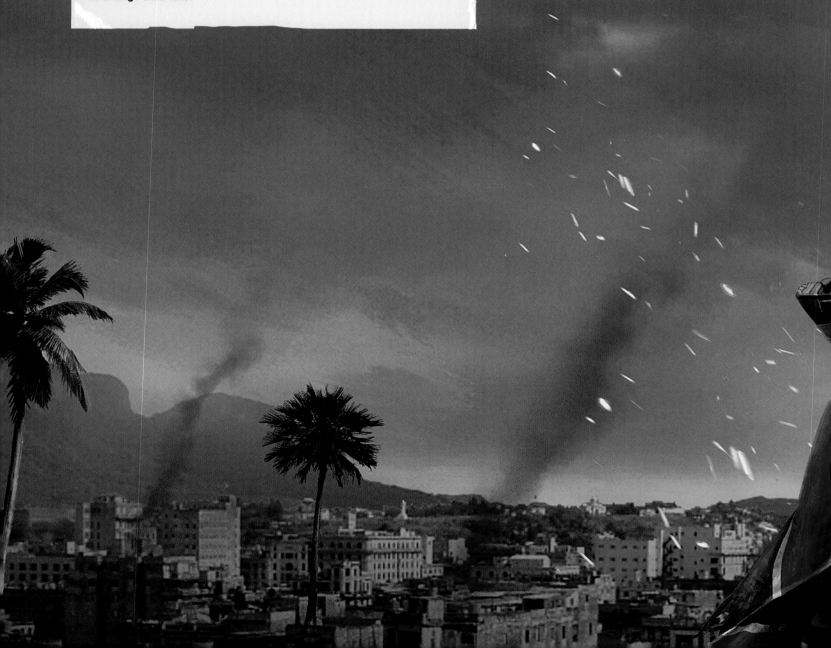

LIBERTAD

The guerrilla group formed by leader Clara García aims to unite all the guerrilla movements in Yara and take down Antón's regime. Its name is Spanish for "freedom," but Libertad is more than just a word—it is an ideal, a dream, a name for the fire that burns in the hearts of all Yarans who hope for a better life. To the outside world, Yara is a nation trapped in a cycle of oppression and revolution, stretching back to the days when Europeans first made landfall in the Caribbean. While its detractors might consider it just the latest in a long line of doomed rebel movements, Libertad aims to break that cycle—to dismantle the structure that supports the corrupt and cruel and rebuild a Yara that is inclusive of all its people once and for all. With the idea of freedom at its heart, Libertad operates with Clara's four-point manifesto: Free Elections, Free the Outcasts, Free Expression, and a Yara Free of Castillos. These four tenets are the backbone of Clara García's vision, one that inspires young Dani Rojas to change their fate.

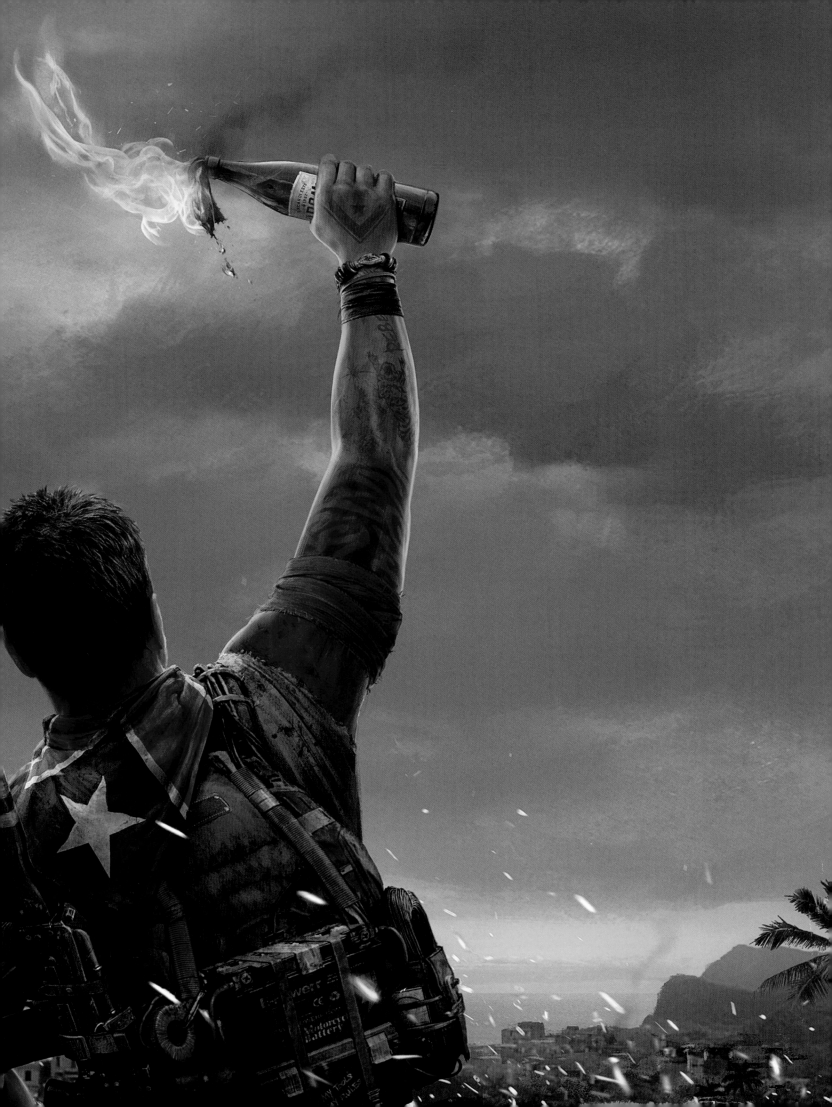

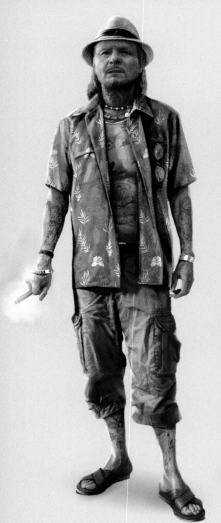
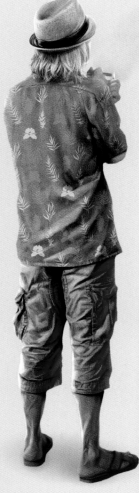

JUAN CORTEZ

Some people break eggs for breakfast. Juan Cortez breaks countries. A washed-up operative specializing in destabilization, he drinks away a bloody past full of wet work, tradecraft, and espionage. But here at home in Yara, he finally has a chance to use his talents to help Libertad wipe Castillo off the map while also feeding his need for the adrenaline of guerrilla warfare. Clara García keeps him close, since his counsel is invaluable and his Supremo devices can turn one soldier into a hundred.

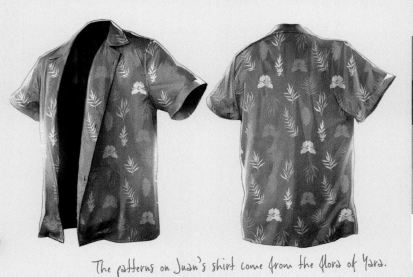

The patterns on Juan's shirt come from the flora of Yara.

Juan's published book on guerrillas is dogeared with age and use, like something he always carries with him.

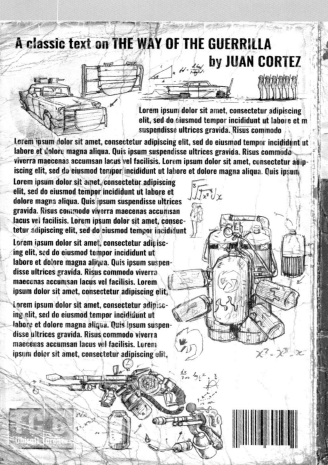

A classic text on **THE WAY OF THE GUERRILLA** by **JUAN CORTEZ**

Lorem ipsum dolor sit amet, consectetur adipiscing elit, sed do eiusmod tempor incididunt ut labore et m suspendisse ultrices gravida. Risus commodo

Lorem ipsum dolor sit amet, consectetur adipiscing elit, sed do eiusmod tempor incididunt ut labore et dolore magna aliqua. Quis ipsum suspendisse ultrices gravida. Risus commodo viverra maecenas accumsan lacus vel facilisis. Lorem ipsum dolor sit amet, consectetur adipiscing elit, sed do eiusmod tempor incididunt ut labore et dolore magna aliqua. Quis ipsum

Lorem ipsum dolor sit amet, consectetur adipiscing elit, sed do eiusmod tempor incididunt ut labore et dolore magna aliqua. Quis ipsum suspendisse ultrices gravida. Risus commodo viverra maecenas accumsan lacus vel facilisis. Lorem ipsum dolor sit amet, consectetur adipiscing elit, sed do eiusmod tempor incididunt

Lorem ipsum dolor sit amet, consectetur adipiscing elit, sed do eiusmod tempor incididunt ut labore et dolore magna aliqua. Quis ipsum suspendisse ultrices gravida. Risus commodo viverra maecenas accumsan lacus vel facilisis. Lorem ipsum dolor sit amet, consectetur adipiscing elit,

Lorem ipsum dolor sit amet, consectetur adipiscing elit, sed do eiusmod tempor incididunt ut labore et dolore magna aliqua. Quis ipsum suspendisse ultrices gravida. Risus commodo viverra maecenas accumsan lacus vel facilisis. Lorem ipsum dolor sit amet, consectetur adipiscing elit,

Ubisoft Toronto

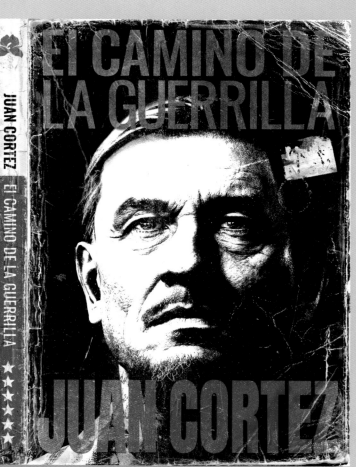

EI CAMINO DE LA GUERRILLA

JUAN CORTEZ

EI CAMINO DE LA GUERRILLA

JUAN CORTEZ

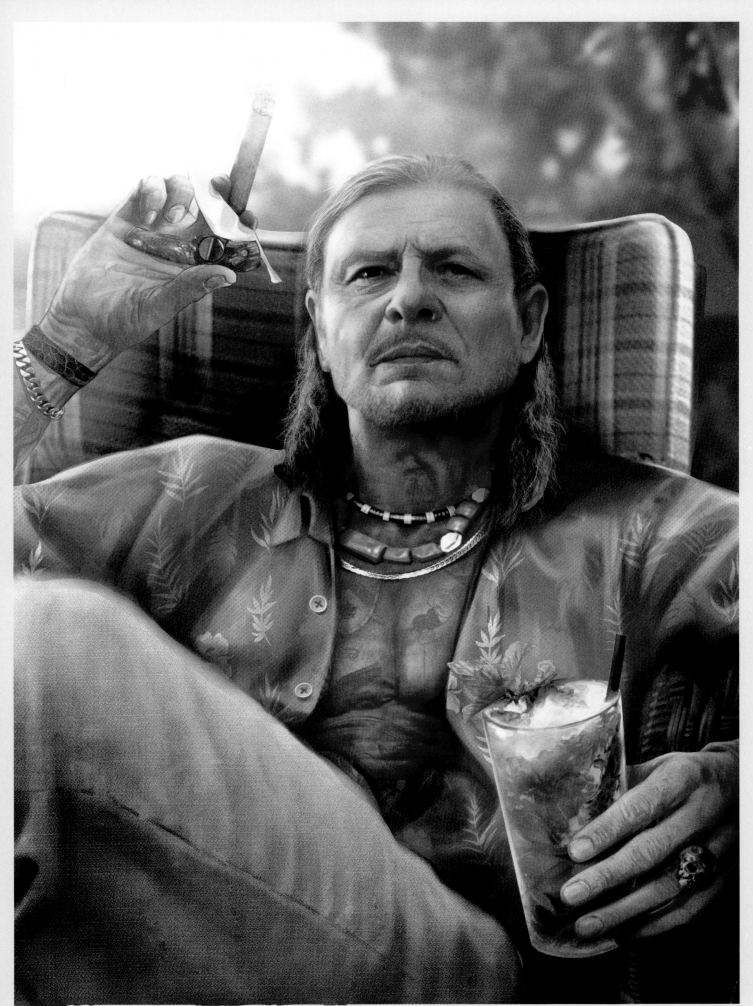

Juan is a jack-of-all-trades, but is also someone who has lived in Yara a long time. His necklaces and tattoos tell a tale of his secret past and many travels.

CLARA GARCÍA

Clara grew up wealthy but would become swept up in the protest movements formed in the heart of the capital city of Esperanza. It was here she eventually came to learn that everything she knew was a lie. After the election of Antón, his brutal crackdown on protests, and his establishment of the Outcast system led Clara to decide that the only means to obtain freedom for every Yaran was armed struggle. She fled the Yaran mainland and started the Libertad movement with an intentionally focused manifesto: Free Elections, Free the Outcasts, Free Expression, and a Yara Free of Castillos.

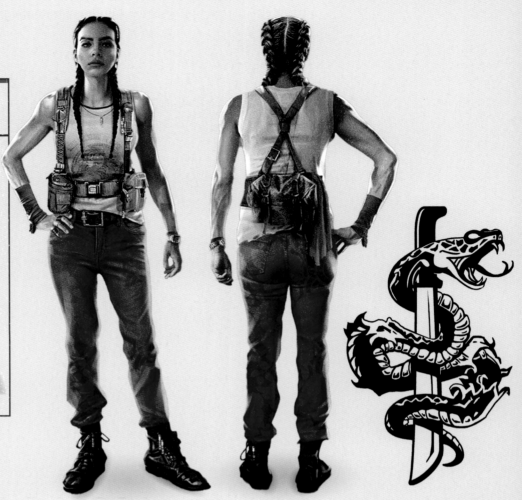

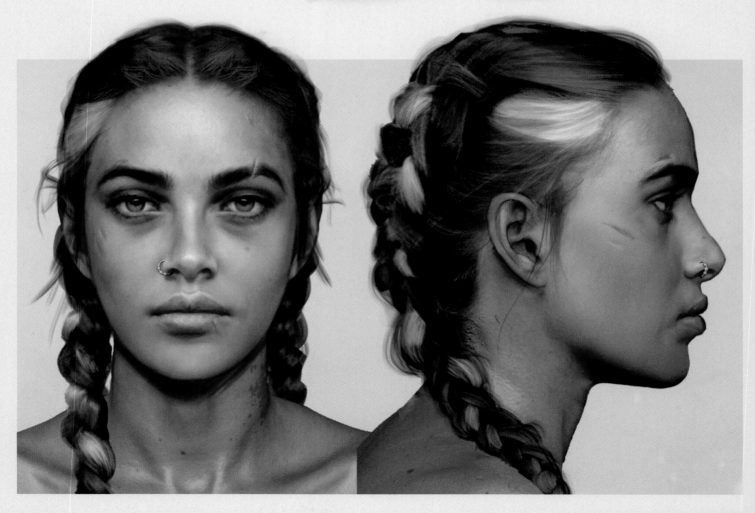

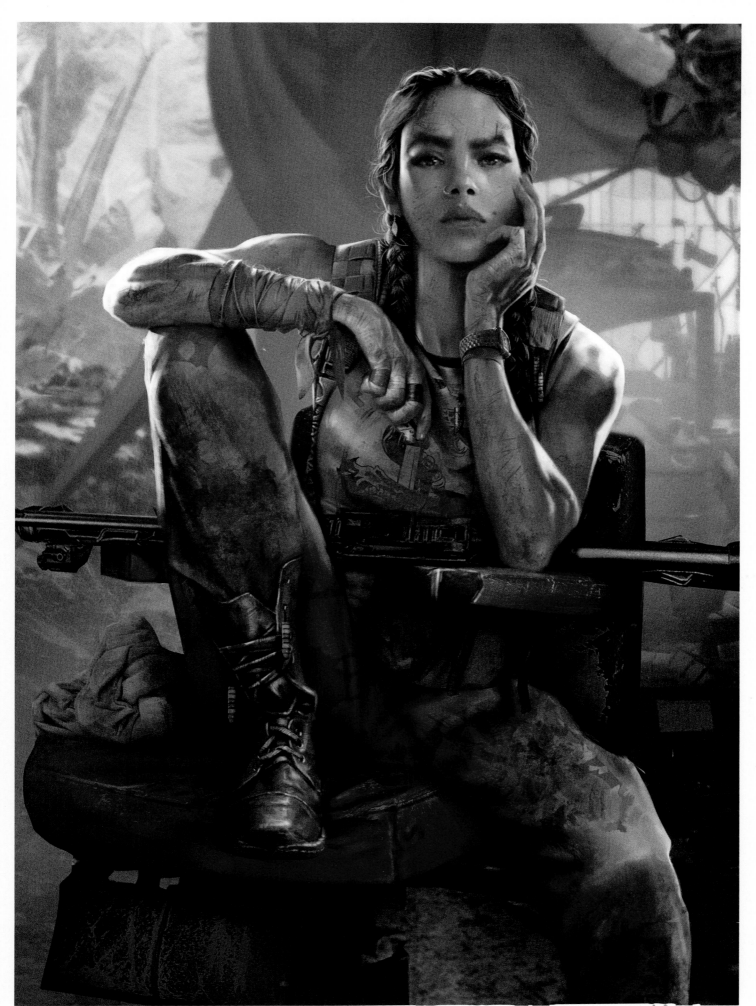

Clara's concept (opposite) was a benchmark for her design. She represents a shift from the iconic guerrilla look to something more modern.

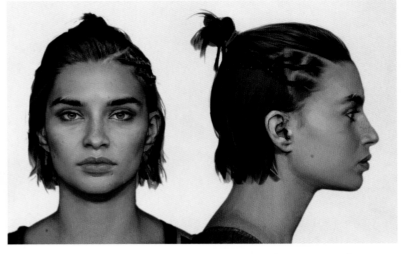

Both looks for Dani share similar visual traits, like the scar above the right brow, the part in the hair, and the skin blemishes. This offers the player a choice but still creates the feeling it's the same character for the sake of narrative.

LIBERTAD
DANI ROJAS

Dani Rojas grew up an orphan in Esperanza, became a cadet in the Yaran Military Academy, and ended up a washout street grifter. They never saw themselves as a revoloutionary, but a failed attempt to escape the country after the deaths of their closest friends landed them right in Clara García's lap. With the ability to connect with the struggles of everyday Yarans, Dani is the perfect person to unite the rebel factions of Yara under the Libertad banner.

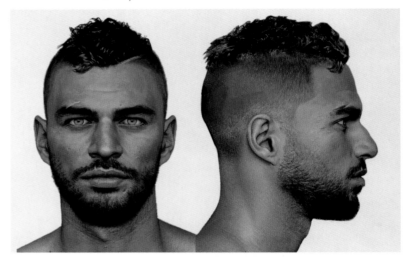

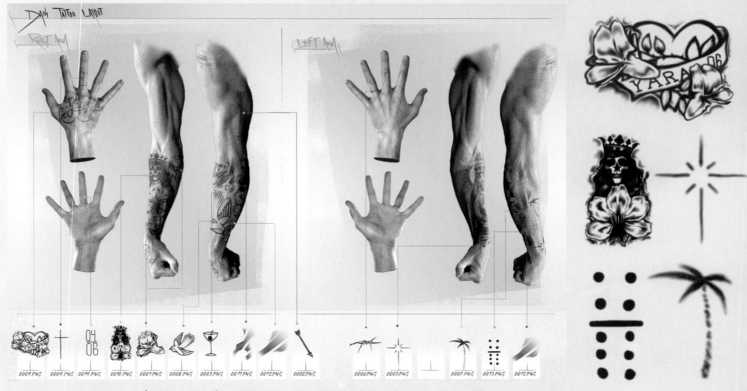

Many of Dani's tattoos come from elements in Yara that ground the character to their birthplace.

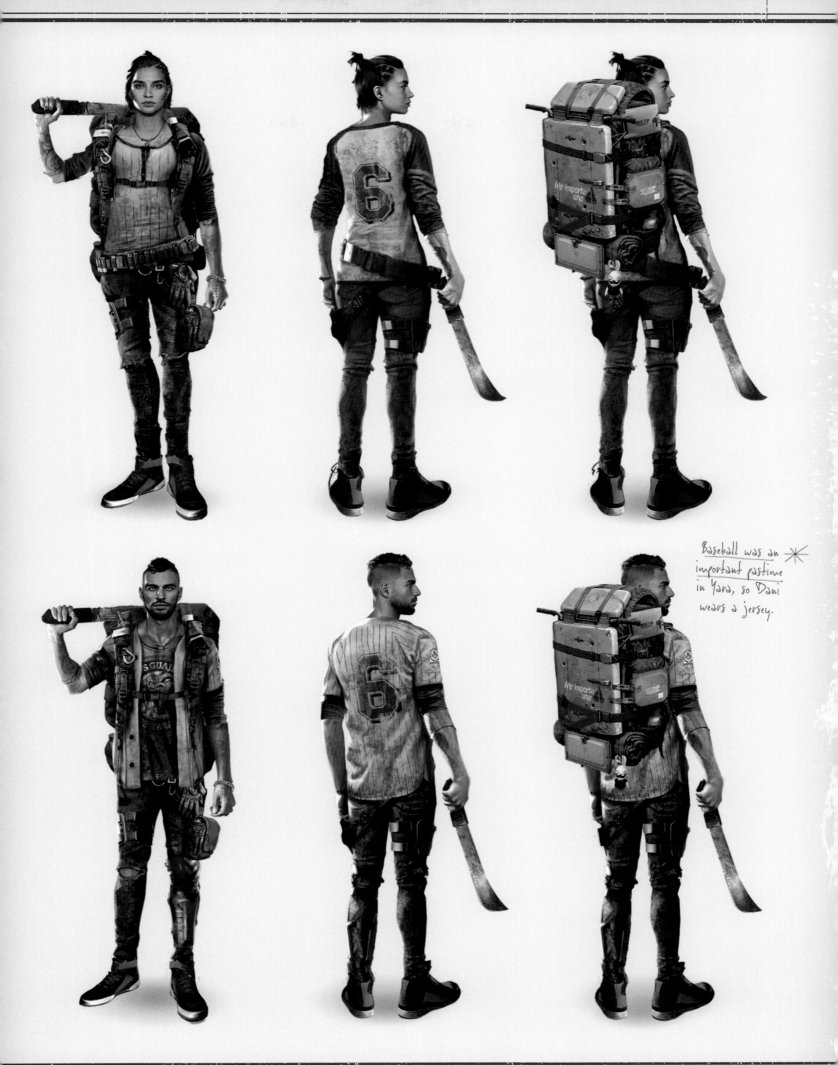

Baseball was an important pastime in Yara, so Dani wears a jersey.

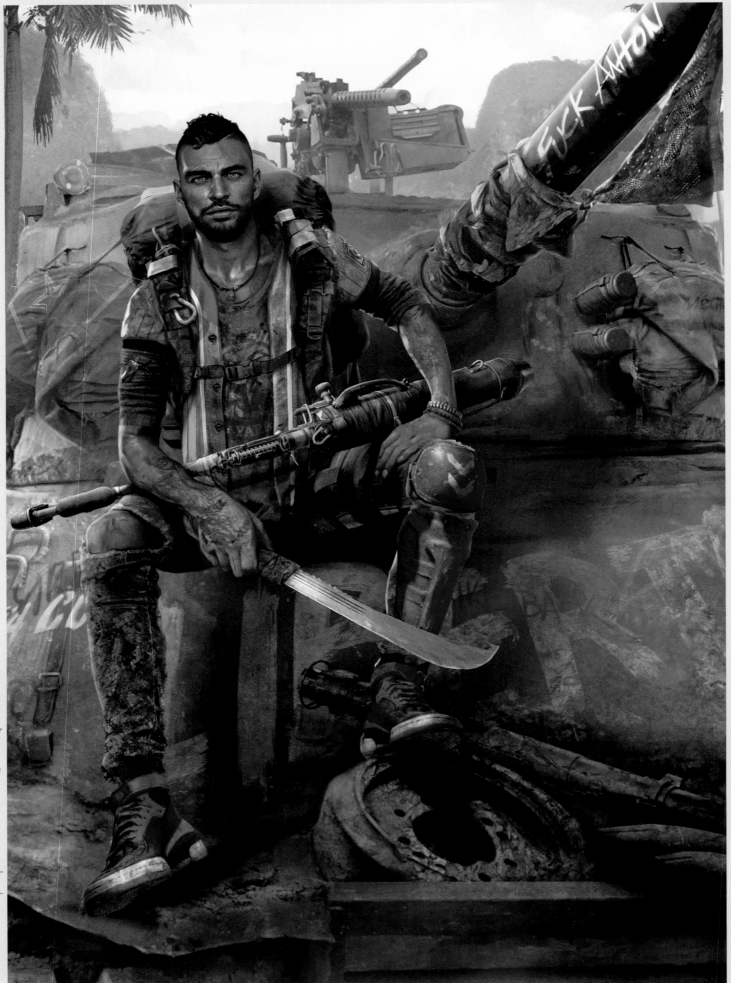

These concepts of Dani give us a look at the gear and grime seen at the beginning of the conflict. Guerrillas often take photos of themselves with the spoils of war.

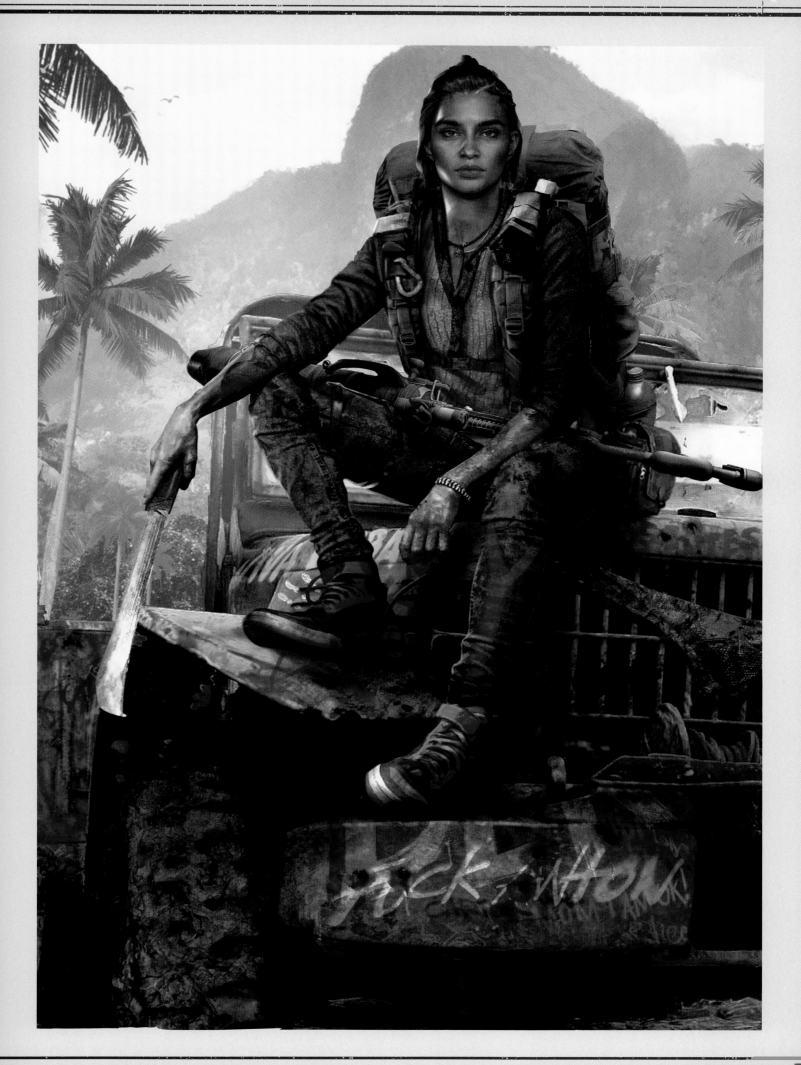

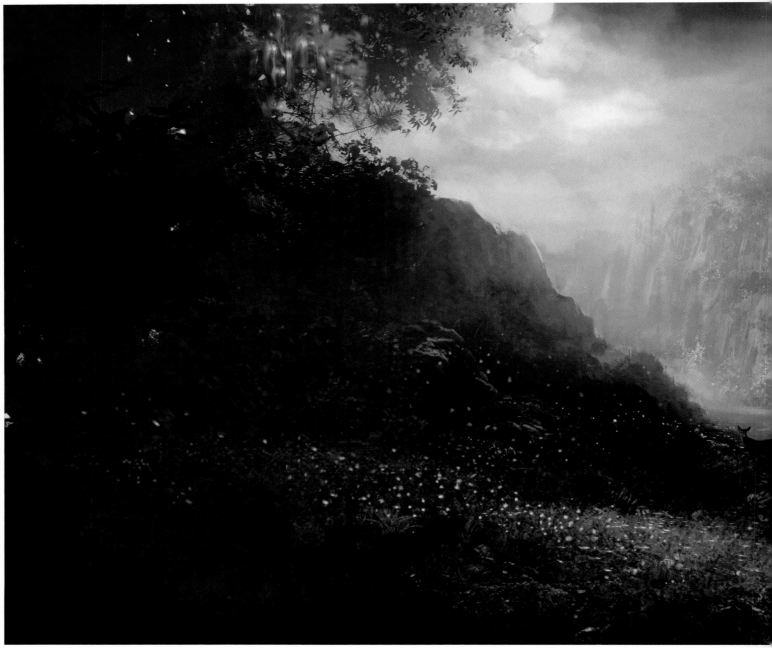

Examples
of how the
guerrilla
code and
player
guidance
can be
used.

 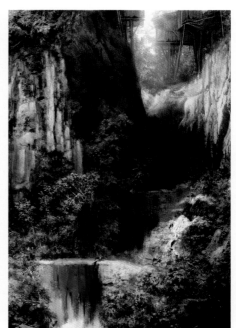

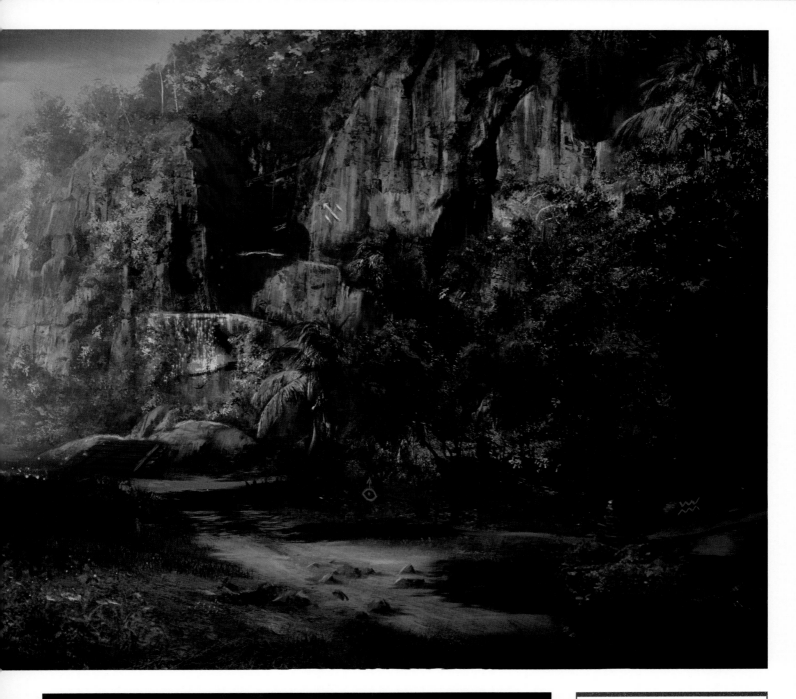

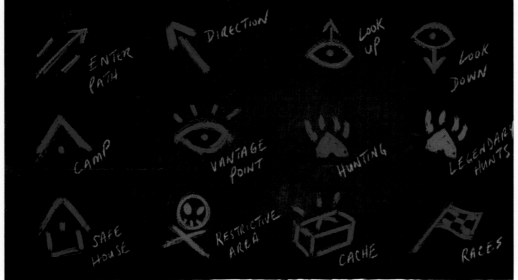

Libertad uses a code of symbols to guide their members across Yara.

GUERRILLA PATHS

Moving in secret, Libertad helps its members—and anyone who sympathizes with their cause—to locate places and items of interest through a coded visual language. Arrows and symbols guide guerrillas along secret paths toward shelters, safehouses, caches, vantage points, hunting grounds, and recreational activities. They will also warn of dangerous or unfriendly areas to help sympathizers avoid the military.

Concept of
the station
used to
access the
Guerrilla
Columns
feature.

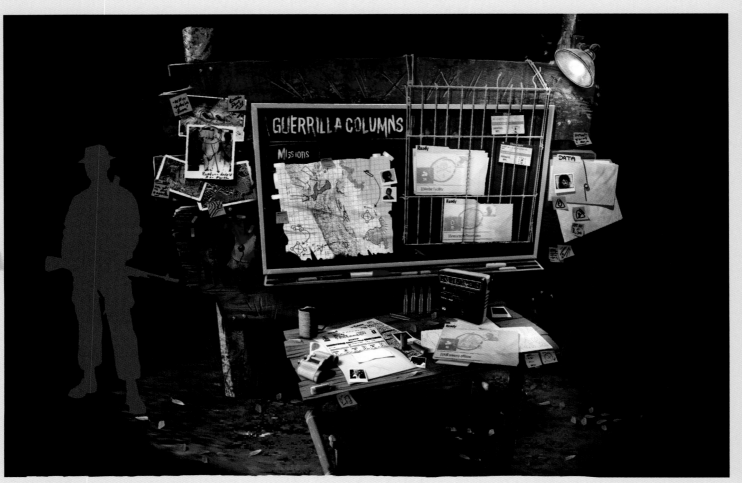

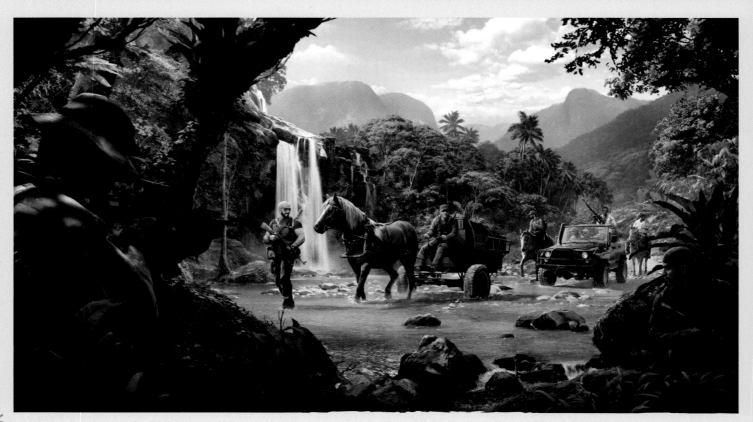

An early concept showing a guerrilla ambush before any
designs were established for the different factions.

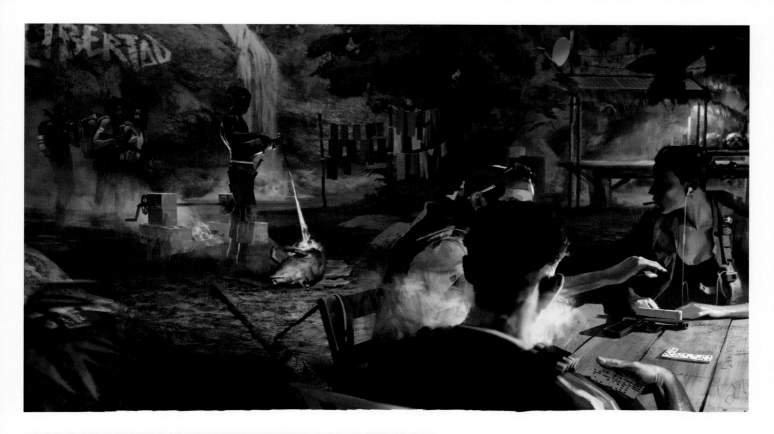

GUERRILLA CAMPS

Secretive by nature, guerrillas never stay in one place too long. When they do congregate in larger groups, they choose isolated areas and occupy existing homes and farmsteads to disguise their true purpose. The Montero ranch in Yara's Madrugada region is one such camp: a family estate hidden in the *mogotes* where guerrillas live, eat, sleep, train, strategize, and socialize.

The camps show daily life and community in addition to weapons training.

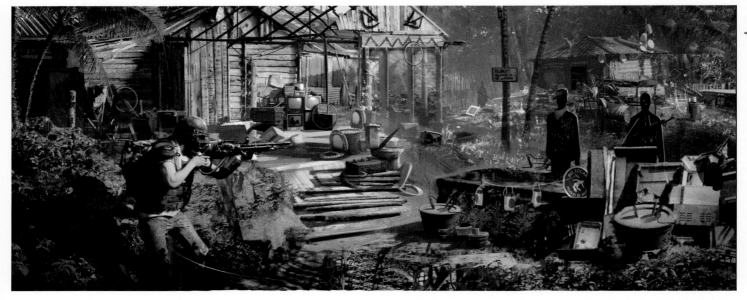

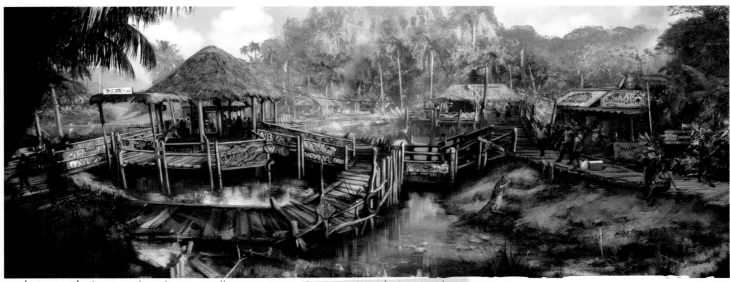

Máximas Matanzas set up their guerrilla camp in an abandoned crocodile breeding farm.

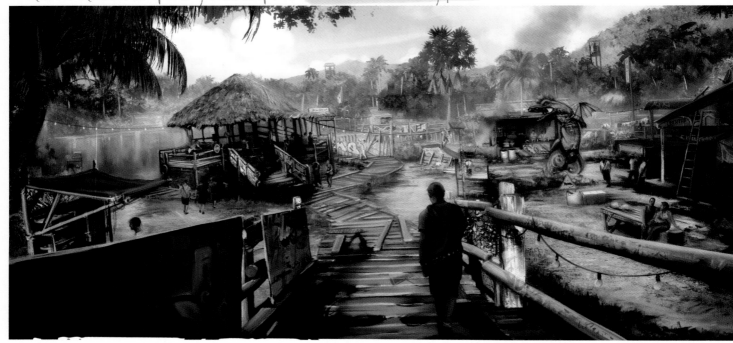

GUERRILLA CAMPS

Yara's different rebel factions hold court all over the country, from the swamps of the Valle de Oro to the mountain peaks of El Este. Each hidden camp is hard to find and even harder to enter, thanks to constant surveillance that ensures the military never catches wind of their presence.

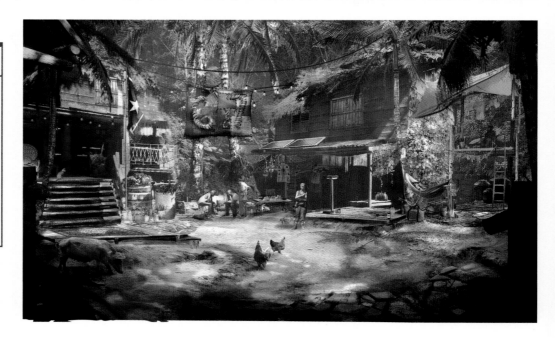

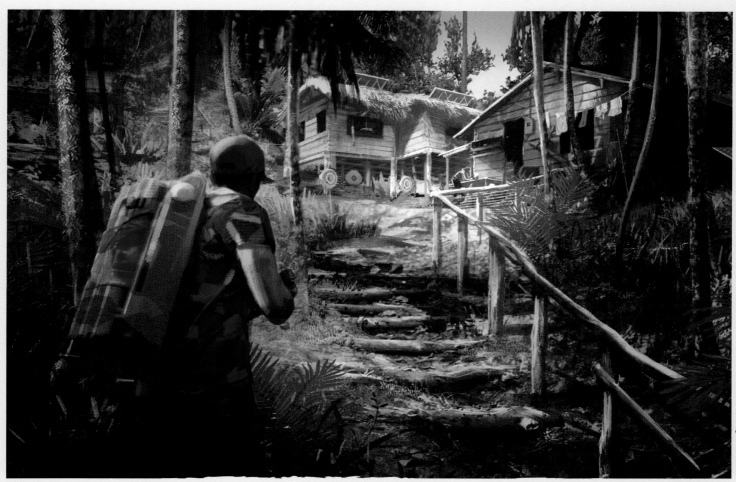

Huts and homes need to be colorful when viewed against the dense green vegetation of the mountains.

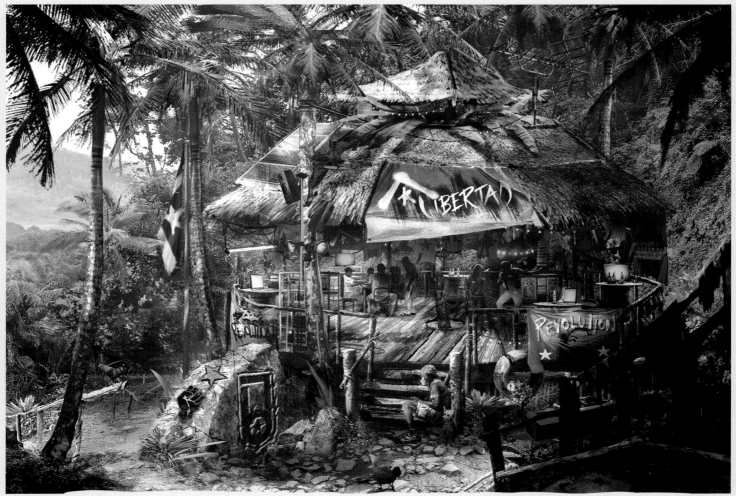

The camp of the Legends of '67 can be found deep in the jungle and high up in the Sierra Perdida.

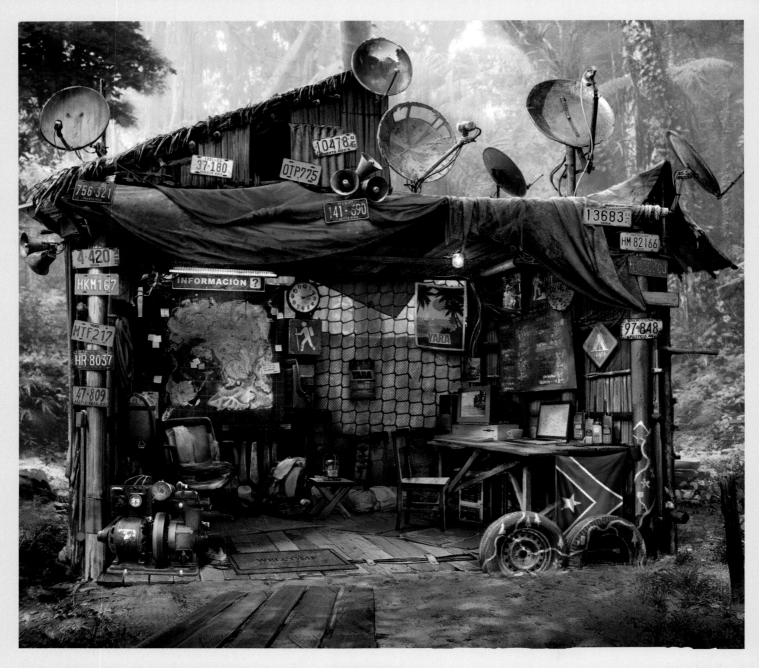

CAMP UPGRADES

The *resolver* visual style is also translated to the different camp upgrades that can be acquired.

Balancing "gamification" with realism is always a challenge. Things need to feel a little over the top but still possible.

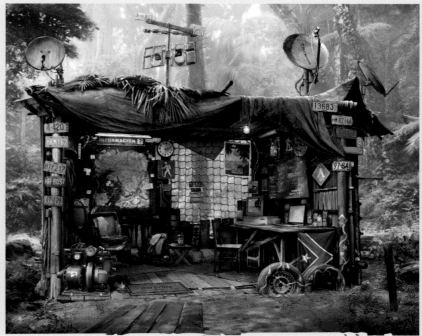

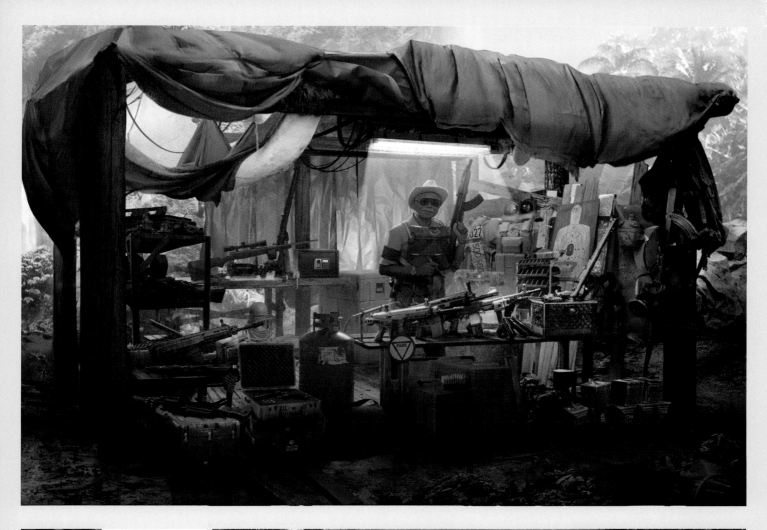

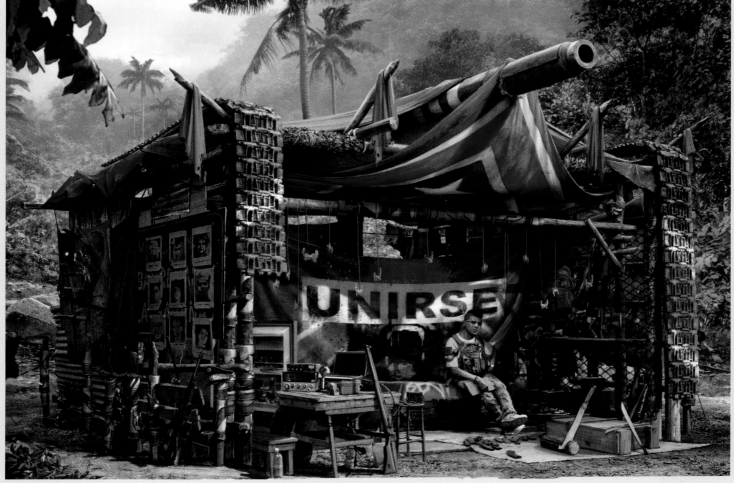

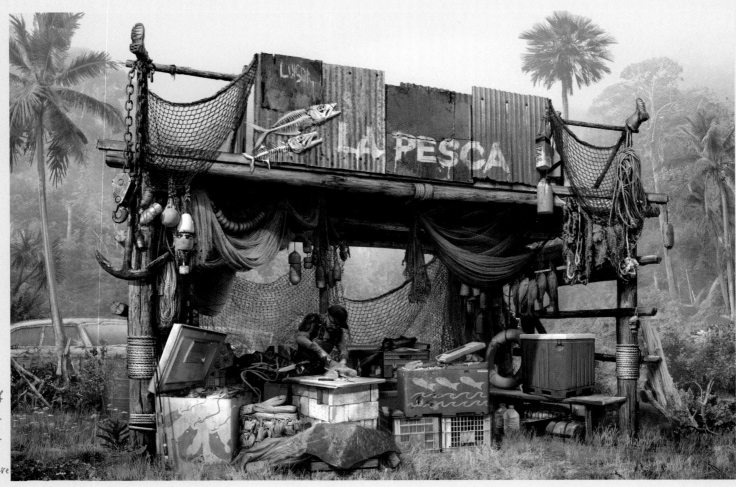

The camp visually upgrades as more resources are devoted to its growth.

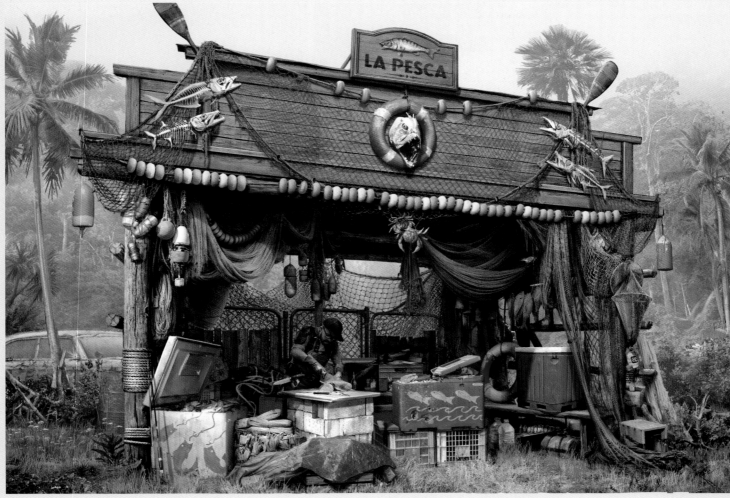

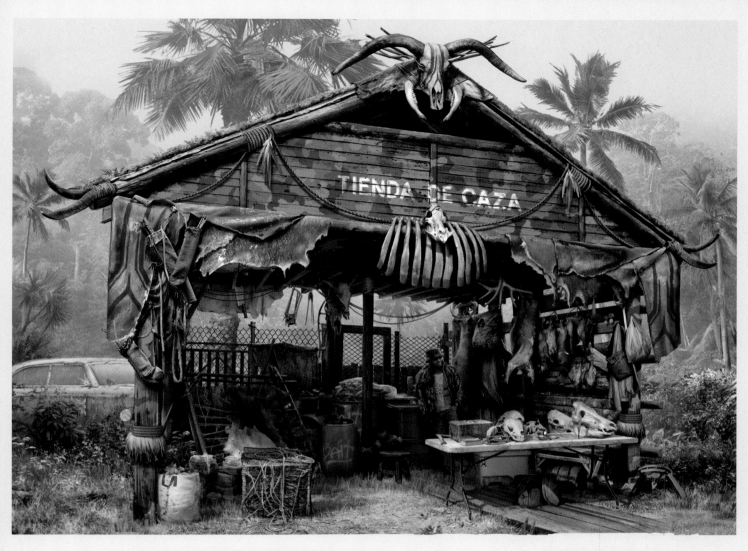

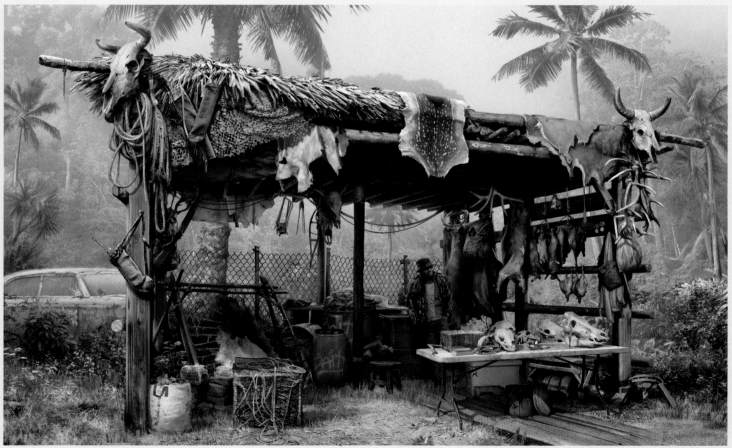

Many of the stations are dressed with elements that represent their use. More resources are seen with every upgrade.

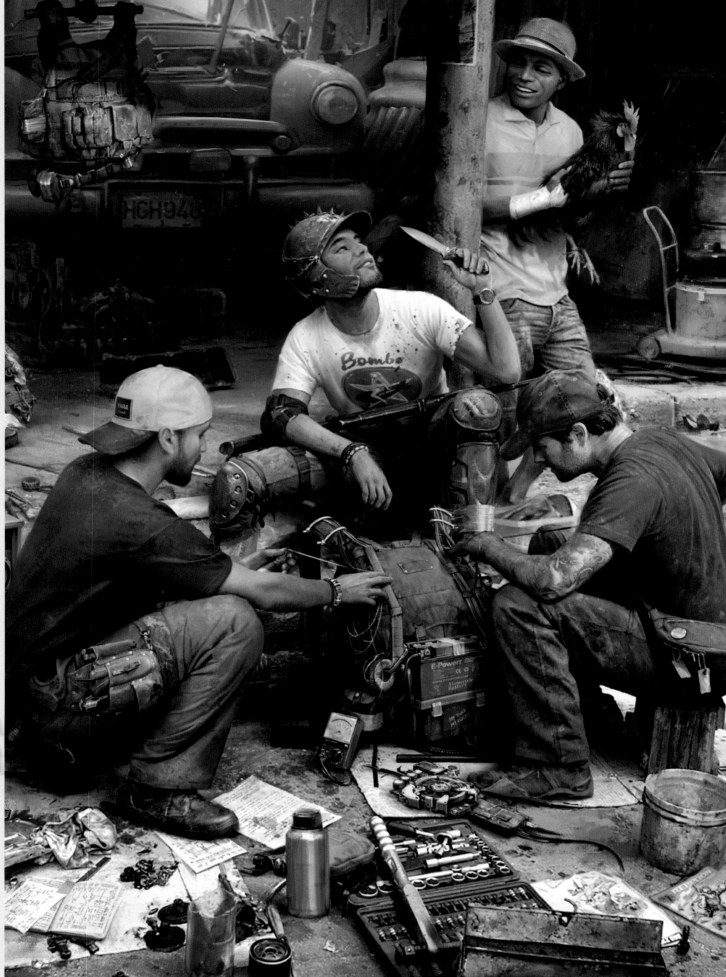

One of the best concepts showing the modern guerrilla look affecting the "resolver" philosophy.

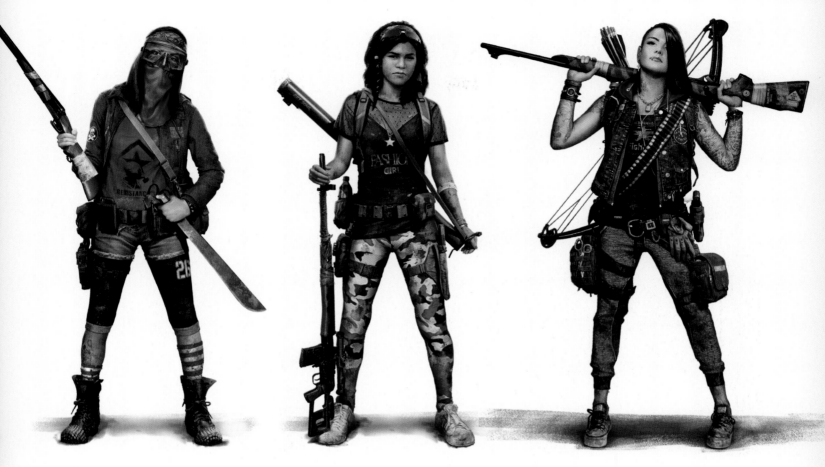

Some of the very first concepts for the guerrilla style. It shows modernity, personal expression, and the ingenuity of resolver crafting. These are often civilians taking up arms. It's David vs. Goliath.

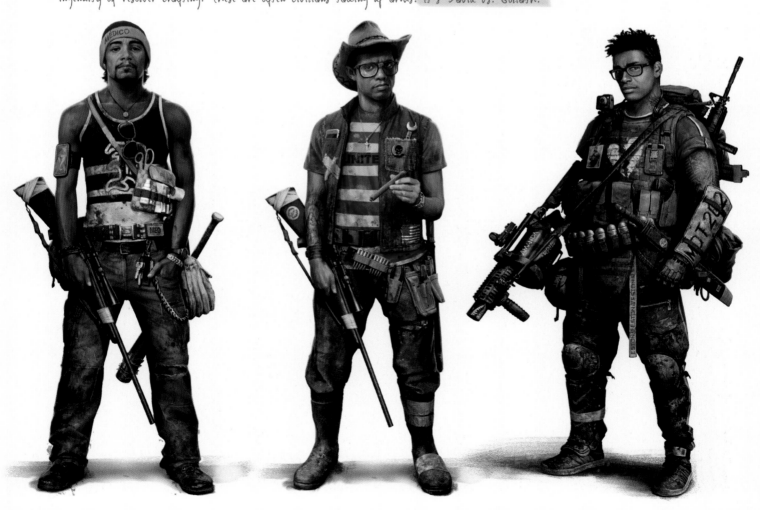

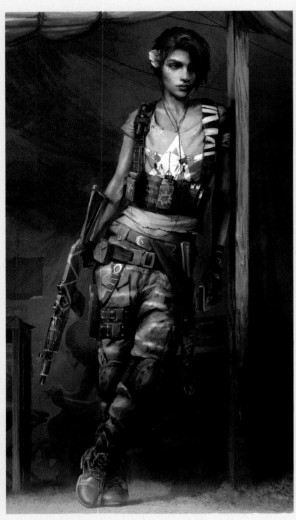

One of the earliest concepts of Dani.

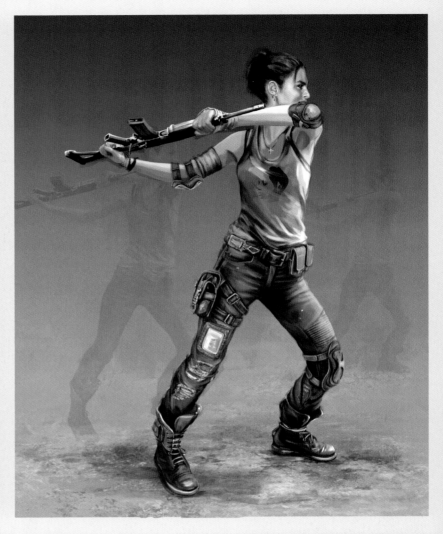

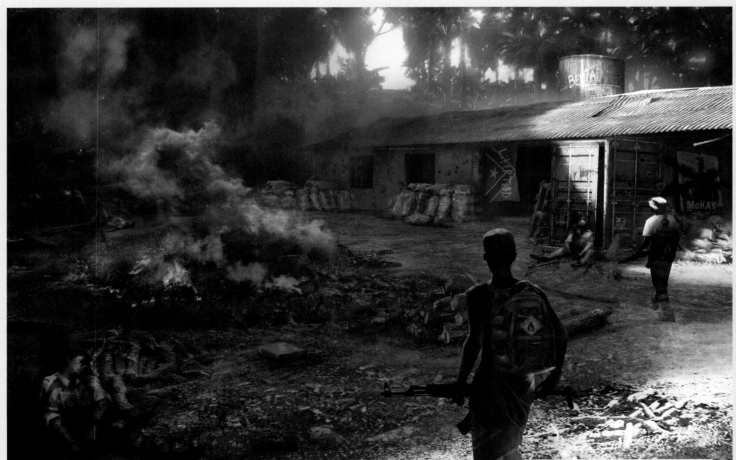

Exploration for the liberation of an outpost.

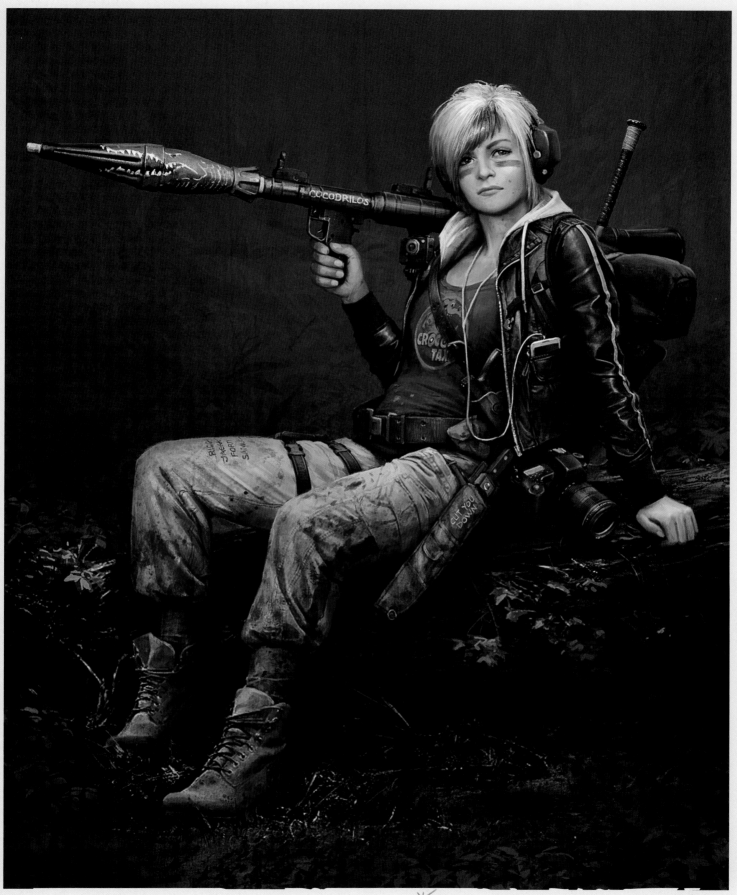

* Another early concept to define the modern guerrilla look: personal style that is grounded in the world.

Player gear has to show a level of craftsmanship and ingenuity. These modern guerrillas don't have access to military resources, so they have to adapt by creating their own camo patterns and assembling gear from household items.

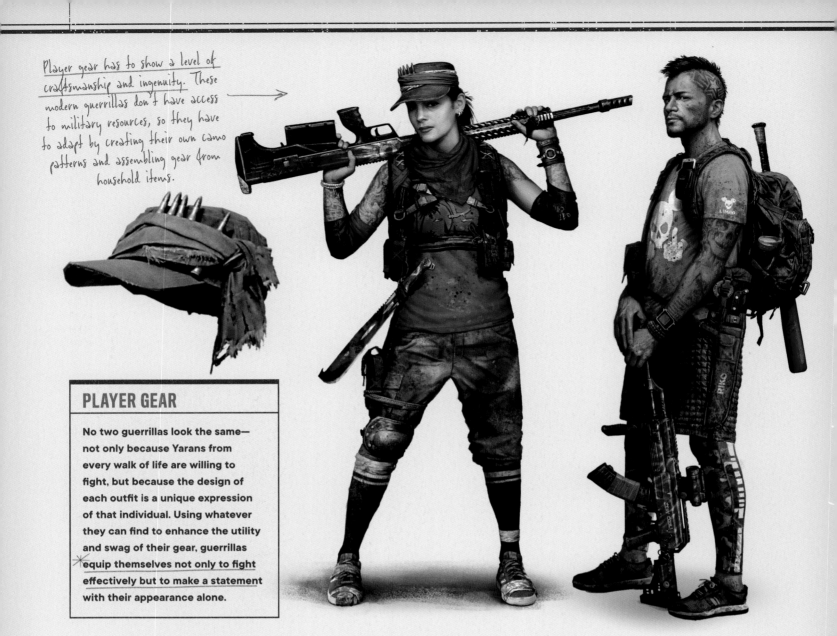

PLAYER GEAR

No two guerrillas look the same—not only because Yarans from every walk of life are willing to fight, but because the design of each outfit is a unique expression of that individual. Using whatever they can find to enhance the utility and swag of their gear, guerrillas equip themselves not only to fight effectively but to make a statement with their appearance alone.

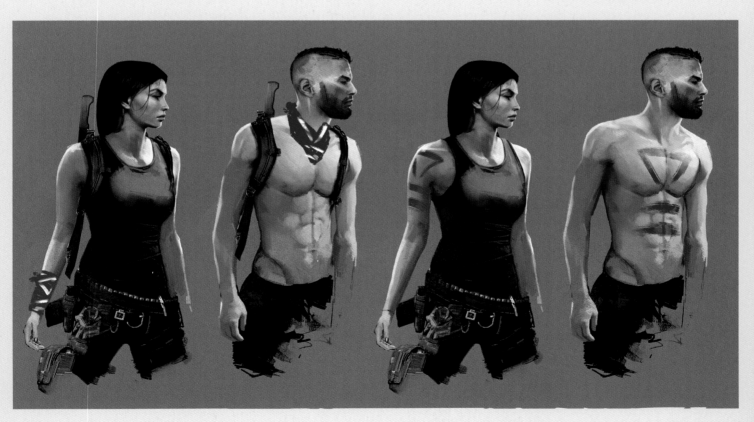

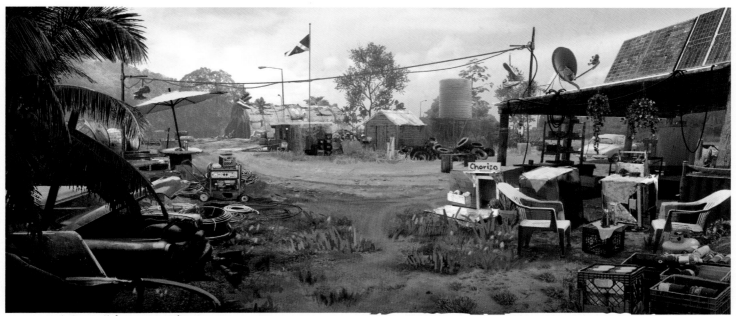

Concept for Philly's house in Madrugada.

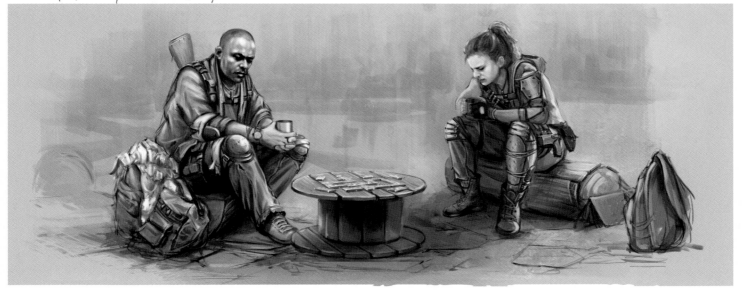

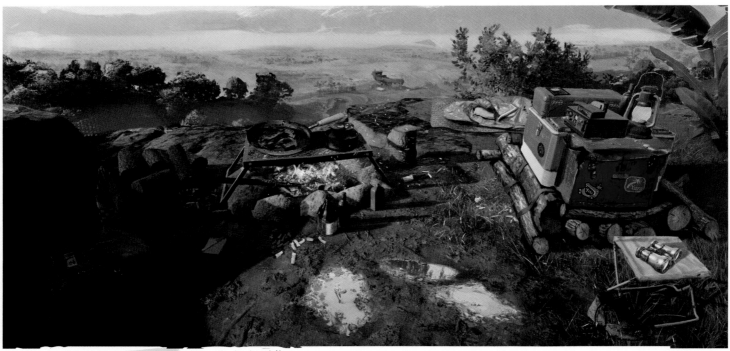

Small points of interest also affect storytelling.

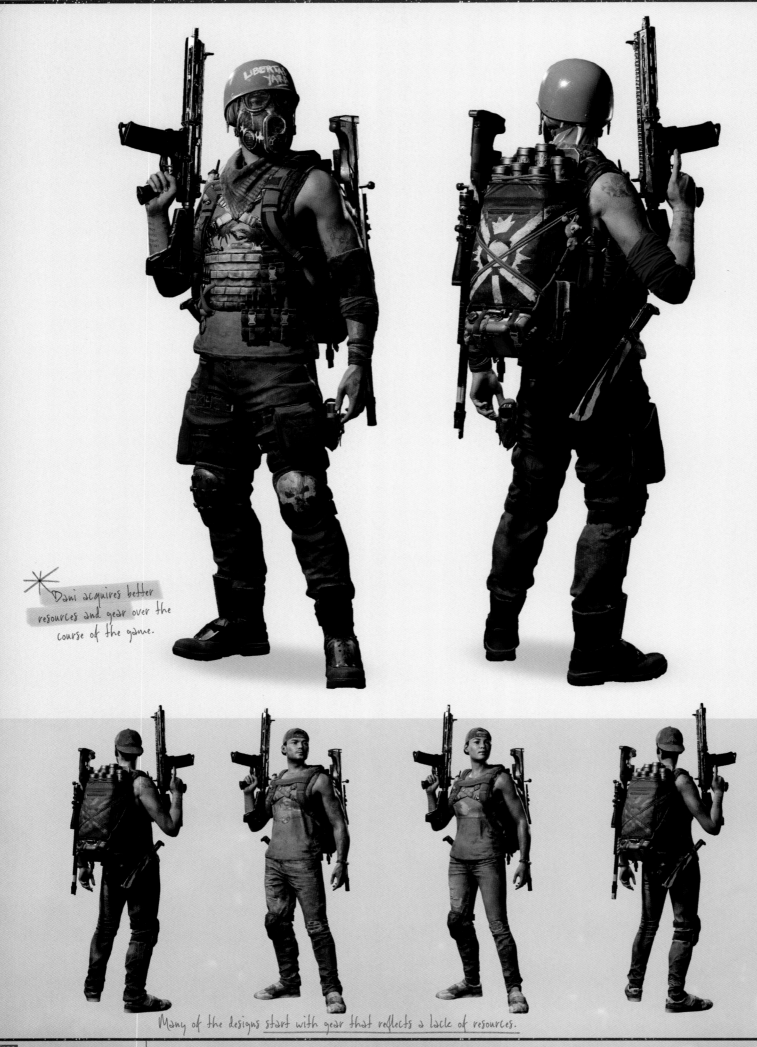

Dani acquires better resources and gear over the course of the game.

Many of the designs start with gear that reflects a lack of resources.

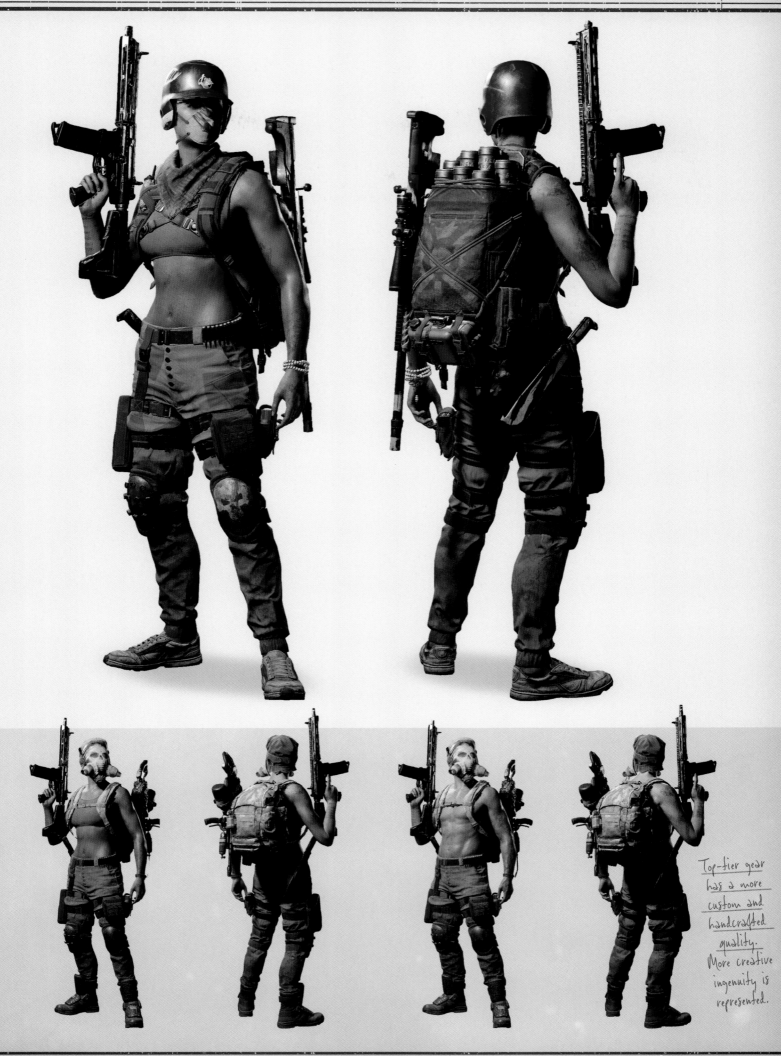

Top-tier gear
has a more
custom and
handcrafted
quality.
More creative
ingenuity is
represented.

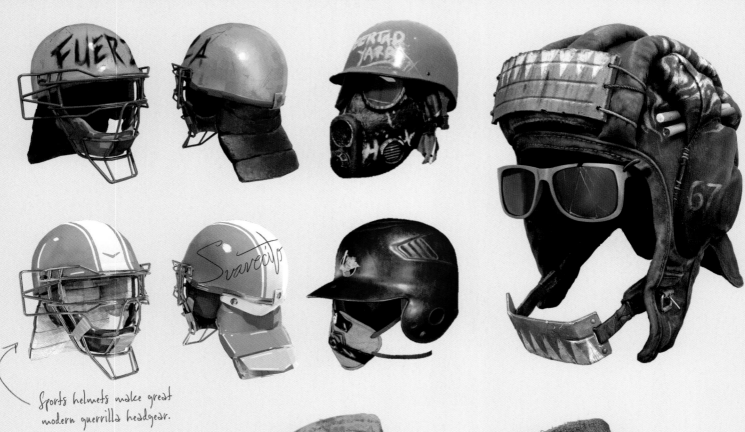

Sports helmets make great modern guerrilla headgear.

RESOLVER AESTHETIC

Most guerrilla equipment is DIY by necessity, but that doesn't mean guerrillas won't try to personalize their gear anyway. When a revolutionary accentuates their gear with paint, slogans, attachments, personal accessories, and more, it's as much about making a statement as it is about survival.

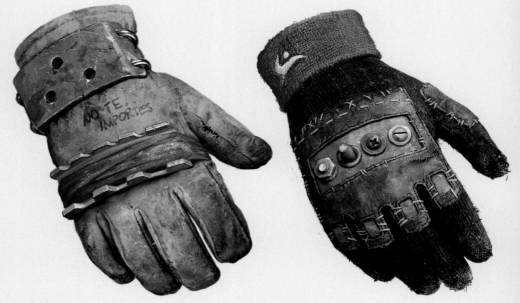

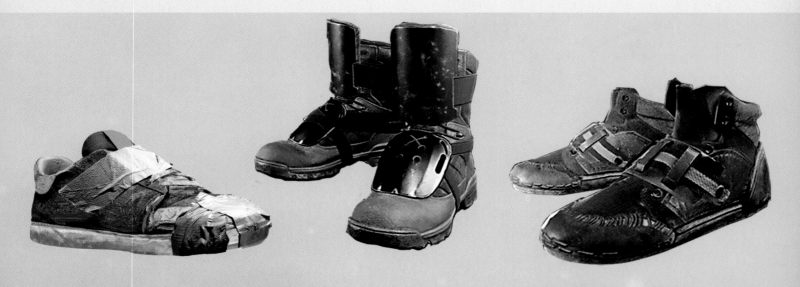

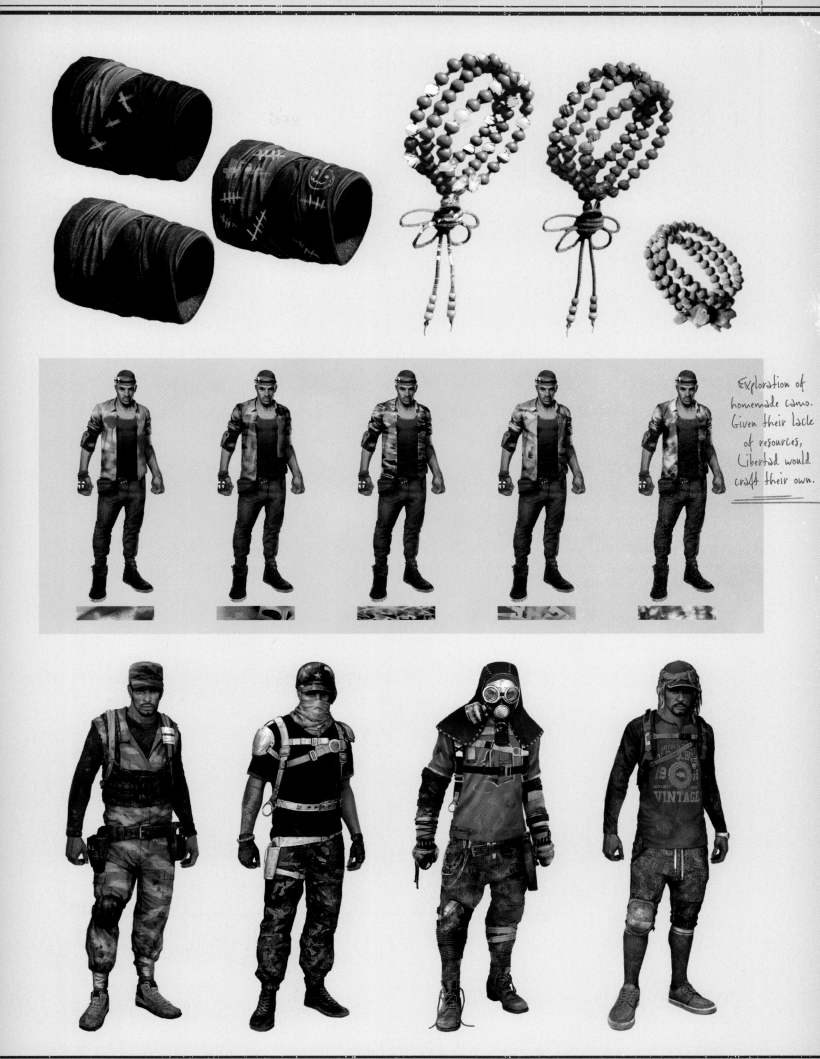

Exploration of homemade camo. Given their lack of resources, Libertad would craft their own.

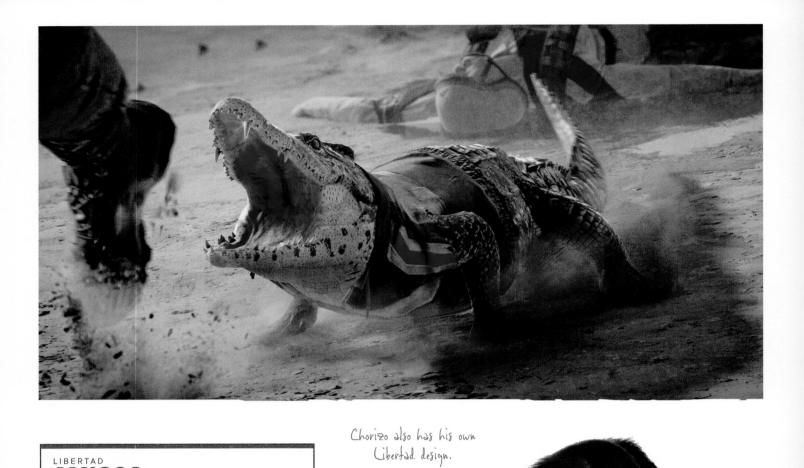

LIBERTAD
AMIGOS

Dani Rojas has a special bond with animals, which is why it's no surprise the most extra-ordinary critters in Yara sometimes decide to offer their help. With powerful personalities and even more powerful abilities, these adorable amigos are utterly loyal and will carry out any command—even in the heat of battle.

Chorizo also has his own Libertad design.

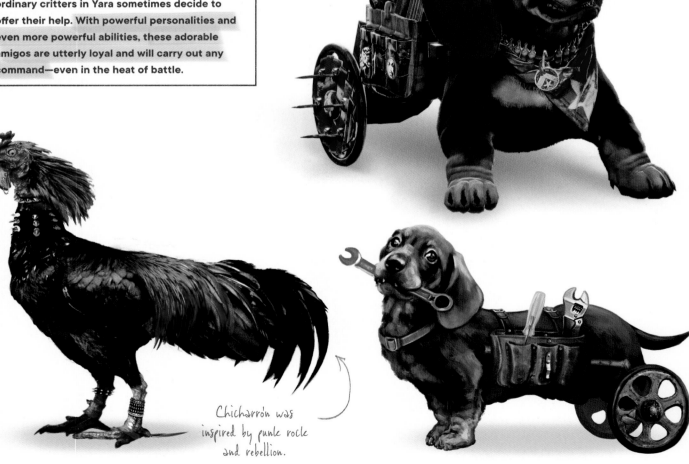

Chicharrón was inspired by punk rock and rebellion.

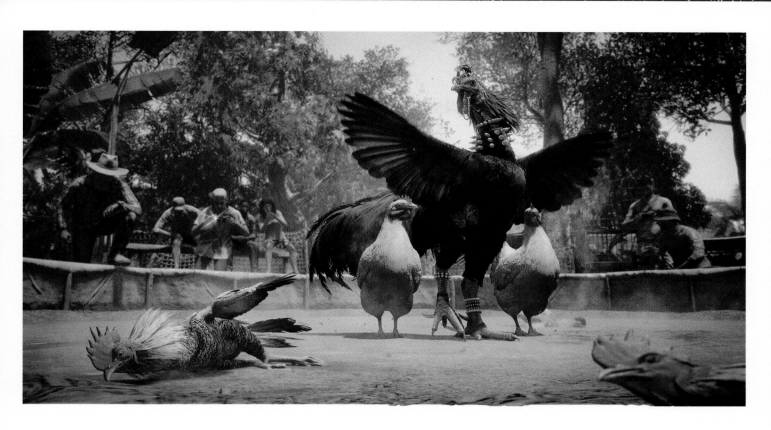

Guapo went through many iterations to get a visual that was unique. The team observed rare orange cave-dwelling crocodiles and gave him a jacket inspired by vintage Russian track wear.

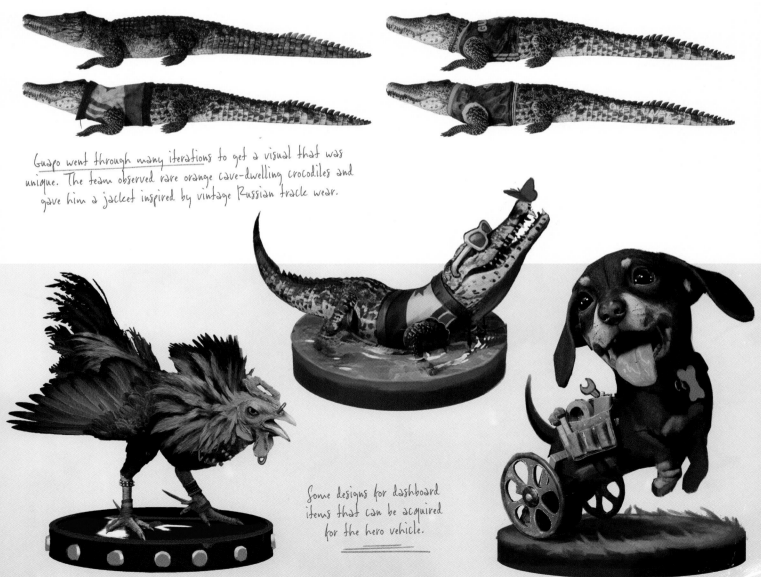

Some designs for dashboard items that can be acquired for the hero vehicle.

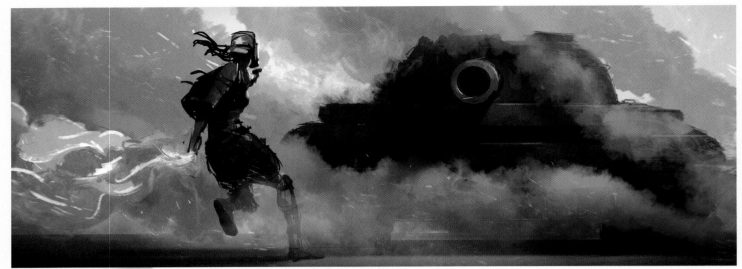

Some fun explorations using colorful smoke grenades and tanks.

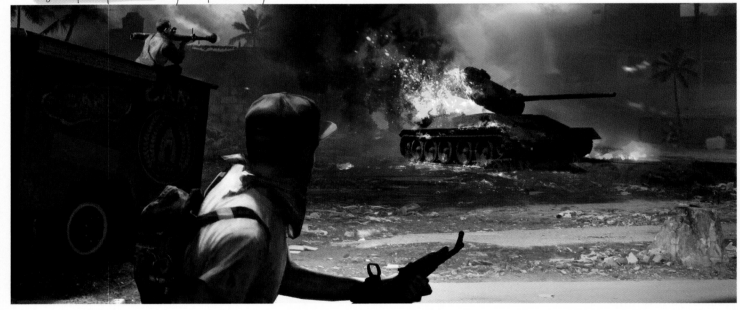

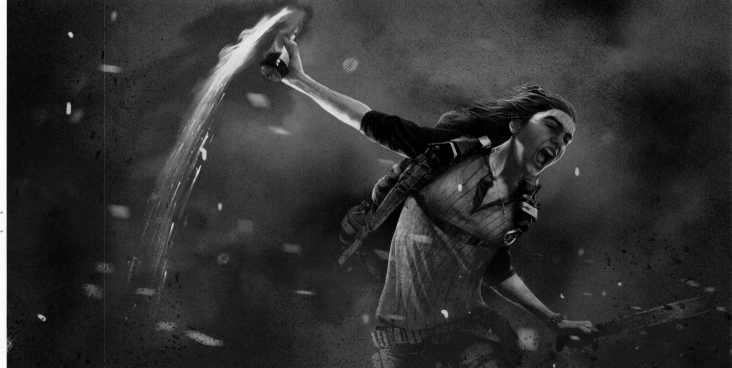

More marketing exploration with Dani hurling a Molotov cocktail.

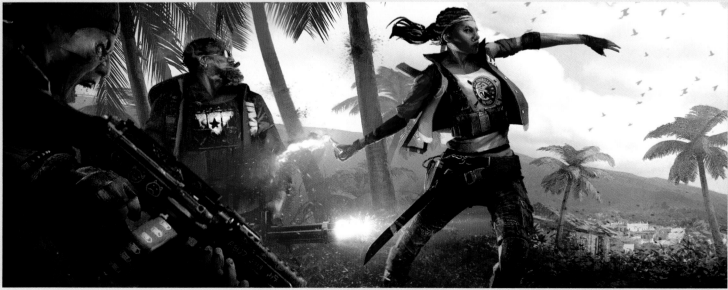

Early concept process to help pitch the idea of modern guerrillas in action.

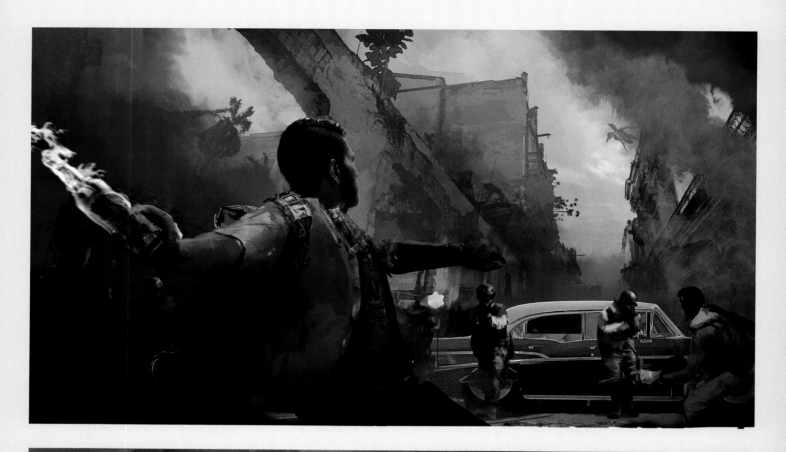

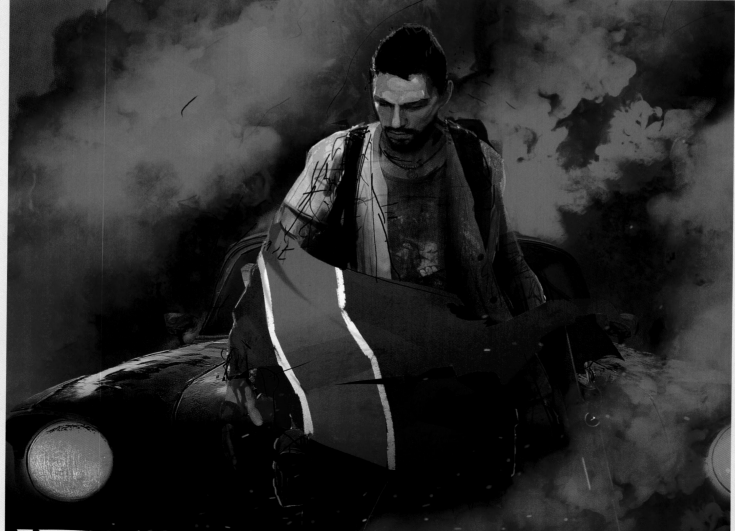

Quick studies of Dani for presentation materials.

✱ Emotion is important in setting the correct mood for these narrative concepts for the guerrillas.

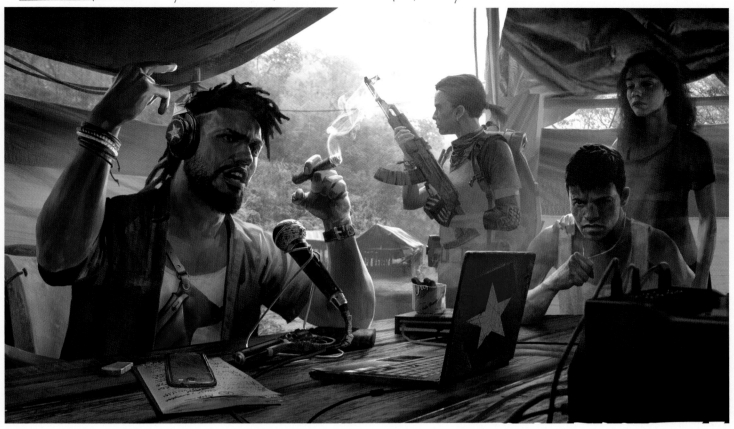

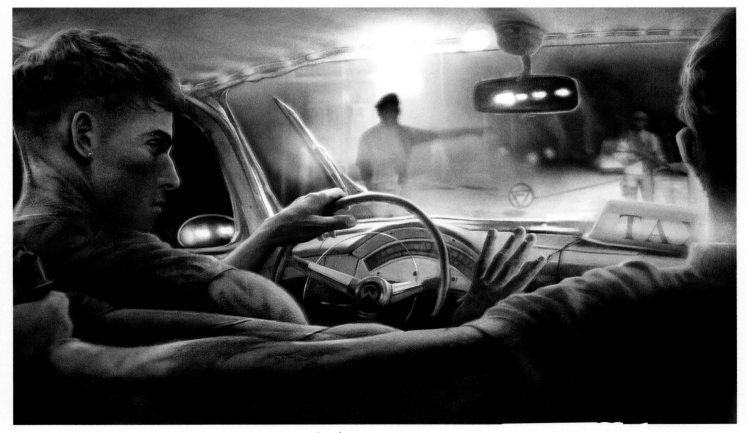

A glimpse of the faceless oppressors causes an emotional and tense exchange between guerrilla members in their vehicle.

LIBERTAD'S LOOK

Sociopolitical movements live or die by their public image, and Libertad knows this—which is why they have cultivated a striking, powerful aesthetic their members can display at all times. The distinctive blue armband is the primary identifier and visual motif.

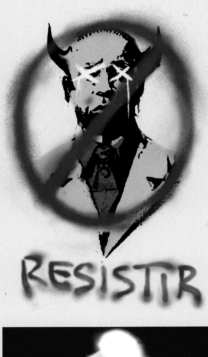

RESISTIR

¡YARA LIBRE!

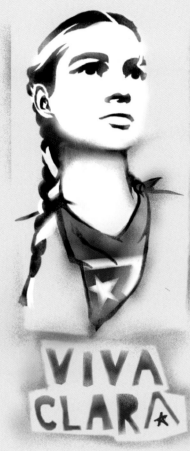

VIVA CLARA

The stenciled art evokes an iconic and hopeful look for Clara and Libertad while keeping other graffiti to an angry and chaotic style.

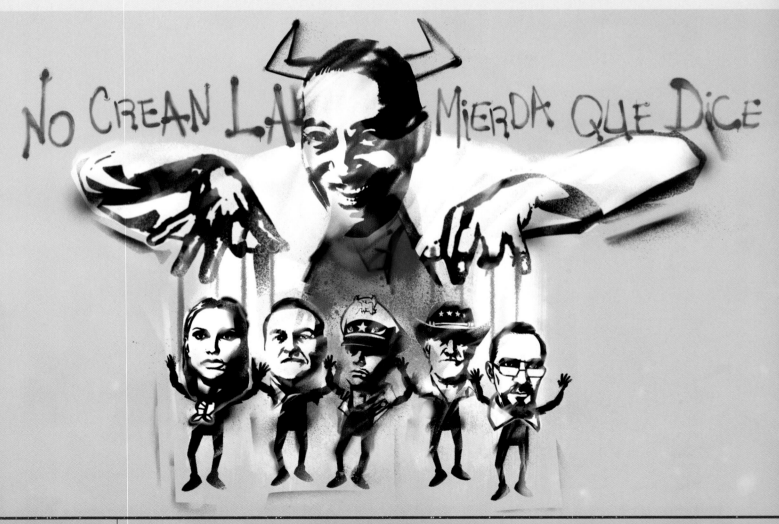

NO CREAN LA MIERDA QUE DICE

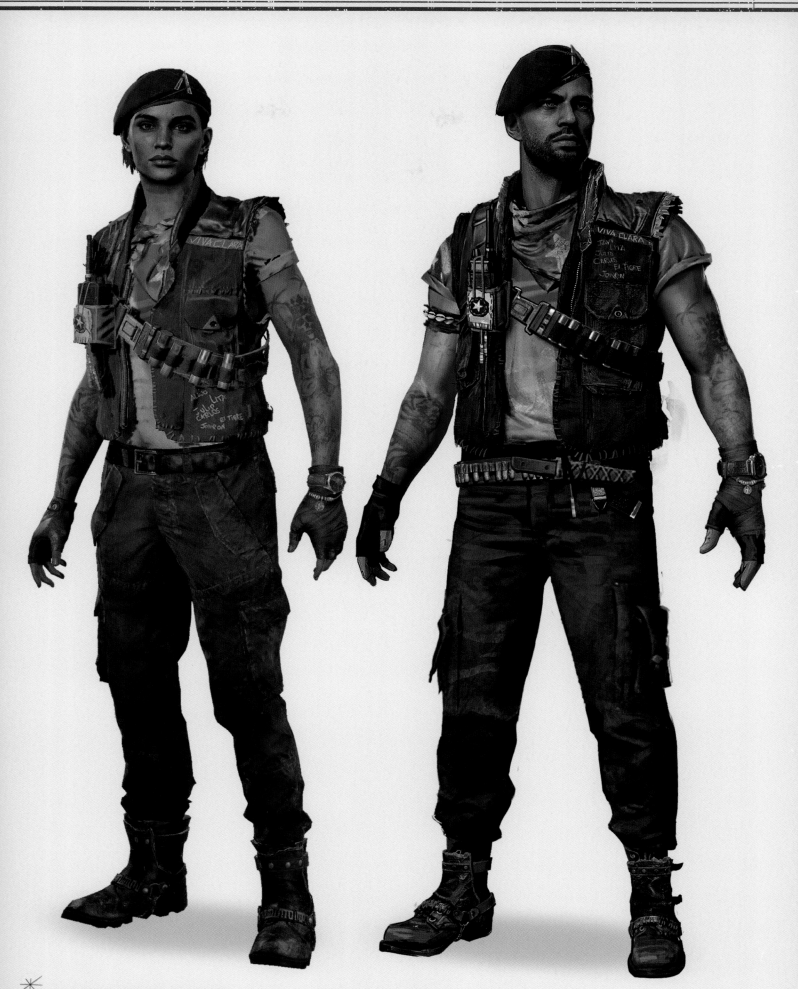

Dani takes on the mantle of leadership and commands Libertad as they begin their final battles with Castillo. Dani has transformed into a true revolutionary leader, uniting the factions of Yara and inspiring fierce loyalty from the guerrillas as, together, they attack the heart of Castillo's regime.

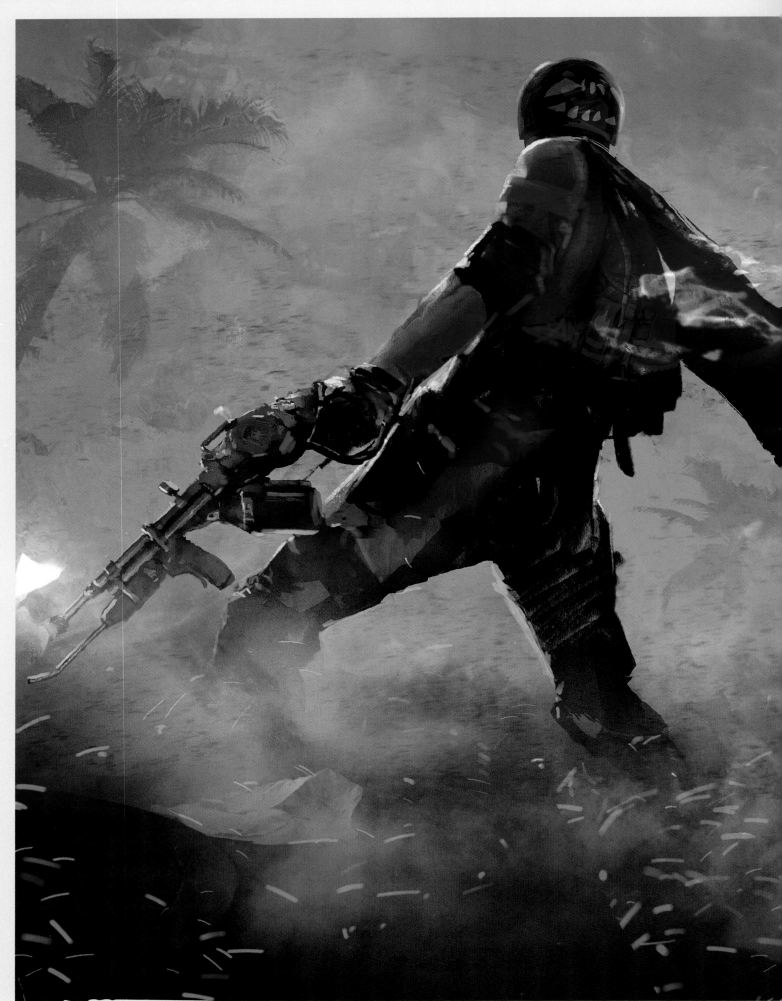

Inspired by photos of modern civil unrest, a Libertad guerrilla wears the Yaran flag as a cape.

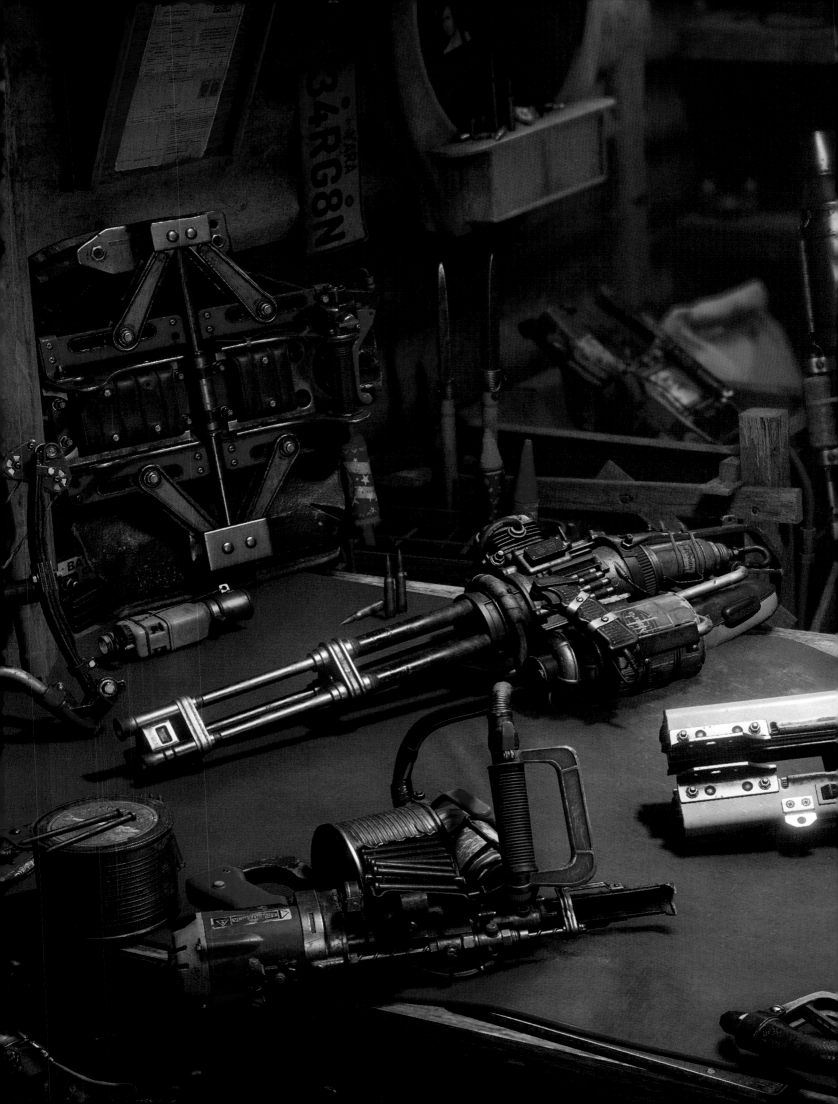

RESOLVER

The Spanish verb meaning "to solve" takes on an entirely unique sense in Yara and is one of the most important cultural inspirations that *Far Cry 6* borrows from real-life Cuba. *Resolver* is a philosophy and a way of life, born from being cut off from the rest of the world for over fifty years by a Western embargo. The resulting economic limitations have inspired creative solutions to complex problems. Cars are repaired with sewing machine parts. Inflated condoms are used as fishing bobbers. Old tires are sliced up and used as protective padding. To be Yaran is to embrace *resolver* as both a necessity and a way to express one's ingenuity and resourcefulness—and when fighting a guerrilla war where supplies are scarce, it's the best method when you need a little to go a very long way.

RESOLVER
SUPREMO BACKPACKS

As both a native Yaran and a veteran spymaster, Juan Cortez is the world's leading expert on taking everyday objects and turning them into brutally effective weapons of war. His back-mounted Supremos, inspired by the Yaran comic book heroes he loves, are designed to grant one guerrilla the fighting power of a hundred. They cater to a wide variety of combat styles, allowing the user to stand up to an entire army through clever use of strategy and loadout.

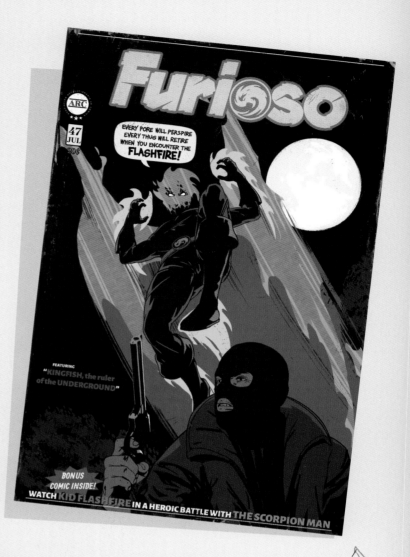

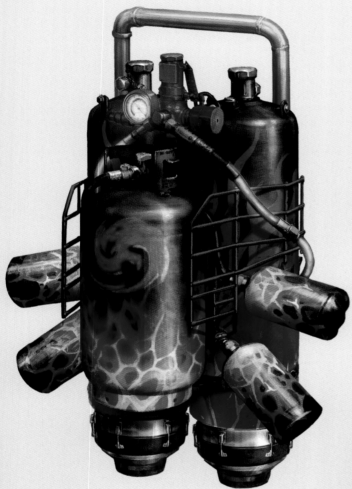

Many of these Yaran comic books were designed to inspire the looks of the Supremo backpacks.

FURIOSO

"I don't know what 'inflammable' means, but this fucker is flammable, I'll tell you that."
—Juan Cortez

A high-risk, high-reward option for guerrillas focused on chaos, the Furioso ejects superheated fuel from downward-facing nozzles at a rate high enough to lift the user off the ground.

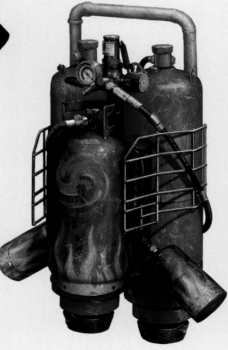

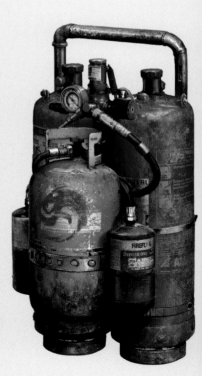

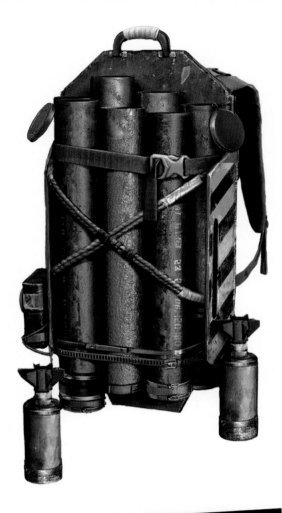

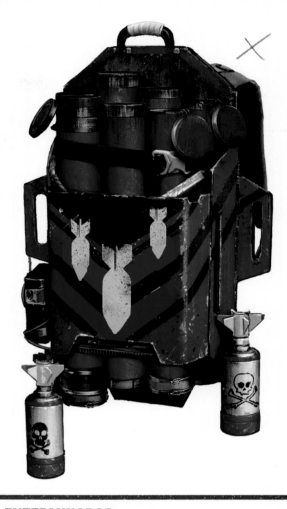

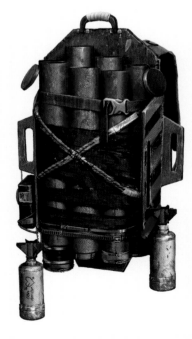

EXTERMINADOR

**"I'm fucking tired of hearing 'less is more.' More is more."
—Juan Cortez**

Designed to significantly boost the potential firepower of a single fighter, the Exterminador does exactly what it says on the tin. It's little more than several sections of PVC piping that act as rocket-propelling launchers—but in most combat scenarios, it's more than enough to wipe the entire battlefield clean.

The comic covers had to evoke the feeling the player is expected to have when using the backpack.

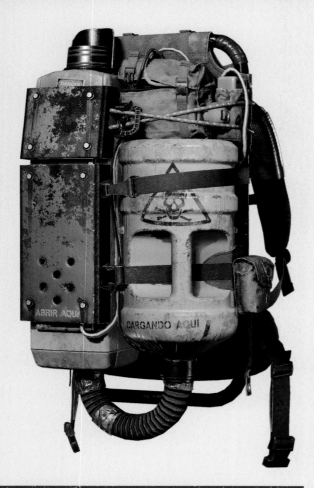

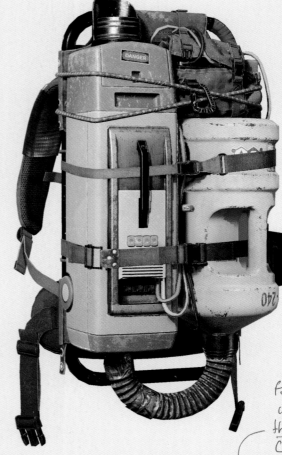

Fantasma's comic cover is based on the poison frogs of Central America.

FANTASMA

"Nobody survives contact with a ghost. I've seen those TV shows." —Juan Cortez

Inspired by a comic book antiheroine assassin who fights the legions of the damned, the Fantasma is ideal for careful hunters who want to wield the touch of death.

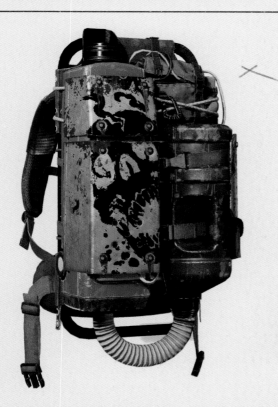

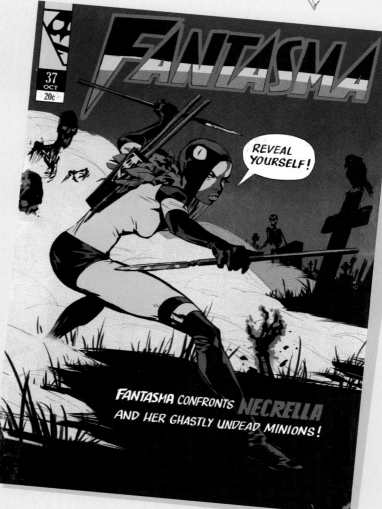

The progression of backpack visuals was important. More details, items, and personalization were added in each stage.

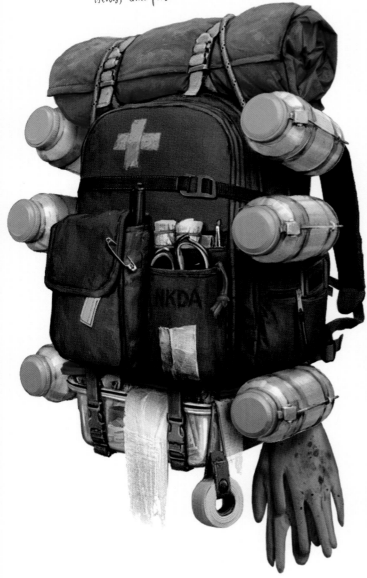

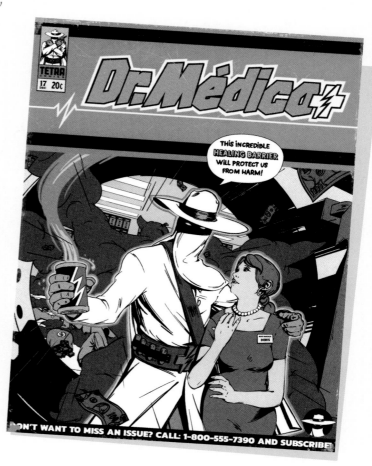

MÉDICO

"I left the Hippocratic oath behind in the jungles of South Africa. Heal *and* hurt, that's my motto." —Juan Cortez

A unique coagulant compound developed with the help of the CIA is dispersed in a cloud of "healing gas" from canisters strapped to the Médico, ensuring any guerrilla and their allies can stay in the fight.

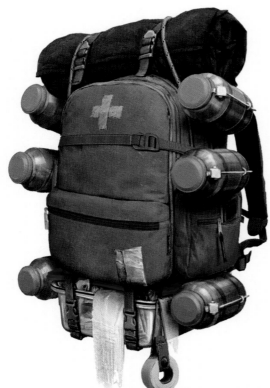

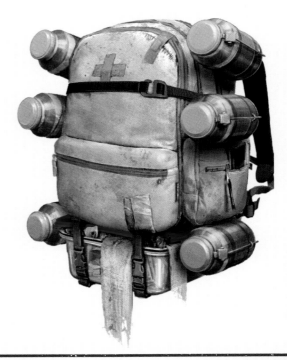

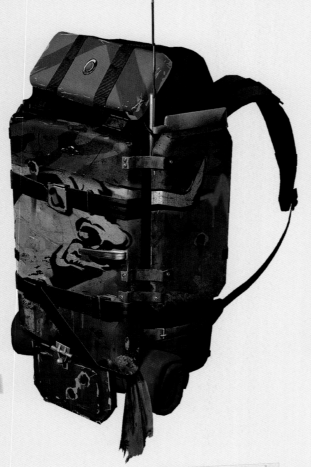

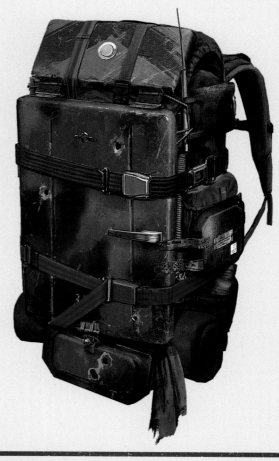

The artists had fun creating backstories for the comic characters.

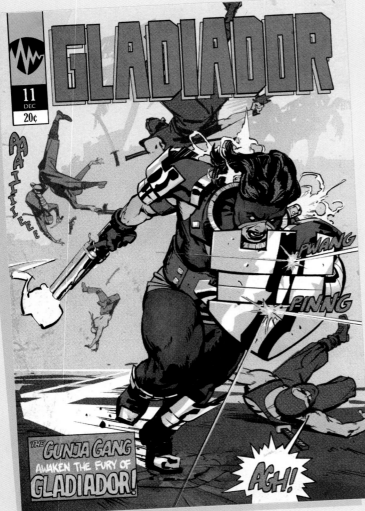

GLADIADOR

"I have a couple 'special brews.' Some are for drinking. This one's for injecting." —Juan Cortez

Juan cooked up a unique intravenous hormonal cocktail that temporarily boosts a user's senses while simultaneously dulling their nerve endings, allowing them to charge into battle without feeling any pain.

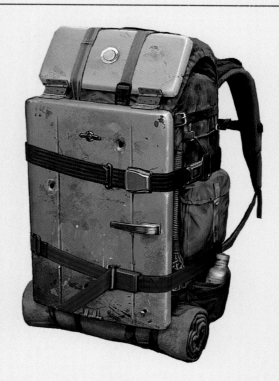

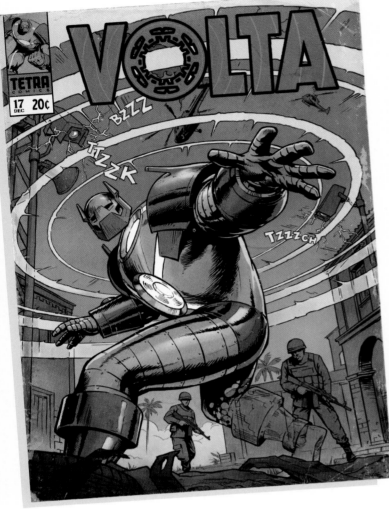

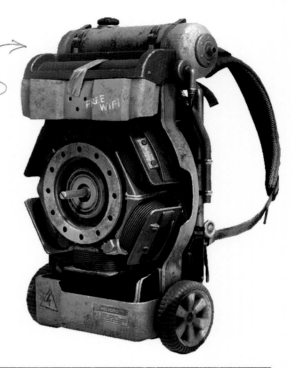

The Volta backpack is designed with elements from a lawnmower and copper coil transformers.

VOLTA

"People rely too much on tech these days. Take it away, and they're like naked babies." —Juan Cortez

Using an electromagnetic coil stolen from a power generation plant, the Volta emits an EMP blast that disables all electrically powered technology in a radius around the user. To the FND, who rely on everything from helicopters to security cameras, it's a force to be reckoned with.

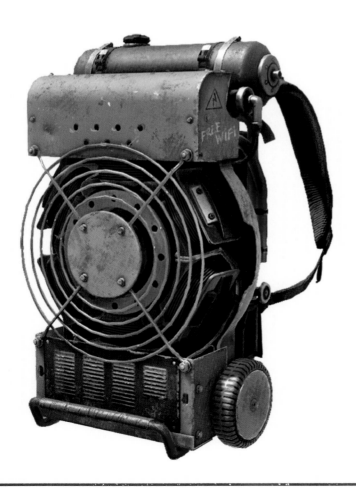

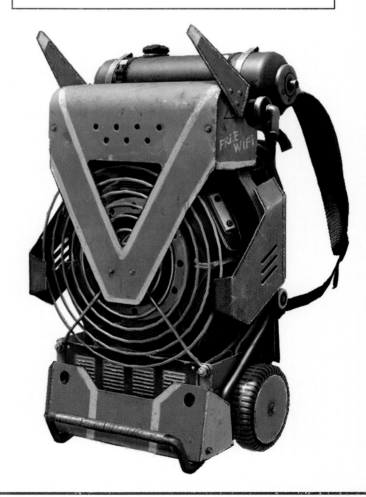

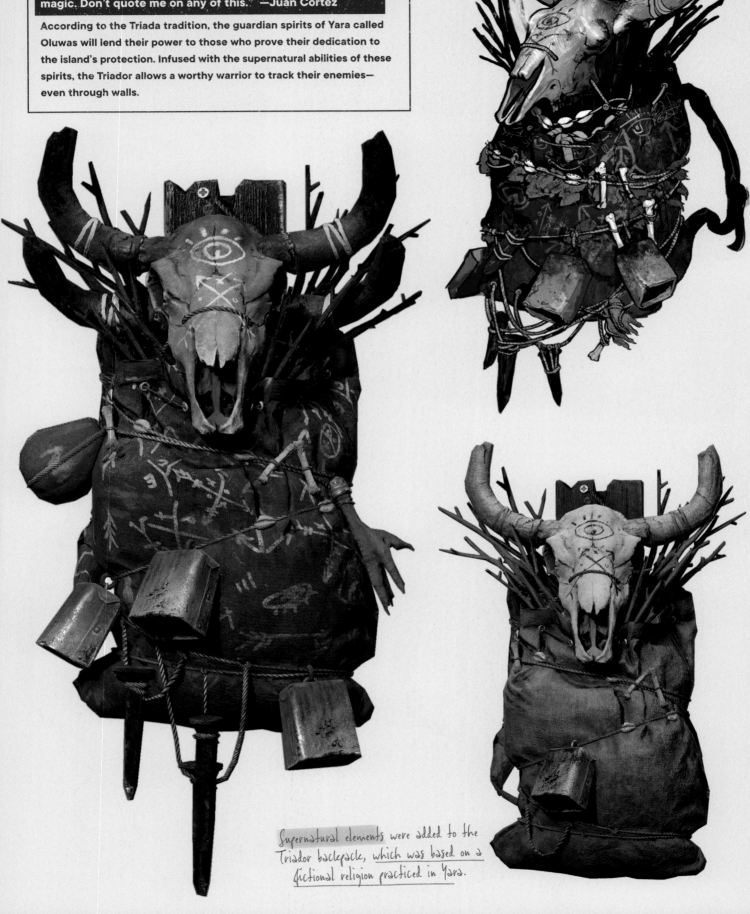

TRIADOR

"I don't know where Dani got this from. And I don't believe in magic. Don't quote me on any of this." —Juan Cortez

According to the Triada tradition, the guardian spirits of Yara called Oluwas will lend their power to those who prove their dedication to the island's protection. Infused with the supernatural abilities of these spirits, the Triador allows a worthy warrior to track their enemies— even through walls.

Supernatural elements were added to the Triador backpack, which was based on a fictional religion practiced in Yara.

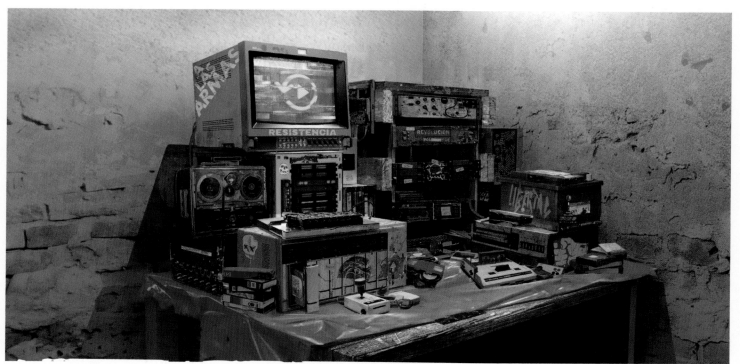

Inspired by makeshift personal computers in Cuba, this is a "resolvered" Libertad workstation.

The player's workbench also boasts imperfection and ingenuity.

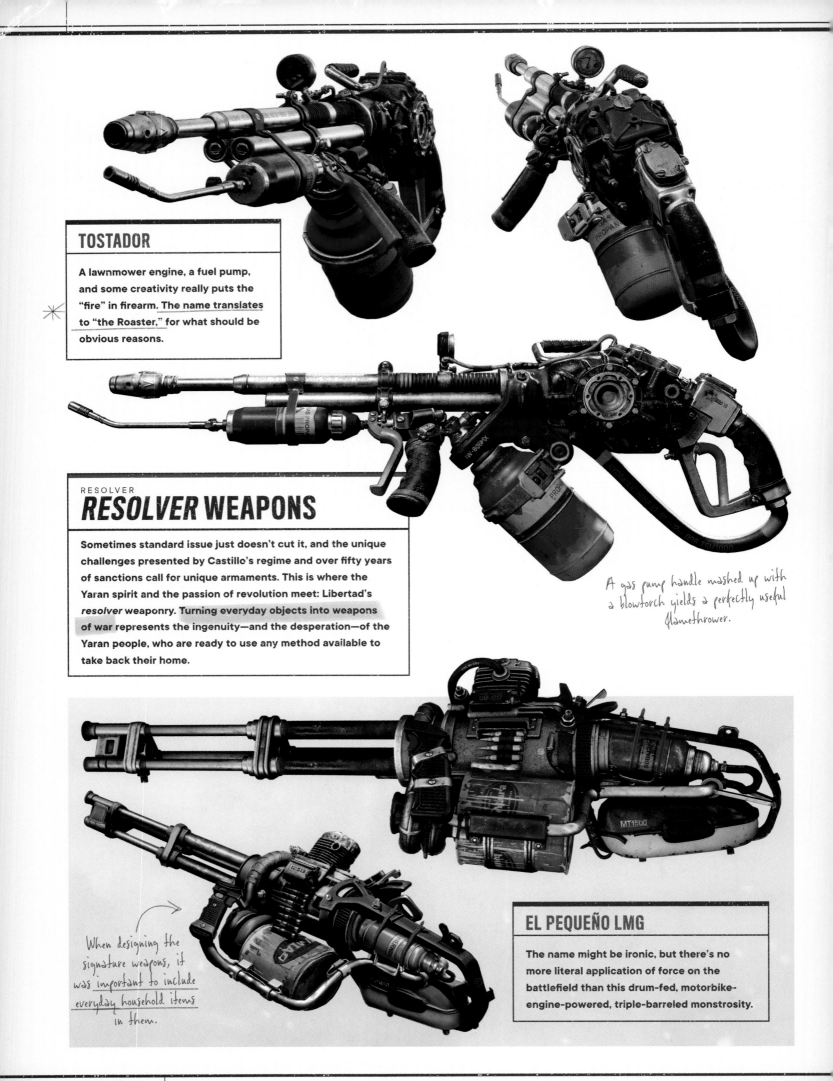

TOSTADOR

A lawnmower engine, a fuel pump, and some creativity really puts the "fire" in firearm. The name translates to "the Roaster," for what should be obvious reasons.

RESOLVER
RESOLVER WEAPONS

Sometimes standard issue just doesn't cut it, and the unique challenges presented by Castillo's regime and over fifty years of sanctions call for unique armaments. This is where the Yaran spirit and the passion of revolution meet: Libertad's *resolver* weaponry. Turning everyday objects into weapons of war represents the ingenuity—and the desperation—of the Yaran people, who are ready to use any method available to take back their home.

A gas pump handle mashed up with a blowtorch yields a perfectly useful flamethrower.

When designing the signature weapons, it was important to include everyday household items in them.

EL PEQUEÑO LMG

The name might be ironic, but there's no more literal application of force on the battlefield than this drum-fed, motorbike-engine-powered, triple-barreled monstrosity.

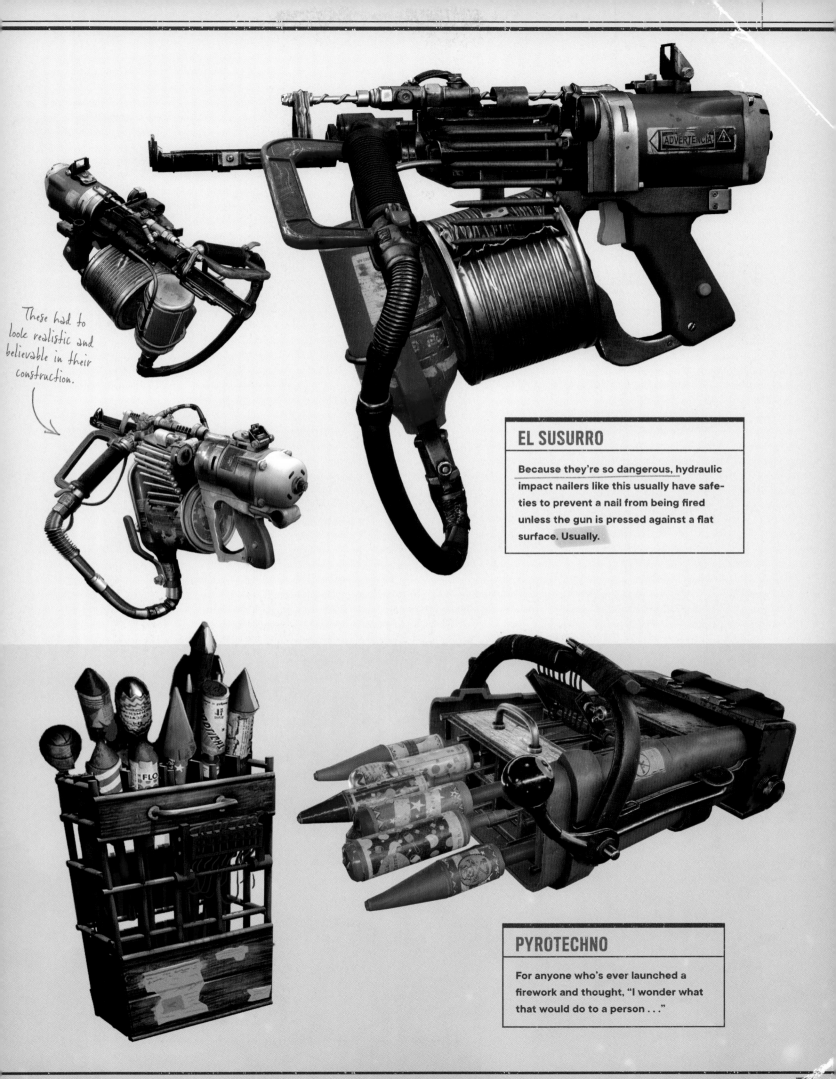

These had to look realistic and believable in their construction.

EL SUSURRO

Because they're so dangerous, hydraulic impact nailers like this usually have safeties to prevent a nail from being fired unless the gun is pressed against a flat surface. Usually.

PYROTECHNO

For anyone who's ever launched a firework and thought, "I wonder what that would do to a person . . ."

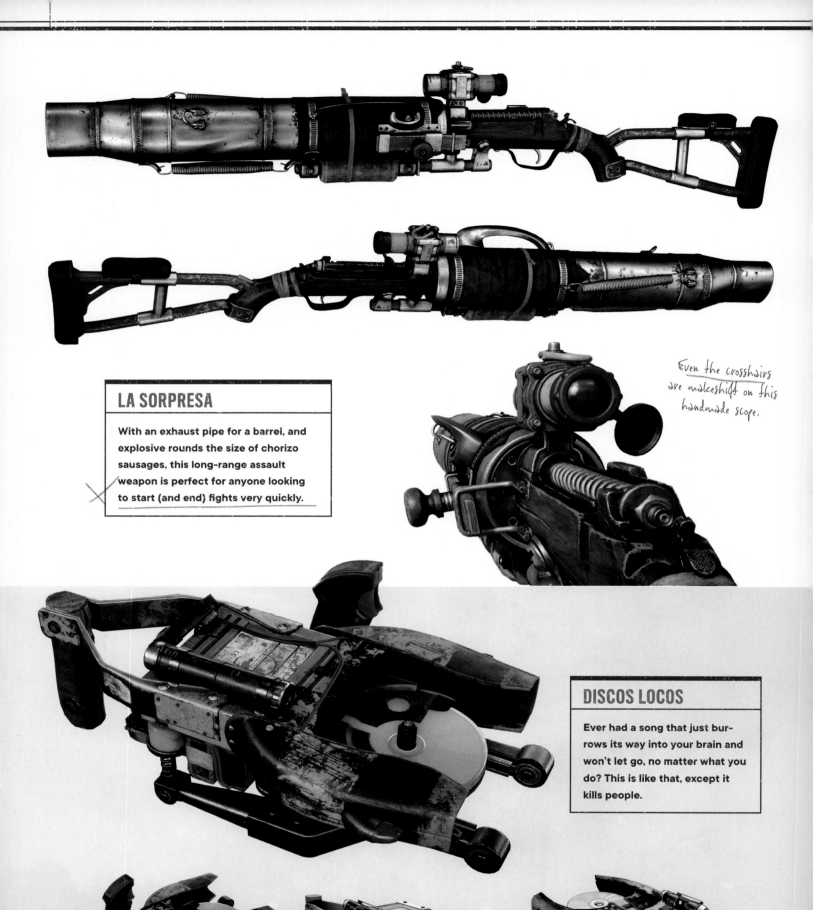

LA SORPRESA

With an exhaust pipe for a barrel, and explosive rounds the size of chorizo sausages, this long-range assault weapon is perfect for anyone looking to start (and end) fights very quickly.

Even the crosshairs are makeshift on this handmade scope.

DISCOS LOCOS

Ever had a song that just burrows its way into your brain and won't let go, no matter what you do? This is like that, except it kills people.

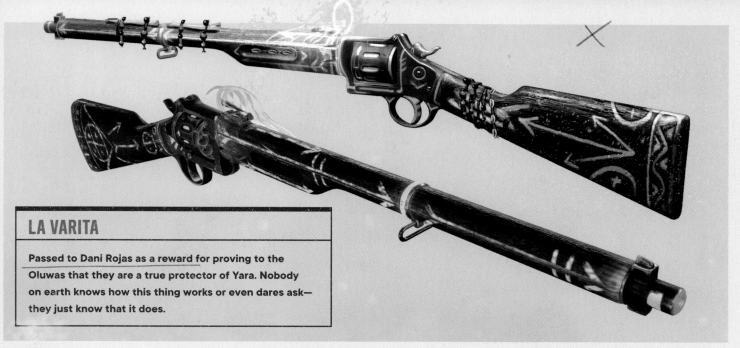

LA VARITA

Passed to Dani Rojas as a reward for proving to the Oluwas that they are a true protector of Yara. Nobody on earth knows how this thing works or even dares ask— they just know that it does.

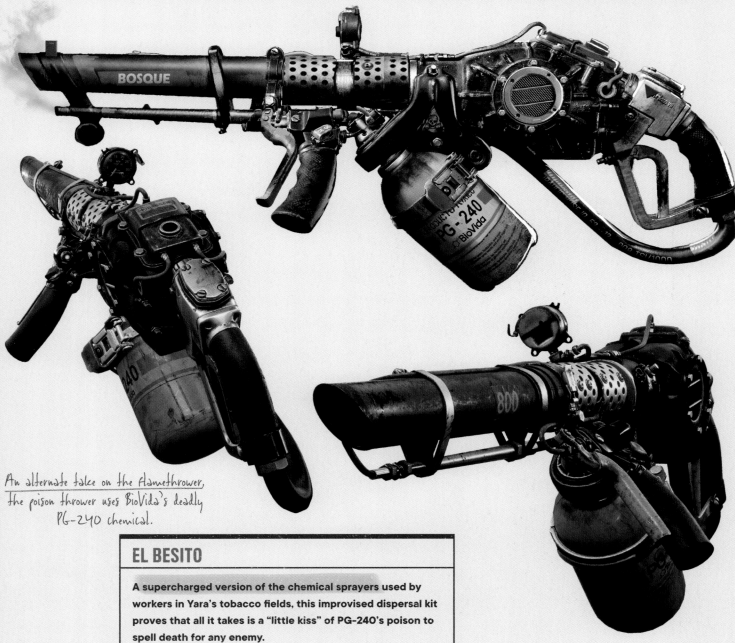

An alternate take on the flamethrower, the poison thrower uses BioVida's deadly PG-240 chemical.

EL BESITO

A supercharged version of the chemical sprayers used by workers in Yara's tobacco fields, this improvised dispersal kit proves that all it takes is a "little kiss" of PG-240's poison to spell death for any enemy.

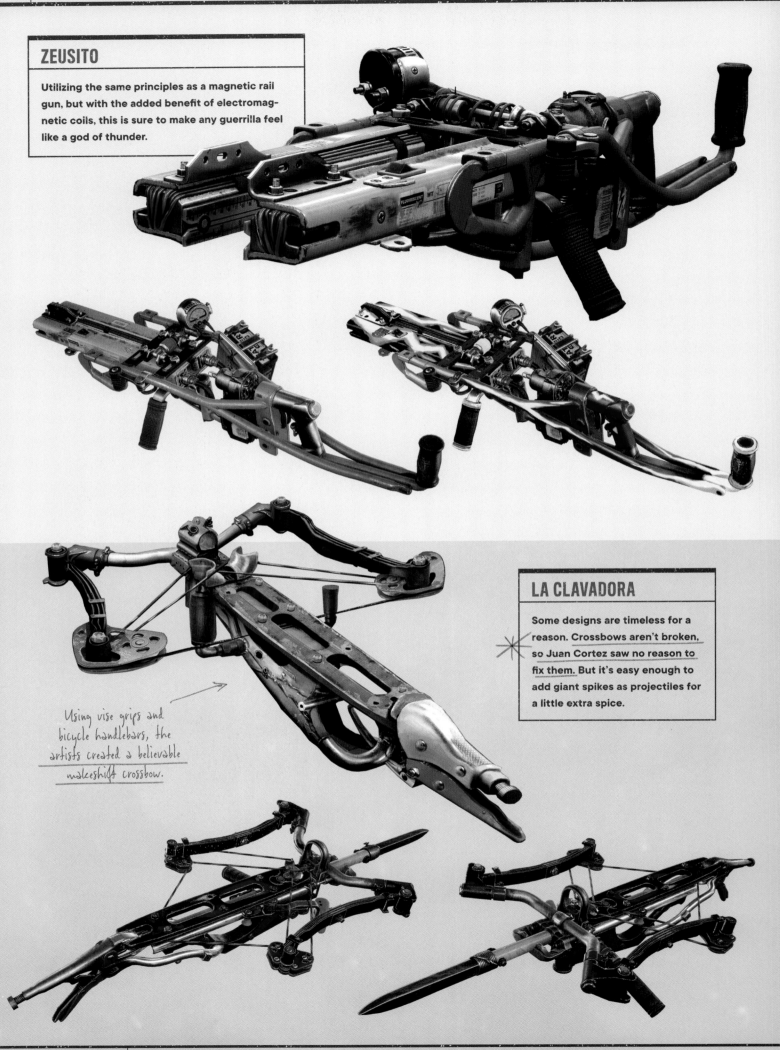

ZEUSITO

Utilizing the same principles as a magnetic rail gun, but with the added benefit of electromagnetic coils, this is sure to make any guerrilla feel like a god of thunder.

LA CLAVADORA

Some designs are timeless for a reason. Crossbows aren't broken, so Juan Cortez saw no reason to fix them. But it's easy enough to add giant spikes as projectiles for a little extra spice.

Using vise grips and bicycle handlebars, the artists created a believable makeshift crossbow.

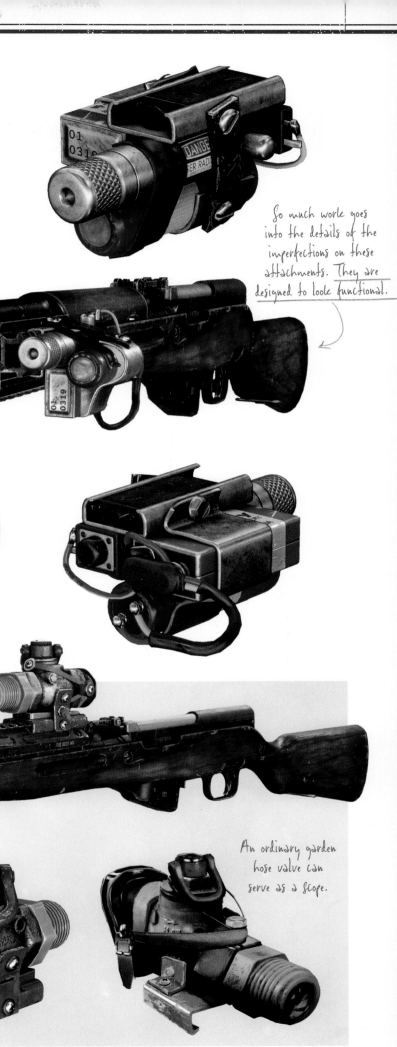

RESOLVER
RESOLVER ATTACHMENTS

Properly manufactured aftermarket add-ons are hard to come by in Yara, so the resourceful guerrilla knows that it's easier to just make them yourself. Household items, hardware equipment, salvaged military munitions, and whatever else is found lying around can be put to better use as scopes, silencers, sights, and more.

So much work goes into the details of the imperfections on these attachments. They are designed to look functional.

An ordinary garden hose valve can serve as a scope.

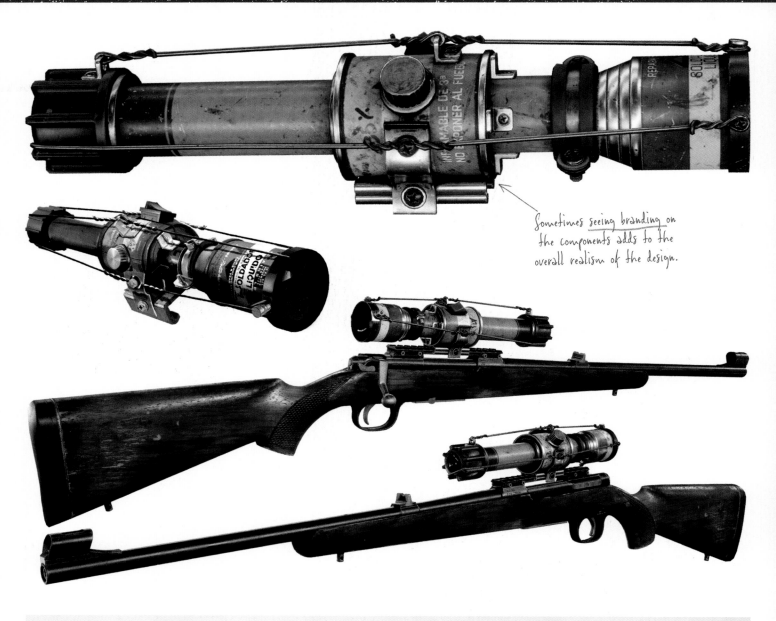

Sometimes seeing branding on the components adds to the overall realism of the design.

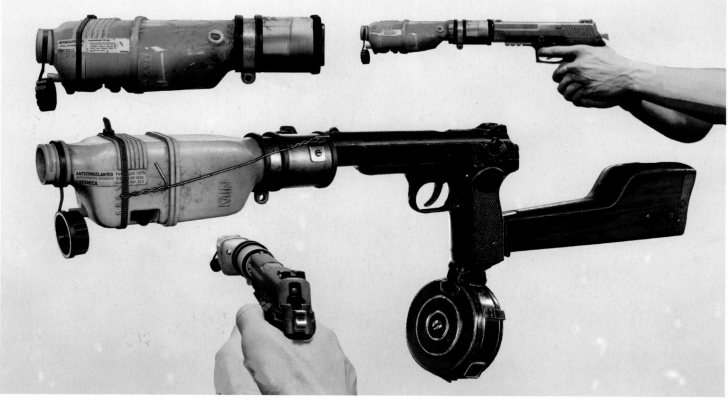

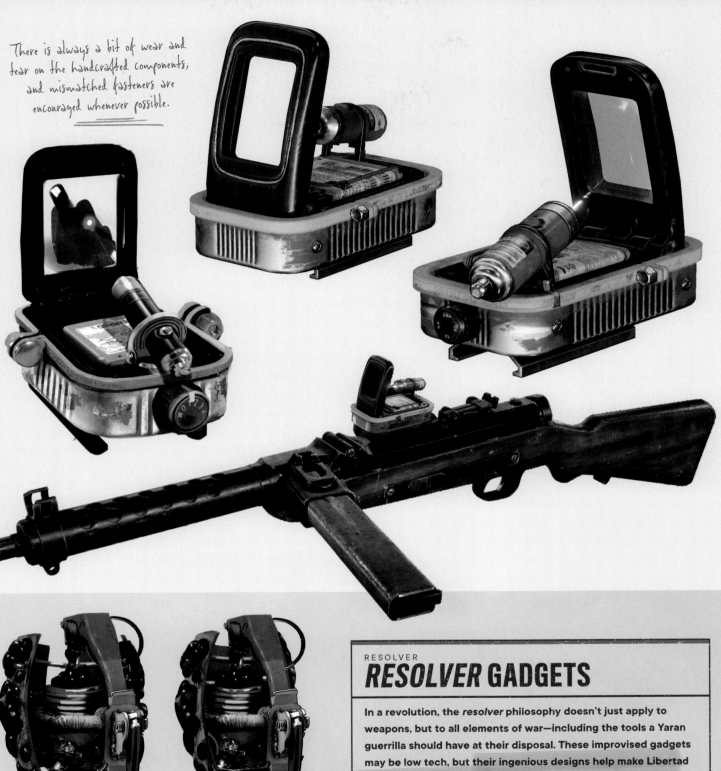

There is always a bit of wear and tear on the handcrafted components, and mismatched fasteners are encouraged whenever possible.

RESOLVER
RESOLVER GADGETS

In a revolution, the *resolver* philosophy doesn't just apply to weapons, but to all elements of war—including the tools a Yaran guerrilla should have at their disposal. These improvised gadgets may be low tech, but their ingenious designs help make Libertad an unpredictable and ever deadly foe for Castillo's regime.

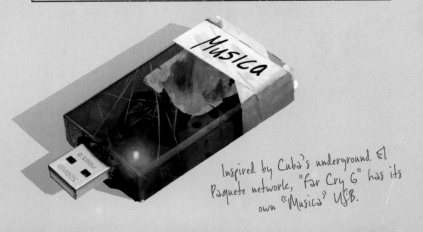

Inspired by Cuba's underground El Paquete network, "Far Cry 6" has its own "Musica" USB.

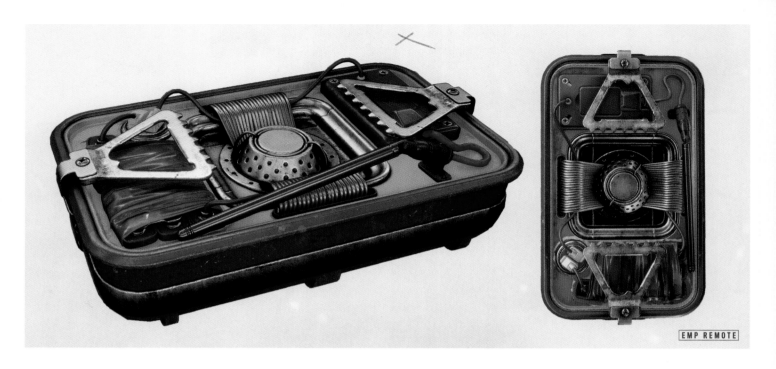

EMP REMOTE

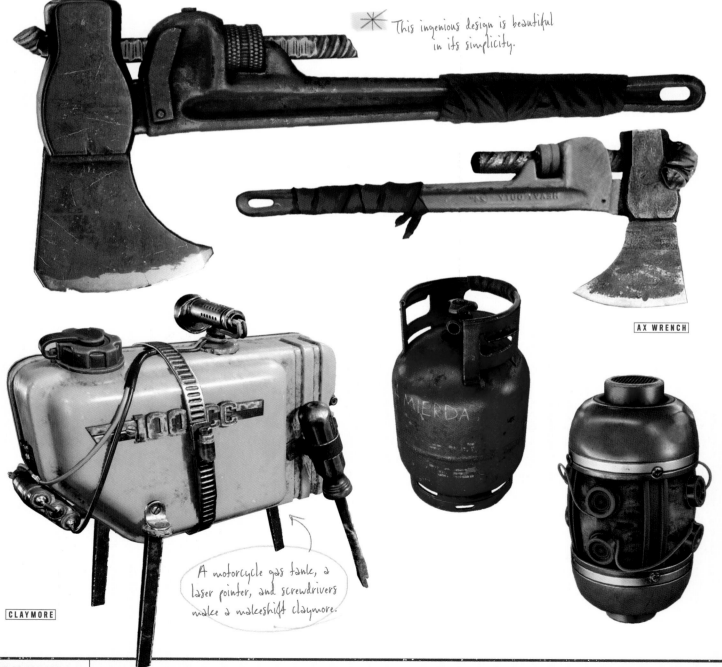

✳ This ingenious design is beautiful in its simplicity.

AX WRENCH

A motorcycle gas tank, a laser pointer, and screwdrivers make a makeshift claymore.

CLAYMORE

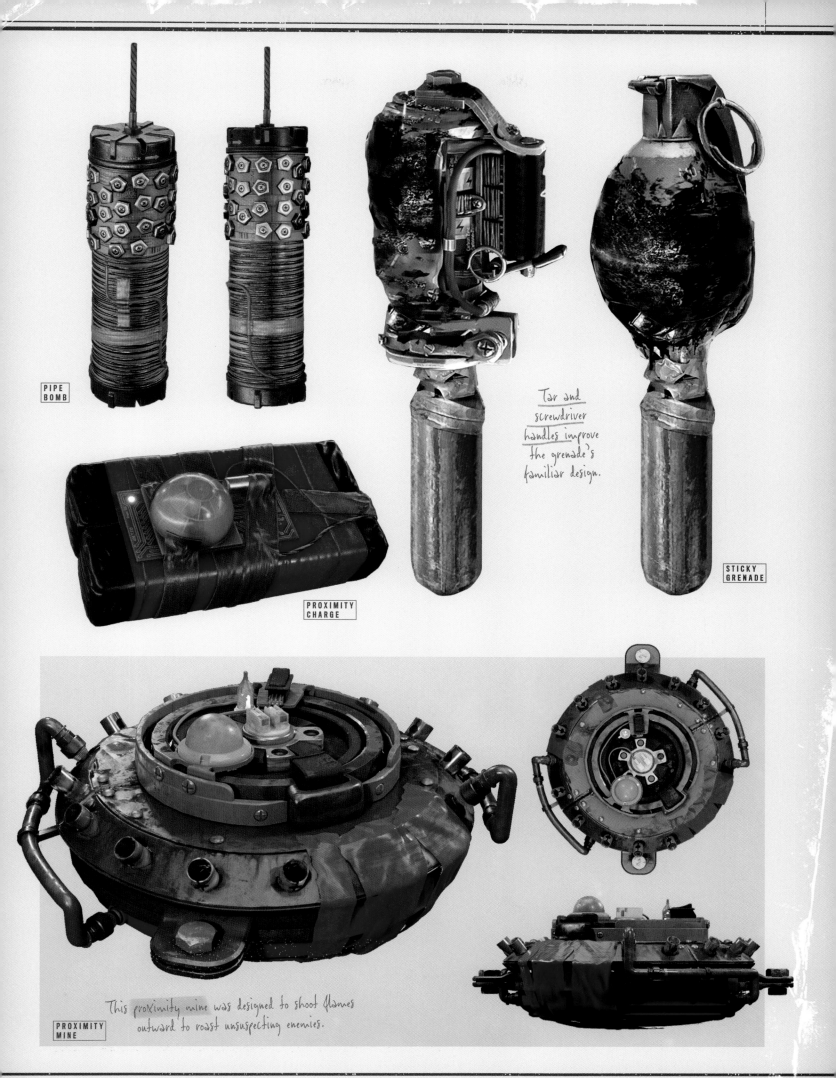

PIPE
BOMB

PROXIMITY
CHARGE

Tar and
screwdriver
handles improve
the grenade's
familiar design.

STICKY
GRENADE

This proximity mine was designed to shoot flames
outward to roast unsuspecting enemies.

PROXIMITY
MINE

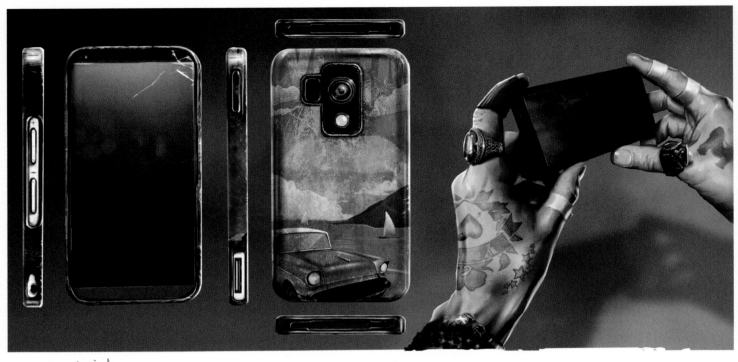

Dani carries a Yara-inspired cellphone.

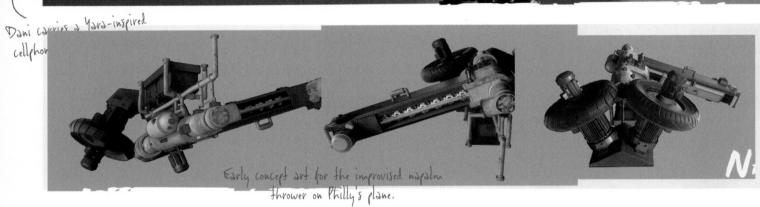

Early concept art for the improvised napalm thrower on Philly's plane.

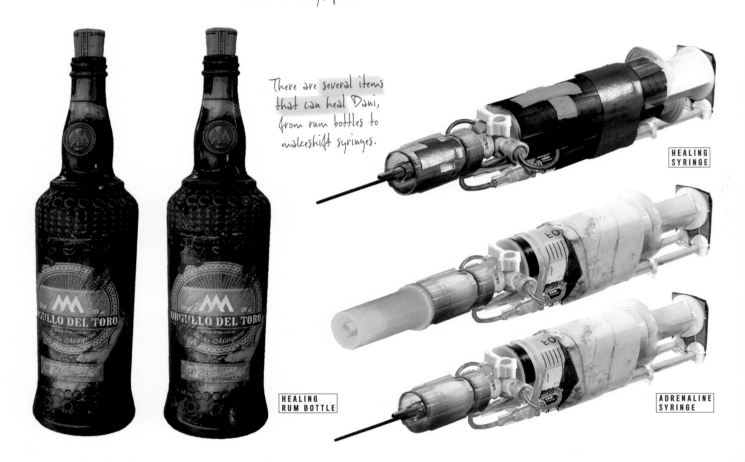

There are several items that can heal Dani, from rum bottles to makeshift syringes.

HEALING
SYRINGE

HEALING
RUM BOTTLE

ADRENALINE
SYRINGE

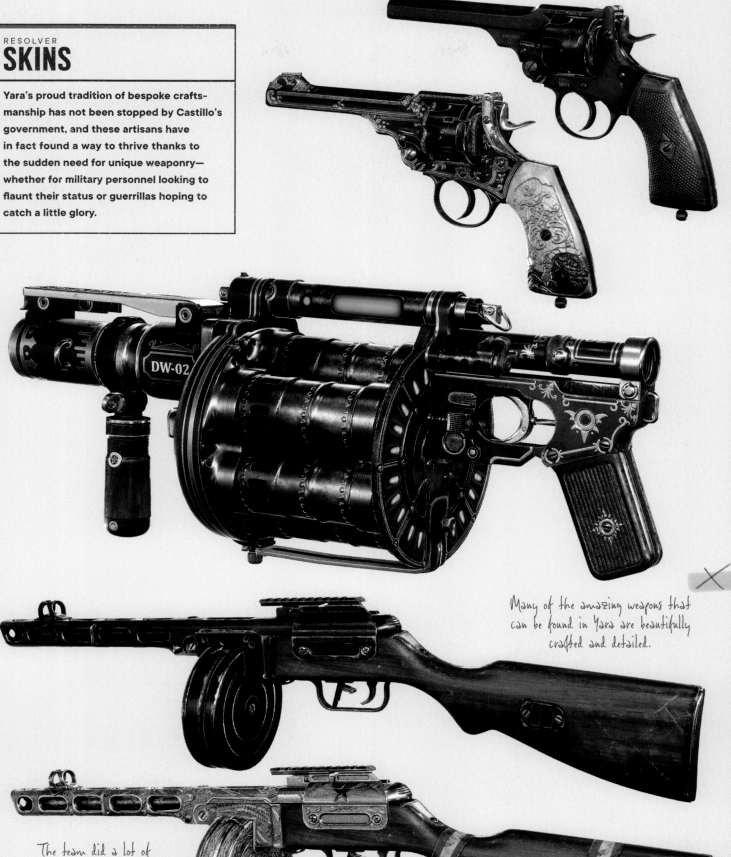

RESOLVER
SKINS

Yara's proud tradition of bespoke crafts-manship has not been stopped by Castillo's government, and these artisans have in fact found a way to thrive thanks to the sudden need for unique weaponry—whether for military personnel looking to flaunt their status or guerrillas hoping to catch a little glory.

DW-02

Many of the amazing weapons that can be found in Yara are beautifully crafted and detailed.

The team did a lot of research into a wide array of themes and genres for these skins. These are the ultimate personalized weapons.

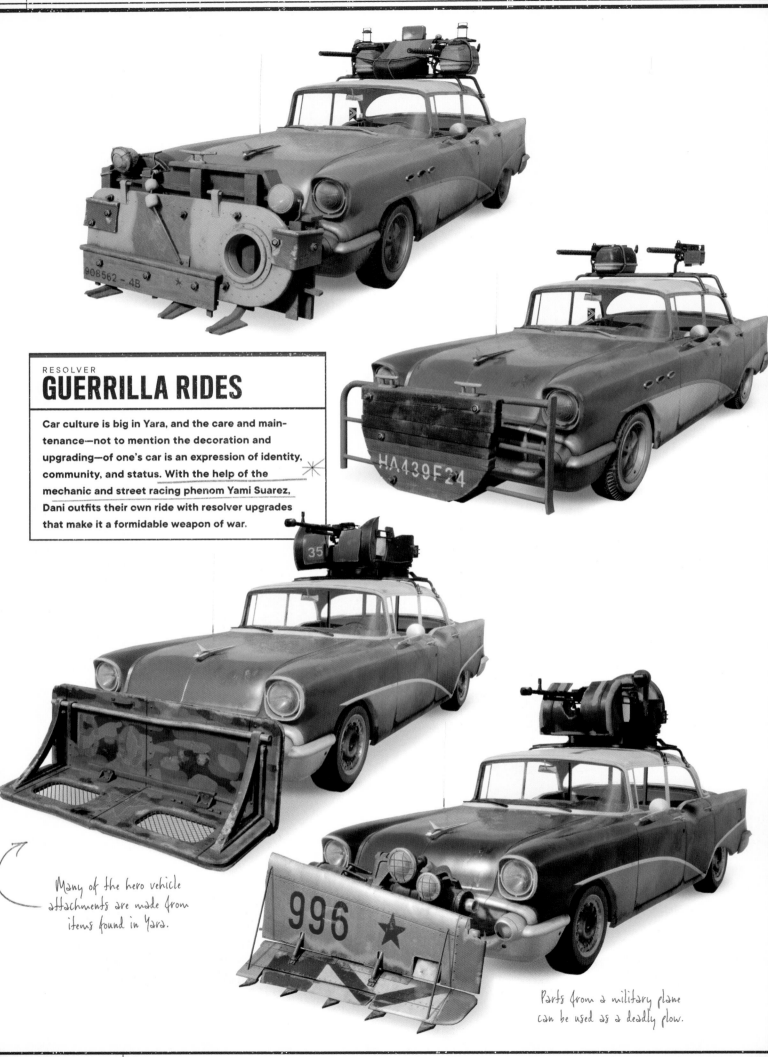

GUERRILLA RIDES

Car culture is big in Yara, and the care and maintenance—not to mention the decoration and upgrading—of one's car is an expression of identity, community, and status. With the help of the mechanic and street racing phenom Yami Suarez, Dani outfits their own ride with resolver upgrades that make it a formidable weapon of war.

Many of the hero vehicle attachments are made from items found in Yara.

Parts from a military plane can be used as a deadly plow.

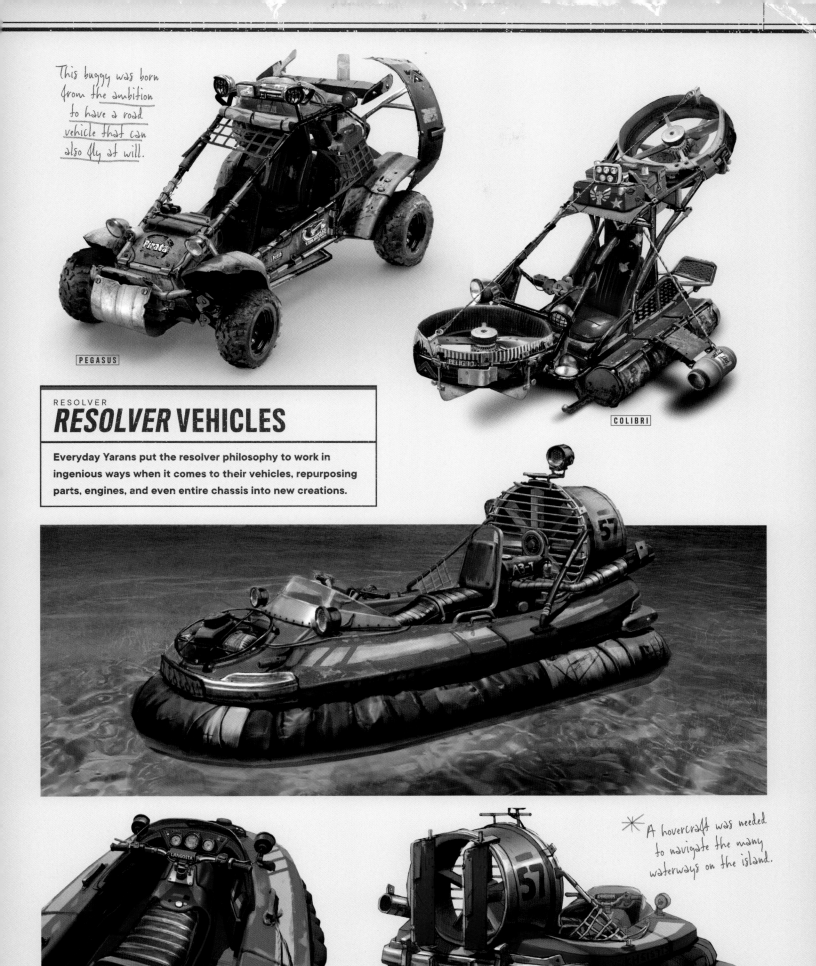

This buggy was born from the ambition to have a road vehicle that can also fly at will.

PEGASUS

COLIBRI

RESOLVER
RESOLVER VEHICLES

Everyday Yarans put the resolver philosophy to work in ingenious ways when it comes to their vehicles, repurposing parts, engines, and even entire chassis into new creations.

* *A hovercraft was needed to navigate the many waterways on the island.*

HOVERCRAFT

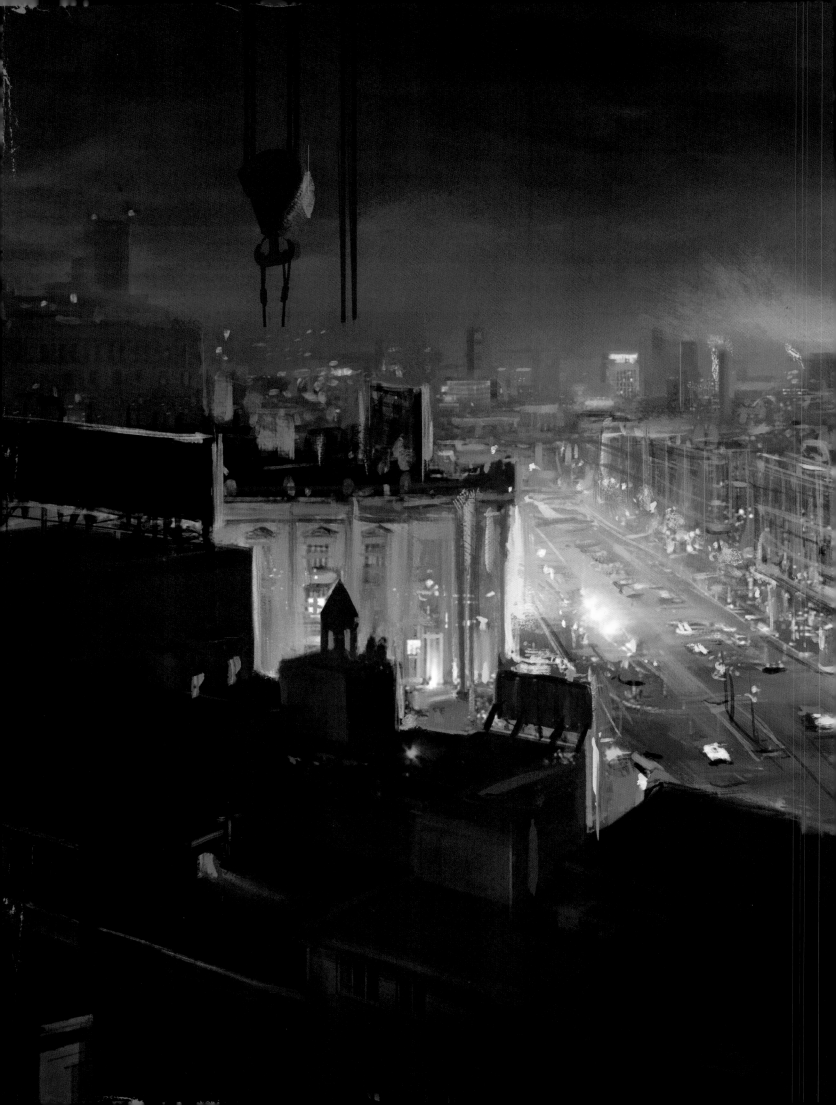

CHAPTER 06
UNITE THE REGIONS

Yara is as diverse as it is large, encompassing many different biomes, cultures, and histories across its wide expanses. Each region is utterly unique and therefore has its own majestic beauty and its own problems—from the theft of ancestral land in the west to the corruption of trade in the east and the cultural war breaking out in the heart of the island. This means Libertad have their work cut out for them in finding a way to satisfy the varied needs of Yara's people and convince them to take up arms against Castillo.

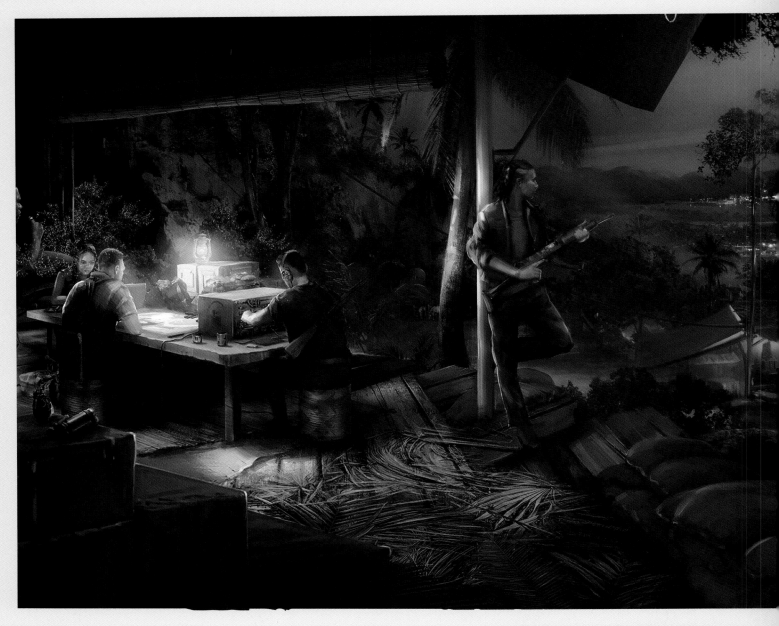

MADRUGADA

The western regions of Yara are the country's agricultural powerhouses, where its native tobacco has been grown and harvested for centuries. From the verdant beaches in Aguas Lindas, to the sky-splitting *mogotes* of Lozanía, to the rolling fields of Costa del Mar, the west is home to what many consider Yara's toughest people. These residents live off the land and prize family, tradition, and honor above all things. Since the Viviro infrastructure rolled in and seized their ancestral land, many citizens of Madrugada now find themselves desperate, poisoned, and destitute, but determined to reclaim their home.

The Montero family gravesite is settled in a peaceful and serene location.

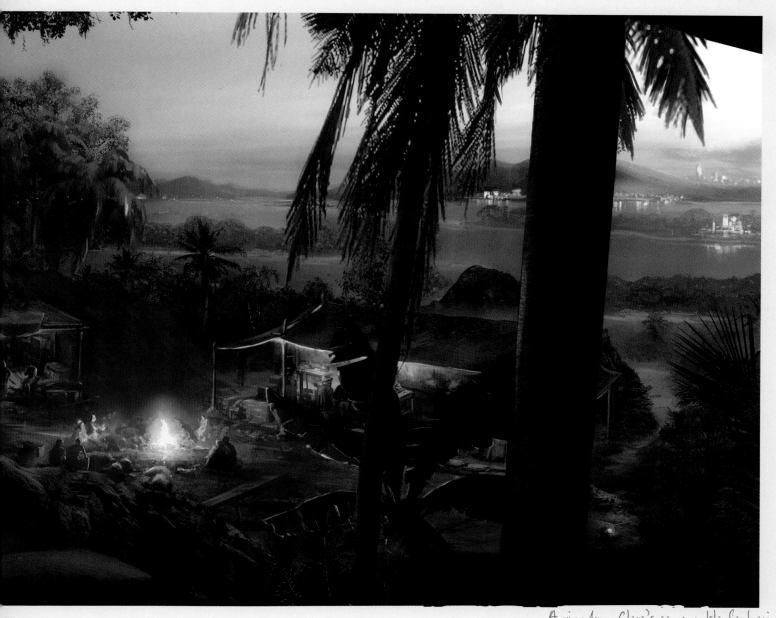

A view from Clara's camp on Isla Santuario.

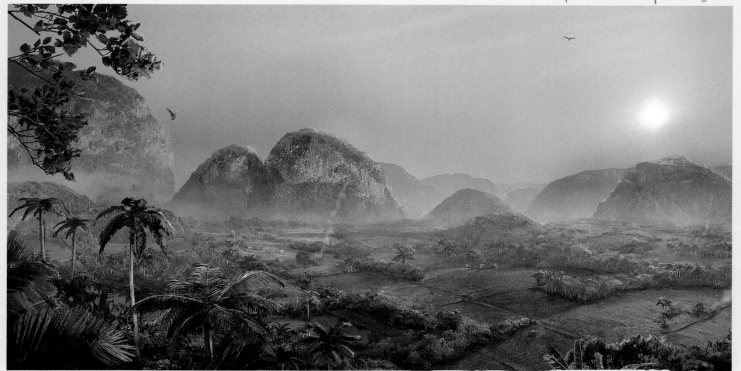

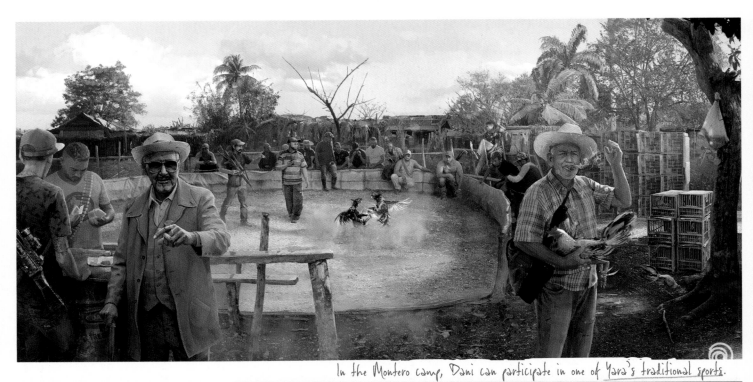

In the Montero camp, Dani can participate in one of Yara's traditional sports.

TRADITION

Nothing is more important to the people in the west than the preservation of their way of life. This is why pastimes and cultural practices that may be considered outdated to outsiders are still proudly on display, like the brutal cockfights that bring in dozens of spectators and a steady flow of cash daily.

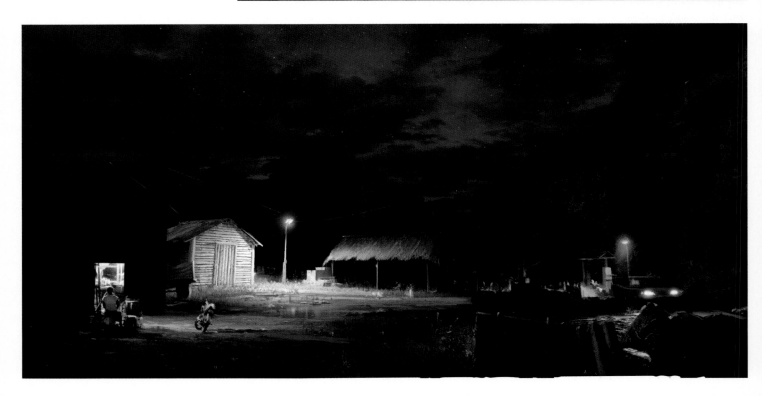

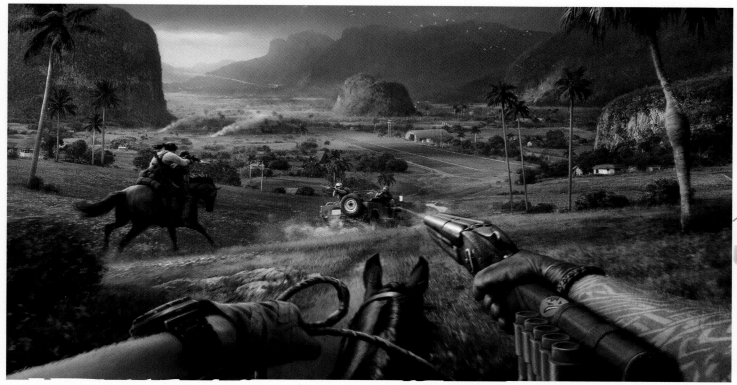

An early concept to explore the first-person horseback riding in Yara.

Light studies of a shoreline against the limestone hills.

COASTLINES

Sandy beaches, sheer cliffs, and verdant greenery make Madrugada a paradise on Earth, where the sunsets are guaranteed to take one's breath away. Of course, the natural beauty disguises a host of dangers, including aggressive wildlife, lethal riptides, and an ever-increasing military presence.

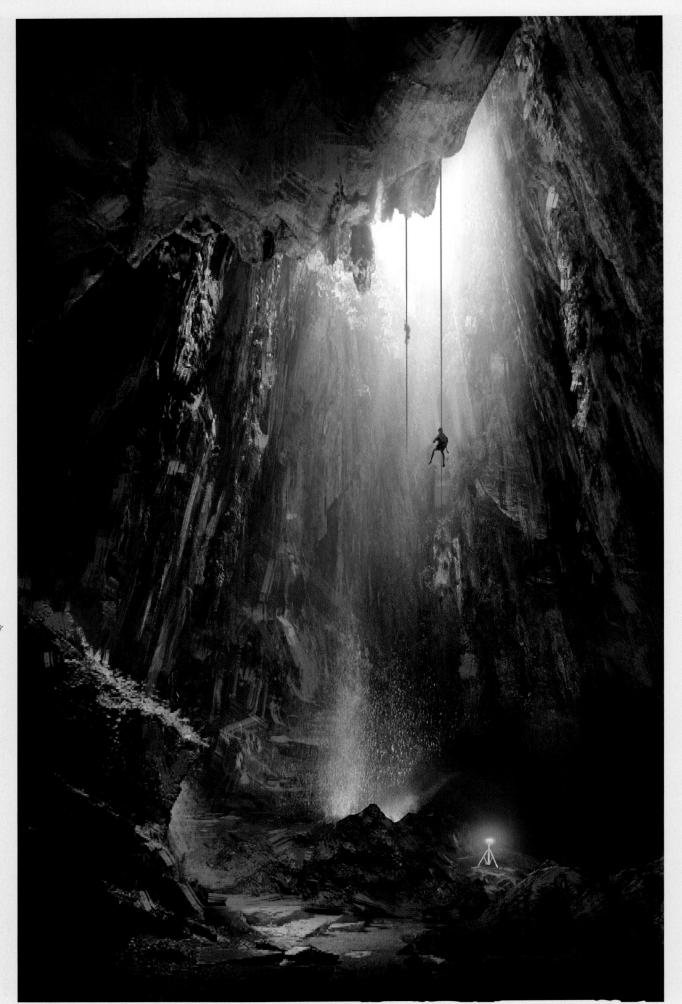

Concept exploration for the hidden Oluwa caves.

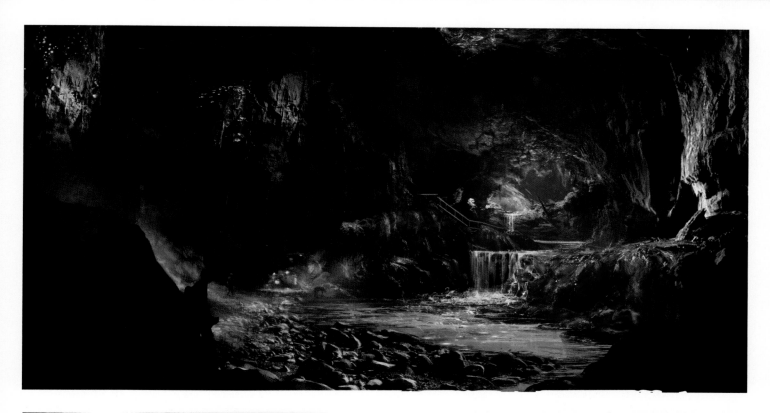

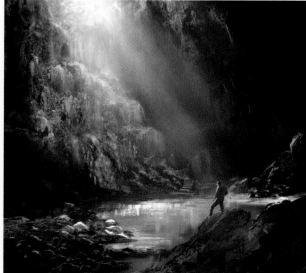

GEOGRAPHY

For all of the awe and splendor of Yara's mountains and *mogotes*, there lies within them an even more astounding natural wonder: networks of ancient cave systems that have gone largely unexplored by humankind. Used as refuges and hiding places by many subversives throughout Yara's history, from the pirates of the seventeenth century to the enslaved workers of the eighteenth and right up to the revolutionaries of today, these caves represent the unmapped potential of a country that has struggled to break free from oppression since its first days.

The cave entrances need to be somewhat visible from a distance. The goal is to lure the player in, but to give them exciting challenges as they try to reach those areas.

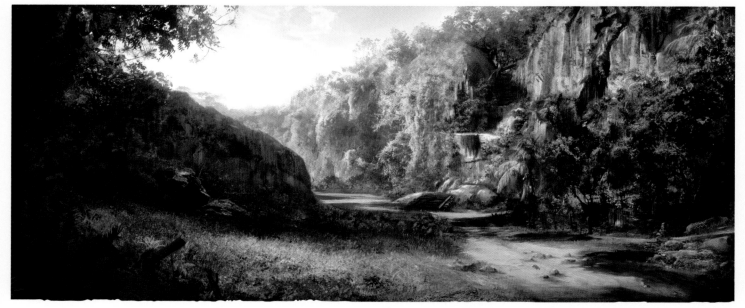

Far Cry tends to excel at melding the familiar with the unexpected. The creative team calls the recipe "the WTF element." It requires lots of creativity.

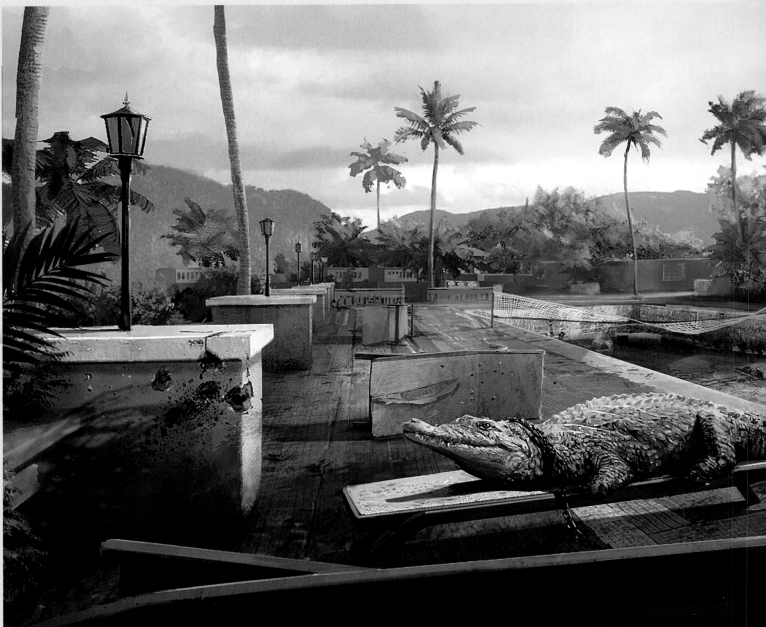

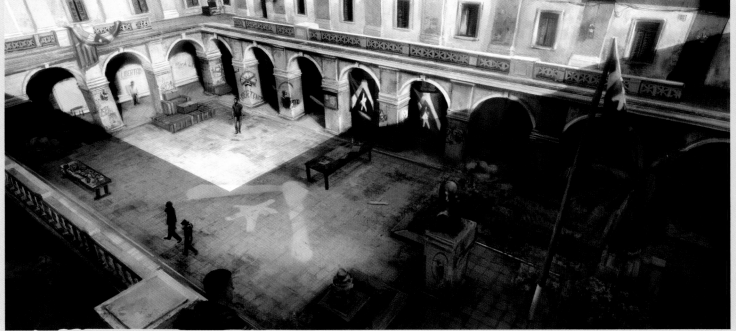

A liberated interior courtyard.

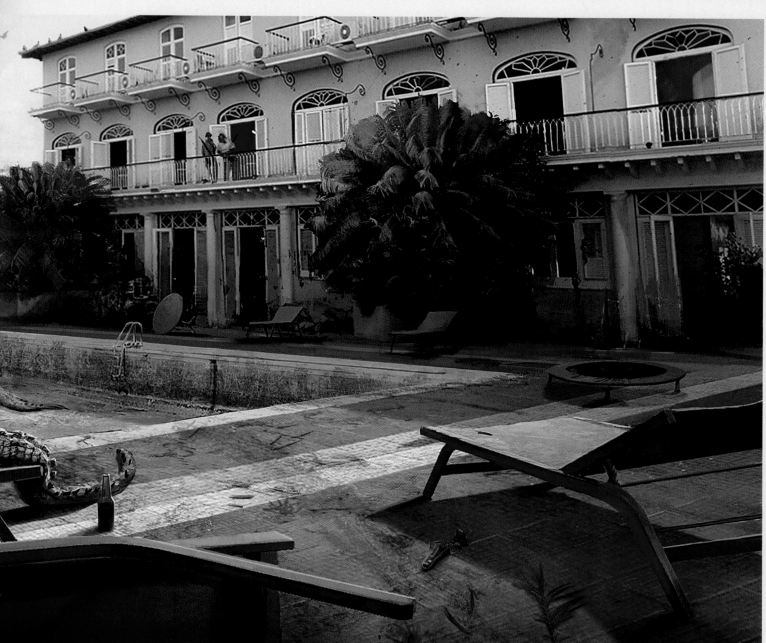

Beautiful and twisted, the bedrock of Far Cry.

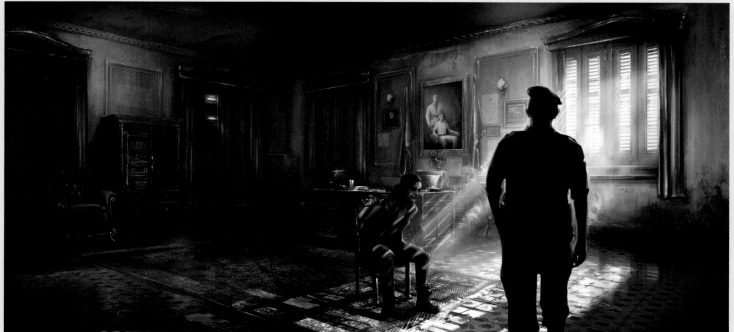

Espada being held by military forces.

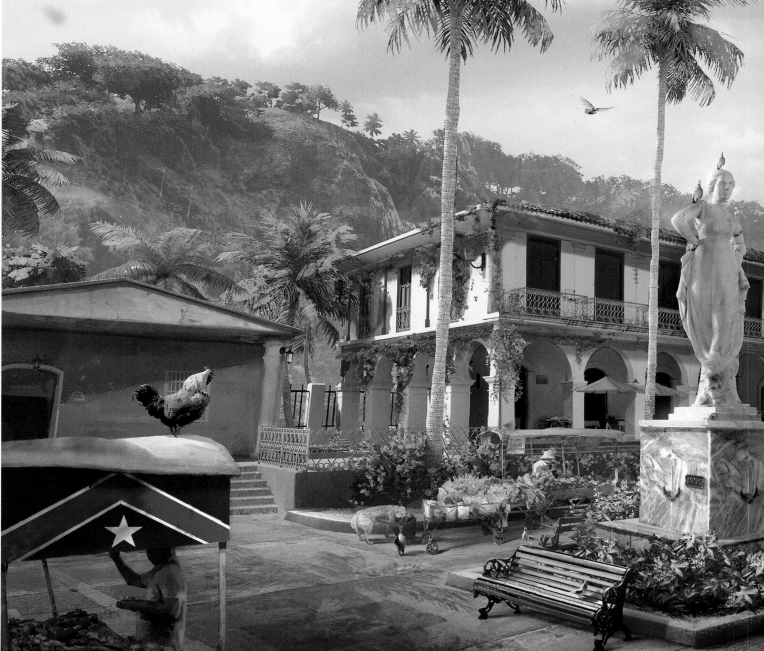

Yaran towns often will have a plaza with a small cathedral and government building where civilians can gather. This one is inspired by Cuba's Plaza Mayor.

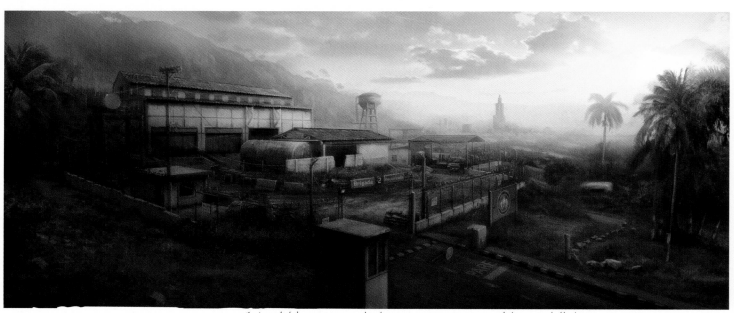

A beautiful mood concept of an armored-division military installation.

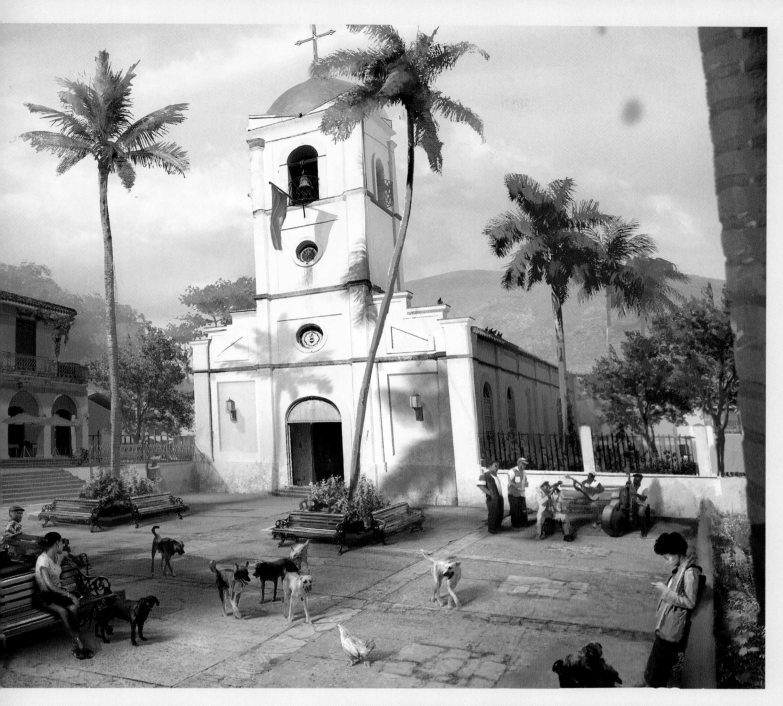

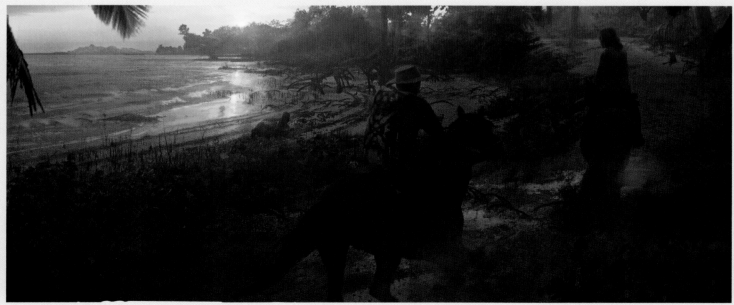

More of that WTF element popping up.

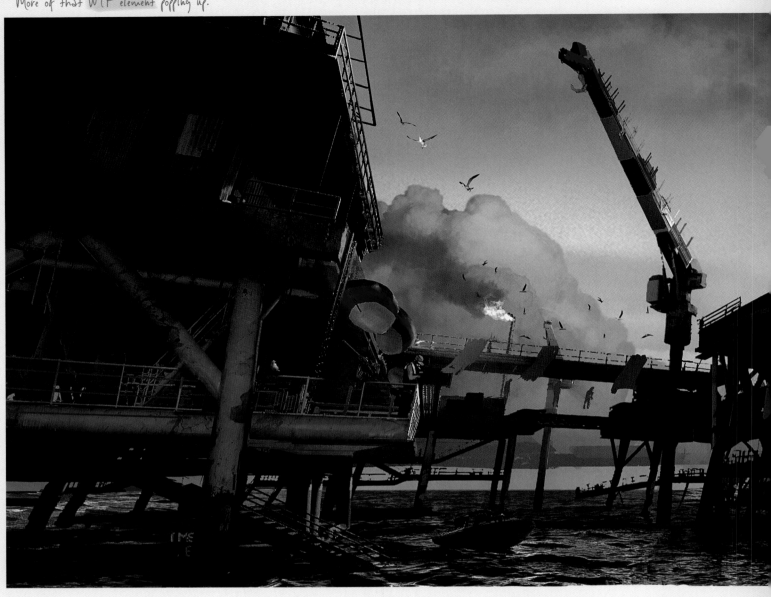

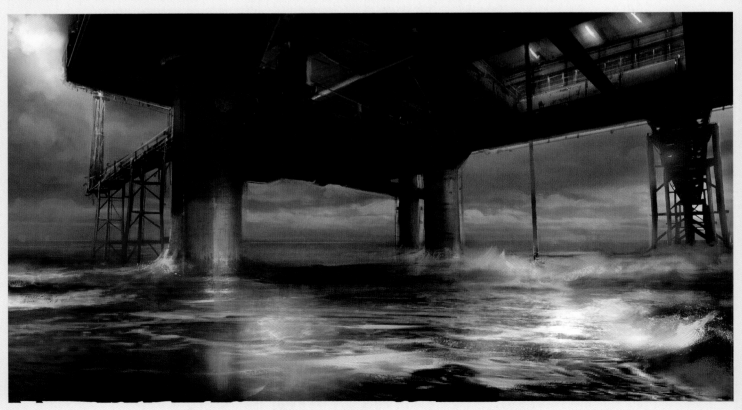

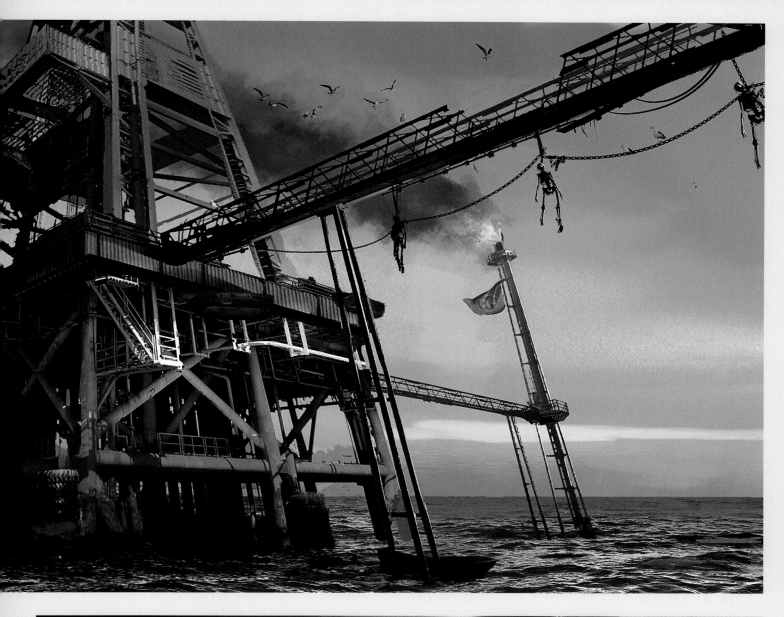

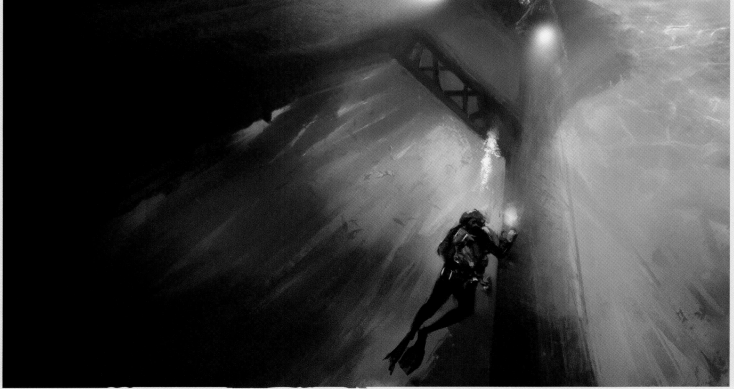

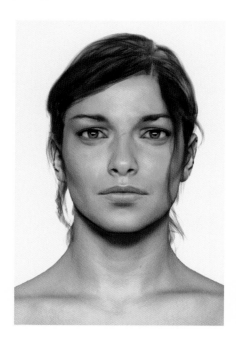

CAMILA "LA ESPADA" MONTERO

Scion of the Montero family and a formidable guerrilla, Camila—or "the Blade," as she's known to her enemies—has a complicated family history. She also has an intense hatred for the regime, especially General José Castillo, who leads the military effort to steal her people's land and livelihood.

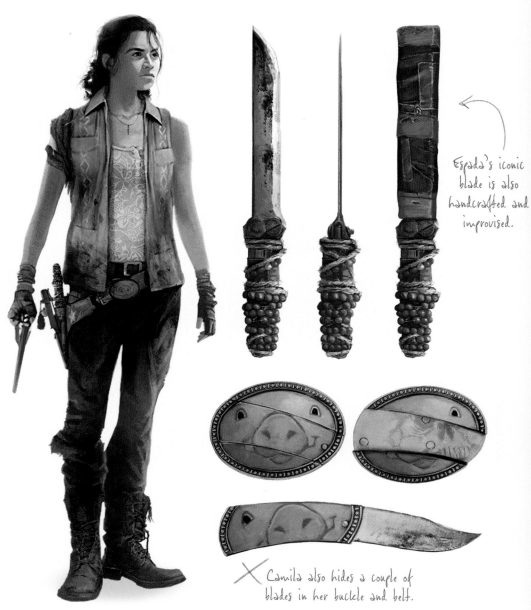

Espada's iconic blade is also handcrafted and improvised.

Camila also hides a couple of blades in her buckle and belt.

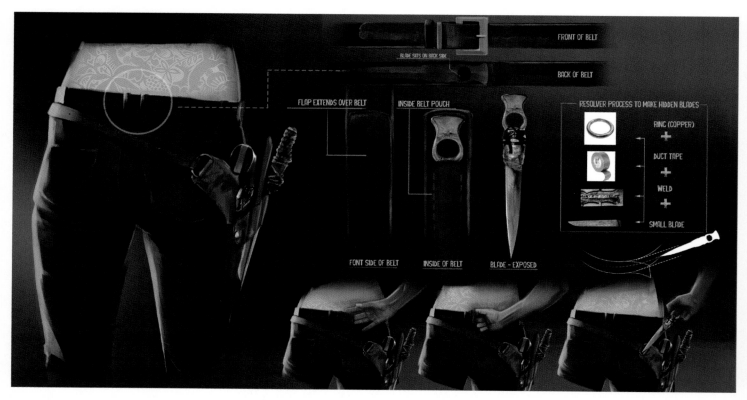

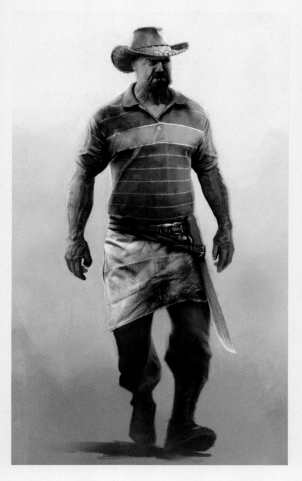

CARLOS MONTERO

Patriarch of the Montero clan, croc wrestler, and all-around cowboy, Carlos is even tougher than he looks, but he's an intensely proud family man and a fiercely loyal ally. All eyes are on him to lead the resistance in Madrugada, but his methods may be too stuck in the past—just like he is.

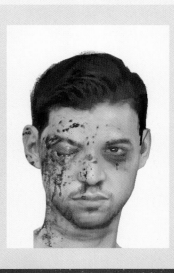

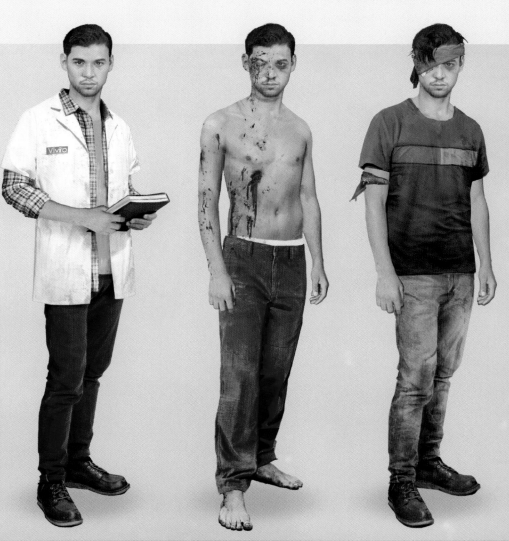

ALEJANDRO MONTERO

Black sheep of the Montero clan and Camila's younger brother, Alejandro had a rift with his father that led to him joining the regime's Viviro program as a chemist—a betrayal his family can't forgive. His sister, however, still believes he can be brought back into the fold.

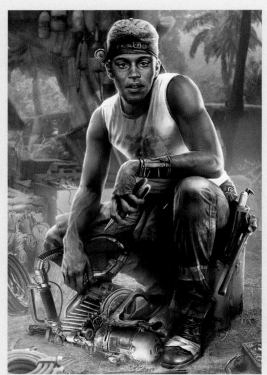

PHILLY BARGAZA

Philly is the man who probably understands the concept of *resolver* more than anyone in Yara. He can make anything out of anything with just a little bit of elbow grease, a smile, and some "Philly magic." With his pup Chorizo by his side, he provides the Monteros with all the equipment they need to fuel their private revolution.

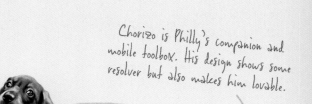

Chorizo is Philly's companion and mobile toolbox. His design shows some resolver but also makes him lovable.

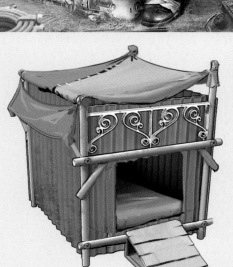

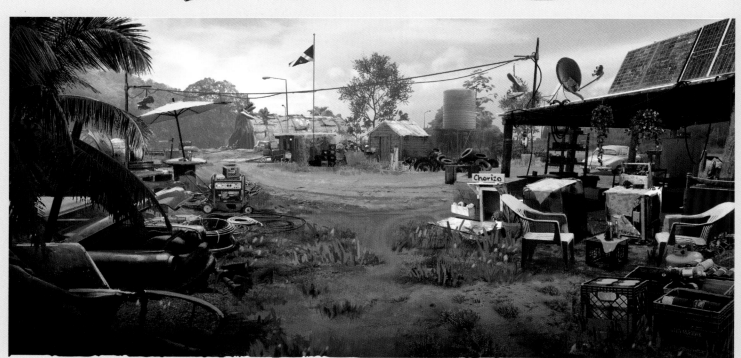

A view of Philly's yard, where the Philly magic happens.

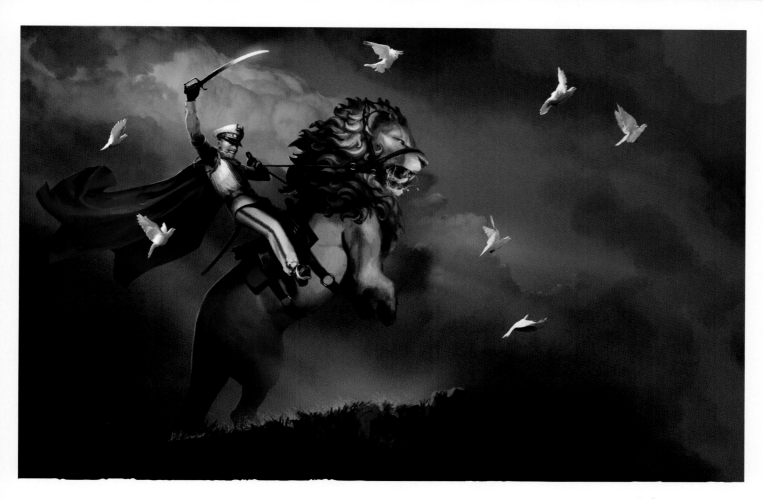

GENERAL JOSÉ CASTILLO

Antón's diminutive nephew José—better known to the farmers and guerrillas of Madrugada by his insulting nickname, Napoleón el Pequeño (Little Napoleon)—is a cruel and petty tyrant with delusions of military grandeur, and Libertad's primary target in the west.

José is a narcissist, admires Napoleon, and adorns himself with the eagle symbol. Eagle designs can be seen on his saber and boot tips, and even on his helicopter.

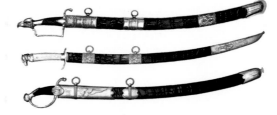

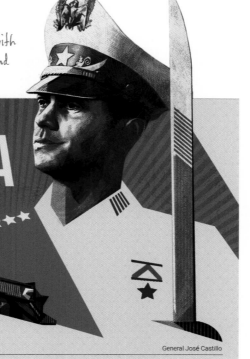

LA FUERZA
ES EL CAMINO A LA
VICTORIA

 Ministerio de Defensa

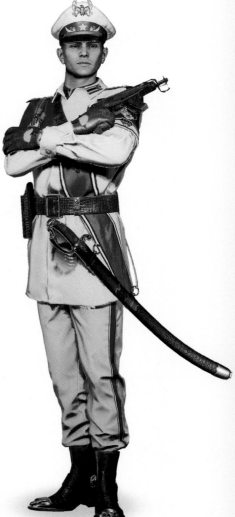

General José Castillo

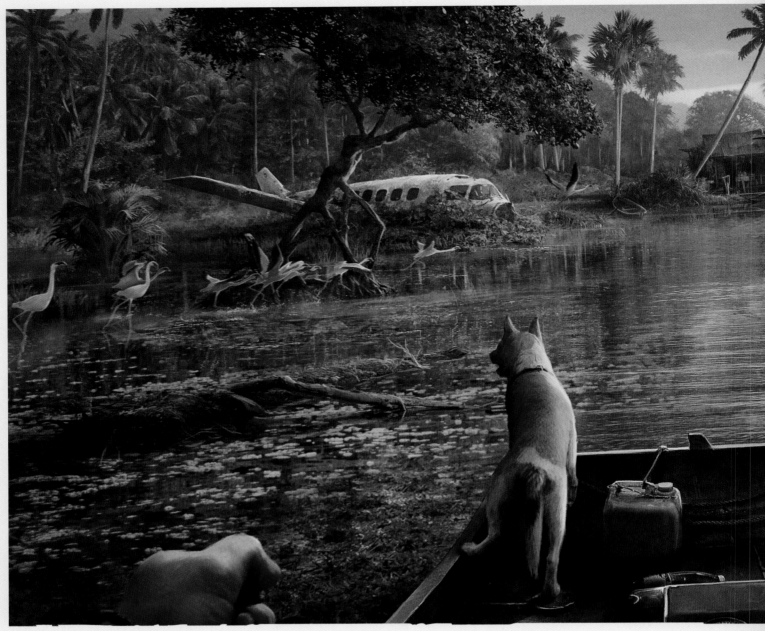

VALLE DE ORO

The "Valley of Gold" is the nexus of Yara, where all roads intersect. It's home to some of Yara's most diverse geography, from its vast stretches of swampland to its rolling mountain ranges. Its people are just as diverse and pride themselves on their rich history and culture, from music to art—which is why the presence of Yara's minister of culture and chief propagandist, María Marquessa, is driving them to rebel.

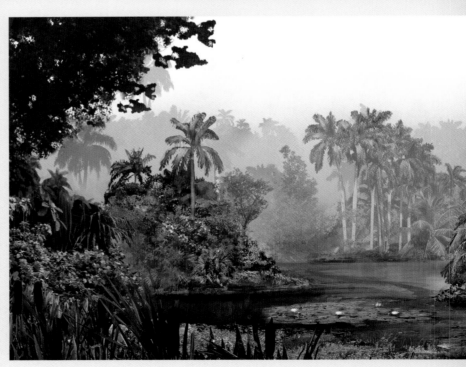

The swamps of Balaceras are among the unique locations of the game's world.

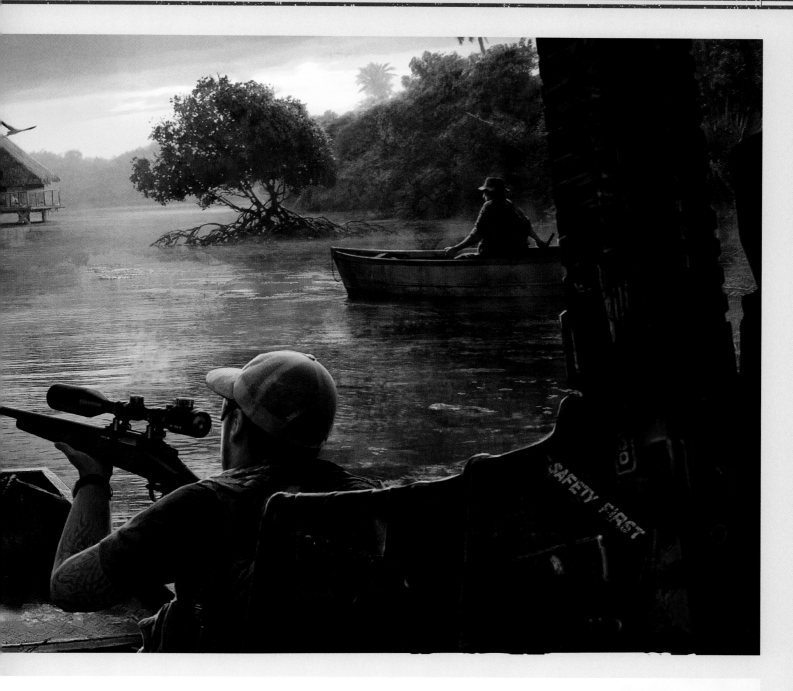

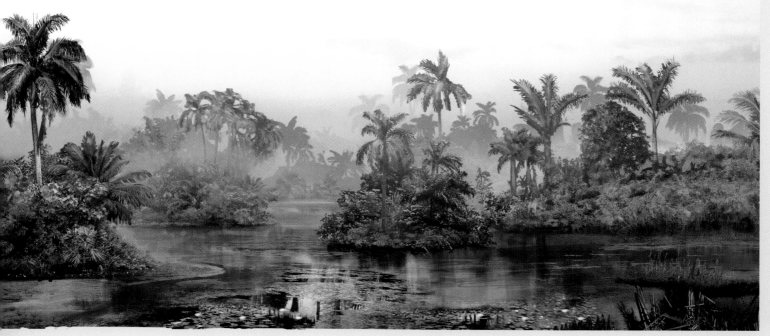

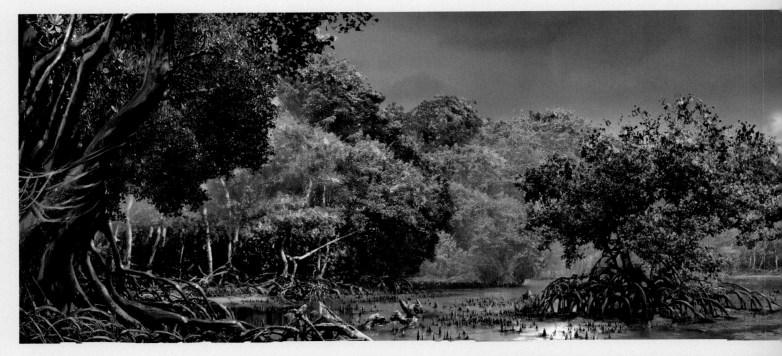

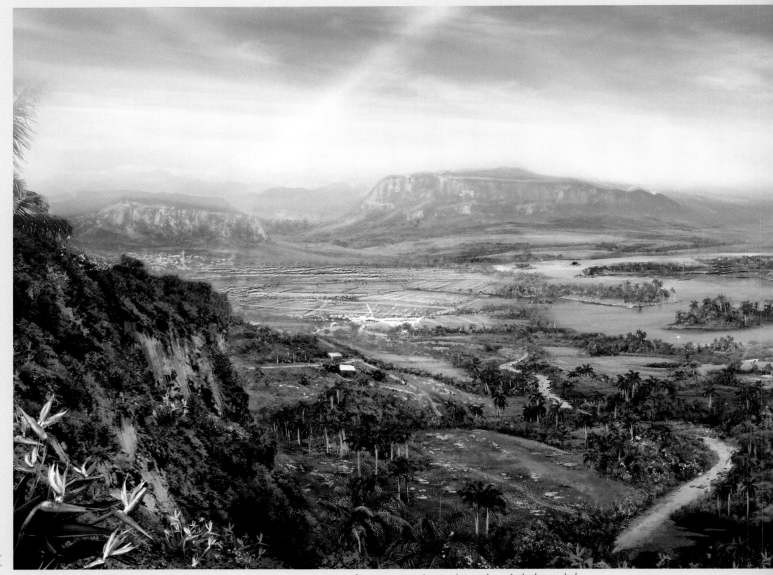

Yara had to have a heartbeat. To be a place to escape to, despite Antón's mark. A land of beauty. A testament to why the Castillo family has coveted the island—and why in the end, everyone is willing to die for Yara.

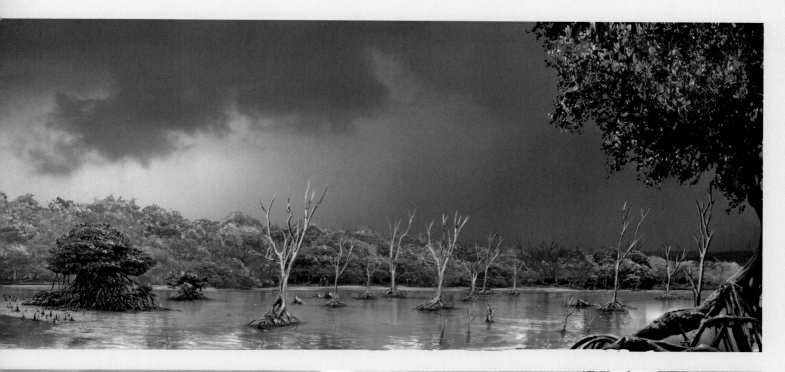

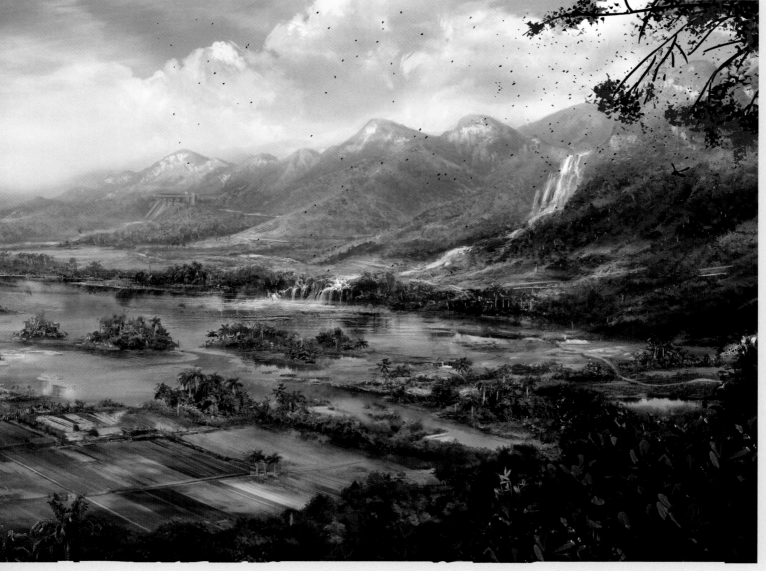

Exploration of hidden Libertad guerrilla symbols as part of the landscape.

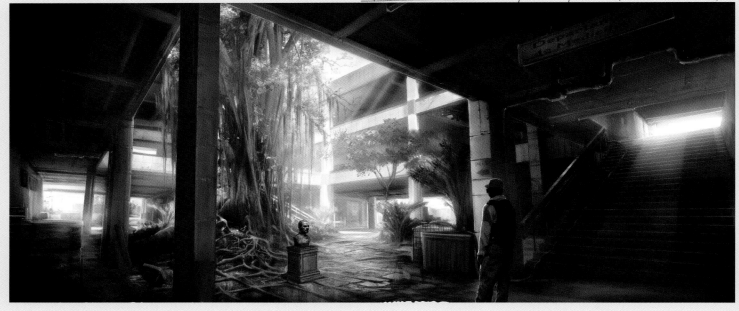

Interior lighting studies for a courtyard and María's television station.

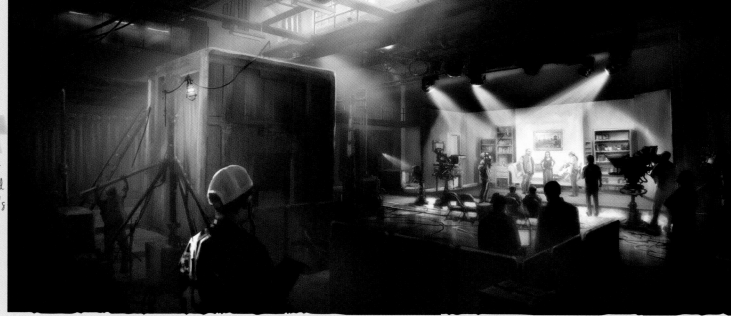

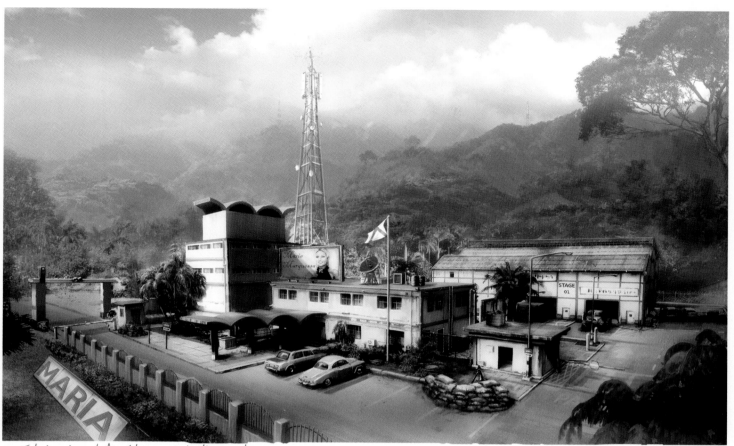

Exterior view of María's communications center.

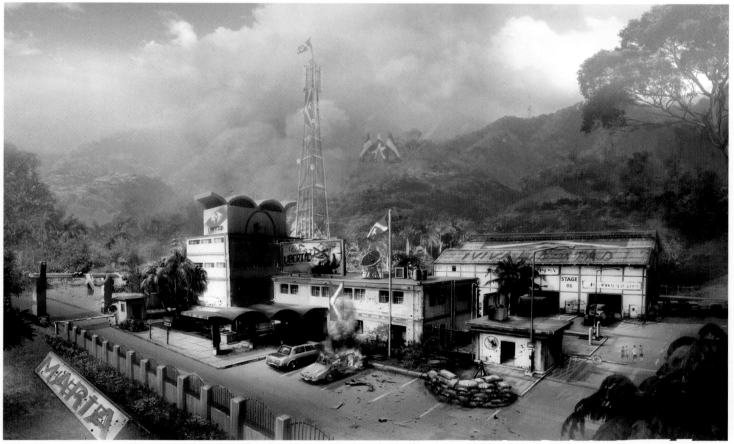

Libertad rebrands the outpost after they have taken it over.

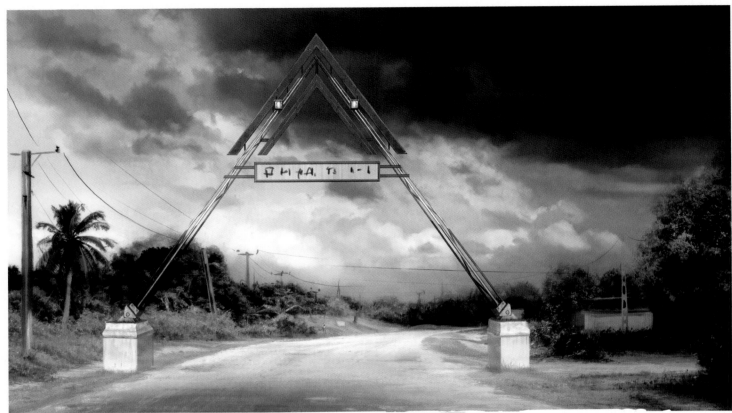

The red chevron is often used to mark Antón's military locations.

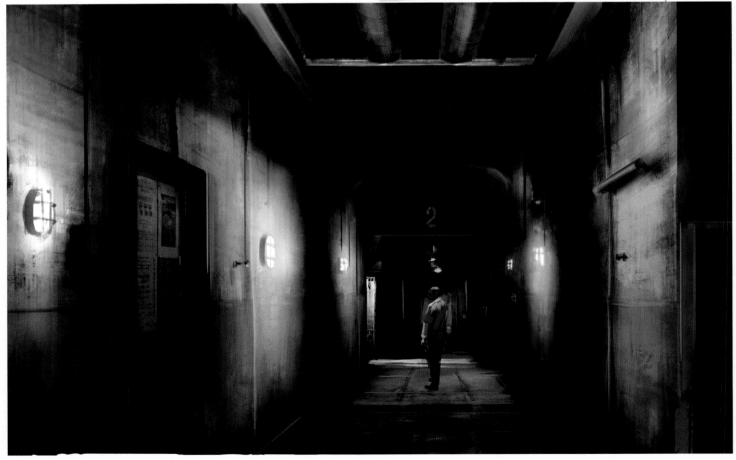

Interior lighting study for an underground bunker.

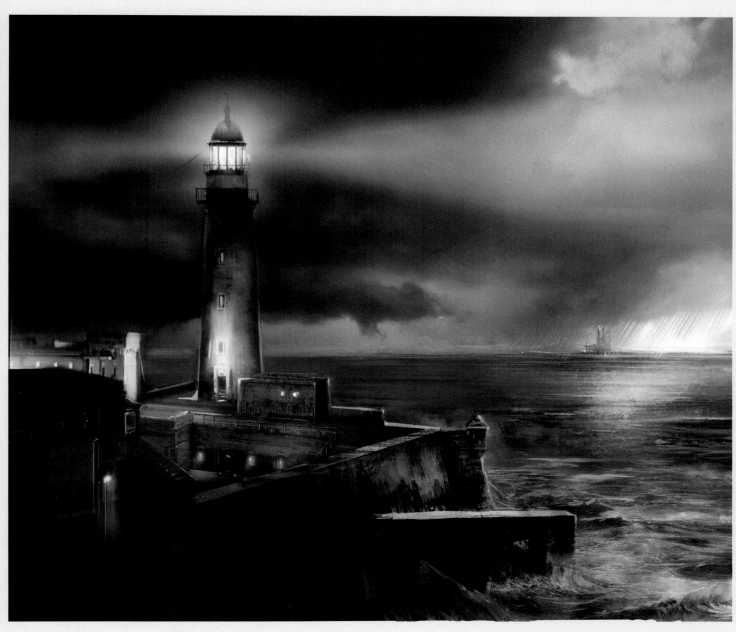

Lighthouses and old Spanish forts pepper the coastline of Yara.

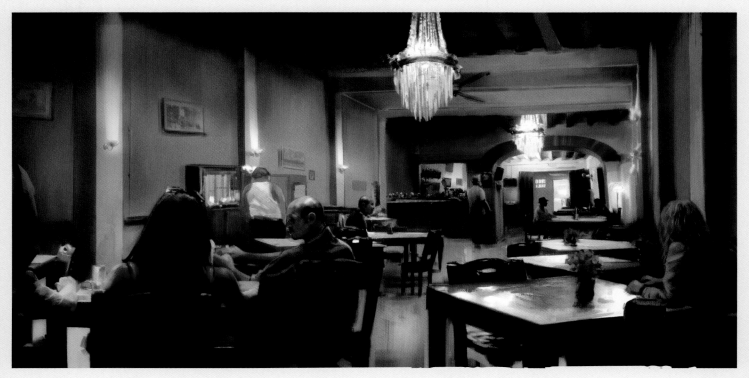

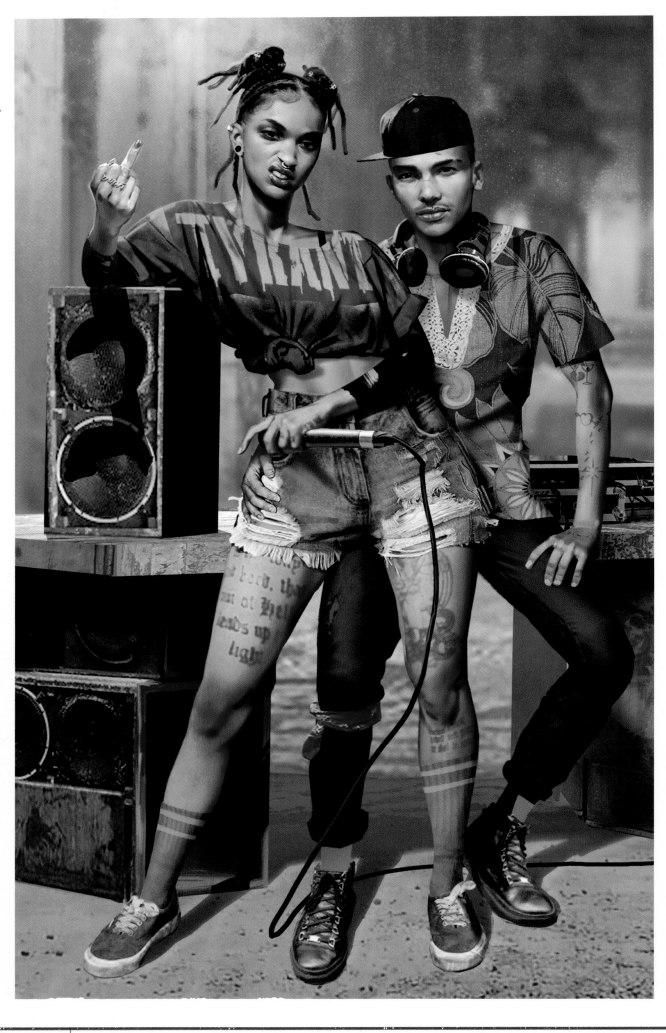

An early concept for Talia and Paolo. Their designs give them dueling personalities wrapped in rebellious branding.

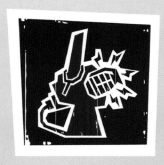
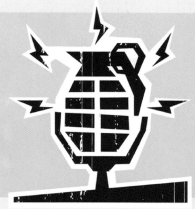

The branding for Radio Libertad and Máximas Matanzas is inspired by punk rock and militant rap fliers.

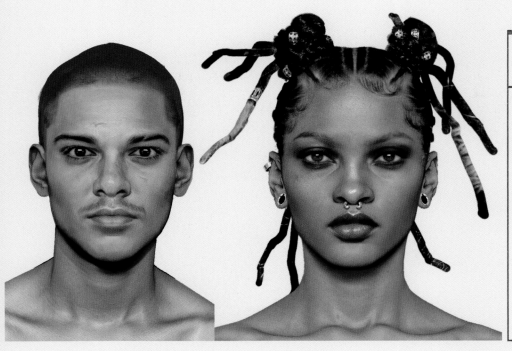

UNITE THE REGIONS
TALIA & PAOLO

Talia Benevidez and Paolo de la Vega are the musical nuclear attack that is Máximas Matanzas, Yara's premier underground protest rap duo. They are the ones that first introduced Clara García to the oppression of Yara, and it's even rumored Talia coined the name "Libertad" for the guerrilla group. Talia and Paolo are yin and yang, fire and ice—these two are at each other's throats as often as they're in each other's beds, and their fiery protest music gives the people of Yara a voice they need now more than ever.

Talia and Paolo's tattoos were specially designed to add layers to their backstory and personality.

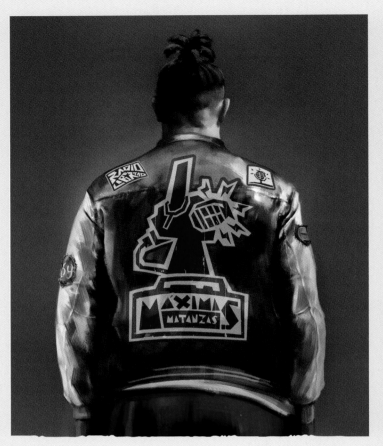

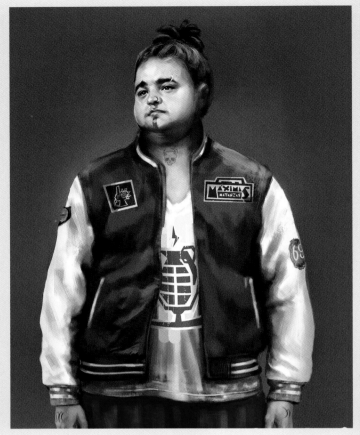

PAZ "BICHO" DUARTE

A Mexican expat from a rich family, Bicho never found a place to belong—until he arrived in Yara and attached himself to his favorite musical group, Máximas Matanzas, that is. He became their de facto roadie, manager, hype man, and number one fan. After a violent riot ignited by a Máximas Matanzas concert in Esperanza, he's on the run with the rest of the group, but with Dani's help, he might yet find a place for himself in the revolution too.

Bicho is a superfan and wears all the swag.

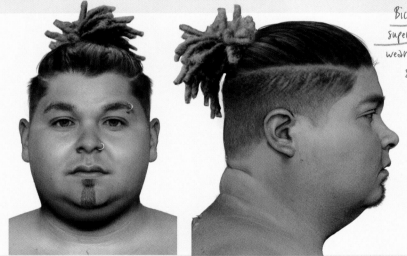

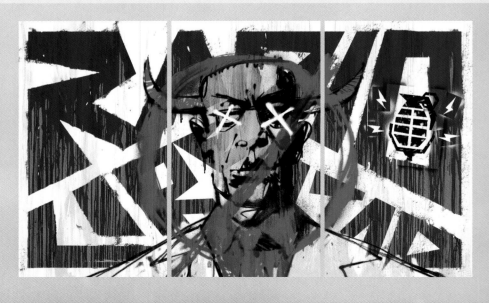

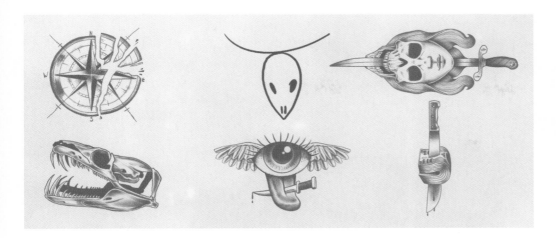

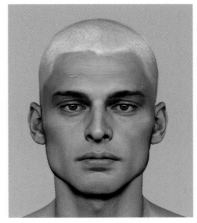

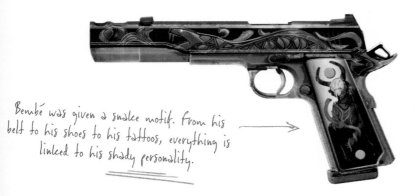

Bembé was given a snake motif. From his belt to his shoes to his tattoos, everything is linked to his shady personality.

BEMBÉ ALVAREZ

Underground kingpin of Valle de Oro and a man of many faces, Bembé is a businessman who deals in everything from arms to human trafficking. Young, suave, and ruthless, he doesn't discriminate against any type of customer . . . so long as they can pay.

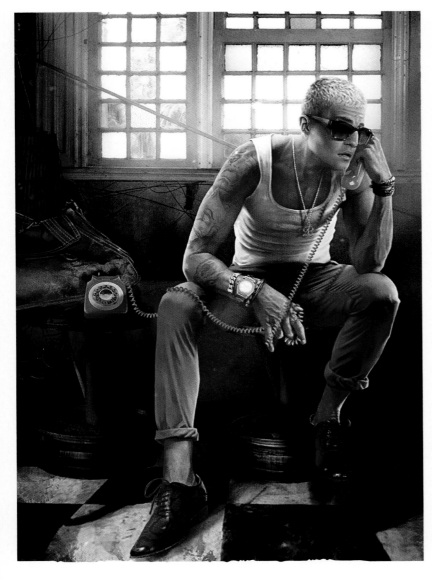

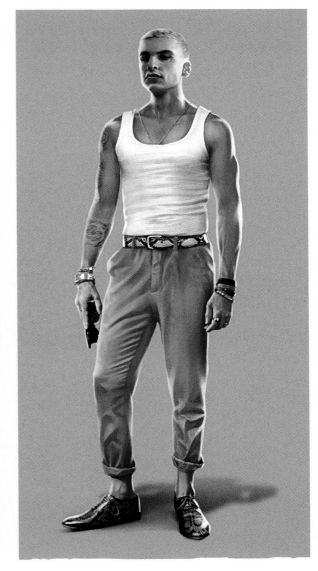

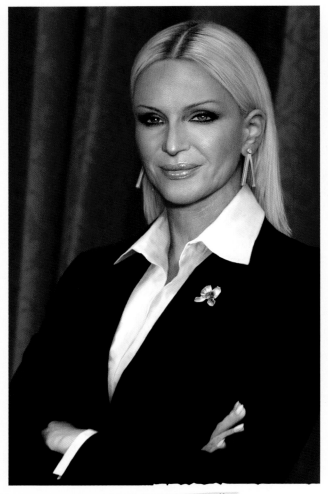

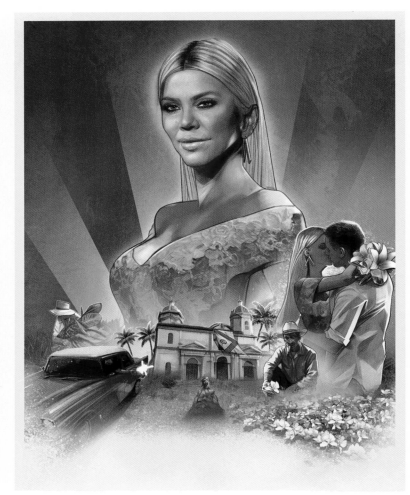

María was inspired by older Latina soap opera divas. The artists gave her a look of royalty and celebrity to go with her aging beauty.

MARÍA MARQUESSA

A former telenovela star and a savvy opportunist, María's Marquessa succeeded in turning a floundering acting career into a political rebirth that landed her in Antón Castillo's inner circle and in charge of his regime's censorship and propaganda. Many believe Diego Castillo is the product of their secret affair.

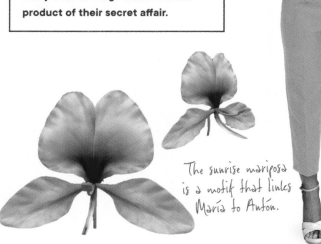

The sunrise mariposa is a motif that links María to Antón.

750 mL 40% alc.

ORGULLO DEL TORO

El ron favorito de *María Marquessa*

REPUBLICA DE YARA
sello de
Garantia
de procedencia para el producto

MARÍA MARQUESSA
PRODUCTIONS

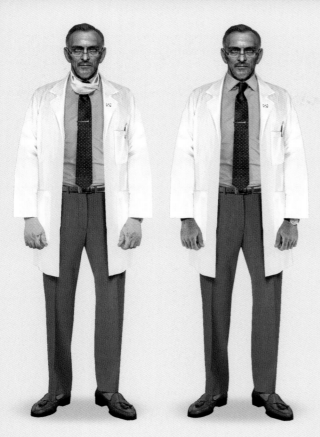

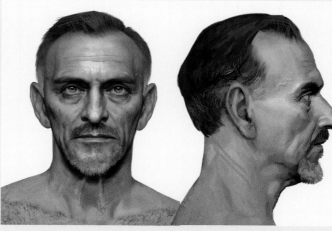

El Doctor shares the same color palette as the BioVida branding.

DR. EDGAR REYES

A brilliant biochemist and pharmaceutical innovator, Dr. Edgar Reyes is the mastermind behind the Viviro cancer treatment drug. His exacting nature and utter disregard of ethics led him to create the Outcast program to fuel his ambitions. Dr. Reyes is also Antón's personal physician.

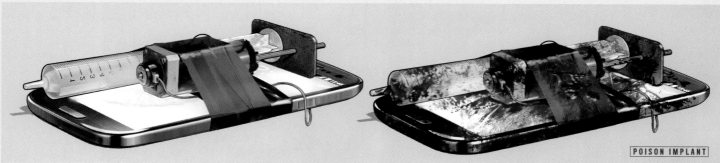

POISON IMPLANT

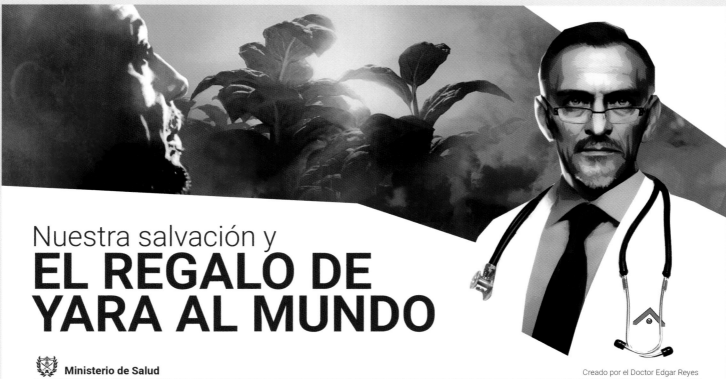

Nuestra salvación y
EL REGALO DE YARA AL MUNDO

Ministerio de Salud

Creado por el Doctor Edgar Reyes

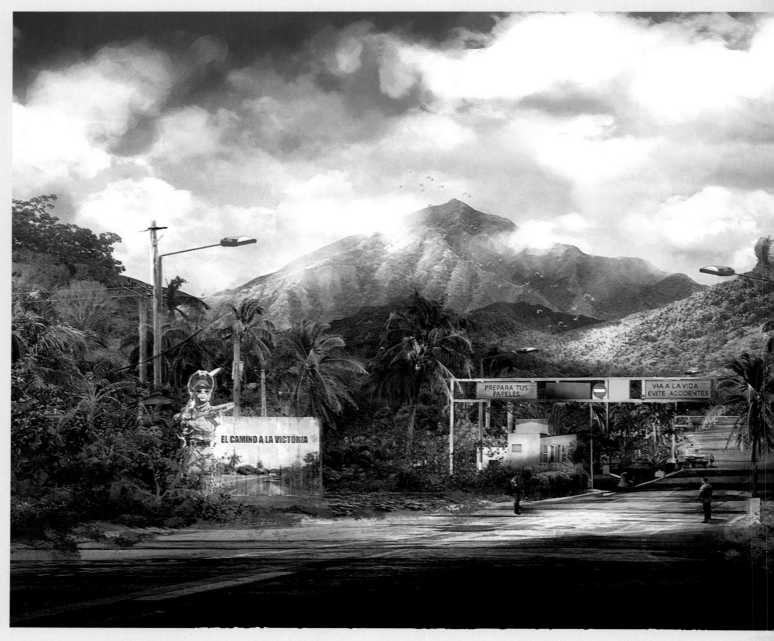

EL CAMINO A LA VICTORIA

PREPARA TUS PAPELES

VIA A LA VIDA EVITE ACCIDENTES

EL ESTE

Yara's most mountainous region is also its most lush, with towering peaks reaching above thick and foreboding jungle. It's a place where old and new are constantly at odds, where its newer infrastructure takes root on historical sites and its younger generation mistrust their elders. Its once thriving coastal ports are suffering under the double blow of military oversight and a strangled import/export industry run by Sean McKay.

View from La Joya and the northeastern shoreline. ➝

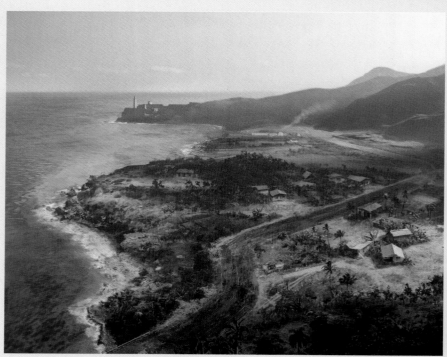

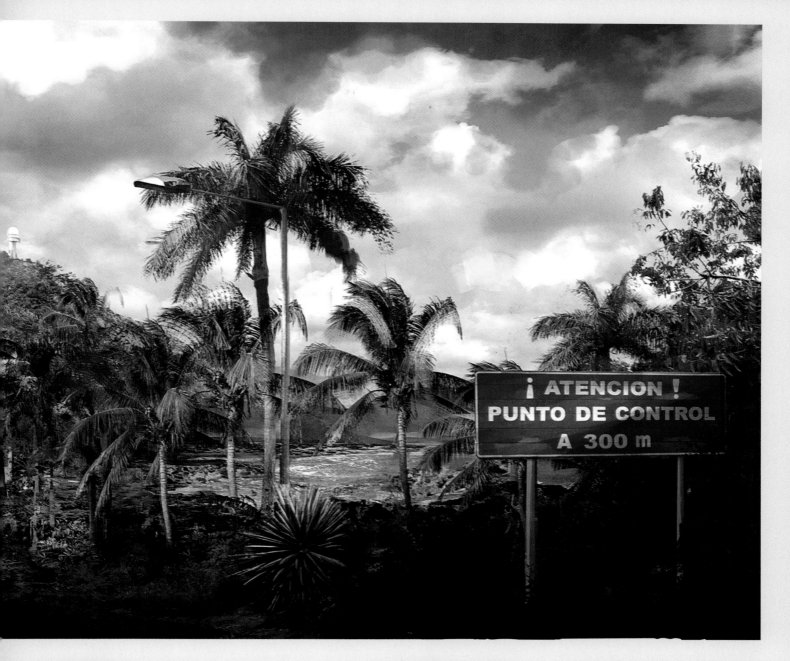

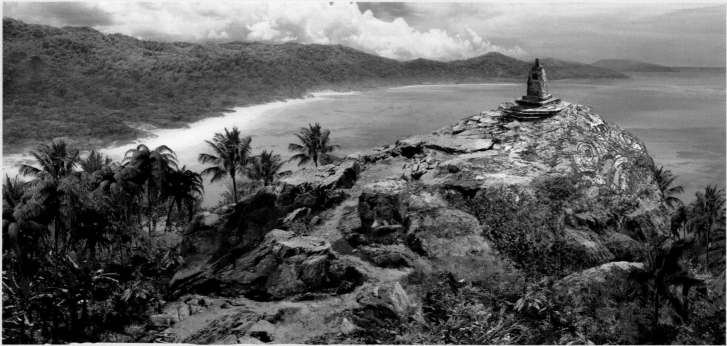

Early concept for the memorial to Lobo located at the peak of Sierra Perdida.

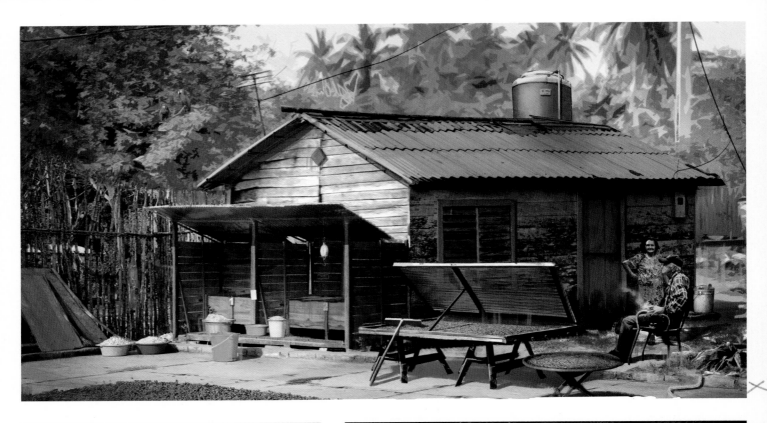

LIFE IN THE EAST

One of El Este's primary agricultural products
is coffee, with countless farms where beans are
grown, gathered, cleaned, roasted, and shipped.
Because trade off the island is restricted, these
bean farmers have been able to maintain their
livelihoods by supplying their fellow Yarans with
the coffee they need.

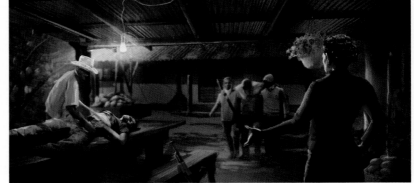

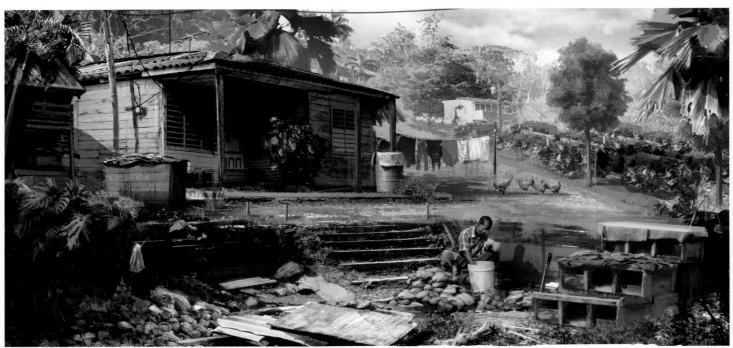

The Fernando region was particularly interesting to develop; based on the cacao-producing region of Baracoa in Cuba, it represents a traditional Cuban agriculture virtually unchanged for centuries. The region was meant to look impoverished and isolated but colorful and warm, a reflection of its inhabitants, who gladly help those in need but have often paid the price for it.

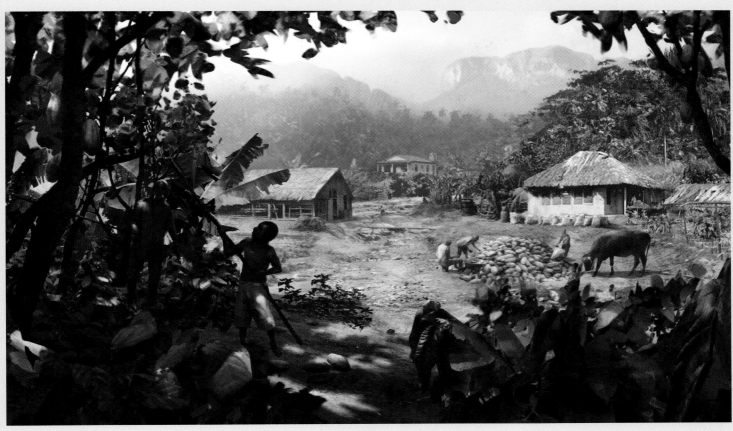

Early concept of cacao bean gathering.

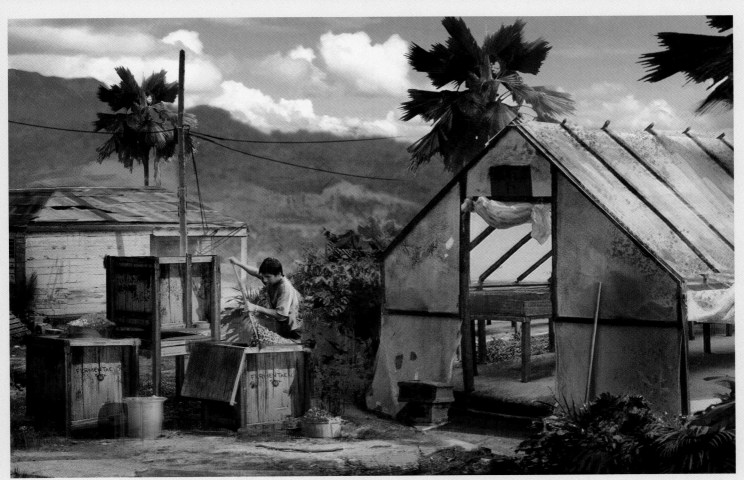

The cacao valley of Fernando is visually very similar to its real-like inspiration. The cacao trees grow sheltered by the jungle. The pods are split, and the pulp is extracted; the pulp must first ferment inside large wooden crates before it can be sun dried and finally roasted.

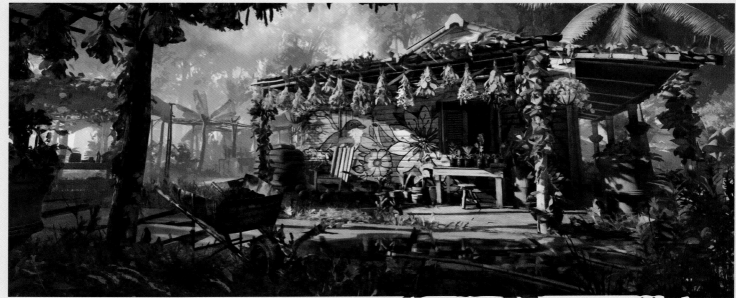

The naturopath's house. She is one of Lorenzo's many children in Yara.

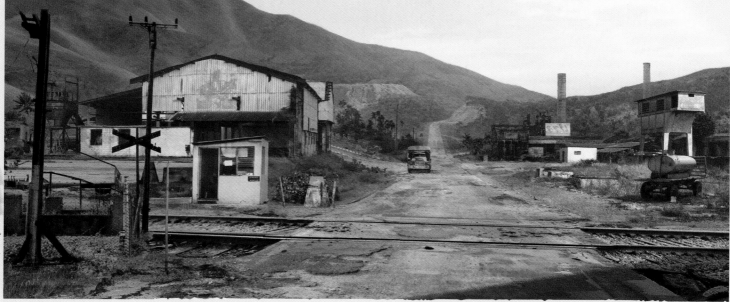

Abandoned railway crossings are common across Yara.

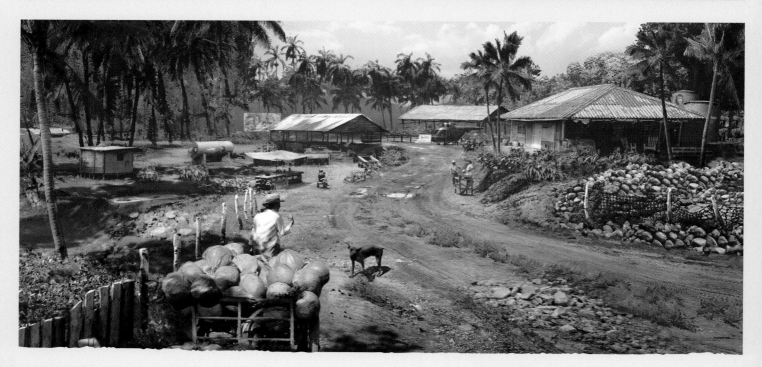

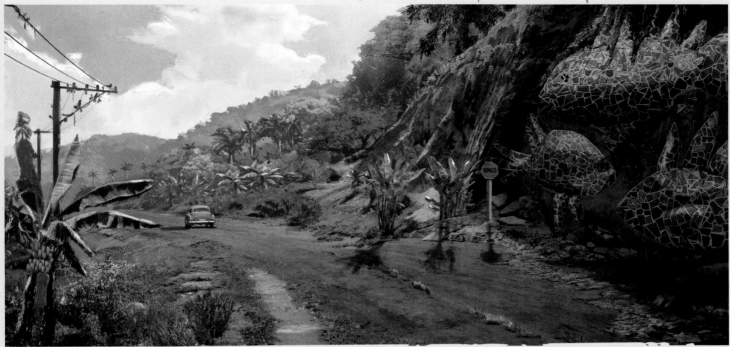

Mosaic tile art is a motif used in the eastern provinces.

A study to differentiate subregions with iconic and recognizable symbols.

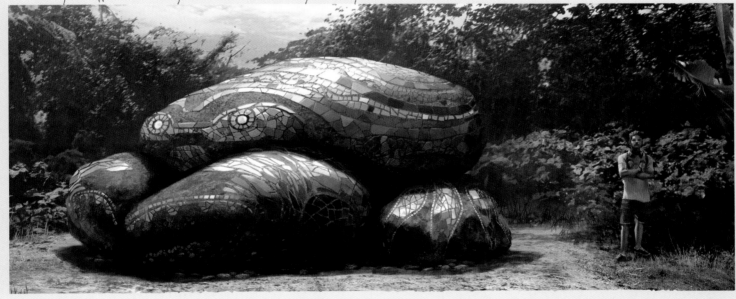

The crab rock landmark is used by El Tigre to help Dani find the guerrilla camp.

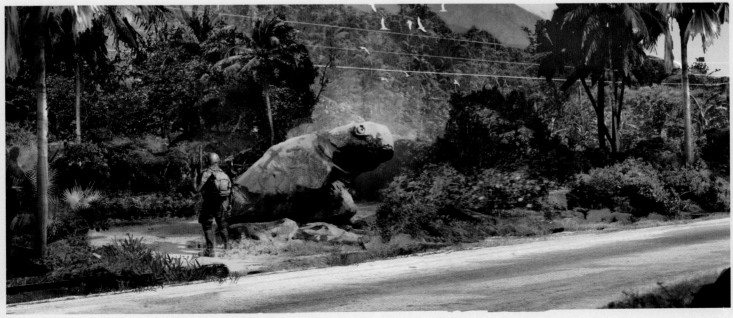

An iconic marker used for navigation.

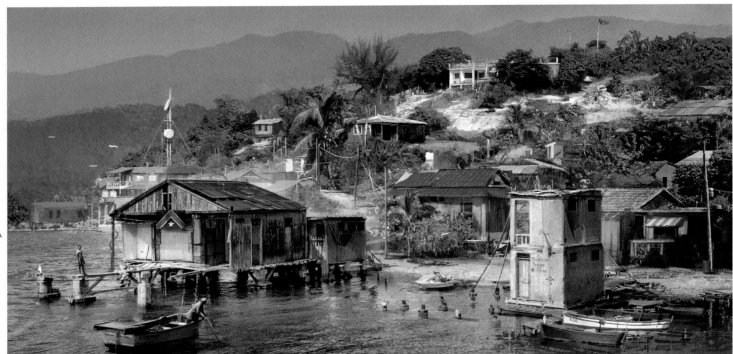

A small fishing village on the northeastern coast.

IMPORT/EXPORT

Strict governmental control over international trade has been an element of Yaran life since the American embargo was instated in the last quarter of the twentieth century, leaving Yarans to subsist on technology and goods that are decades behind the rest of the world. Under Castillo's plan to "rebuild paradise," Yara is partnering with foreign interests like McKay Industrial Shipping & Freight to ensure that this stranglehold is maintained.

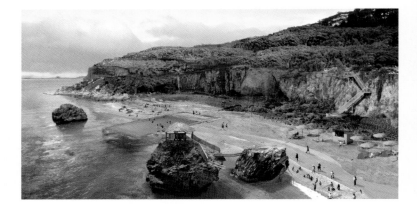

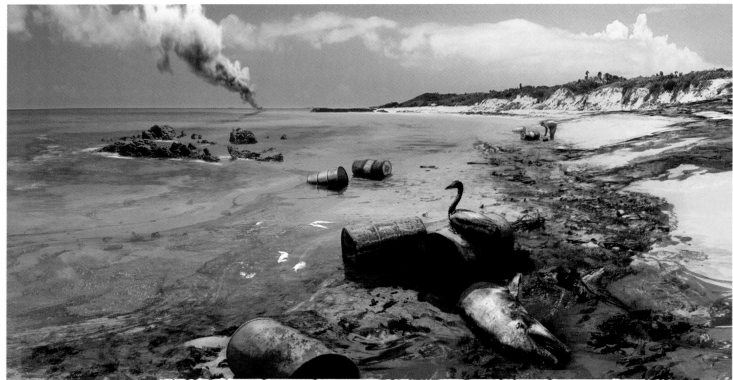

A recurring theme in "Far Cry 6" is the idea of progress and the price associated with it. The polluted area of La Joya (based on Moa, Cuba) was meant to contrast with the otherwise beautiful landscape.

In El Este, one can find much of Yara's industry linked to McKay. This site belonged to an old mining operation that was closed in the 1980s due to potential environmental fallout. McKay took over this crumbling infrastructure and reopened the mine. Environmental and safety issues be damned if there is a profit to be made.

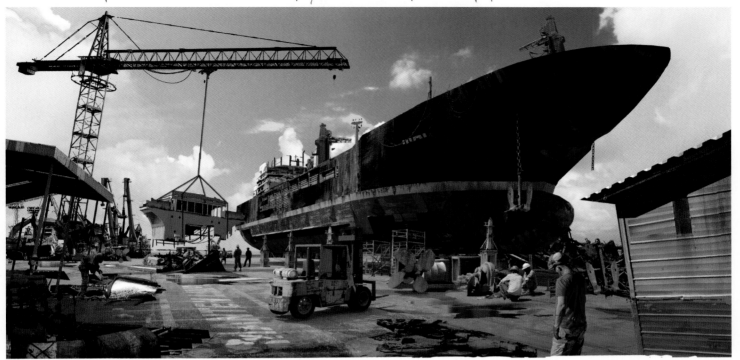

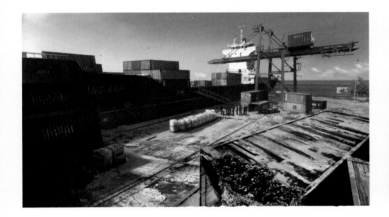

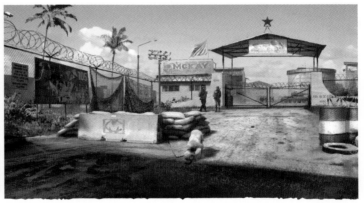

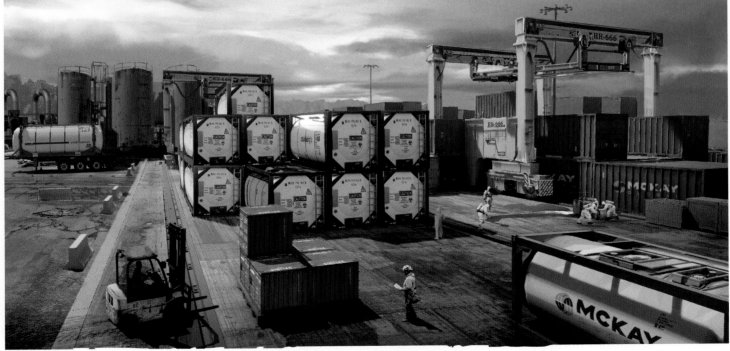

Eastern Yara was meant to be earth and jungle; McKay's world is steel and concrete.

The village of Maldito, based on Yumurí, Cuba, was created as a representation of what awaited those who challenged the established rule. Its inhabitants were massacred, and the village remains as a warning.

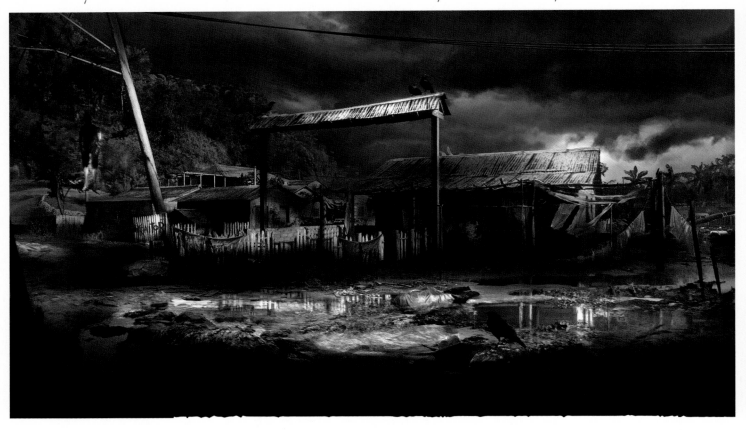

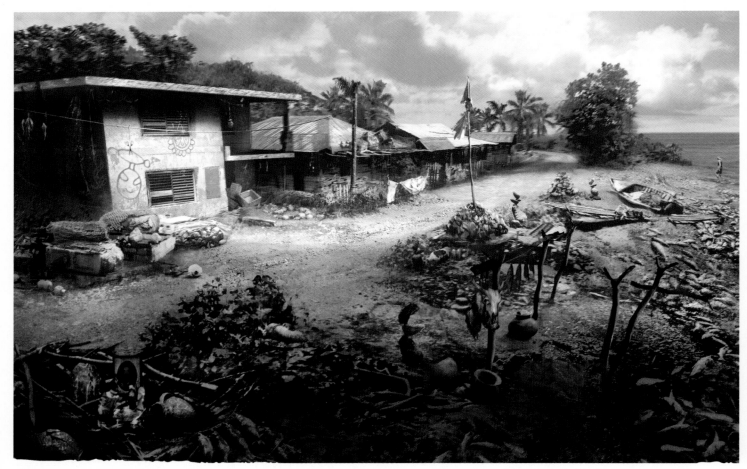

A great example of coastal living in Yara.

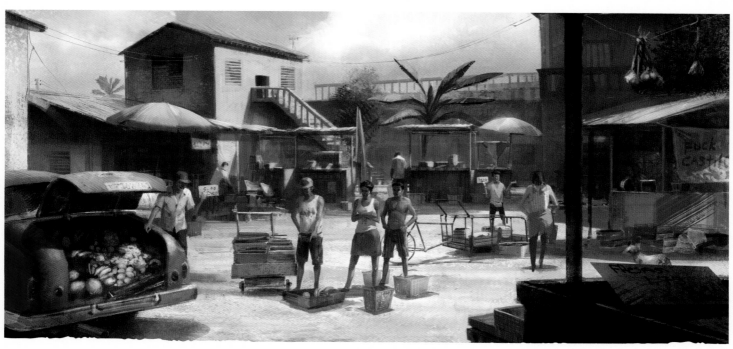

The crest of the town of Concepción: its images represent the cacao industry, the coconut oil industry, Columbus's landing, and a regional bird.

PRIMMO GEMMA DE YARA

The market of Concepción is meant to be a representation of the markets seen in Cuba. Of their entire production, Cubans can keep 10 percent for personal use or to sell or trade in the markets. The Yarans in this time of crisis resort to similar methods in order to subsist.

CONCEPCIÓN

A historical landmark and bustling harbor town based on the real Cuban city of Baracoa, Concepción was the first Spanish settlement in Yara, founded by Christopher Columbus. Today, it's a bastion for civilian supporters of the rebel movement La Moral, who flout military control at every opportunity and pride themselves on being an infestation that Castillo can't exterminate, no matter how hard he tries.

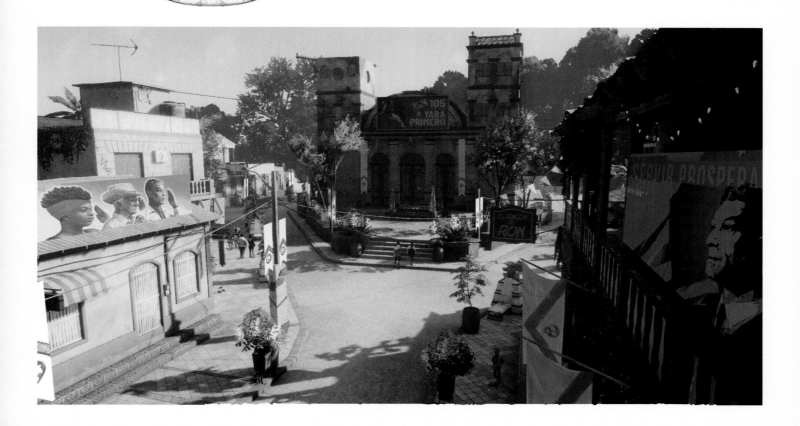

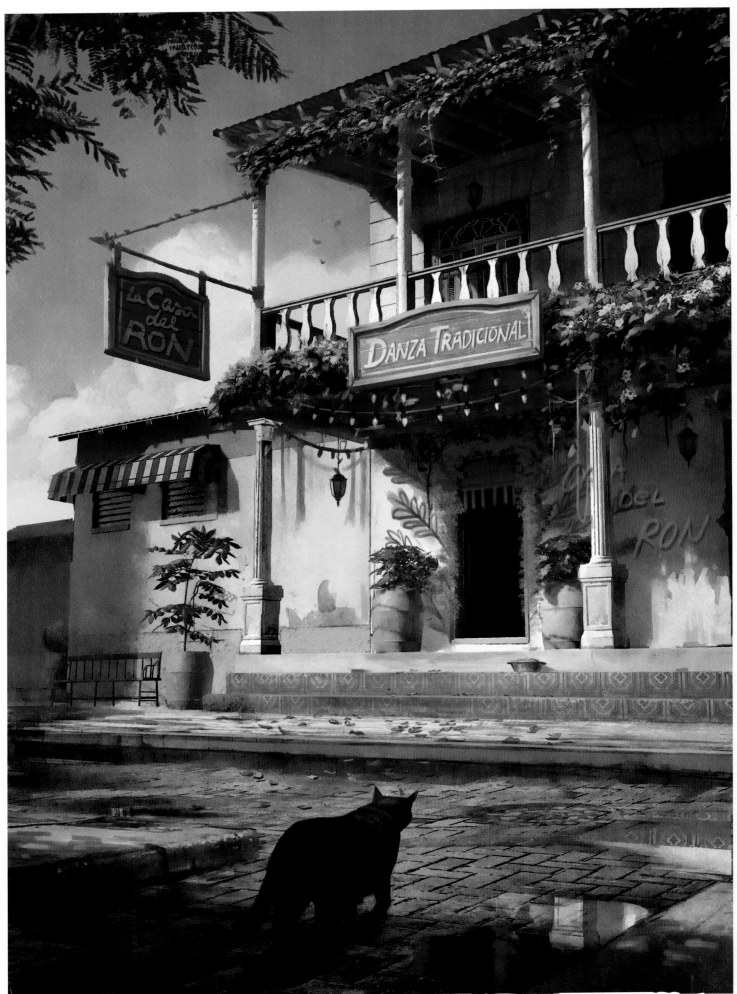

A typical Yaran nightclub. On Saturdays, locals dance to traditional music here.

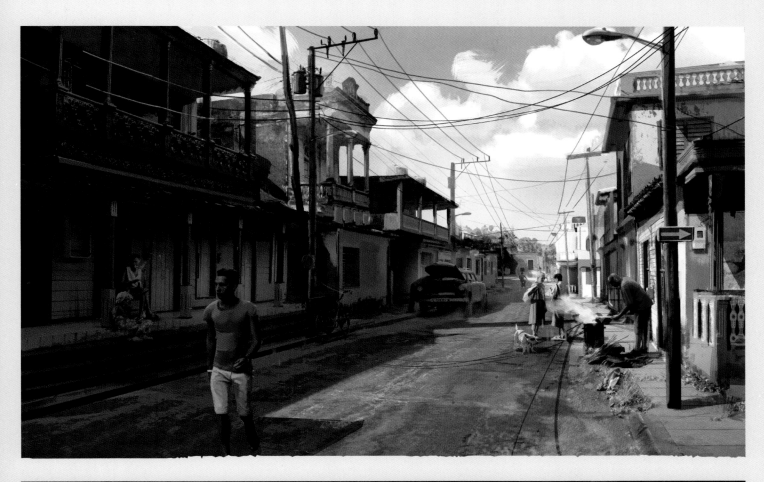

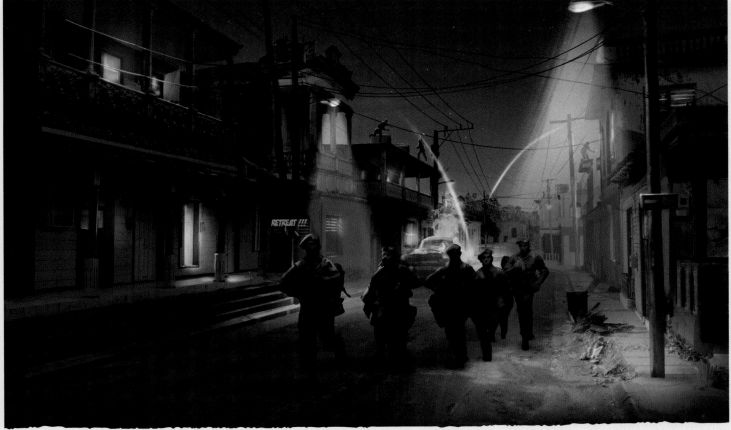

✗ The architectural style of Concepción is eclectic (due to its long history as one of the
first cities in Yara) and vernacular (function over style). At night, the mood of the
town flips completely and reflects the tension of totalitarian rule.

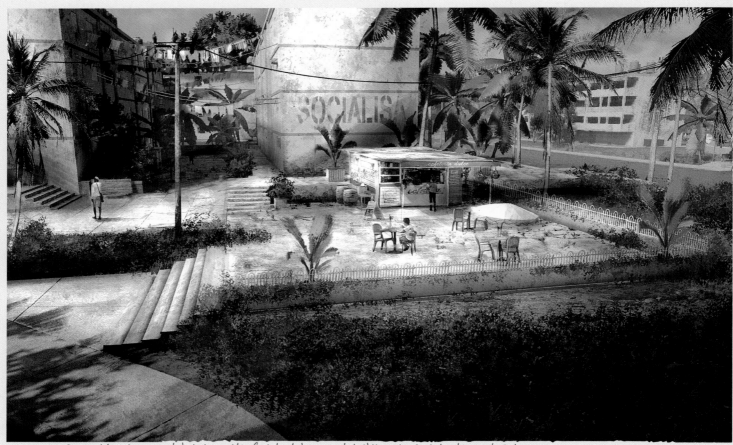

Concepción mixes coastal design with Soviet-style cement buildings inspired by those of Cuba.

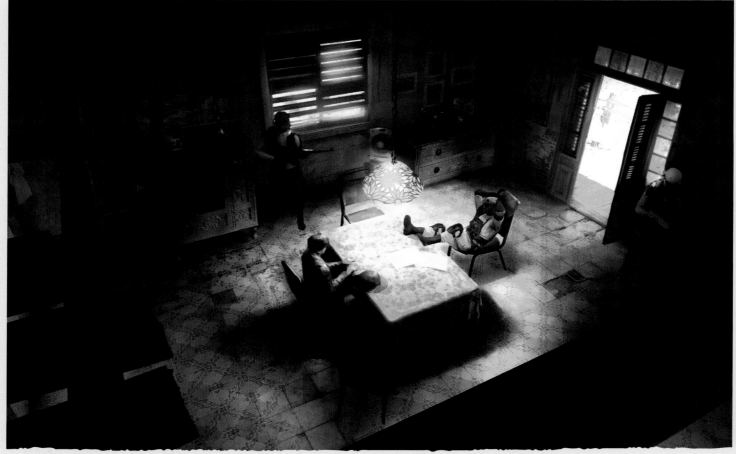

Interior layout concept for the interrogation
of a suspected loyalist to La Moral.

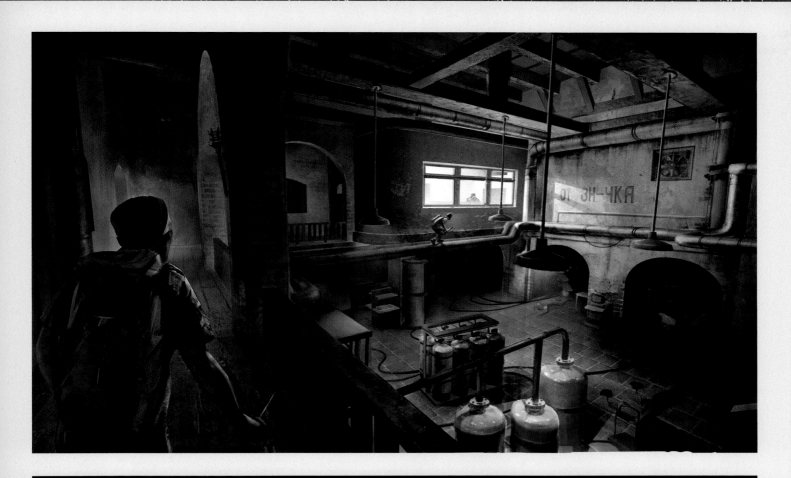

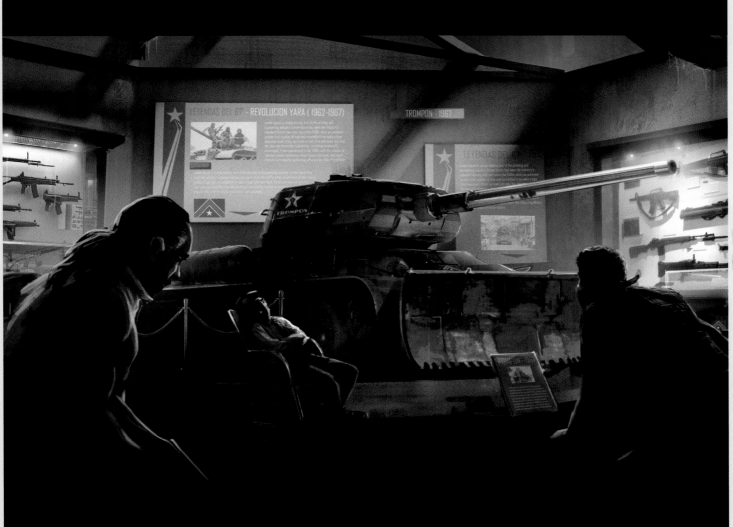

Raid on the Museo de Historia. After he rose to power, Castillo made sure museums presented his own narrative of Yara's revolution.

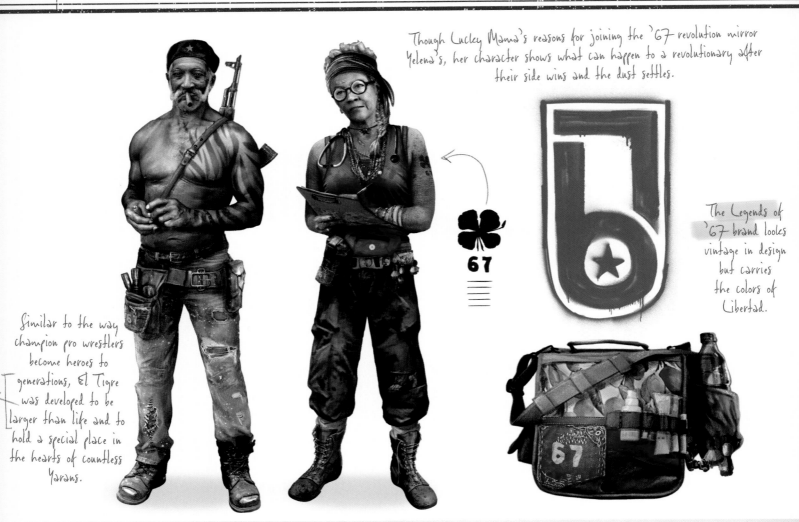

Though Lucky Mama's reasons for joining the '67 revolution mirror Yelena's, her character shows what can happen to a revolutionary after their side wins and the dust settles.

67

The Legends of '67 brand looks vintage in design but carries the colors of Libertad.

Similar to the way champion pro wrestlers become heroes to generations, El Tigre was developed to be larger than life and to hold a special place in the hearts of countless Yarans.

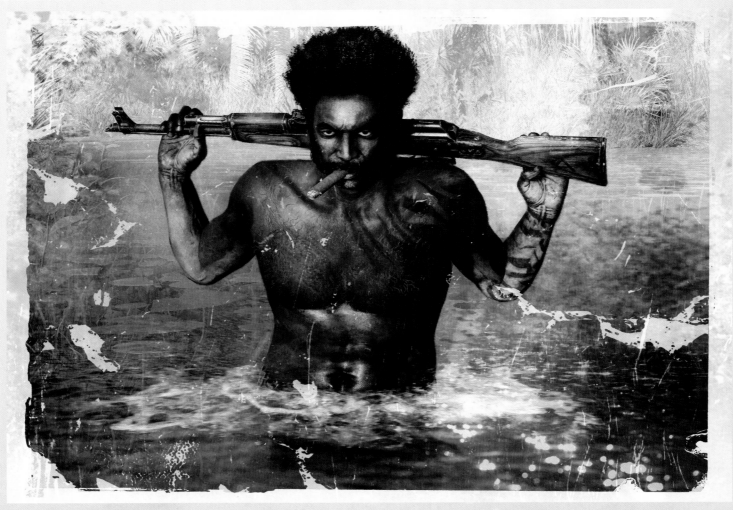

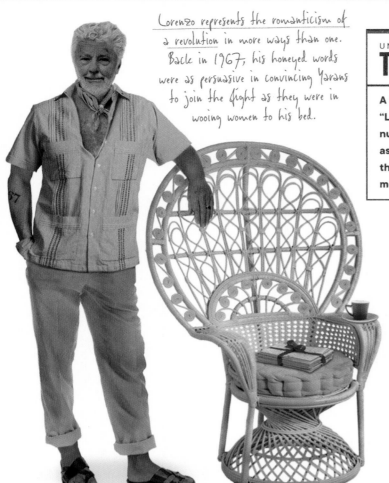

Lorenzo represents the romanticism of a revolution in more ways than one. Back in 1967, his honeyed words were as persuasive in convincing Yarans to join the fight as they were in wooing women to his bed.

THE LEGENDS OF '67

A few heroes of Yara's previous revolution, known as the "Legends of '67," still remain in El Este. They do little but nurse old wounds and watch from their mountain redoubt as their country transforms under Castillo. This angers the young guerrillas of La Moral, who turn to modern methods to succeed where their elders have failed.

As he is an epically negligent father, Lorenzo's distinctive mole is the only thing he ever shared with his children.

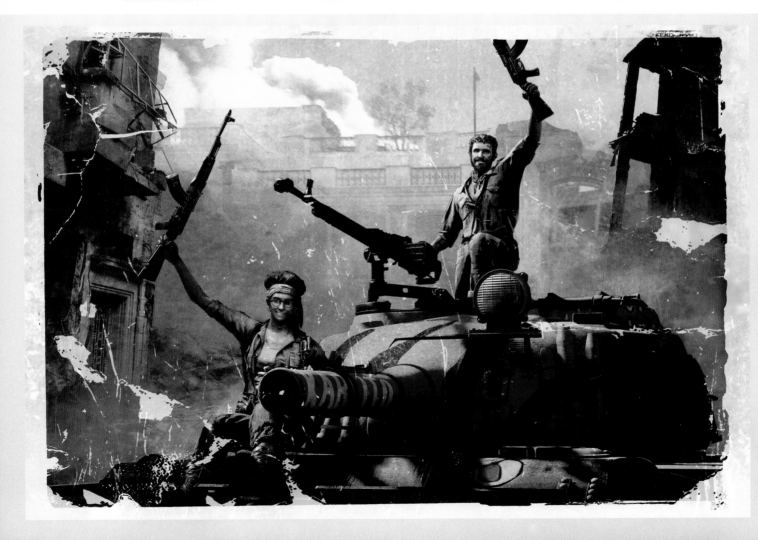

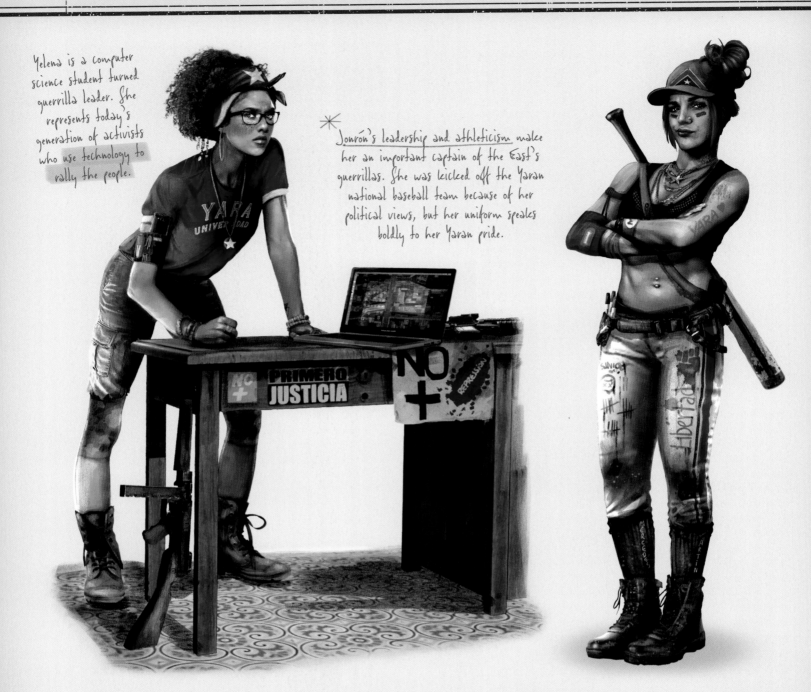

Yelena is a computer science student turned guerrilla leader. She represents today's generation of activists who use technology to rally the people.

Jonrón's leadership and athleticism make her an important captain of the East's guerrillas. She was kicked off the Yaran national baseball team because of her political views, but her uniform speaks boldly to her Yaran pride.

PRIMERO JUSTICIA

NO +

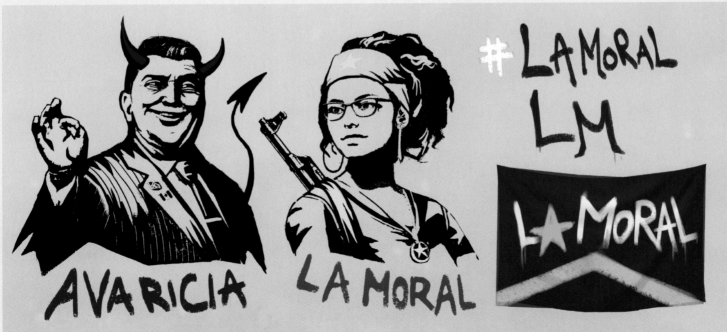

AVARICIA

LA MORAL

#LAMORAL
LM

LA★MORAL

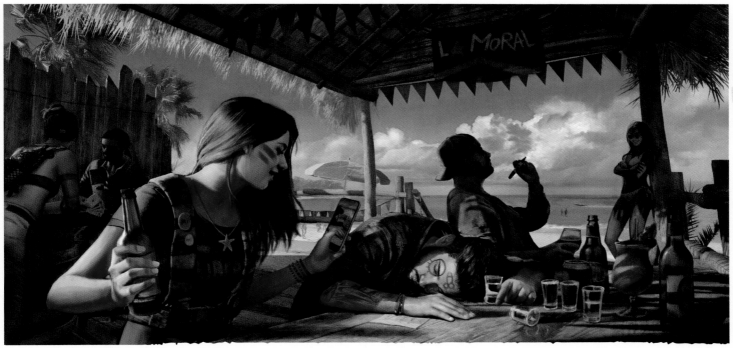

East Yara is about the contrast between old-school guerrillas and young ones. It was important that they felt different. The young rebels are still kids and sometimes act like it.

UNITE THE REGIONS
LA MORAL

The young rebels of El Este, organized and led by the firebrand Yelena Morales (from whom the group takes its name). Morales, a student turned activist turned guerrilla, garnered national attention when a video of her standing up to police went viral. Now, she aims to unite the disparate rebel groups in her region under one banner and stand up to Castillo's corruption and tyranny.

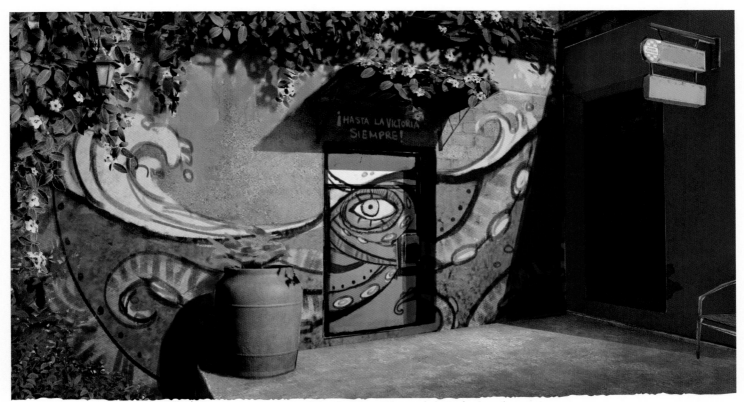

The mural on La Moral's HQ was inspired by a style of Afro-Cuban art typical of eastern Cuba.

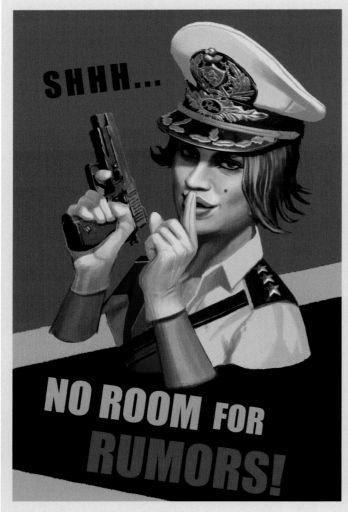

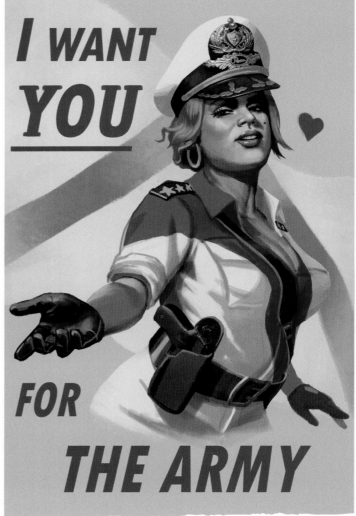

Rosa Mel's propaganda was inspired by World War II pinup posters; it fits her style.

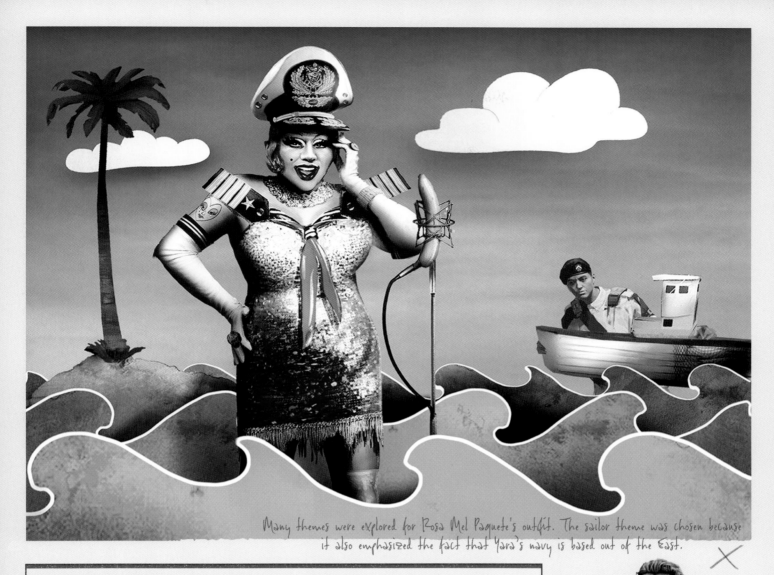

Many themes were explored for Rosa Mel Paquete's outfit. The sailor theme was chosen because it also emphasized the fact that Yara's navy is based out of the East.

ROSA MEL PAQUETE

Gilberto Rosario—better known as Rosa Mel Paquete—is a drag queen and guerrilla sympathizer who strikes back at a hypocritical and prejudiced government by amassing a spy network under the guise of his night job as a performer. Confident, politically savvy, and extremely charismatic, Gilberto fights for human rights through a unique form of playful resistance.

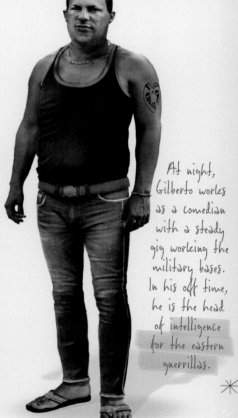

At night, Gilberto works as a comedian with a steady gig working the military bases. In his off time, he is the head of intelligence for the eastern guerrillas.

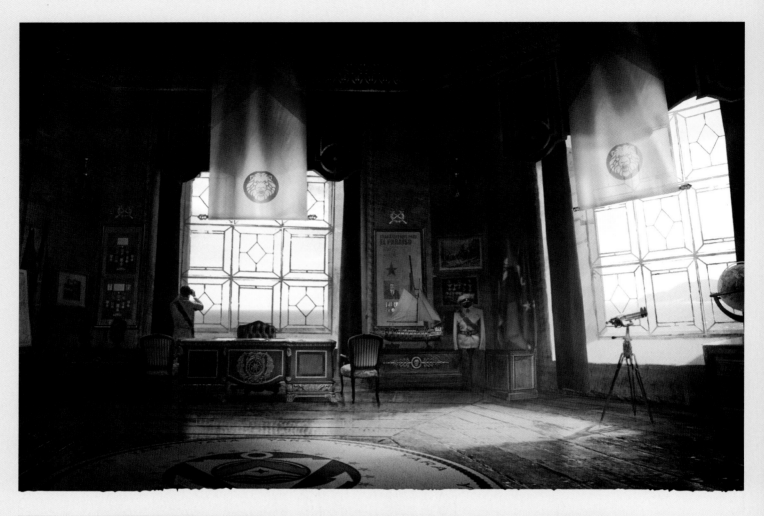

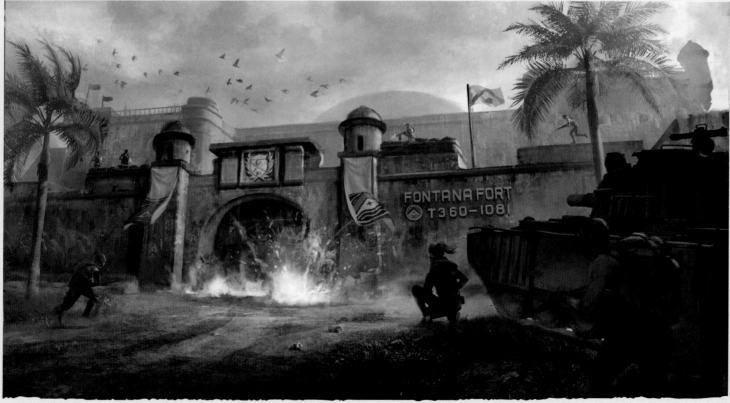

FONTANA FORT
T360-1081

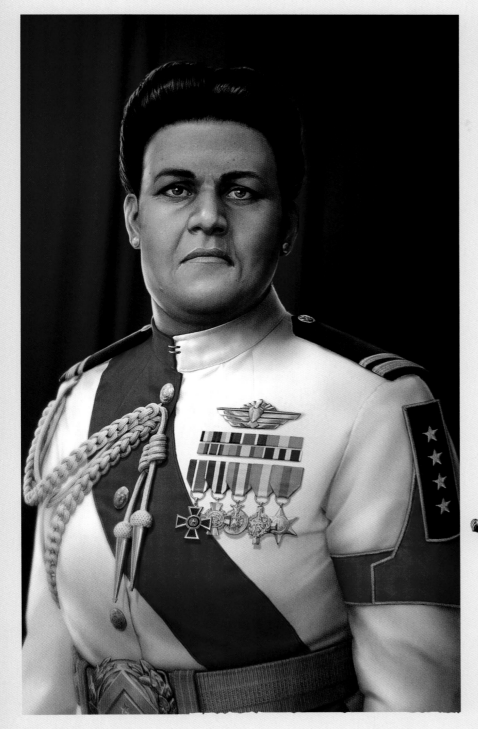

ADMIRAL BENÍTEZ

This ruthless maritime commander rose through the ranks of Yara's navy through the application of sheer force. She maintains an iron grip on the shores of El Este through a fearsome blockade and a working arrangement with import/export magnate Sean McKay. The admiral brutally punishes any who try to flee the country through her ports.

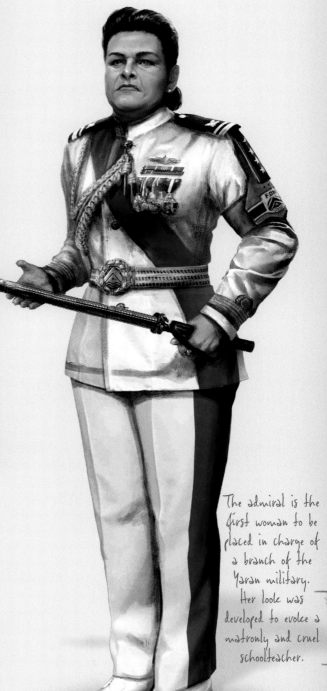

The admiral is the first woman to be placed in charge of a branch of the Yaran military. Her look was developed to evoke a matronly and cruel schoolteacher.

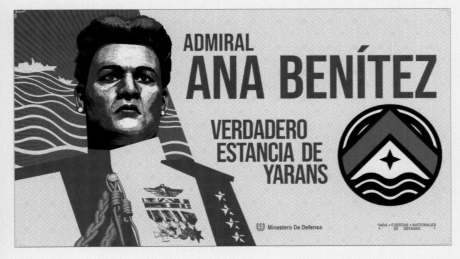

ADMIRAL
ANA BENÍTEZ

VERDADERO
ESTANCIA DE
YARANS

Minestero De Defensa

YARA + FUERZAS + NACIONALES
DE DEFENSA

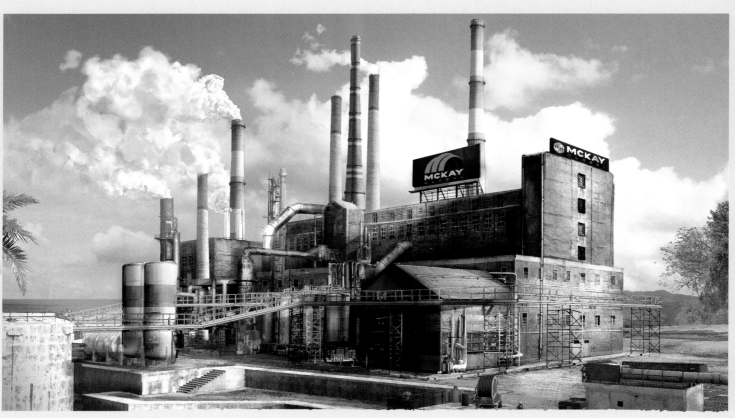

Based on a nickel refinery in Moa, Cuba, this crumbling building was taken over by McKay in order to develop a weaponized version of the Poison.

TO SAFEGUARD THE BEAUTY OF YARA SO THAT FUTURE GENERATIONS CAN ENJOY!

MCKAY
G L O B A L

McKay is no stranger to propaganda and manipulating public opinion. While he is slowly destroying Yara's environment, he prefers that people see him as a benefactor.

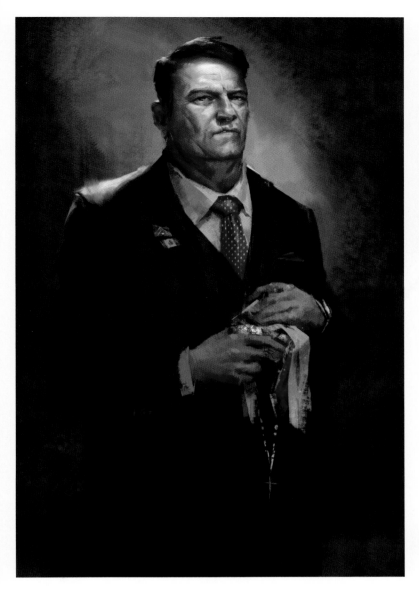

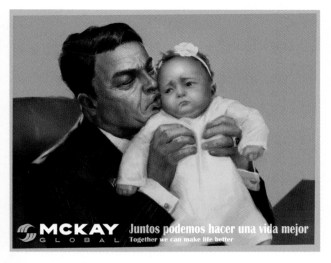

UNITE THE REGIONS
SEAN MCKAY

A Canadian import/export magnate and ruthless corporate tycoon, McKay heads the McKay Industrial Shipping & Freight company, which serves as a front for his international black-market smuggling operations. He brokered a deal with Antón for exclusive rights to all shipping in and out of Yara, along with control of production facilities to produce the PG-240 chemical. As access to the world outside Yara is critical to Viviro's success, McKay also enjoys a hefty cut of its profits.

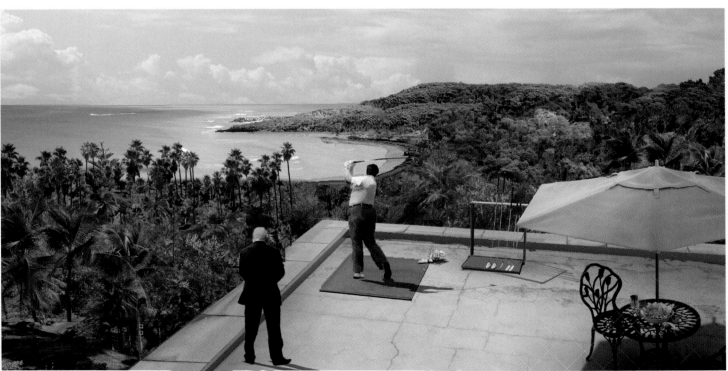

McKay was meant to seem arrogant and full of himself while at the same time possessed of the ability to persuade and influence people.

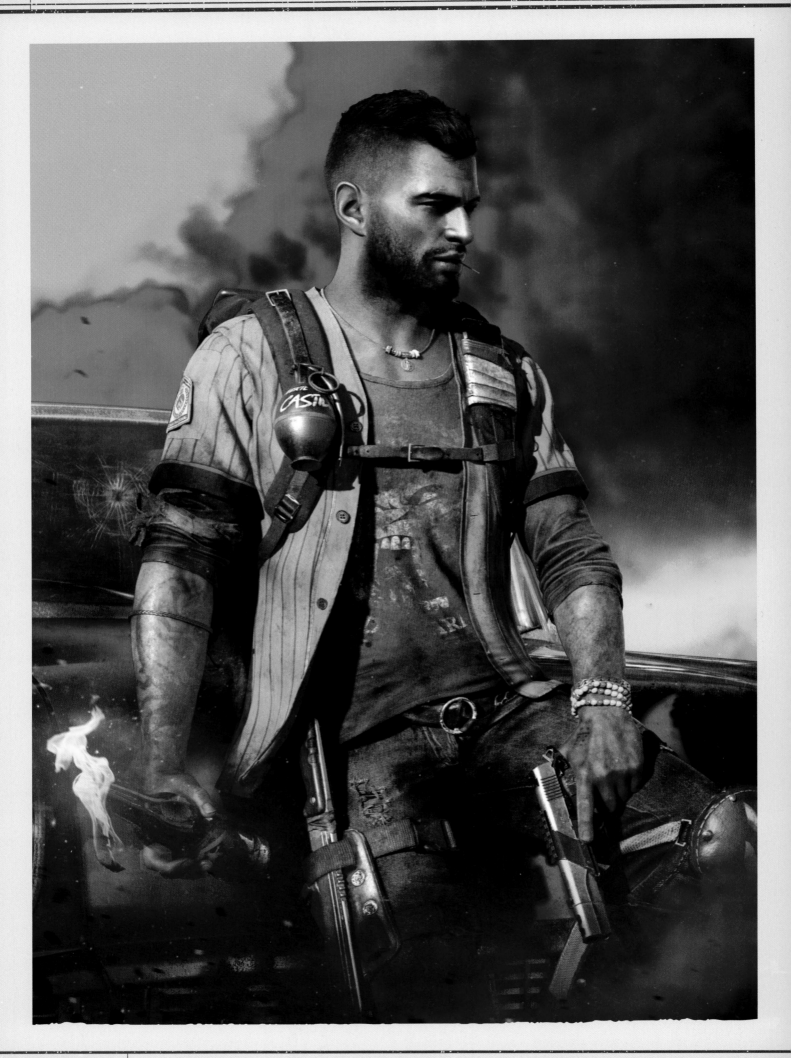

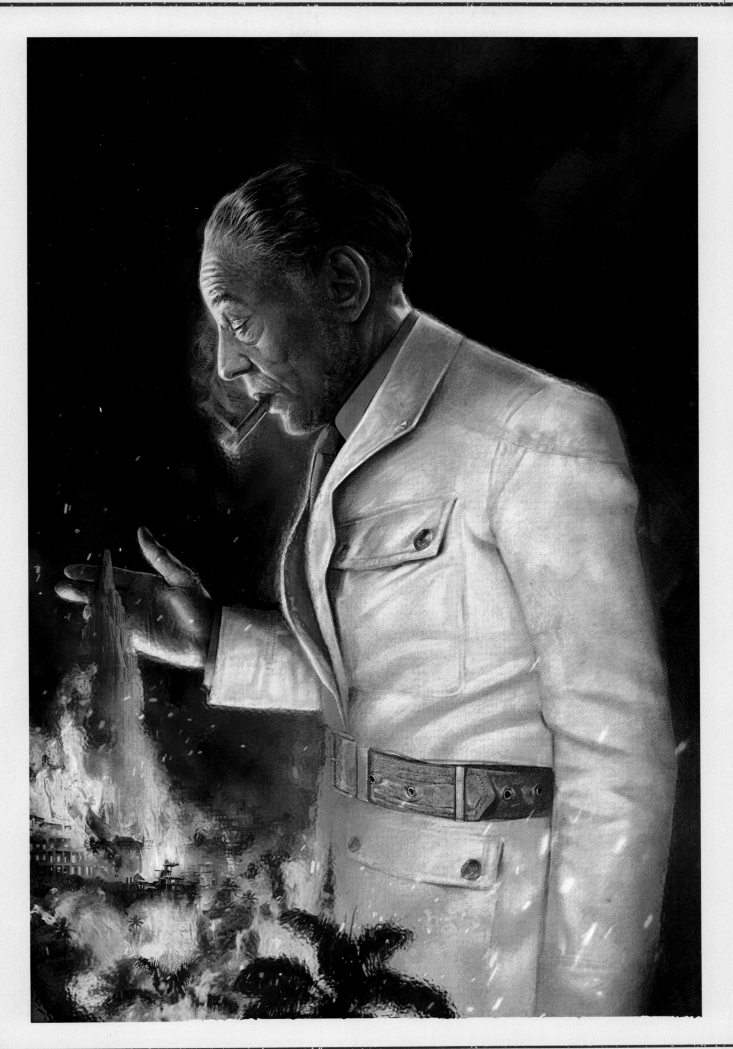

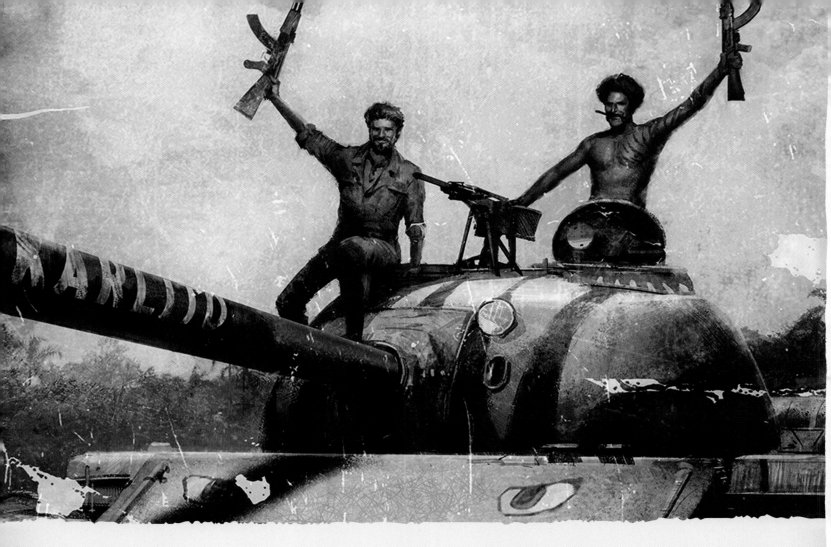

UBISOFT TORONTO

Denny Borges – Art Director

Christopher Babic – Associate Art Director (World)
Haine Kim – Associate Art Director (World)
Billy Matjiunis – Associate Art Director (Biomes)
Judy Suh – Associate Art Director (Object Bank)
Nick Tan – Associate Art Director (Branding and Gameplay)
Elliot Mallon – Associate Art Director (Characters)
Ian Marsden – Associate Art Director (UI)
Andrejs Verlis – Associate Director (World)

Branko Bistrovic – Lead Concept Artist
Marco Brunelleschi – Concept Artist
Jake Griffith – Concept Artist
Steve Hong – Concept Artist
Damjan Lazic – Concept Artist
Paul Leli – Concept Artist
Rachel Marsden – Concept Artist
David Mattiacci – Concept Artist
Damir Musken – Concept Artist
Dhenzel Obeng – Concept Artist
Vitalii Smyk – Concept Artist
Brian Zuleta – Concept Artist
Christophe Malarmey – Product Director
Bonnie Lim – Product Manager

Edwin Chan – Graphic Design Lead
Stuart Ure – Graphic Design Lead
Vincent Leli – Graphic Designer
Rob Sgrignoli – Graphic Designer
Amanda Properzi – Graphic Designer
Tyler Deblock – Texture / Graphic Artist

UBISOFT MONTREAL

Marco Beauchemin – Assistant Art Director (World)
Dominic Laforge – Assistant Art Director (World)
Greg Rassam – Assistant Art Director (Weapons and Vehicles)
Mathieu Faber – Lead Artist (Characters and Wildlife)

Fernando Acosta – Concept Artist
Ying Ding – Concept Artist
Stephanie Lawrence – Concept Artist
Serge Meirinho – Concept Artist
Miguel Angel Mendez Huerta – Concept Artist
Namwoo Noh – Concept Artist
Seifeleslam Ragab – Concept Artist
Pascal Savignac – Concept Artist
Mederic Ellul-Gravel – Product Manager

UBISOFT BERLIN

Eric Felten – Lead Concept Artist
Guido Kuip – Lead Concept Artist
Alexander Erhart – Concept Artist
Philipp Grote – Concept Artist
Helene Maas – Concept Artist
Noud Van Miltendburg – Concept Artist

Cover art: Helix Montreal

TEXT & CAPTIONS

Navid Khavari, Justin Cummings, Richard Elliott, Denny Borges, Branko Bistrovic, Marco Beauchemin, Dominic Laforge

A heartfelt thank you to our army of artists from World, Narrative, Object Bank, Concept, Characters, Wildlife, Branding, Gameplay, Weapons, Vehicles, UI, and Marketing across many Ubisoft studios who helped bring Yara to life.
Special Thanks: Mederic Ellul-Gravel, Caroline Lamache, Kay Huang, Daniel Ebanks, Graham Yaxley, Jacques Marcoux, Alexandre Letendre, Omar Bouali, Jennifer Owen, Chiara Turzi, the Wildlife Team at Ubisoft Shanghai, Brent Ashe, Helix Montreal, Christophe Ziatyk, and Yves Guillemot.

And a huge thank you to our *Far Cry* fans worldwide!

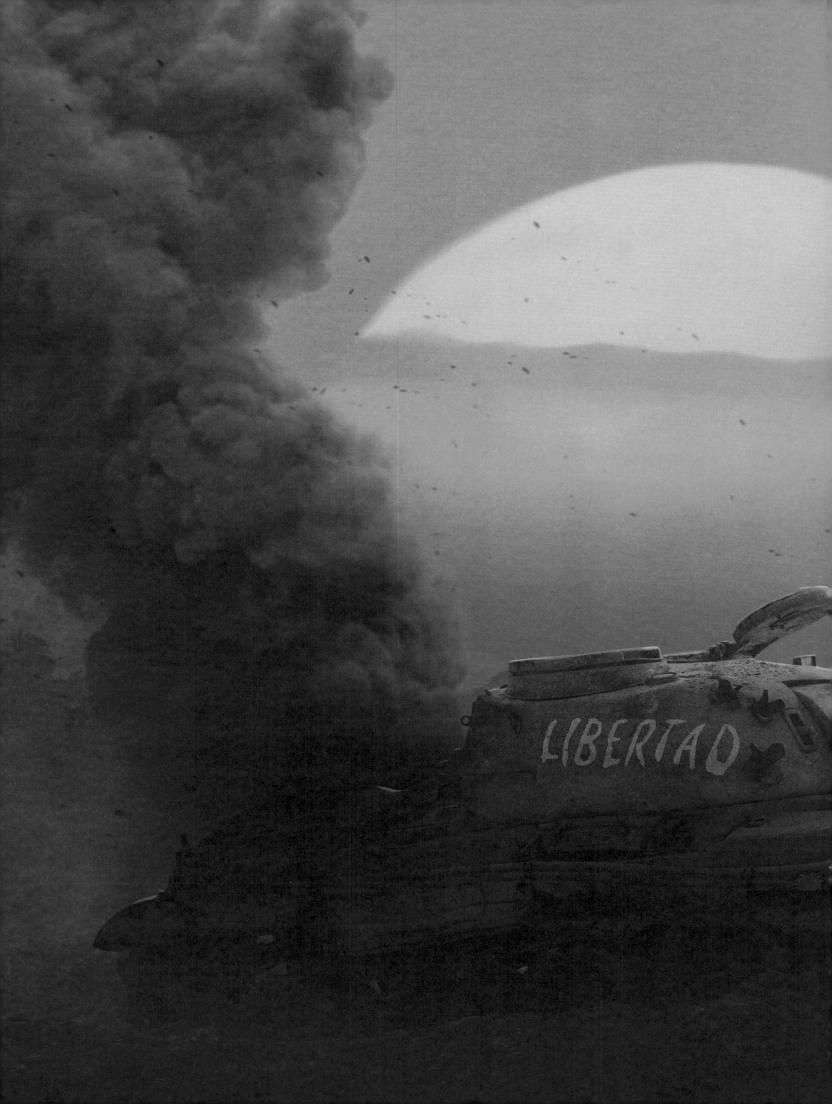